GLOUCESTER MASSACHUSETTS

ROCKPORT
PUBLISHERS

Design Secrets:
Products 2

50 Real-Life Projects Uncovered

Projects chosen by the Industrial Design Society of America

Cheryl Dangel Cullen and Lynn Haller

© 2004 by Rockport Publishers, Inc.
First paperback edition published 2006.

First published in the United States of America by
Rockport Publishers, Inc., a member of
Quayside Publishing Group
33 Commercial Street
Gloucester, Massachusetts 01930-5089
Telephone: (978) 282-9590
Fax: (978) 283-2742
www.rockpub.com

Library of Congress Cataloging-in-Publication Data available

ISBN-13: 978-1-59253-292-6
ISBN-10: 1-59253-292-6

10 9 8 7 6 5 4 3 2 1

Cover: Madison Design & Advertising, Inc.
Layout: Raymond Art & Design

Printed in China

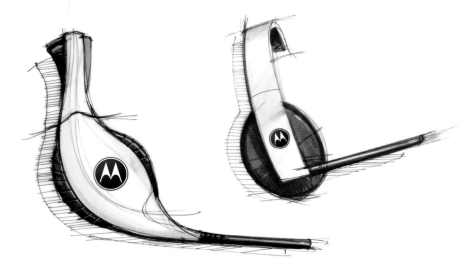
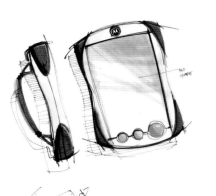

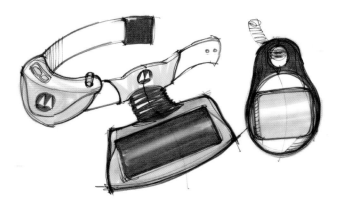

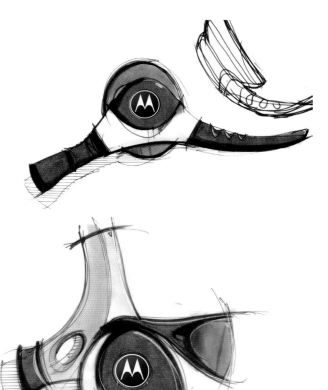
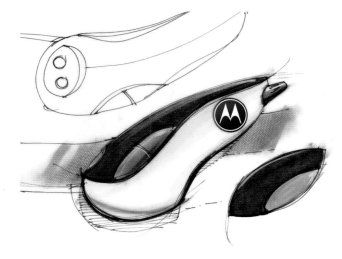

Motorola NFL Headset

contents

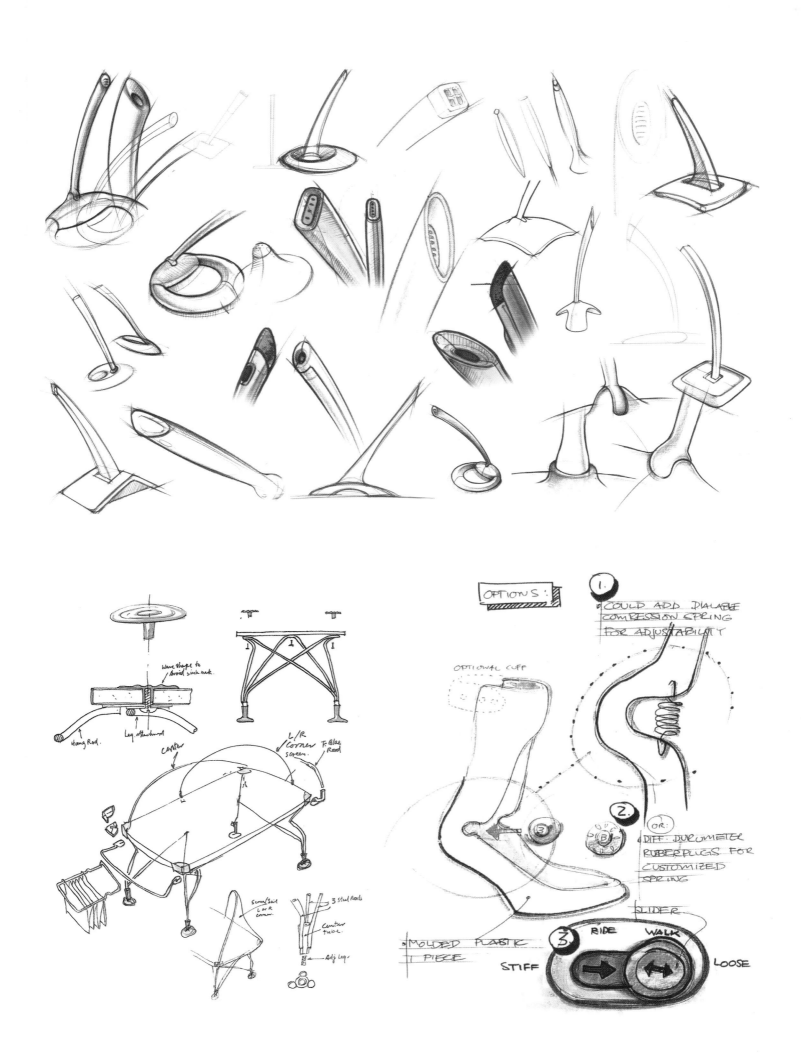

OPTIONS:

1. COULD ADD DIALABLE COMPRESSION SPRING FOR ADJUSTABILITY

OPTIONAL CUFF

2. OR: DIFF. DUROMETER RUBBER PLUGS FOR CUSTOMIZED SPRING

MOLDED PLASTIC 1 PIECE

3. SLIDER

RIDE WALK
STIFF LOOSE

Wave shape to avoid sink mark.

Hang Rod. Leg attachment.

Center L/R Corner screen. F. Glas Rod

Screw/Sail L or R corner. 3 Stud Rods

Center tube.

Adj. Leg.

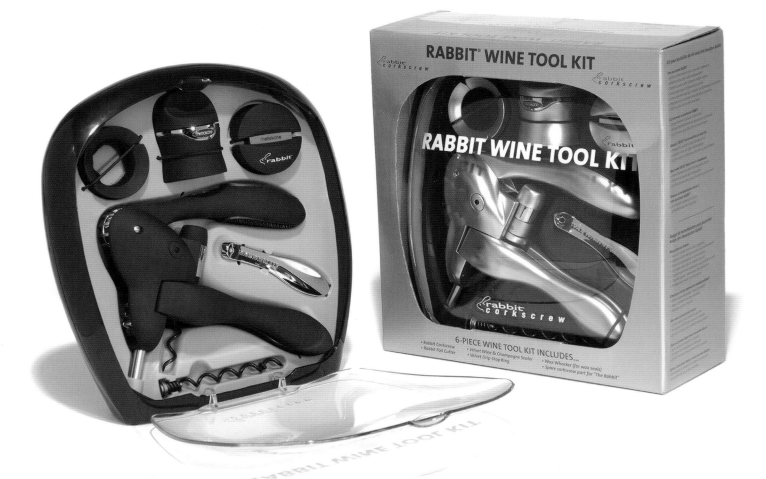

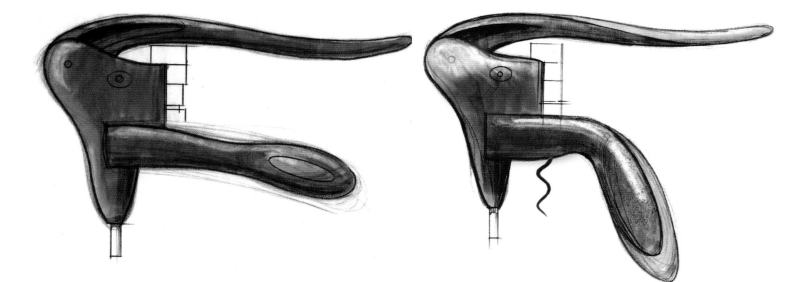

The Rabbit Corkscrew

Introduction

Design, a secret? In far too many ways, yes.

If you think industrial designers lay out factories, or if you consider them an anachronism in your company because they show you sketches and talk about the product experience, you—like most people—are having trouble pinpointing the contribution of industrial designers to business and the world around us.

"Secret" no more. This book, Rockport Publishers' second in this series, reveals the thinking and processes, the concepts, hurdles, and outcomes of industrial design's best efforts from the past three years. You'll see sketches, models, and final products. You'll read about how material choices were made to create a useful and pleasant feel, permit a particular form, or improve cost-effectiveness and ecological responsibility. You'll understand the approaches taken by designers in their user research, how they draw in cultural anthropologists, human factors engineers, other experts, and the users themselves to better understand what the user really needs and wants, not just what the user thinks would be best. You'll get a designer's first-hand view of these issues and more, and you'll never look at the products you use with the same eye again!

Perhaps most importantly, you'll have at your fingertips case studies, soup to nuts, of 50 designs that you can feel certain are excellent because they have been honored by the jurors of the Industrial Design Excellence Awards (IDEA). Sponsored by *Business Week* magazine, the IDEA honors work that excels in design innovation, benefits to the user, benefits to the company, ecological responsibility, and appropriate aesthetics.

That means that winning designs are more than dressed-up technological breakthrough, although these often create an opportunity for design breakthroughs. It also means that winners aren't just styling solutions with no depth of thought regarding use, manufacturability, shelf presence, recycling, toxicity, and shipping. The winners have solved the entire problem presented in the analysis of an opportunity.

Who needs to read this book? Anyone who has ever said—or heard—the following remarks.
- "I love the way this thing feels. I wonder how it got to be this way?"
- "Who decided to make this handle rubber? It's great, but why did it take so long to do it?"
- "I need case studies showing industrial design's impact on business strategy and branding for my MBA students" (or board of directors, for that matter).
- "We need case studies on great design solutions so industrial design students can learn from the best."

Design is a secret no longer. This book reveals the stories behind the world's most remarkable products, with fresh depth and visuals that go far beyond what all but the products' own designers are privy to. It's a new read in every way, even for the most experienced industrial designers, and the Industrial Designers Society of America (IDSA) is proud to endorse this book—and this series—and to cooperate in its production.

Kristina Goodrich
Executive Director
Industrial Design Society of America

BMW MINI Cooper How do you **redesign** an **icon?**

That was the **daunting task** set before the design team at **BMW** after the company purchased the **Rover Group** and decided to **redesign** the **Mini Cooper** for the new **millennium**— to turn the Mini into a MINI (as the **new version** is designated).

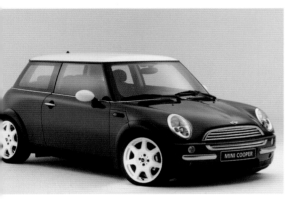

⊘ The MINI Cooper was voted Car of the Year by *Auto Express* magazine immediately upon its release in 2001.

The original Mini—designed by Alec Issigonis in response to the needs of a British public faced with gasoline rationing—was released in 1959 and quickly became both a design and an engineering icon to car enthusiasts throughout the world. While celebrities loved the Mini's chic look, the affordability of the car made it equally popular with less wealthy people. Issigonis' revolutionary design, which included cabin space–saving measures such as a transverse engine with surmounted transmission and wheels positioned on the far corners of the chassis, went virtually unchanged for decades. In 1995, *Autocar* voted the Classic Mini "Car of the Century," and in 1998, *The Guinness Book of World Records* named the Mini the most successful British car of all time. The Mini Cooper model, engineered by race car constructor John Cooper in 1961, capitalized on the original Mini's roadworthiness and developed that aspect further; the Mini Cooper's triple Monte Carlo rally wins between 1964 and 1967 added to the prestige of this model, and thus it was the first Mini chosen for relaunch.

The MINI team had a challenge on its hands—they had to keep the spirit of the original, much-loved design while making the new model fit for the twenty-first century. As Gert Hildebrand, head of MINI Design, points out, "Ninety percent of the car is determined by outside factors—legislation, engineering, production capabilities, materials, costs, marketing, and brand relevance." And many of these factors had changed dramatically since 1959.

One fact was clear: This MINI would have to be larger than the original model. The law now requires air bags; consumers expect high-fidelity audio components, plush seating, and air conditioning. These features—none of which were included in the original Mini—require space. There were demographic issues, too. Says Hildebrand, "People are 4 inches (10 cm) larger than they were in 1959, so the car had to be bigger."

With these parameters in mind, the MINI team decided on the theme of this new model: "From the original to the original," an acknowledgment of the Mini's iconic status and the team's desire to preserve the design features that made the original such a classic. "There was so much unique aesthetic capital for this brand that was important to keep," explains Hildebrand, "because no other car has these design features, like round headlamps incorporated in a big hood or an add-on roof that you can paint in different colors."

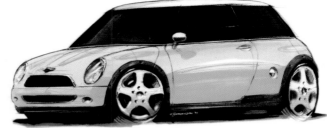

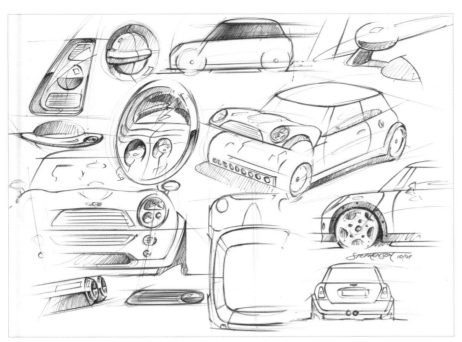

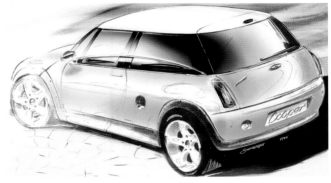

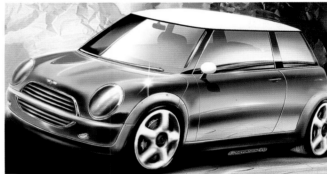

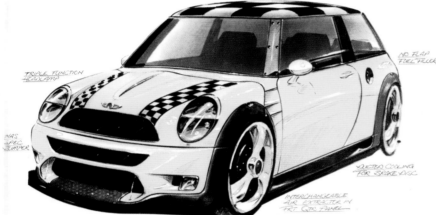

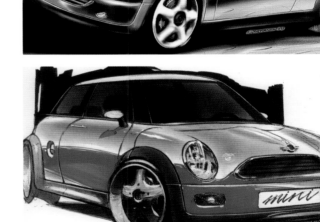

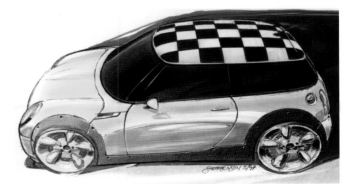

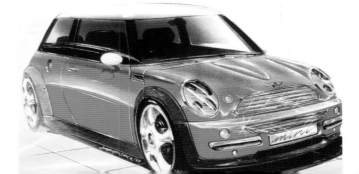

⌃ Above: In these early sketches, the designers began brainstorming about how the circular and semicircular "form recipe" would be carried out in the new model.

⌃ Below: This early sketch, featuring a mesh grille, tips its hat to the racing history of the Mini. The team ultimately rejected the design because they felt it looked too aggressive.

▷ Sketches of the MINI, from the original idea (top) through ideation to presentation (bottom). Hildebrand calls the sketch (top)—drawn by Frank Stephenson—the one where the basic design of the new MINI was born. Further sketches show this idea as it continues to be refined.

In 1995, three teams—one at Designworks in Los Angeles, one at the BMW Group headquarters in Munich, and one at Rover in Longbridge, England—began sketching and brainstorming ideas. Along the way, BMW decided that 10 iconic features would be taken from the classic Mini and transferred to the new model; those features included front-wheel drive, round headlamps, short overhangs, and spats. The team agreed that the "form recipe" of the Mini—both old and new—was its circular and semicircular elements. Hildebrand says, "You have the round headlamps, the round wheels—everything is created around the most functional geometrical element [the circle], so even the door, which is ellipsoid, has circular elements, such as the speakers and the handles."

Nine designs were selected to be made into clay models. While these models featured fully functional interiors, they did not actually run. The models only enabled management to get an idea of how each proposed design would look and feel.

The design team continued to sketch and refine the details of the interior and exterior design. "Modeling is a very expensive process; sketching isn't," says Hildebrand. "The more you sketch,

the faster you can model. That's why car designers must have a greater ability to draw than normal designers, because designing a car is a very expensive and time-consuming process."

Throughout this phase, the team worked to reinterpret the Mini's classic styling for a new era. An average car has 7,000 parts—roughly half of which are visible—so thousands of design decisions must be made at this stage. For instance, some early design sketches featured a futuristic control pod that was ultimately rejected as being too modern to look right in the new car. A center console flanked by down tubes—which brought to mind the roll cages on the old racing Minis—was selected instead. Often, the team explored new interpretations for the MINI but rejected them in favor of the original design solution. For instance, they explored body-colored fenders but ended up choosing the contrast-color fenders of the original Mini.

After reviewing all the ideas, MINI selected a design developed by the Munich team as the design that best exemplified what they were looking for. They based the first, very primitive running prototype on this design. While the prototype was created primarily

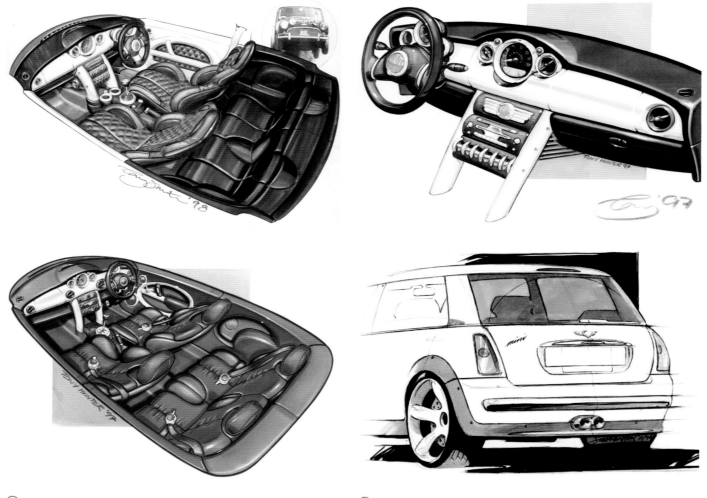

Two of the hundreds of sketches the team created while refining the interior. Since there are more parts in the interior than on the exterior, the interior is more complex; the bottom sketch is closer to the final interior of the car. Both sketches show how the designers attempted to carry out the circular theme in even the smallest details of the interior, such as the air vents and the buttons for the radio.

Above: While the team considered a three-spoke steering wheel, they went with this two-spoke steering wheel because they thought it looked more distinctive. The team also considered putting the speedometer with the rev counter above the steering wheel but ultimately preferred the symmetry of this design.

Below: "The car has three main sides: the side, the front, and the rear," explains Hildebrand. "Normally, when designing, you start with the side and the front, and a lot of designers forget the rear. The rear is a very important part, especially on the MINI, because it's so fast that you normally see it from the back."

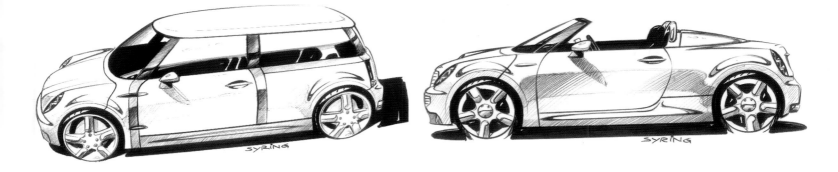

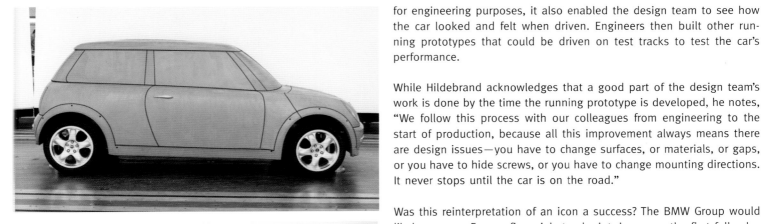

These early brainstorming sketches, by Marcus Syring of the Munich team, provide a peek at where the MINI may be headed; a variation on these ideas— the MINI as a convertible—is scheduled to become a reality in summer 2004.

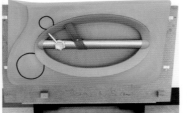

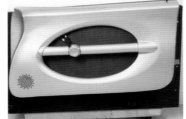

Above: This was only one of the nine clay design models developed by the MINI design team.

Below: The clay model of the door panel, unpainted and painted. Since clay models can be painted, they provide the team with a good opportunity to test various colors and trim. Says Hildebrand, "Color and trim are big issues, especially for the MINI, because it has separate roof colors."

for engineering purposes, it also enabled the design team to see how the car looked and felt when driven. Engineers then built other running prototypes that could be driven on test tracks to test the car's performance.

While Hildebrand acknowledges that a good part of the design team's work is done by the time the running prototype is developed, he notes, "We follow this process with our colleagues from engineering to the start of production, because all this improvement always means there are design issues—you have to change surfaces, or materials, or gaps, or you have to hide screws, or you have to change mounting directions. It never stops until the car is on the road."

Was this reinterpretation of an icon a success? The BMW Group would likely say yes. From a financial standpoint, in 2002—the first full sales year after the relaunch—more than 144,000 MINIs were sold, exceeding expectations by 40 percent. The MINI also grabbed many major design and automotive awards, including *Auto Express* magazine's Car of the Year award (2001) and Edmunds.com Most Significant Vehicle of the Year award (2002). Apparently, the MINI also has some of the star power of its predecessor—it was prominently featured in the 2003 film *The Italian Job*.

Hildebrand expresses satisfaction with the team's work. "If Issigonis had done the car 40 years later," he says proudly, "it would have looked the way it looks now." Even so, the team can't rest on its laurels; as Hildebrand reminds us, "The design process never stops. Even though this car has been in production for two years, we continue to work on improvements." The team is also developing a MINI four-seater convertible, due out in mid-2004.

Chrysler's PT Cruiser (PT is short for **personal** transportation) came about when **senior management** tasked a team of **designers** with exploring what they called a "**tall car** package,"

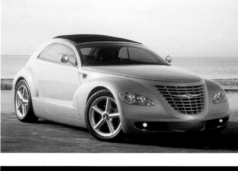

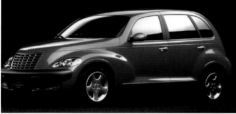

⊗ "The beauty of PT Cruiser is everyone can see a different era in it, but ultimately the vehicle stands on its own for its interior flexibility", says Ferrerio. "Some may look at it and see scenes from a 1930's street scene in Chicago; others may look at it and see Frankie and Annette on a beach in the 1960's; but a younger audience may just fall for the vehicle because it's cool and they can fit their stuff in. And, no matter what you see in the exterior, the interior delivers on that promise by providing a flexibility that makes PT Cruiser a cool vehicle that you can live in."

⊗ The instrument panel is symmetrical, with a 'heritage look." Designers wanted to bring the outside in and originally considered exposing the painted interior door sheet metal, but when this proved impractical, they color-keyed the symmetrically opposite instrument cluster bezel and passenger door air bag for a distinctive appearance.

hoping to create a compact-size vehicle that would offer distinct interior advantages over the usual car in that class.

Despite the PT Cruiser's unique exterior appearance, the car was actually designed from the inside out. The intent was to provide the customer with surprising roominess combined with unexpected seating and cargo-carrying flexibility.

But not just any vehicle would do. The vehicle had to be distinctive and offer the customer greater value than others in its class, so the decision to design a tall car package made perfect sense. A tall car package gives the customer a large-car interior combined with unsurpassed flexibility. DaimlerChrysler called upon its designers' expertise to make the unusually proportioned tall car attractive, both inside and out.

With its heritage-look exterior, the PT Cruiser presented a unique challenge to the interior designers, a team headed by Jeff Godshall, senior manager of interior design, DaimlerChrysler. "From an appearance standpoint, the interior design team operated with the idea that the aesthetic function of the interior is to complete the promise made by the exterior," Godshall says. "Thus the instrument panel is symmetrical, both as a 'heritage look' statement and to easily accommodate right-hand drive conversion with a minimum of additional tooling. We also wanted to bring the outside, inside. We originally considered exposing the painted interior door sheet metal, but when this proved impractical, we color-keyed the symmetrically opposite instrument cluster bezel and passenger air bag door for a distinctive appearance."

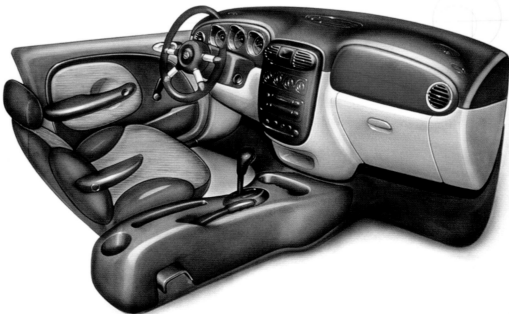

To unify disparate elements within the interior, a circular theme was chosen for the cluster dials, A/C outlets, steering wheel hub, and map pocket detailing. "We considered several different instrument panels, one of which featured large removable speakers at either end. Another panel utilized a motorcycle-style instrument cluster grouping, which clinic participants viewed as fragile. The chosen design featured a 'browless' cluster with the curricular dials recessed in bright-ringed tunnels, thus avoiding the usual overhanging brow," says Godshall.

For functionality, each door trim panel was fitted with a large integral map pocket, but the map pockets' circular see-through holes were the result of the designer's experience with his own children, who were notorious for leaving things behind in the pockets.

When the original manual transmission shift knob and boot looked too conventional, the team came up with the heritage 'cue-ball' shift knob, to the delight of customers. And when the initial corporate steering wheel was judged not in keeping with the interior theme, a new four-spoke steering wheel with a compact circular hub was designed and approved. To improve the vehicle's cargo-carrying ability, a new suspension system was specially designed that enabled the rear wheelhouses to move further outboard, expanding the width of the rear cargo compartment. In each case, the team, with the backing of engineering and product planning, was able to do what was right for the vehicle. Much attention also was given to the five-position shelf panel, a blow-molded plastic tray with carpet on one side. Designed to move as easily as an oven rack, the shelf panel fits into specially designed recesses in the left and right rear quarter panels. In its "tailgate party" position, the panel protrudes beyond the liftgate opening, supported by a simple plastic leg that swivels into position. Owners can use this waist-high shelf as a table for food and beverages. Careful detailing and choice of materials, including chrome exterior and interior door handles and a thoughtfully chosen variety of interior textures and finishes, impart a feeling of quality above customer expectations.

Challenges involved with the design of the PT Cruiser's exterior were also numerous. "Combining the unlikely common elements of a truck and small car was not easy," says Steve Ferrerio, design director of the Advanced Design Studio, DaimlerChrysler Corporation. "The exterior was unlike anything on the road, so when you break into new territory, there's always a bit of tension in the marketplace. Clearly, we hit a sweet spot with the vehicle, and it turned heads.

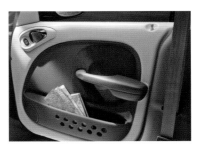

⊽ Additional advantages of the "tall car package" include improved ingress/egress, "command of the road" seating for the driver, raised "theater seating" for rear seat passengers, and generous leg and headroom all around.

⊳ Since kids sometimes leave candy bars and other undesirables in the map pockets, designers integrated see-through holes in them. During development, they also modified the design of each door slightly so each side door armrest and door bolster could be used on both the front and left rear doors, reducing tooling costs.

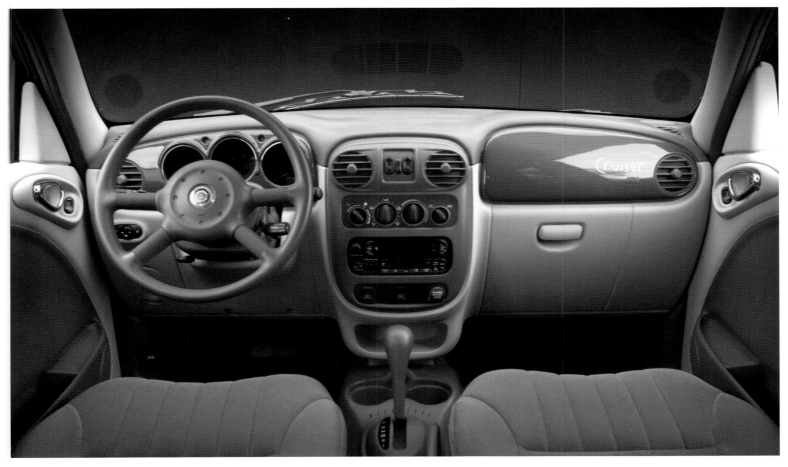

"Part of that appeal, ironically, was there was a true love/hate out there—those that loved the vehicle really loved it and had to have it. Those that hated it on first glance were captivated. That tension created a draw or appeal, and that is what drew the attention to the vehicle."

Ferrerio, who headed up the exterior design, says that the secondary challenge was for the vehicle to deliver on the interior and not just be seen as a novelty. "The PT Cruiser has all the fun and jaw-dropping exterior cues but will also fit an 8-foot (2.4 m) stepladder from the front seat through to the rear based on the seating," says Ferrerio.

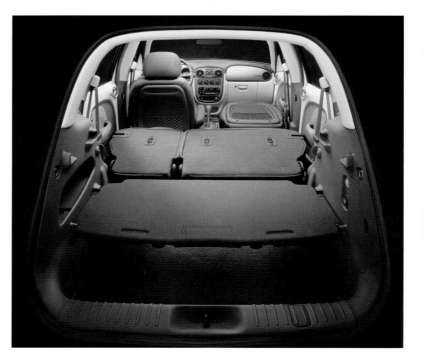

"The ideation process is especially critical when it comes to a project like this," Ferrerio adds. "Normally when a designer searches for a concept or idea, he or she wants the most flexible tool as possible and that is a pencil or ballpoint. 'Something much tighter' is what is used in the rendering of a completed idea. Once a sketch is chosen, the standard three-view orthographic drawing is usually done to communicate that idea to start the 3-D process. In this instance, we worked with a modeler or team of modelers to create a full-size clay model. The model is made to look like a real car as much as possible, including darkened windows, painted body, and a lot of detail, with 2-D mock-ups to complete the image. They are pretty convincing and can be evaluated by upper management to ensure our objectives are being met."

Throughout the design process, Chrysler engineers used the CATIA system. Designers used a combination of freehand sketching and computers. Some tasks, such as the interior door remote handle, however, demanded real-world interaction between the designer and a clay sculptor.

"The design of the interior of the PT Cruiser was a liberating experience. Since both the package and the exterior were so unconventional, the interior design team had to look at designing an interior from an entirely new viewpoint. Nothing was set," says Godshall. "While our initial thinking was to design an interior with a place for everything and everything in its place, our customer focus groups demanded instead a 'duffel bag' approach. 'Give us the space,' they told us, 'and we'll decide how to use it.' Thus we designed the flexible fold-flat/removable seats and the five-position shelf panel, which demonstrate what is possible through creative design. One clinic participant even asked, 'Why don't all cars do that?' Most of all, the PT Cruiser interior is a prime example of the joy of working with a team of people, all of whom spelled the word 'no' K-N-O-W."

"The beauty of PT Cruiser is that everyone can see a different era in it, but ultimately the vehicle stands on its own for its interior flexibility," says Ferrerio. "Some may look at it and see scenes from a 1930s street scene in Chicago; others may look at it and see Frankie and Annette on a beach in the 1960s; but a younger audience may just fall for the vehicle because it's cool and they can fit their stuff in it. And, no matter what you see in the exterior, the interior delivers on that promise by providing a flexibility that makes PT Cruiser a cool vehicle that you can live in."

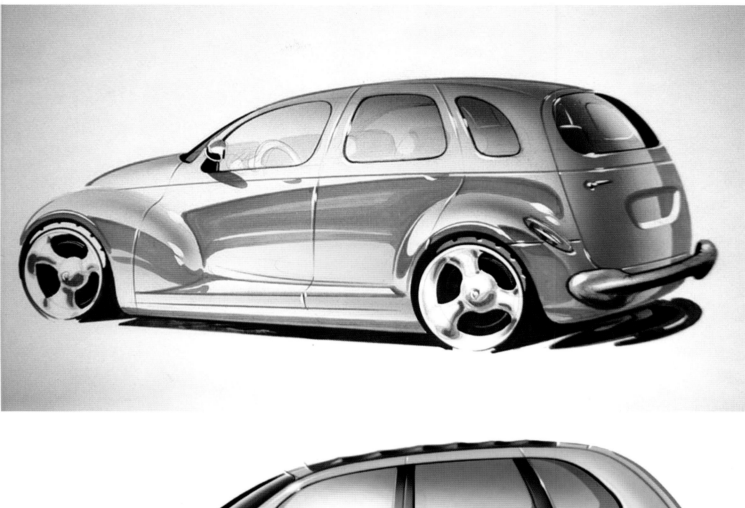

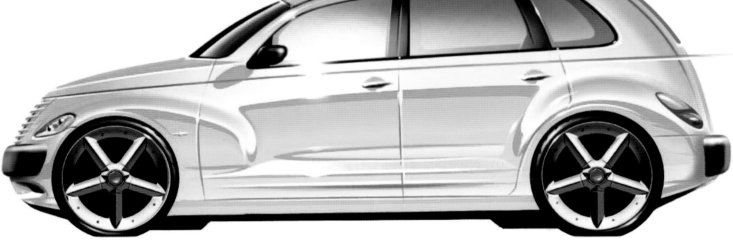

⬰ Opposite top: The PT Cruiser can carry five people in comfort or can be converted into a four-, three-, two-, or even one-person vehicle. The passenger front seat can be folded flat. The rear seats can be folded flat, tumbled forward, or removed entirely. When combined with the innovative five-position movable rear shelf panel, over thirty interior combinations are possible. The flexible interior can even accommodate an 8-foot (2.4 m) ladder with the liftgate closed. Despite its shorter wheelbase, the Cruiser's 120 cubic feet (37 m^3) of interior space is equal to that of the larger Dodge Intrepid sedan.

⬰ Opposite middle and bottom: To arrive at the desired shape of the interior door remote handle, from both an aesthetic and a functional perspective, a clay sculptor took the designer's sketch and carved a model from balsa wood, permitting evaluation by both the eye and the hand. After numerous iterations, the final handle design was determined, satisfying both ergonomic and aesthetic considerations.

⬯ "The exterior was unlike anything on the road, so when you break into new territory, there's always a bit of tension in the marketplace. Clearly, we hit a sweet spot with the vehicle and it turned heads," says Steve Ferrerio, design director, Advanced Design Studio, DaimlerChrysler Corporation, of these early renderings.

Segway Human Transporter If you **lean forward**, do you **fall down**? Well, not usually—your sense of **balance** will **trigger** you to put your leg forward, **preventing** a fall.

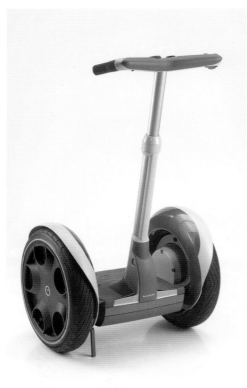

If you keep leaning forward you will intuitively keep putting your legs forward, keeping you upright. This principle of balance is what lies behind the Segway Human Transporter, which uses this principle to keep itself upright while transporting people.

Dean Kamen, an entrepreneur and inventor who holds over 150 patents, observed the problems wheelchair-bound people had with climbing stairs and negotiating sand, curbs, and rocks, and he realized that balance was key to giving these people mobility. In response, he developed the IBOT™ Mobility System, a transport device that restores users' balance while enabling them to see the world at standing eye level. He then saw an opportunity to apply this technology to solve one of the biggest problems faced in twenty-first century urban settings—moving people (and products) relatively short distances while using less energy. As Kamen noted on the Segway's release, "With over 80 percent of the world's population soon to be living in urban areas, we believe that the Segway HT can, over time, play a vital role in these areas."

The system Kamen envisioned also had numerous commercial applications: It could improve the speed and efficiency of mail and product delivery, manufacturing and warehousing operations, and public safety. Kamen put together a team to make his vision a reality.

The engineering team worked to hone a breakthrough technology that the company termed *dynamic stabilization*, a system of gyroscopes and tilt sensors that monitor a user's center of gravity 100 times a second, working seamlessly to maintain the user's balance. Since this was a brand-new technology, the industrial design team worked closely alongside engineering with their own goal in mind: to make the technology less intimidating to users. Says Scott Waters, industrial design manager for Segway, "Our feeling was that, when you're introducing something as new as this, you run the risk of scaring people, and we didn't want this robot with motors hanging off of it and wires everywhere; we wanted it to be very clean and simple and honest."

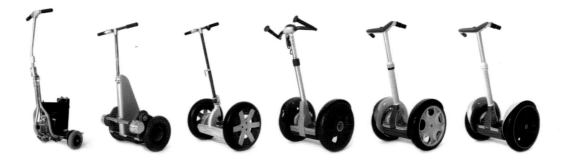

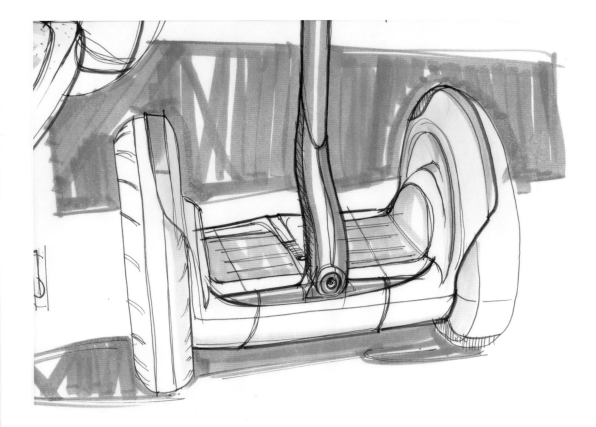

⊘⊘ Three illustrations of the detail of the inner wheel of the Segway: at the top is an early sketch; the photo above is of a $\frac{1}{3}$ scale sketch model crafted in foam; the photo at right shows a detail of the finished product. The close integration of design and engineering throughout the process negated the need for radical changes in design direction through the process of product development.

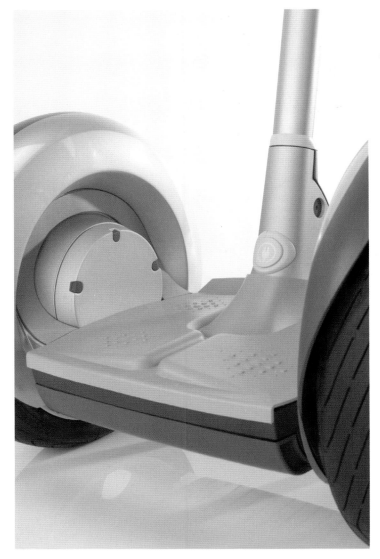

They developed a design philosophy document to guide them in the product's creation. One of the primary guiding principles laid out in this document was one they called "man max, machine min," which Waters explains as "the idea that the hardware of the machine shouldn't take up any more space than is necessary, that any space that could be dedicated to the user should be taken away from the hardware, so the idea literally was to just shrink-wrap the hardware around the technology." The original prototype exposed its mechanical elements to the user, and subsequent early prototypes were boxy and unwieldy. The design team worked to hide the technology and to reshape the vehicle, carving out the airspace behind the fender to minimize the space between the wheel and the body of the machine.

While the feel and the aesthetics played their part in reshaping the vehicle, functionality could not be forgotten: The curve of the fender was reshaped to carefully balance the need to shield users from spray with the need to minimize any bulk that would cause the fender to hit other objects or to be torn off. A round tube was chosen for the control shaft because it was the easiest shape to make both adjustable and sealed.

Planning the materials to be used for the manufacture of each piece also required a careful balance of functionality and aesthetics. While the designers originally planned to make the control shaft from metal tubing, the part did not have the appearance they sought, and combining the electronics and wiring with the handlebar proved difficult. In the end, they decided to make the control shaft plastic; the clamshell was vibration-welded shut, which made it watertight and helped prevent electromagnetic interference.

Many of the other parts were planned to be plastic, both for durability and ease of manufacture, but that created other problems. For the sake of durability, the team had wanted the wheels to be plastic, but aesthetically, this choice proved challenging: Though they planned for the part to be a light color, the team discovered that UV exposure to plastic caused it to yellow. A painted finish was not an option—it would add cost and would chip and scratch easily—so the wheel was changed to a dark color to compensate.

The core structural components are die-cast aluminum, which again created challenges: The design team sought a finish that would hold up to the elements while looking good, so after some experimentation, they chose a powder coating for most of the metal surfaces. Waters says they wanted the finish of the Segway to be as beautiful as the surface of a car or bicycle, but more durable: "We wanted it to be a useful item; we didn't want it to be something you had to constantly be caring for and worrying about. We wanted it to be subservient to the user, not vice versa."

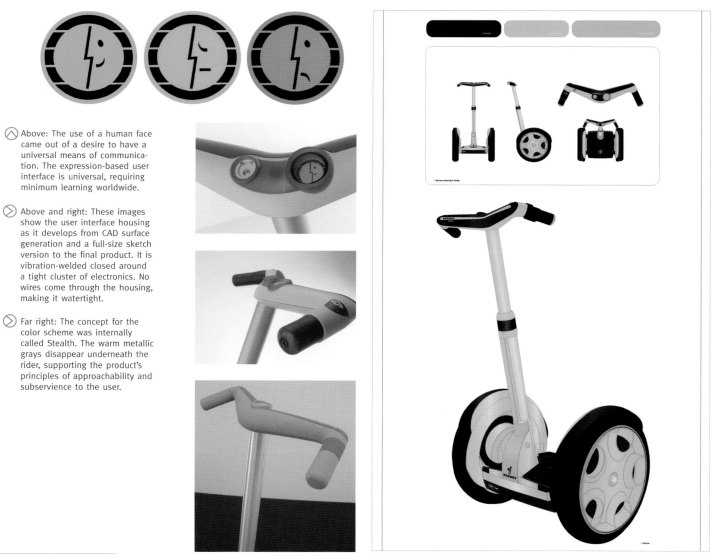

Above: The use of a human face came out of a desire to have a universal means of communication. The expression-based user interface is universal, requiring minimum learning worldwide.

Above and right: These images show the user interface housing as it develops from CAD surface generation and a full-size sketch version to the final product. It is vibration-welded closed around a tight cluster of electronics. No wires come through the housing, making it watertight.

Far right: The concept for the color scheme was internally called Stealth. The warm metallic grays disappear underneath the rider, supporting the product's principles of approachability and subservience to the user.

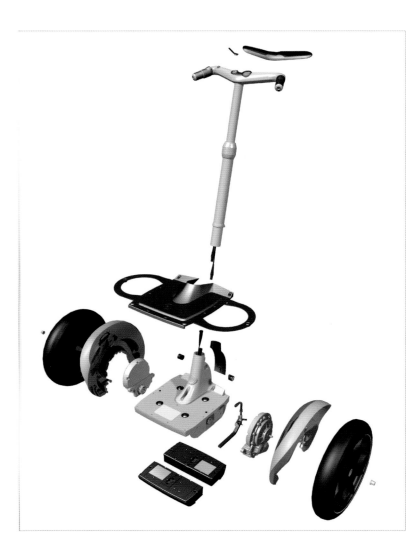

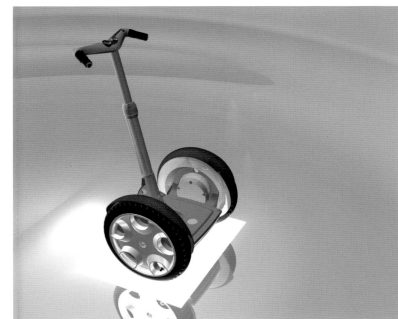

These CAD renderings show the Segway exploded and assembled. It has approximately 20 subassemblies and can be assembled in 20 minutes. Parts such as the motors, transmissions, wheels, and fenders are shared by the left and right sides of the machine, greatly reducing the cost of inventory.

Making the user interface simple and seamless was another key goal. While early prototypes conveyed technical information about heat dissipation off certain components and status of the balancing technology, in the end, the team wanted to distill this technical information and to tell users only what they needed to know. Since they planned to sell the Segway internationally, the team brainstormed ways to communicate to the user without language. "As we were developing this, we discovered that the easiest way to communicate information is through human expression," says Waters. "It's built into all of us—a baby can recognize the smile on its mother's face and smile back, so that was the icon that we used to convey the status of the machine to the user." To signal that the Segway is operating properly, a smiling face appears on the display. If the machine overheats or experiences a malfunction, the display turns red and the face frowns; a simple battery gauge indicates whether the battery is empty or full. The smile on the display has since become an icon for Segway users—at a recent Segway user conference in Chicago, one user proudly displayed the face as an ankle tattoo.

Attention to detail is manifest in every part of the Segway, even in the sound the gears make when it is in motion; the meshes in the gearbox produce tones exactly two musical octaves apart. "The best products out there are crafted to be this experience so every time you push a button it feels a certain way. There are all these tactile and audible qualities that make something what it is," says Waters. "It's not something you would necessarily pick up on unless you were told, but if it's done wrong, you definitely know it."

Throughout the process, the group relied on their own instincts for what the product should be and how it should work; they did not work with focus groups. "Different people have different philosophies here, but it's my opinion that consumers don't necessarily know what they want until you show it to them," says Waters. "And there's kind of a power in having a good group of people together who have strong, intuitive qualities to making something good. I don't believe that a lot of great products are born out of focus groups." The team did do user testing, primarily centered on safety issues.

While it would be hard for the Segway to meet the lofty goals Kamen set for it on its introduction, the Segway has become a product with passionate devotees. It has been adopted or tested by a number of municipalities—including Seattle and Atlanta—and has been tested for more widespread use by the U.S. Post Office. Commercially, it is being used for many of the applications Kamen had envisioned—on college campuses, for public safety, and in manufacturing warehouses. Two new versions have been developed since the product's introduction: the p series is a lighter version, and the e series has cargo capabilities, including a cargo rack, storage bags, and an electronic parking stand.

Waters himself expresses satisfaction with the Segway: "The thing that I like most about it is that I never grow tired of it. It kind of grows with me, which is another principle that we call depth. It should be easy for a beginner to pick up instantly and immediately understand it, but then at the same time you also want it to be like a Stradivarius, you want it to be this beautiful tool that grows with you as you grow in your abilities."

BMW StreetCarver It's extreme. Anyone **bold enough** to take a ride on the **BMW StreetCarver** will experience the **sensation** of snowboarding and surfing on the **street**.

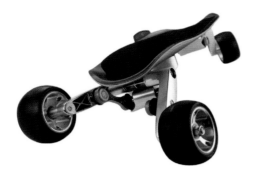

The unique appearance of the StreetCarver caught on among its target market of anyone over 10 years old. It is aesthetically pleasing and functional, too. For instance, the wings protect fingers on sharp curves.

Until now, snowboarders and surfers who wanted a thrill required either snow or water. The experience was possible only in the right season and the right location.

BMW has succeeded in capturing this ride feel and offers all fans of the so-called gliding or soul sports the new BMW Street-Carver—the chance to transfer this passion directly to the road. The idea for the StreetCarver was born more than a decade ago, when a sports accident grounded Rudi Müller, a snowboarding enthusiast and head of chassis construction at BMW, for a week due to a broken rib. "Outside it was still snowing, but for me, the winter was over. So I started thinking that I needed something for the summer, so that I could speed down the mountain meadows." Müller built the first prototypes in his garage. Among his priorities were wheels that could compensate for uneven surfaces and potholes as well as tilt into bends. He decided on single-wheel suspension and a composite steering axle using foam rubber cushions that distort, bringing about a steering movement. In 1994, he registered the patent.

Meanwhile, Stephan Augustin, a design student, was experimenting with scooters, mounting from two to fourteen wheels on their decks. In 1997, he joined BMW. By then, the StreetCarver was out of Müller's garage and past the "U-Boot" stage—BMW's name for products designed without an official development commission. Augustin was teamed with Müller. With no fixed launch date for the product, they worked on it at a leisurely pace with BMW's support. Four years later, the scooter was ready to go into serial production. However, it didn't handle the way the designers wanted it to. Models produced in the mid-1990s were huge by today's standards, weighing 22 pounds (10 kg) and measuring 5 feet (1.5 m) long. They had large rubber tires to allow them to negotiate bumpy mountain meadows without too many falls and correspondingly large turning circles.

Designers didn't like the steering either. It was imprecise, with too much play. They wanted their scooter to be more compact and easier to handle. Augustin experimented with different steering components using his Fisher technical construction kit. That's when he hit on the solution: ball-and-socket joints that function like a hip joint.

Müller took a serial part from the rear axle of the BMW 5 Series chassis, where it acted as a stabilizer for wheel control. Then, he replaced the previous model's foam rubber cushion with four pendular supports. With that, he and Augustin got the result they were after.

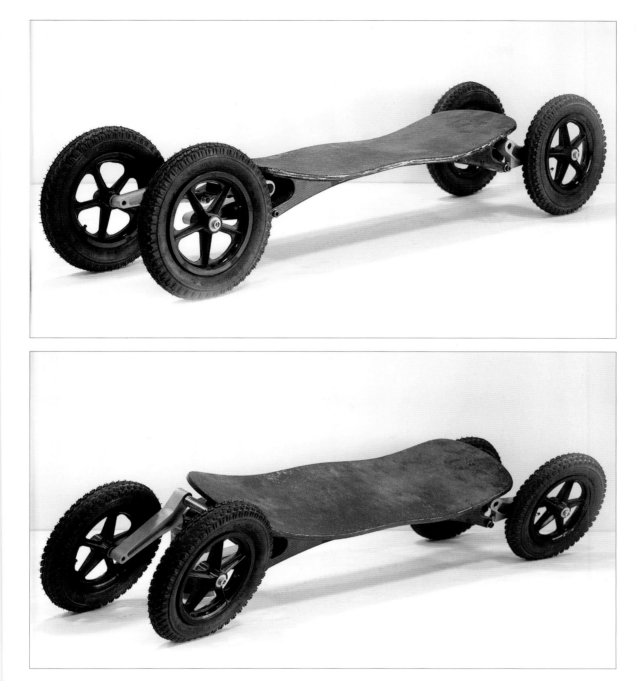

The 1995 model was too big. It had 12.5-inch (32 cm) wheels, weighed 22 pounds (10 kg), and measured more than 5 feet (1.5 m) long.

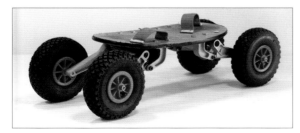 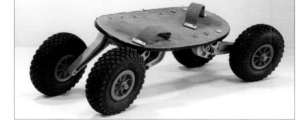

The wooden successor was only 3.25 feet (1 m) long. The wide wheels and loops for the feet were intended to provide safety on tough terrain.

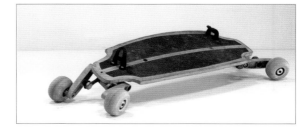

The steering geometry was perfected for this model. The ball-bearing polyurethane wheels stem from the running sections of escalators.

With its progressive steering response, the rider can precisely change the direction of the StreetCarver by merely shifting his or her weight, or "carving." This makes possible spectacular, rapid steering maneuvers that heighten the excitement of the ride. When traveling at high speeds, the StreetCarver stabilizes itself using the rider's weight. This provides a calm and controlled ride feel even when taking extreme corners.

The symmetrical deck or standing surface is manufactured exclusively for BMW. The ride is cushioned thanks to a sophisticated combination of wood and fiberglass inserts, while nonslip rubber Grip-Tapes offer the rider stability. After all, "if you're going fast, you need a firm surface under your feet," says the product literature.

The tires are actually low-profile rollers made of polyurethane. When the running surfaces of the rollers wear down to a certain depth, in-dicators become visible. At this stage, the dual-section aluminum rim can be dismounted and the running surface replaced.

The StreetCarver, offering a high-speed thrill ride that defies gravity without fuel consumption, debuted on the market in spring 2001. By September of that year, BMW had sold 3000 units via their website and won numerous design prizes.

"To work on an exotic project like this with the professional background support of BMW was unique and exciting, and I learned that BMW is not only a car company—it has also a great design culture in combination with perfect engineering," says Augustin. "Skateboards and long boards existed, but nobody expected a board from BMW, so the product was a first."

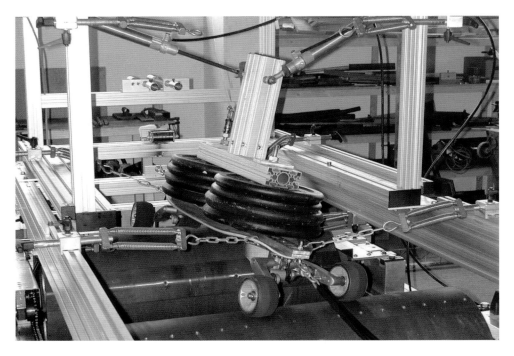

Prior to market launch, a testing agency ran the StreetCarver across asphalt rollers for more than 37 miles (60 km) bearing a load of 220 pounds (100 kg). An uneven bounce simulated peak loads that a rider would encounter when riding over curbs.

In 1997, the developers discovered an alternative to foam rubber—a pendular support like that on the BMW 5 Series automobile, only smaller. Integrated with the aluminum chassis of the StreetCarver, the supports provide the wheel suspension and enhance the ride response.

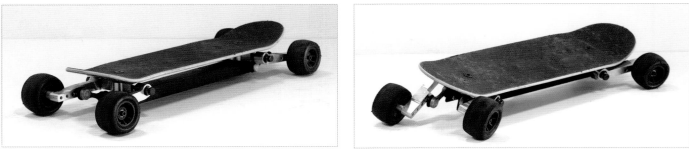

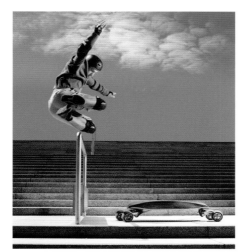

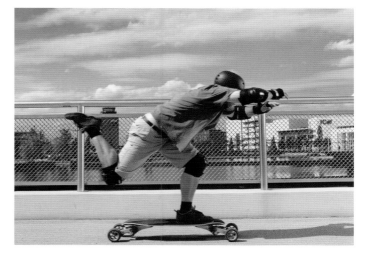

⬡ Above: The primary design challenge was to create an easy-to-use long board with the built-in agility of a skateboard. The designers strove to obtain the movement of a surfboard or snowboard.

⬡ Above right: The StreetCarver ushers in a new generation of roller sport, offering high speed with precise curving quality, a real snowboard feeling with radical curve possibilities thanks to its steering mechanism.

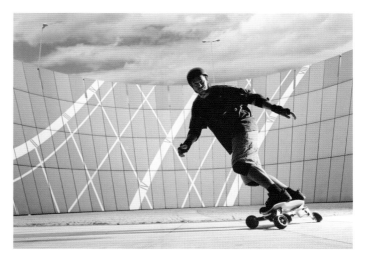

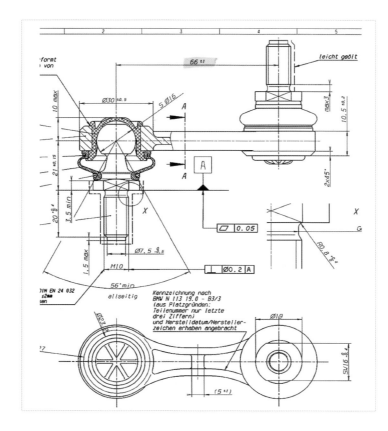

⬡ As with the gripping edge of a snowboard, the running board lifts in a curve. Weight and pressure shift along with the user's body weight. The board then automatically lowers into the straight-running position.

⬡ ⬡ The pendular supports that replaced the foam rubber cinematics of the earlier prototype look like hip joints and came from the rear axle of the BMW 5 Series automobile, where it was used to help stabilize the wheel alignment.

Wahoo Sailing Dinghy
Everyone can **set sail** for adventure with this **revolutionary** sailing vessel that makes **sailing fun**—even for the **novice**.

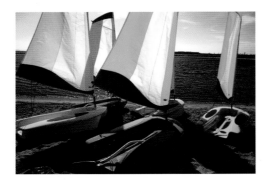

⊗ The production Wahoo—the easiest dinghy to sail—features eye-catching colors and a friendly design.

⊘ Designers created the original M-hull as a vaporetto to suppress waves, and therefore erosion, on the fabled waterways of Venice, Italy.

Anyone who has sailed knows the drill: "Whatever you do, do not sail in shallow water with the centerboard down and pull it up when beaching." This stern caution, coupled with the high skill level required to operate most sailing dinghies, keeps people at bay, intimidating even the most experienced sailors.

The Wahoo Sailing Dinghy was created to make the sport easier and open it up to children of all ages and women in particular. "Bringing a dinghy up on the beach requires the skills of an acrobat," says William Burns, managing partner, Mangia Onda Company. "One must let the sails out, pop up the rudder, and pull up the centerboard, all while trying to keep the boat sailing in the right direction."

Burns, and his partner, Chuck Robinson, both avid sailors, knew first-hand that the sailing market needed an easy-to-sail dinghy. "Many people are afraid to try sailing because there are too many lines and handles or because they are afraid of turning over the boat and being unable to right it safely," says Burns.

"Sailing a Wahoo is simple—just grab the tiller, pull in the sail sheet, and go!" he says.

Interestingly, the solution to simplified sailing is in the hull—and specifically, the patented M-hull. Burns and Robinson formed the Mangia Onda Company in 1997 to develop the M-hull as a solution to the wave damage problem along the walls of the canals in Venice, Italy, created by water buses, or vaporetti. Their collaboration produced the Mangia Onda Vaporetto, which features an M-shaped hull that captures the bow wave with skirts on either side of the boat and rides on a cushion of air moving through two tunnels spanning the length of the hull. This design not only minimized the boat's wake but also increased its stability.

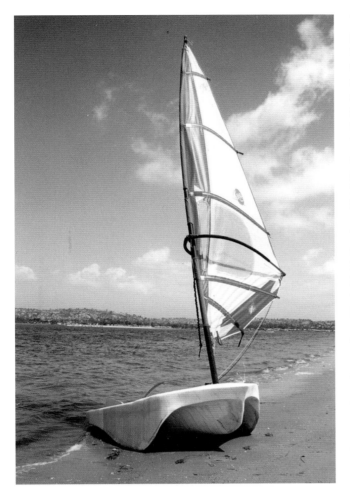

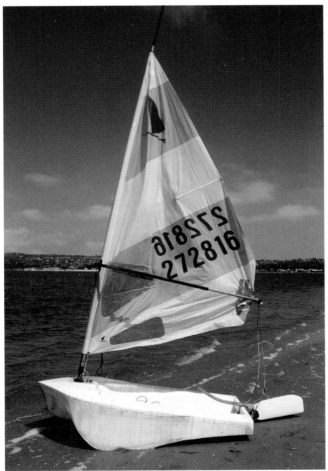

The pair realized that the same hull features that made the powerboat successful could be modified slightly to make a superior sailing dinghy. "By exaggerating and reshaping the skirts, we could create a sailboat that didn't need a centerboard—a huge step toward simplified sailing," says Burns, explaining that when a sailboat sails upwind, it needs to resist the sideways push of the sails with a centerboard for leeway control. The skirts of the Wahoo automatically provide this self-regulating leeway control. The harder the wind pushes, the more the boat heels and the deeper the skirts bite into the water. The tunnels of the M-hull provide dynamic stability by capturing the bow wave and making the dinghy more stable. Additionally, the skirts provide a convenient point of leverage to right a flipped dinghy.

The Wahoo has a cantilevered sail with a single line, a simple rudder system, and large, easy-to-grasp connections. The single batten and lack of boom means sailors don't have to worry about head injuries from a swinging boom. "These features create a nonthreatening sailing experience—something the sailing market has lacked," Burns adds.

The Wahoo consists of only four parts: the rudder, sail, mast, and hull. Nevertheless, even simple product designs don't always run smoothly. The first challenges were to adapt the M-hull design from a powerboat application to a sailing one and to prove that the concept would indeed make sailing easier. The designers began with pencil concept sketches, diagramming the side force and righting moment objectives and then explored variations of the M-hull powerboat design for a sailing dinghy.

Throughout the process, the designers relied on naval architecture and graphic design programs to design and develop the dinghy. For example, they created a computer model of the concept and shaped the hull with Maxsurf Professional and performed virtual hydrodynamic and hydrostatic tests and stability analysis with Hydromax Professional. They built the first full-size prototype out of foam and fiberglass and used a windsurfer mast and sail to evaluate the concept on the water.

⌄ From the computer models, a prototype consisting of foam and fiberglass was developed and built. A simple windsurfing sail was used.

⌄ It wasn't all smooth sailing for the Wahoo. A problem was discovered with the bow of the prototype, requiring modifications.

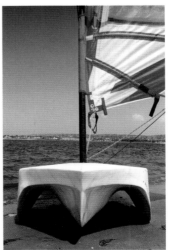

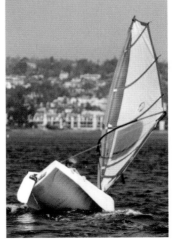

Once the hull was proven, designers tackled the other parts of the dinghy, completely redesigning the sails, rudder, tiller, and lines to make sailing easier. They used Ashlar-Vellum's Cobolt to design and model the rudder and other components.

"We started with a clean slate and were not hindered by designs of the past," remembers Burns. "The sail development required five prototypes. We wanted a sail that eliminated the boom, was controlled by one line, and automatically unloaded the wind when overpowered to prevent capsizing."

Getting the battens to line up correctly was another hurdle. Designers attempted different angles and finally found the right location for the single vertical batten. The final sail shape is a box-head style, meaning it has extra area near the top that induces a twist when the wind increases, reducing the heeling force. Designers added flotation to the top of the sail to prevent the boat from flipping completely upside down.

The rudder system was tricky, too. "We wanted the connections to be easier to grasp and install, especially in bumpy conditions with significant waves," says Burns. The resulting rudder system has a large handle with a large hole into which the rudder fits, making it easy to use. Designers replaced the small $\frac{1}{4}$-inch (0.5 cm) hinge pins typically found on a rudder with an easy-to-use 2-inch (5 cm) connection. The final rudder design is both cost-effective and efficient.

The final challenge was an aesthetic one. Because the designers wanted to attract more people to sailing, especially children, the boat had to look "less like a science experiment and more like a toy," says Burns. So far, that wasn't the case. Early drawings gave the boat an aggressive look with sharklike characteristics.

They brought in Greg Siewert of Siewert Design to give the boat a friendly look. He developed a second prototype and with modifications to the rudder, sail, and other components, the boat took on a more rounded appearance, with fewer hard edges. This alone makes the design more friendly looking and safer. We also decided to increase the height of the seats and add thick neoprene padding for a more ergonomic sailing position and to keep the sailors drier," explains Burns.

Inching closer to actual production, the designers choose five fun colors for the boat, packaged it with a matching sail, and gave it a whimsical name, Wahoo. By the time it went into production, designers had built the mold and produced five working prototypes.

In the end, the Wahoo is remarkable for its nonthreatening design, innovative M-hull, and simple-to-use controls. The M-hull design eliminates the need for a centerboard and improves stability with its manta ray wings. The kick-up rudder and lack of centerboard make beaching a breeze, according to designers. "The setup and operating controls have been simplified like no other sailing dinghy on the water," says Burns. "In a matter of minutes, even first-time sailors can be off the beach and having fun. By creating a comfortable and simple boating experience, we hope to encourage kids of all ages to adopt sailing.

"We had great fun developing the Wahoo, and it shows in the final product," says Burns. "The most valuable lesson we take from this project is that a simple design is not necessarily simple to design. The final product uses only a handful of parts, but the simple and easy operation of the Wahoo belies the large design effort that went into creating it. Even on a small project like the Wahoo, working with quality partners on a team is the best insurance for success."

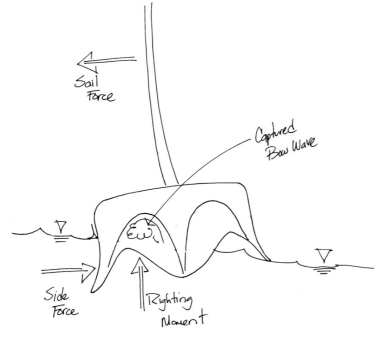

The M-hull was modified for the early dinghy.

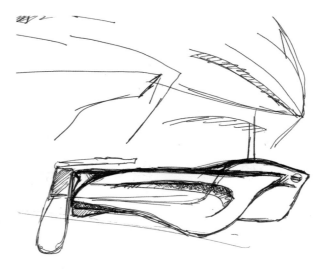

Some of the early dinghy concepts—inspired by sharks—looked too aggressive and intimidating.

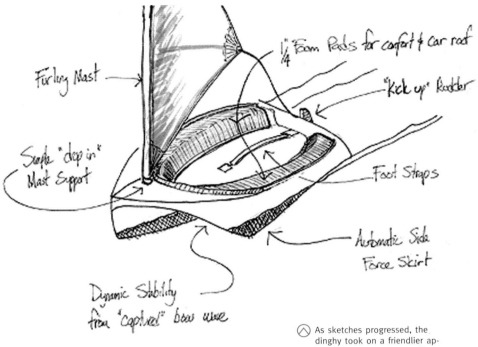

Furling Mast

Simple "drop in" Mast Support

1/4" Foam Pads for comfort & car roof

"Kick up" Rudder

Foot Straps

Automatic Side Force Skirt

Dynamic Stability from "captured" bow wave

⬡ As sketches progressed, the dinghy took on a friendlier appearance to encourage sailing.

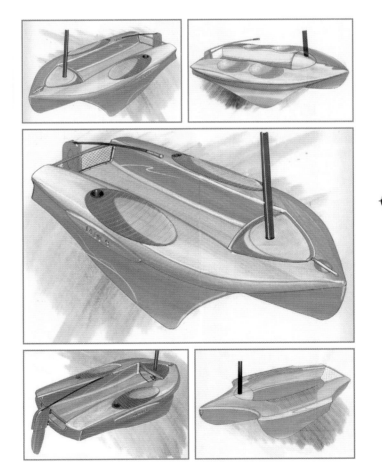

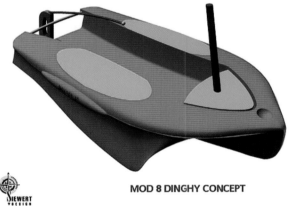

MOD 8 DINGHY CONCEPT

⬡ Left and top: With the help of Greg Siewert, several friendly versions were rendered in color.

⬡ Above: Once the look of the dinghy was finalized, designers modeled the hull and various components in Maxsurf and Ashlar-Vellum Cobalt.

Windsurfing Sails Collection

"We held a microscope to the **windsurfing** experience in order to **design** the 2003 **Neil Pryde** windsurfing **sail collection.**

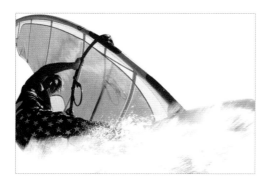

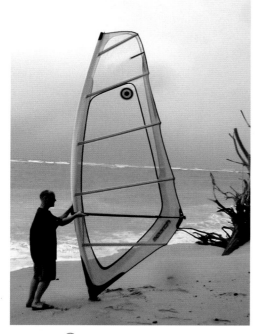

We wanted to create an unconscious meaning of performance," says Thomas Meyerhoffer, who heads Meyerhoffer, the design studio retained to assist Neil Pryde, the number-one sailmaker in the world of windsurfing, in developing a recognizable silhouette that would become a company hallmark and convey the performance standard that Pryde owns in the market.

What Meyerhoffer saw under the microscope was unremarkable. "The windsurfing market has been stagnant in the last 10 years. It was in a spiral that went deeper and deeper, with designers using the basic shape of the sail and plastering it full of graphic elements from flames and circles to fairly tacky images. Sails ended up looking like your basic Hawaiian shirt. That was the commonality for the market. The challenge was to break out of the mold."

For Meyerhoffer, an avid surfer, breaking out of the mold meant going the opposite direction. If the market was glutted with flashy graphics, he would go for utter simplicity. "For me, the sail had two components: the technical/functional and the emotional. This is a very high-tech product. It has excellent materials, excellent performance that has been purified in the last 20 years. It is very efficient; you can sail very fast with these things, even at speeds in excess of 60 miles (66 km) per hour. Through the design, I wanted to connect on an emotional level, too, with the shapes and how it was cut."

The studio first stripped the sail to its core and composed a zero-graphic model before reintroducing design elements to coexist with each model's inherent performance requirements. Meyerhoffer utilized the sail's frame as the signifier that informed all visual clues in the design process. A visual language was developed to articulate the streamlined efficiency that the racer would expect and how that might differ from the wave surfer's desire for maneuverability.

Defining the windsurfing experience enabled the design to follow the narrative of each surfer's ambition with particular visual content. "A product needs to touch one's dream," notes Meyerhoffer. The collection consists of nine sails, from those built for speed to those built for waves. As Meyerhoffer conceptualized the line, he saw the commonality of the models as an outline that encircles

⊘ Above: This freestyle sail, called Expression, is built to be a lighter sail because freestyle surfers need to be able to move it around a lot more in the water. Less frame equals less weight for a lighter sail, so again, the transparent window changes to meet the form and function.

⊘ Below: This signature model was developed as a high-performance wave sail. It has a simple shape and is almost entirely transparent. The element common to this sail and others in the line is the border, which works in different ways for different models but provides a unified look.

⊘ This wave sail, called Core, has a more graphic look and a smaller transparent window. "It's for the Hawaii dude who does a lot of freestyle moves," says Thomas Meyerhoffer, designer. It is showy and appeals to a young demographic that wants something expressive that still works within the frame concept.

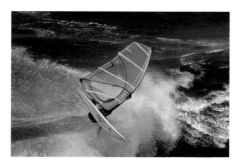

frame concept_line

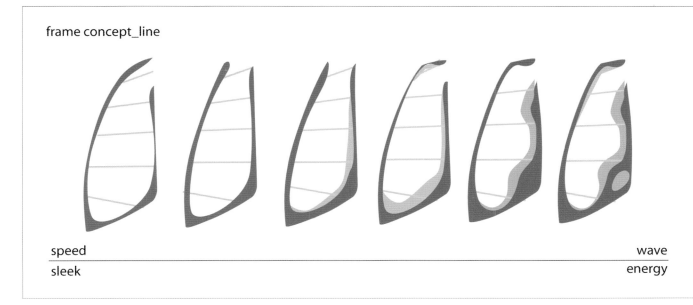

speed wave

sleek energy

⊘ Meyerhoffer's concepts on a continuum from the sleek sails built for speed to those requiring reinforcement and strength to handle high-energy waves. The red frame is basic to every sail in the collection, and it opens up more and more depending on the type of sail. The speed sail is wide open as opposed to the wave sail, which is closed and reinforced.

⊘ The sails are made of high-tech fabric and are stitched with pockets into which fiberglass battens are inserted. The mechanism that protrudes from the pocket is used to adjust the tension.

a frame; inside the outline, the sail would be totally devoid of design—transparent. He sketched this concept on a continuum from the sleek sails built for speed to those requiring reinforcement and strength to handle high-energy waves.

"The line goes from the racing sail to the more intermediate to specific wave sails, which will do different things for the user. The wave sail needs to be more reinforced. It's a high-energy style, and it is emotionally a different thing than speed sailing, which is very efficient, light, and fast," says Meyerhoffer. He developed a red frame around the sail. This frame is basic to every sail in the collection, and it opens up more and more depending on the type of sail. In speed it is wide open, whereas the wave sail is closed and reinforced.

There are those "looking for function, while other wave sails in range are more emotionally decorated and lively and [the latter] are for surfers who want to have more impact on the water," says Meyerhoffer.

"These new sails are particularly subtle and elegant," states Simon Narramore, Neil Pryde brand manger. "This is really what I see as the Neil Pryde trademark. The purely aesthetic parts of the product

design have now been elegantly engineered into the sail themselves rather than layered on at the end with colored materials."

What did Meyerhoffer learn from this experience? "I got a little bit better at windsurfing," he jokes. "But more important, I learned that it is worth fighting for something you believe in. We had a lot of resistance from within the organization, and when you think of windsurfing, you think of it as a younger sport, yet everybody in the industry is very conservative.

"They are very wary and didn't seem to believe in the concept to start because they are traditionalists. They can't change. It is really interesting. You'd think they'd be ahead of their time, but to the contrary. What worked for me was staying true to the original concept and elaborating and refining it until I had a product that worked and a design story that is complete. Then, people understood."

People do understand. Meyerhoffer's designs were well received by the public. "This is the second year, and the reception is still growing. Neil Pryde's total market share has grown more than 20 percent in a down year. We are now starting to see other people take after this. It is important to continue to work to create the design story. Ultimately, it will prevail."

Burton Ion Snowboard Boot

It's not often that an **industrial design** firm gets to play a role in winning an **Olympic** gold **medal**. But that's what **happened** when **One & Co.**

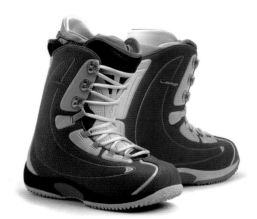

This version of the Burton Ion snowboard boot uses high-end European textiles and radio frequency welding to create structure and reduce weight—improving comfort and performance.

In these initial thumbnail sketches, the design team brainstormed how to incorporate what they learned about progressive power into a snowboard boot design.

designed the Burton Ion snowboard boot: While wearing this product, American Ross Powers won the 2002 Olympic gold medal in the snowboarding halfpipe competition—arguably the ultimate testimony to the performance capabilities of the boot.

Such an achievement would not surprise snowboarders, however; Burton has long been the market leader among companies creating equipment for this burgeoning sport, and Ion is its top-of-the-line product. Burton's market expects a lot from the company's products, but that carries with it its own rewards. Says Jonah Becker, partner at One & Co., "One of the benefits of working with Burton, which is such a respected market leader, is that people look to them for innovation—both functional innovation and style leadership—so that gives us a certain amount of leeway." One & Co.'s six-year relationship with Burton had already familiarized them with the general goals of designing a new product for this line—increased performance and comfort and a new look.

Tasked to create a boot that was the most progressive on the market, both functionally and aesthetically, One & Co. began by consulting Burton's teams of pro riders. From them, the design team found out what worked and what didn't on the previous year's models, what new tricks and new types of riding the riders were doing, and how they dress when riding and how that affects their interactions with the products. The One & Co. team—all snowboarders themselves—also spent time riding with the pros at Burton's testing facility at Mount Hood in Oregon. Says Becker, "A lot of them are putting their lives at risk, when it comes down to it, and they want whatever is going to function the best when they're dropping off 60-foot (18 m) cliffs or snowboarding in back country in Alaska."

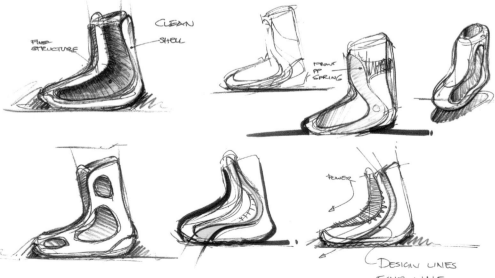

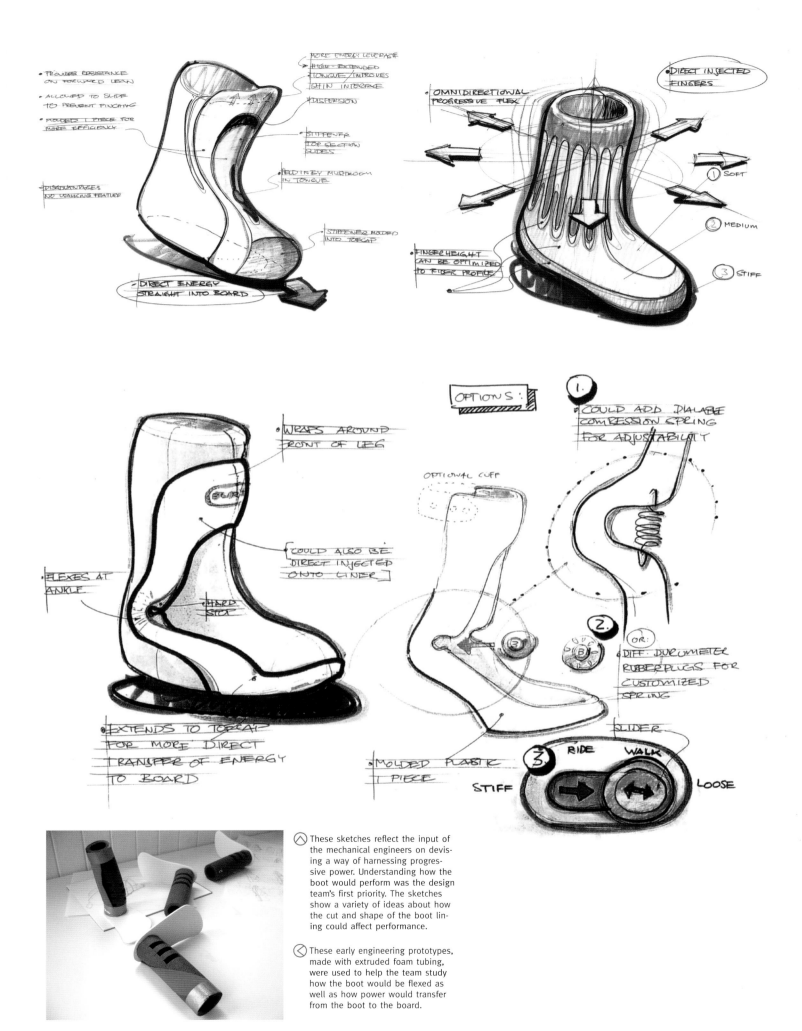

These sketches reflect the input of the mechanical engineers on devising a way of harnessing progressive power. Understanding how the boot would perform was the design team's first priority. The sketches show a variety of ideas about how the cut and shape of the boot lining could affect performance.

These early engineering prototypes, made with extruded foam tubing, were used to help the team study how the boot would be flexed as well as how power would transfer from the boot to the board.

Of course, as with most athletic gear, style was also an important consideration, and the pro riders provided useful feedback in this area too. "Their riders are, for the most part, very well informed, they're traveling internationally, they're very tech-savvy," says Becker. "I can't tell you how many times I've asked pro riders what their favorite thing is, and they answer, 'An iPod.'" Finding out what these sophisticated trendsetters were wearing, driving, and listening to helped the One & Co. design team ensure that the look of the boots would be as leading-edge as their function.

The design team also began analyzing how to improve the performance of the boot. "It's not very often that you have actual mechanical engineers working on footwear," says Becker, but that is exactly what happened on the Ion: Engineers were called in to cultivate what Burton calls the "progressive power" of the boot. Together, engineering and design analyzed the creation of the appropriate biometric flex in the boot while efficiently transferring power to the board—in particular, judging the interplay of hard and soft materials. "What's interesting about snowboarding is you have this progression of materials and hardness, starting with the human body and the foot, which although it is strong and structural has some soft points," says Becker. "And then you wrap it in a boot that has a combination of textiles and molded parts, and then you go into a fully molded binding and pressboard that are made of very hard materials."

To test how both power and flex could be attained, design and engineering tore up old boots and, with hot gluing and riveting, created their first engineering prototypes. Further prototypes were created with extruded foam tubing; a variety of cut patterns and support braces were tested with the foam tubing to see how they affected function. The prototypes were then tested by the pro team, alongside the designers; whenever part of the boot wasn't flexing right or was creating a "hot spot" for the rider, the designers would take a dremel or knife to the boot—sometimes right on the mountain—and reshape the prototype, later integrating the change into the design of the boot. The team went back and forth a number of times until they were satisfied with the boot's function. The final version of the design features a liner that uses radio frequency welding rather than layered fabric to create stiffness and structure.

One & Co. also looked for ways to eliminate mass from the outsole, to keep the boot as light as possible. Through research and trial and error, the team discovered that the lugs, which were of a heavy rubber, were needed only on the heel and toe of the outsole—the places that touch the board. Traction on the shank area is less important than it would be on a hiking boot—since snowboarders walk mostly on snow, not logs—but arch support is still crucial, so injected plastic, which is both more structured and lighter than rubber, was used for arch support on the shank.

Concurrently, the designers refined the look of the new boot. The team considered using radio frequency welding technology, which was already being used in the construction of the interior of the boot, to stiffen and add structure to the exterior textile. The initial concept included a pixelated pattern, meant to make for a smooth transition from the welded material into the textile, but, in the end, this idea was too difficult to implement consistently on the large array of sizes they needed to offer. In the final design for the Ion, the designers allowed the high-quality materials

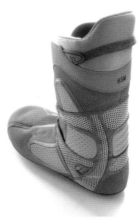 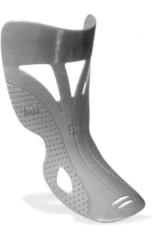

For the liner of the boot, radio frequency welding is used to directly mold an elastomeric structure to the textile upper, yielding more support at a lighter weight. Eliminating as many overlapping layers of fabric as possible strengthened the boot while minimizing possible hot spots caused by overlapping material edges.

The Burton Ion is lined with a molded tongue insert. Its tapered hourglass shape flexes with the rider while adding stiffness, transferring power from the front of the leg through the toe of the boot directly to the board. This increases the response time between boot and board and improves the rider's performance.

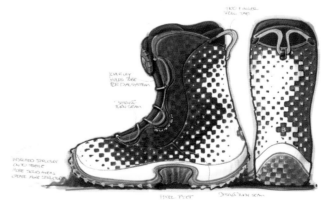

These preliminary style sketches explored ways of marrying style and function in the boot.

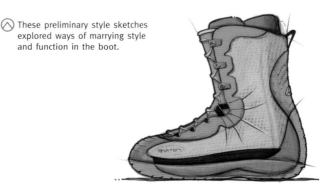

○ On this near final version of the outsole, the team has settled on the minimum number of rubber lugs necessary to create the proper traction on the board, since rubber makes the boots heavier. Varying the durometers of the EVA midsole optimized impact and power transfer.

○ Two-dimensional CAD modeling of the outsole; the cross section shows the injected plastic arch support, which is crucial to both performance and comfort.

and processes used in the construction of the boot to speak for themselves. This styling decision began to edge the look of the Ion away from its original skateboarding influence and toward the high-quality, high-performance look of gear for other winter sports. "There's always been a very strong skateboarding influence in the snowboarding market," says Becker. "I think what's interesting about the Ion is it's a bit of a break from that, and I think it was the start of a new trend."

Once the total design was refined, the team provided their 2-D CAD drawings to the manufacturer, who redrew them at the factory and then produced multiple samples until the designers were satisfied. The pro riders continued to test the samples through the spring and summer on Mount Hood. Since that is where all the other snowboard manufacturers test, the final samples are covered during testing to keep the look of the new line a secret from the competition. The boots also have to please the toughest critic of them all. Says Becker, "The founder of the company, Jake Burton, is probably still riding 200 days a year and is very closely involved with the pro team and all the product development. I believe he may have been testing in Argentina in the summer."

The verdict? During testing, Burton had this to say: "The stuff I'm testing is ruling. The Ions somehow continue to improve. The bottom line is the stuff keeps getting better and the sport gets more and more fun." Gold medalist Ross Powers might agree with that.

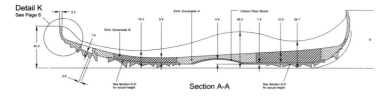

Section A-A

Section B-B

Lateral

View F-F
See Page 2

STX Fuse Lacrosse Stick
Products can be overdone and **overhyped**, but when it came to the **design** of the **STX Fuse Lacrosse Stick** that uses **overmolding**, the industry saw a real **breakthrough**.

The STX Fuse in play.

Paul Kolada believed his concept for an overmolded lacrosse stick had merit, so he filed away the idea but never forgot about it.

Priority Designs had developed a variety of STX lacrosse sticks, and among the many concepts they presented was one where a soft material was fused to the nylon head to create both hard and soft areas in a process called overmolding. "They liked it and filed it away," says Eric Fickas, designer. "Paul Kolada, the principal of our firm, kept pursuing it because he thought it had merit."

Kolada had taken a Proton, one of STX's most successful sticks, and dug into it to create cavities. He poured material on it to create an overmolded prototype. "I don't know a lot of approaches where the cart led the horse," says Fickas, "but it clicked. STX saw this could be special and unique and no one was doing anything that could remotely come close to this on the market."

Coincidentally, STX had been thinking the time was right to update this very stick. Using the basic form of the Proton, designers created early sketches and suggested the idea of repeating ribs that would be less abusive to players and would cushion the impact of the ball rather than deflect it off the hard nylon. "We learned where we'd get the most bang for the buck in placing the overmolding details," Fickas says.

While overmolding was proving to be a great idea, designers were challenged when it came to bonding the materials. They needed to achieve a chemical bond so that the molecules of both materials would fuse. Because nylon is resistant to chemical bonds, they had to help the process along by placing pinholes in the nylon structure that allowed the overmolding material to flow through the head of the stick, producing both a mechanical and a chemical bond.

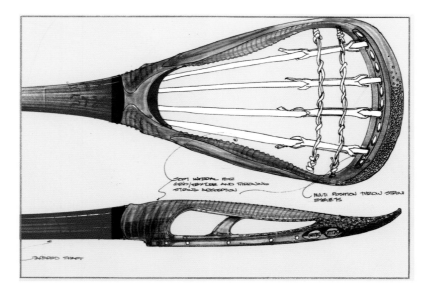

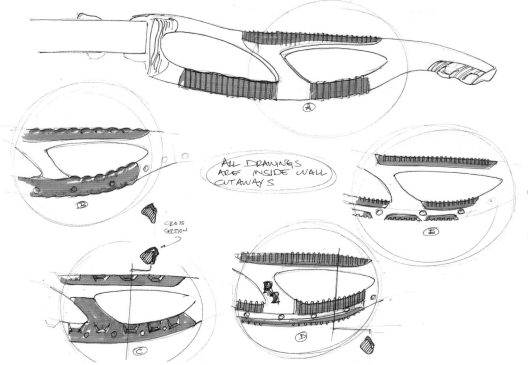

ALL DRAWINGS ARE INSIDE WALL CUTAWAYS

CROSS SECTION

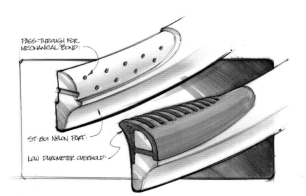

⊲ A collection of initial brainstorm sketches showing the location of the overmolding details.

⊽ Bottom: The first drawing that cemented the design direction shows a side view of stick, identifying the top rail where the overmolding would be and how it would creep through the sidewalls.

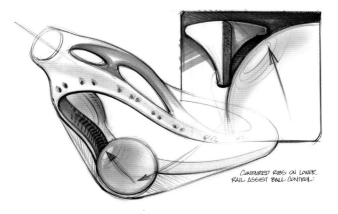

CONTOURED RIBS ON LOWER RAIL ASSIST BALL CONTROL

⊲ Designers needed to find a way to bond the softer overmolding material to the nylon base. The solution was to put pinholes in the base nylon so that the overmold material would flow through, resulting in both a mechanical and a chemical bond.

PASS THROUGH FOR MECHANICAL BOND

ST-801 NYLON PART

LOW DUROMETER OVERMOLD

SOFT, RUBBER-LIKE RIBS AID IN CATCHING THE BALL

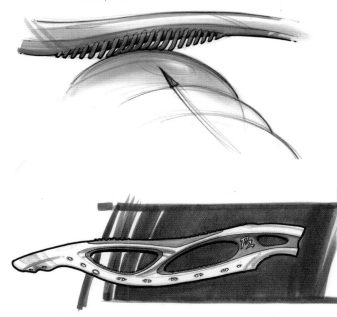

Next, the design team met with their overseas vendors. "After the meeting, we made sketches of how the mold would go together so everyone would be on the same page," says Fickas.

From there, they developed a computer model using Alias software, being careful to stay within the parameters of the sport. "The rules we needed to abide by are very strict as to the size, shape, and materials used," says Fickas. "We created a model in Alias and that let us control the geometric and sculptural form that we came up with."

While aesthetics are important, a big part of developing a lacrosse stick is its functionality and playability. "If it looks great but fails in practice, who have we helped?" Fickas asks. To ensure a stick with the right balance of weight and stiffness, designers used a software program to evaluate the model for stress, among other attributes. The program "tells us where the stick is not strong enough, so we can add material, or where it is too strong,

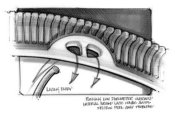
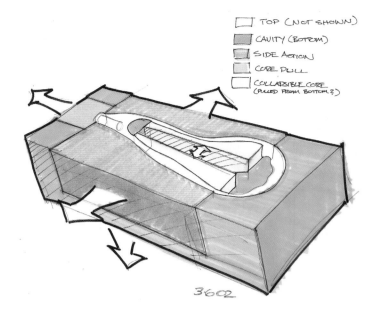

⬦ Whenever possible, designers avoided placing overmolding in exposed areas or around the product's lace holes, where it would be prone to wear off.

3602

□ TOP (NOT SHOWN)
▨ CAVITY (BOTTOM)
▨ SIDE ACTION
□ CORE PULL
□ COLLAPSIBLE CORE (PULLED FROM BOTTOM 2)

so that we can balance weight and stiffness. We want a stick that is as light and as strong as possible." Half a dozen tweaks later, they got it right.

Designers went back to Alias, refined the model, and presented it to the client for approval. Before getting final client approval prior to sending it to manufacturing, designers put the P2, as it was called originally, into Pro/Engineer software. Eventually, the stick's name was changed to Fuse.

To ensure they had everything right, the team prepared sales samples in-house for final user feedback. If anything could be tweaked, now was the time to do it.

Designers made their final revisions and shortly after that, actual Fuse lacrosse sticks went into production. "You don't think about what is hard and what is easy when you're working on a product, you just get the job done," says Fickas. "Looking back, the research was tough. It was hard to locate materials to do the job." "This product is the result of a lot of tenacity," adds Kevin Vititoe, designer. "Paul made it happen by continually pushing what he knew was a good idea. He didn't just file it away. He kept his eye on the market and found the right time to make that idea work. He also kept his eyes open for new materials and new processes, and he looked at other products to find how he might use those design ideas and materials in another arena."

That's what happened with the Fuse. "Now the Fuse has become a catalyst for a new market," says Fickas. "Other sticks have come out because of this. The market is still growing where these processes may be used. The Fuse has opened a floodgate."

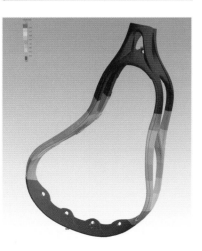

◉ Left and above: Designers met with their vendors and created a sketch of how the mold, comprising seven pieces, would go together.

◉ To help refine the form, the designers developed a computer model in Alias that let them control the geometric and sculptural form of the product.

◉ To achieve the right balance of weight and stiffness, designers used software that evaluated the stick for stress.

> While most sticks are made of one piece of material, this stick is made of two. The nylon base (which is ghosted in this view) was developed first, followed by the over-molding. "The overmolding didn't add any stiffness or structure to the part, while the nylon had to bear all the stress of the product," explains Vititoe.

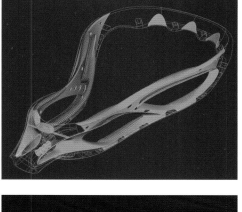

> STX's marketing group used this render-ing of the new lacrosse stick to gauge consumer interest in the product. "It gave the client something to use to start mar-keting," says Kevin Vititoe, designer. "They had not yet invested money in tooling and things, so with this rendering in hand, they could get the heads-up on how popular the stick might be."

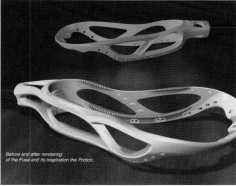

Before and after rendering of the Fuse and its inspiration the Proton.

> Final parts were not ready for a catalog shoot, so designers created another sam-ple, strung it, and took the photo.

> Priority Designs created 50 sales samples in-house. From top left, the basic nylon structure formed the base of the unit; next, the overmolded material was added; and finally, the parts were cleaned up by hand.

> Research indicated where the overmold-ing should be placed. Ribs along the top rail where it contacts players on the fore-arm make the stick less abrasive. In addi-tion, when the ball hits hard nylon, it tends to be deflected, whereas the ribs cushion the impact, allowing the ball to bounce off the rib and back into the pocket, keeping it safer and more secure.

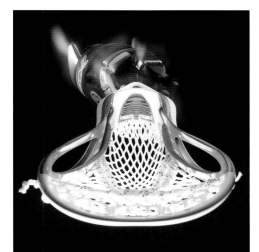

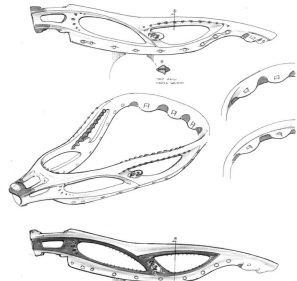

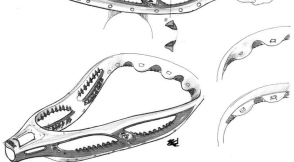

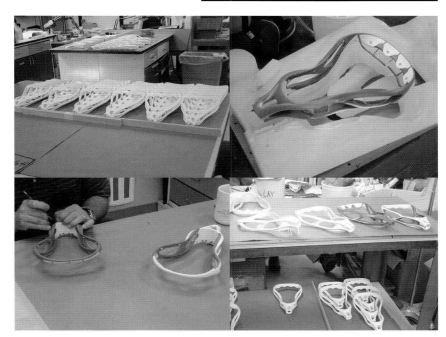

GALAXY Systems

"It should **spin**, it should be **crazy**, and it's cool if it makes you **throw up**." That was the feedback **KOMPAN** got during user testing to develop a second **generation** of GALAXY playground systems, **designed** for six- to twelve-**year-olds**.

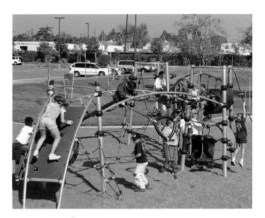

The GALAXY system consists of five families of play equipment. Four of them—stabiles, anchors, links, and accesses—can be connected at various angles and directions to make constellations of various sizes. The fifth family—mobiles—are freestanding components that can help widen the options for play.

While keeping these words of their user base in mind, KOMPAN had goals of its own. Unlike the first edition of the system—a limited set of fixed solitary products sold as supplements to play areas—this new generation of GALAXY would be modular, to allow buyers to adjust the equipment to accommodate site variation or to expand user capacity at will. This new generation would also improve on the previous edition by providing a wider and less repetitive array of play experiences for users. The system would be accessible from the ground, allowing children in wheelchairs to approach and use the systems without assistance. And, of course, the design would look good both in urban and natural settings and would be visually appealing both to children and to the adults who would be buying the equipment.

In rethinking the system, the team was not starting from scratch; they hoped to retain and build on principles that were integral to the success of the first version. Both the aesthetics and concept of the original system were inspired by the work of the sculptor Alexander Calder. His colorful and playful style was a natural for a playground. There was a reason for his famous statement, "My fan mail is enormous. Everyone is under six." The mobiles and stabiles (mobiles that are planted in the ground rather than hanging) that he invented inspired an architecture distinct from the post-and-platform structure so prevalent in playground equipment design. The steel-pole construction of the previous GALAXY system differentiated it from the systems KOMPAN offered for younger children, which are made from wood.

In researching their target market for GALAXY, KOMPAN had an advantage they weren't used to—many of their previous playground lines targeted two- to eight-year-olds, but targeting older children meant better communication. "This age group is different in that you can talk to them and get feedback," says Ulla Hansen, a designer at KOMPAN. Through talking with these users as well as with teachers and child development experts, KOMPAN's design team discovered that children this age were both independent and social—interested in relating to, and competing with, their friends during play. These children love to explore and be challenged by their world—Hansen calls them "little world pilots." To suit these users, the equipment had to be open, both to enable a variety of creative approaches and to allow the children to relate to and learn from each other. In addition, it must continue to provide a challenge to the children or they will quickly become bored, especially in a school setting, where they might be faced with the same playground equipment for years.

This small-scale model of the Meteor Shower was built to help the team visualize this piece of equipment.

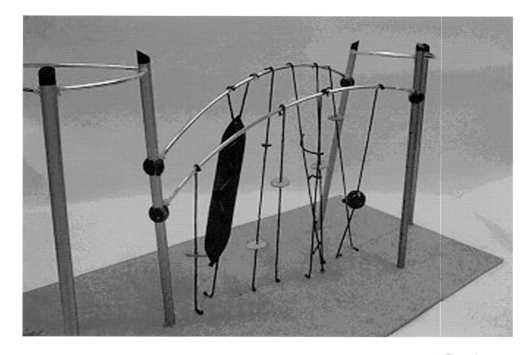

This first sketch of the Meteor Shower mobile already has the playful feel of the work of Alexander Calder, one of the visual inspirations for the GALAXY system.

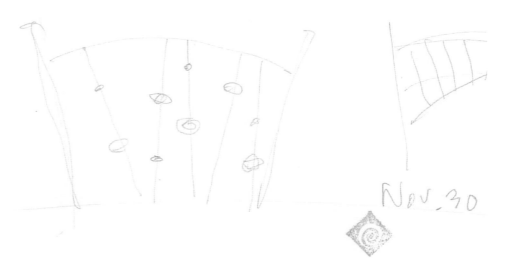

metior shower ladde

Nov 30

A CAD model of the Meteor Shower.

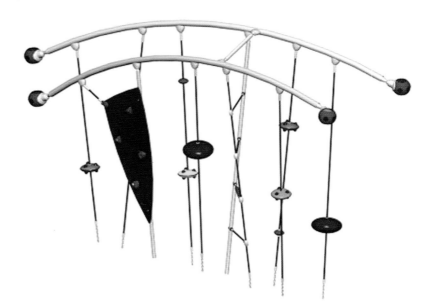

Armed with this knowledge, the designers began by building on the stabile and mobile architecture they had used so successfully for the first generation of GALAXY. They wanted to avoid using the word *structure* to describe the new GALAXY system: While this word is used commonly for playground equipment, the team at KOMPAN felt it didn't fit the dynamic nature of the GALAXY line of equipment. They came up with the idea of calling the systems *constellations* and began brainstorming ways they could make the system more flexible and adaptable; three sizes of constellations would be offered.

They started working on developing a geometry for the system. The stabiles were planned to act as the centerpiece of each constellation of play equipment. Stabiles are built on a frame of three galvanized poles, each positioned at a corner of an equilateral triangle, with each pole leaning toward the center of the triangle and bound together by a top frame; up to five connector balls, which are used to join the poles, can be mounted on each pole, creating numerous attachment points at a variety of heights and angles for play components. The design team had to find a way to make the stabiles expandable and flexible; they decided on a radial system generated by two types of lines, those intersecting two legs of a stabile and those entering the center point and one leg of a stabile. With this system in place, the team was able to begin developing link activities that would span the stabiles.

As development progressed, the team realized they needed to create a system of smaller stabiles, both for visual and price differentiation, and created a new family of equipment called *anchors*. Another family of equipment, the link family, was developed to join stabiles and anchors to one another. Members of a fourth family of access activities flow out in different directions and engage with the surroundings. The fifth type of equipment, the mobiles, are solitary activities that can supplement a constellation.

Within each of these categories, the designers brainstormed ways they could create a dynamic play experience. They came up with a number of innovative equipment ideas that would challenge and grow along with children. One piece of equipment that reflects this strategy is the Supernova, an orbiting ring, mounted on six secure legs, that turns around a 10-degree tilted axis; the slope of the ring ensures that it spins faster for larger children and slower for younger children, so the piece retains its interest for the same child over a longer period. The patent-pending Nebula orb is mounted to angled stainless-steel augers and can be rotated in a helical movement up and down the augers; the child has the choice of creating a personal climbing track, taking a softly spinning tour from top to bottom, or simply engaging in the tactile experience of spinning the orb.

The team first built smaller models out of cardboard, for internal presentations, and then set about building full-scale, working prototypes that could be tested with children. They tested the equipment on a site they had rented, then took the equipment to schools in both rural and urban settings. By watching the children interact with the equipment, they quickly found out which concepts the children approved of. "Children are merciless consumers," says Hansen. "They are not polite."

Breaking the mold in playground equipment has paid off for KOMPAN. The system was rapidly accepted, both in North America and in Europe, and with the release of GALAXY Extreme, KOMPAN continues to extend the possibilities of the system.

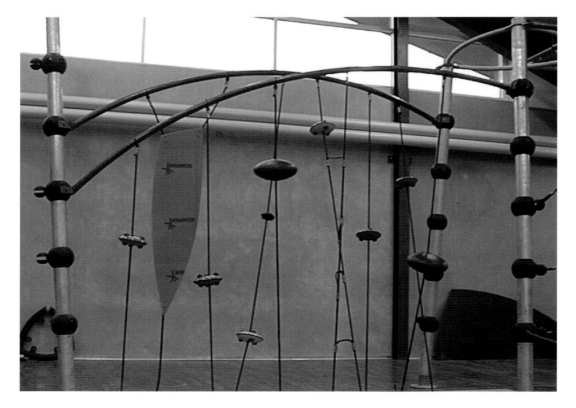

◁ In this scale model, the team has refined the details of the ladders on the pillars on either end of the Meteor Shower.

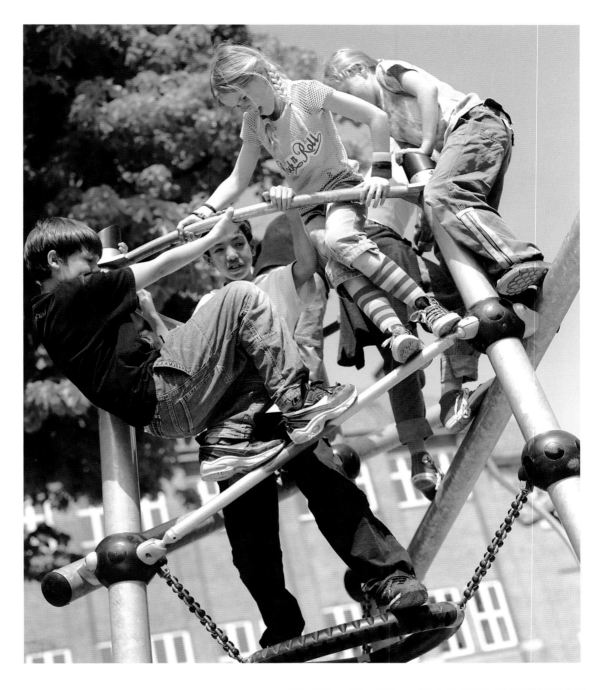

⊘ The GALAXY system was built to be ground accessible, opening it to children who use wheelchairs. Since compliance with the Americans with Disabilities Act is an important decision factor for product selection, this feature makes the GALAXY system more marketable.

⊘ Left: One of three versions of the Spica, one of the items in the mobile family. Each of the three types reacts in a different way to the child's movement.

⊘ Right: The Skygame cultivates strength and coordination; its multiple tracks also allow children to compete with one another. The plastic handgrips are carefully designed so the child's hand never comes into contact with the bar, preventing the pinching of fingers.

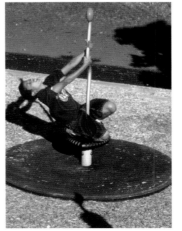

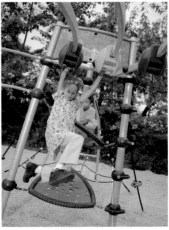

Neurosmith Musini Toys aren't just toys anymore, the well-designed ones entertain, engage, and educate.

⊘ The Musini, whose name combines the words *music* and *Houdini*, the legendary magician, transforms vibration into music and in doing so, can play to any rhythm or vibration it receives.

▷ Opposite: Early sketches of the Musini resemble the traditional flying saucer from outer space that sits on the floor and is supported by four short legs.

The Musini does just that. Named for music and the legendary magician, Houdini, the Musini is a musical instrument that children age three and up can play simply by dancing or tapping on a surface on or around the product. That's because it transforms vibration into music and in doing so, can play to any rhythm or vibration it receives.

"The technology is a revolutionary and highly inventive adaptation of Piezo technology that essentially creates a seismograph for less than a dollar, as opposed to hundreds of dollars. The technological solution came about in one of the most unusual ways that we as designers had ever been exposed to," says Ravi K. Sawhney, founder and CEO of RKS Design, Inc.

"The chief technologist of Neurosmith was challenged by his teenage son to codevelop, as a parent and child activity, a sensing device that would alert him when his sister was approaching so, sight unseen, he could surprise her or anyone else. Playing around with technologies, the two of them came up with one that worked. Taking it further, the technologist took the device to work, connected it with music, and allowed it to compose music based on the length and intensity of the signal generated. When the new president and CEO of Neurosmith saw the device and what it was doing, he flipped. The rest is history," Sawhney says.

The primary challenge with the design of the product was homing in on the target age group and then developing a product that could be priced competitively. "The technology and play of the concept had been incorporated into a juvenile aesthetic and was being received extremely well. However, the product had initially been targeted at three- to five-year-olds. In testing the product, the audience revealed itself to be primarily three- to thirteen-year-olds but extended to sixty-year-olds and beyond," Sawhney remembers. "The cost of technology for three- to five-year-olds was typically between $10 to $20 due to their boredom factor. The play in the product could be endless with the possibilities for its integration of the total universe of music and sounds, but the product needed to sell for $60 at retail, significantly higher than the initial target audience's product offerings would command." Tasked with getting the product ready to ship in time for Christmas 2002—just four short weeks away—the design team had to reposition the product for this new price point and audiences consisting of both parents and children. "The design team was inspired with a new and unique interface experience, and after dancing around a test model, fell in love with the playfulness of the technology," says Sawhney. "From that point, everything was on a super-accelerated time frame to get a new and market-appropriate design to the marketplace. This was your typical four-week cradle-to-grave design program."

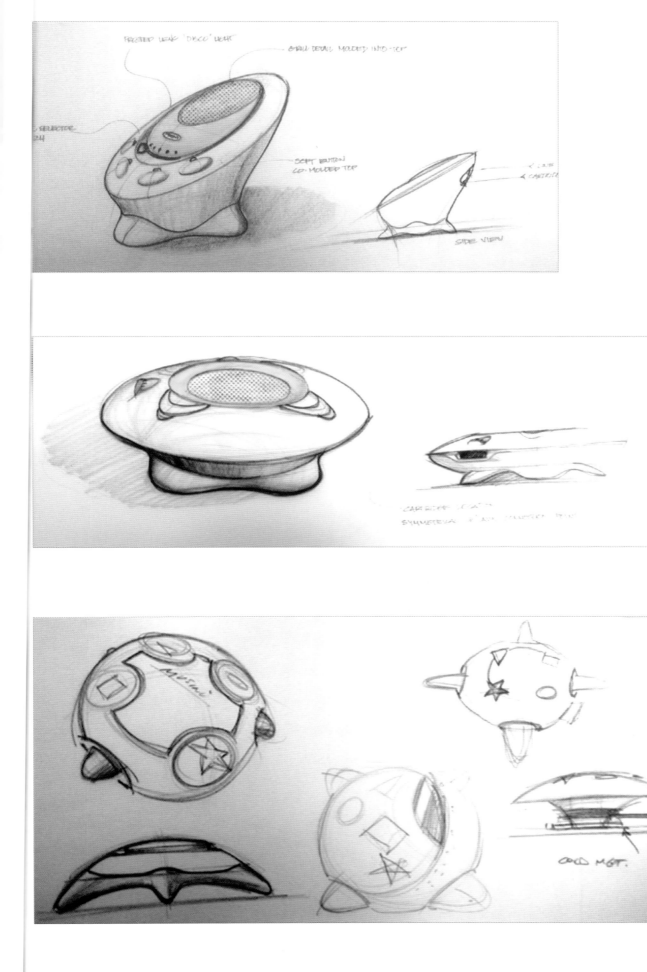

Designers tackled the project using CoCreate's SolidDesigner, Alias Studio Tools, and ProEngineer as their primary tools. Surfcam CNC software running on Windows NT was used to create the prototype and models.

Designers used PsychoAesthetic to map related products within the market segment. Then they started sketching, developing CAD and study models and CNC-machined prototypes, and performing graphics and color studies while they engineered and continuously critiqued and modified the designs. All this activity led to creating a full prototype in ProEngineer for production tooling.

On its release, the Musini was targeted to a broad market and designed so users could select from a variety of music options that come with the product and as well as purchase additional cartridges if they want more choices of musical and instrument selections. Neurosmith's revenues climbed from $5 million a year to more than $50 million after the launch, Sawhney reports.

"As we think back on that first meeting with Neurosmith's CEO, we knew we were getting ourselves involved in a very special project," he says. "Little did we know then just how challenging the project would become. But, as with the Musini, it's usually the most challenging projects that prove also the most rewarding."

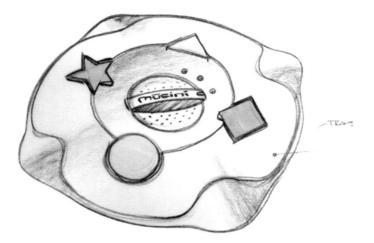

Above and bottom: As the design was fleshed out, colors and detailed design elements were added, including the on/off switch, a translucent frosted housing, and lights that glow from beneath.

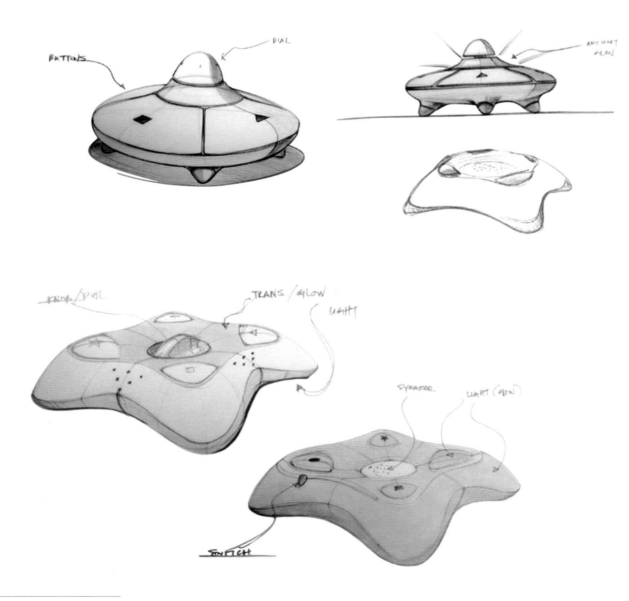

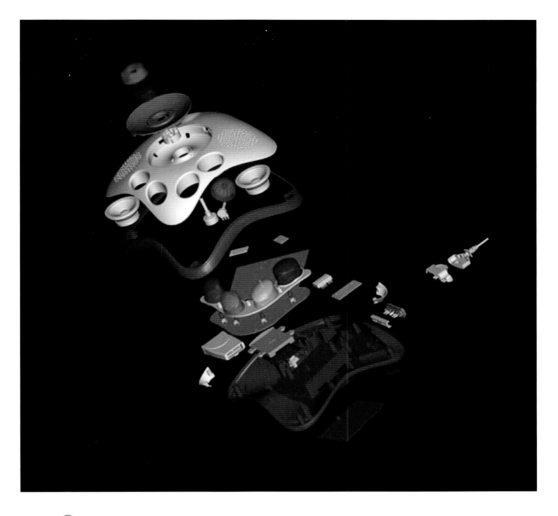

◇ An exploded view of the Musini looks complex, but the technology that makes it work is relatively simple.

◇ Originally thought to be a product for three- to five-year-olds, the Musini, which can play simply by dancing or tapping on a surface on or around the product, was found to be equally as popular with children at heart who are aged 60 and up. Users can select from a variety of music selections that come with the Musini or purchase additional cartridges with other musical and instrument selections.

Fisher-Price Intelli-Table When Fisher-Price decided to partner with **Microsoft Corporation** to develop **toys**, **Fisher-Price** saw an opportunity to **update its image** in this increasingly **technology-**oriented market.

⊗ The final version of the Intelli-Table, shown with all three of the disks that came with it when the product was launched; since the original launch, one of the disks has been eliminated.

⊗ An Alias modeling of the original concept; this table features a more typical color palette for Fisher-Price, which favors the clean, pure look of white on many of their toys. The designers at Microsoft worked to broaden the palette on this product; though this image shows the table as white, Fisher was pleased that in the final design, white was used only for one of the disks, not the table itself.

⊗ Early sketches showing the original concept—a ballchute mechanism that was ultimately rejected for safety reasons.

Microsoft was already involved in the toy area—its technology had a hand in top-selling toys such as Barney and the Teletubbies—and Fisher-Price was especially interested in capitalizing on technological developments such as the LED featured in Microsoft's Teletubbies dolls, which light up in a variety of different ways, depending on the child's interaction with the doll. The two companies formed a team of industrial designers, project managers, electrical engineers, software engineers, and a child psychologist. Brainstorming a number of ideas utilizing Microsoft's patented LED and software, the team decided that they wanted a product that would grow with the children and continue to challenge and involve them for years. They wanted something interactive and educational as well as durable and safe for their target market, toddlers. Microsoft would design and produce the product (with input from Fisher-Price), and Fisher-Price would distribute the product and pay Microsoft a royalty for it.

The team hit on the idea of a table that featured a disk with the interactive LED on top. The toy would be for children from ages nine months to thirty-six months; the disk could be removed so that a younger child could play with it on the floor, while older children could pull up on the table and interact with it while standing. The original concept featured a ballchute mechanism—the child would drop a ball in a hole in a disk, and the ball would then hit a sphere inside the table, which would direct it into an interior bowl, where it would swirl around and come out into one of the six pockets in the legs or sides. The team explored a variety of interactive elements: A sensor in the hole might be able to recognize different shapes or colors and play different songs for each kind of ball, or the bottom bowl could be transparent, allowing the child to see the ball rolling by before it finally emerged from of the pocket.

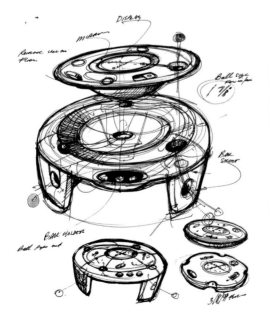

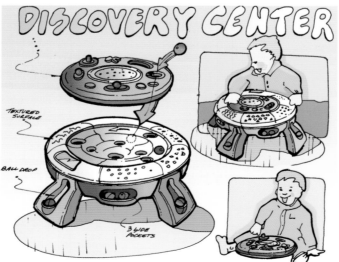

Right: Here, the design team was examining different ways of detailing the legs. Since they had decided that the product would be packaged with its legs detached from the table, the designers also worked on developing a key feature that would allow consumers to lock the legs securely onto the table.

Below:Once the ballchute concept had been rejected, the interior of the toy was freed up for other uses; the team decided to use this space to store the additional disks, and in sketches like this one started exploring how the pieces would fit together.

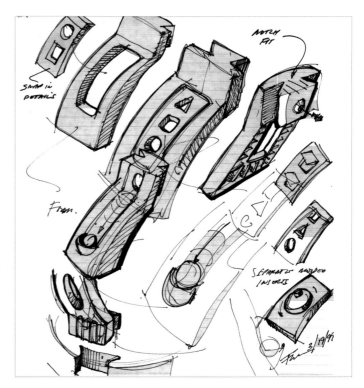

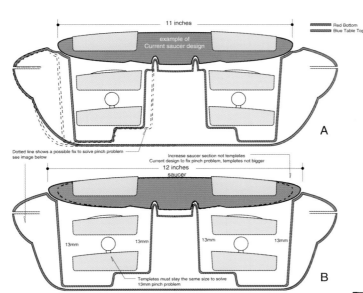

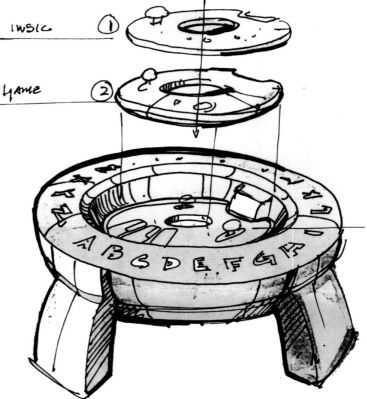

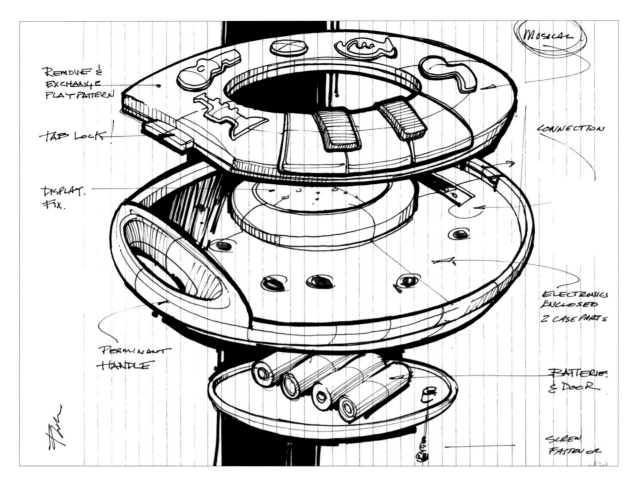

REMOVE &
EXCHANGE
PLAY PATTERN

TAB LOCK!

DISPLAY
FIX.

PERMINANT
HANDLE

MUSICAL

CONNECTION

ELECTRONICS
ENCLOSED
2 CASE PARTS

BATTERIES
& DOOR

SCREW
FASTENER

⊘ Top: An exploded view of the second prototype of the Intelli-Table, now without the ballchute.

⊘ Above: This computer sketch used Macromedia Director to mock up sounds and light arrays for presentation to Fisher-Price.

◁ Two early designs for the disks showing the more iconic treatment of buttons favored by Microsoft but rejected by Fisher-Price.

The team thought that a slightly space-age look for the product would update Fisher-Price's image. Steven Fisher, senior industrial designer for Microsoft and lead designer on this project, says, "As a designer, I wanted to come up with an aesthetic that was a little bit more sophisticated than Fisher-Price would typically do. I think Fisher-Price was interested in us doing something new." This design direction was also apparent in the sophisticated surfacing details that were chosen for the original design.

"We built a full-functioning prototype and presented that to Fisher-Price, and everybody was really excited about it," says Fisher. "We wanted to take it through Fisher-Price's safety group, and it was determined that there was too much risk of children sticking their arms through the openings, so we actually bagged the whole idea of this balldrop, which was unfortunate, because we thought it really was a cool added feature."

The team went back to the drawing board and realized that eliminating the ballchute meant eliminating the spherical shape inside as well, freeing up space to develop additional disks that could be stored in that part of the table. They also experimented with other ways of adding value to the product, such as putting additional features on the other side of the disks and putting letters on the outside of the bowl.

They also worked on fine-tuning the features that would be included on the disks. In designing elements such as buttons, "we were really interested in trying not to play down to the children," says Fisher. "We felt like we could represent an instrument, but it didn't need to be really cutesy. And we disagreed with Fisher-Price on that." Fisher says that though the Microsoft team preferred an iconic treatment, and the Fisher-Price team wanted a more-cartoonlike approach, the cartoon approach that won out ended up complementing the final product better.

The appearance of the disks was not the team's only concern; fine-tuning how the children would interact with, and learn from, the disks was also a high priority. The team had two aces in the hole: Fisher-Price's extensive testing facility and child psychologist Erik Strommen. Strommen was able to organize testing and research with children at Fisher-Price's testing facility. "He had a lot of information about the kinds of things that kids at certain ages were interested in," says Fisher, "so we probably had a bit of an advantage with his knowledge." While the original interactive elements were presented to Fisher-Price using Macromedia Director files, the prototypes used for testing on the children were built by a Chinese company called Jetta, which had extensive experience engineering electronic toys. With these prototypes, the team was able to test how the sliders and buttons on the products would feel and work.

A second round of full-scale prototyping followed. Says Fisher, "This program went so fast—we built a working prototype of this in two weeks, a full-scale version of it." This second version of the table was smaller than the first, at Fisher-Price's request; there were practical considerations, such as the cost of materials and packaging for the larger version, but Fisher-Price also wanted to make sure that the product wasn't too overwhelming and unwieldy for parents. At this stage, the team also worked to refine the mechanism by which the table was able to recognize which disk was installed (a certain combination of bumps on the disk would hit buttons in the table) as well as the way the buttons and switches on the disk interacted with the table.

In the end, through trial and error and close collaboration, the team created a toy that was selected by the *Today* show as the Best Toy of 2000. Sales far exceeded Fisher-Price's expectations, leading to an extension of the product line with the addition of the Photo Fun Learning Smart Screen Intelli-Table. Though Microsoft has gotten out of the toy arena, Fisher-Price continues to express interest in working with Microsoft.

"I think we came a long way, and the project turned out to be very successful," says Fisher, "and I think that has a lot to do with the collaborative relationship with Fisher-Price and brainstorming the opportunities we had after we took the ball play out."

A sketch where some of the surface detailing is being finalized.

KI Intellect Classroom Furniture

Ask people about their **experiences** in school, and you'll get a variety of reactions: Some will wax **nostalgic**, while others will **shudder with dread**. But there's one memory that everyone will share: the discomfort of the **classroom furniture** they **encountered.**

The KI Intellect line of classroom furniture is designed to meet the needs of the modern classroom. Its lightness and flexibility of design helps students and teachers reconfigure the classroom; its ergonomics allow students to learn in comfort.

The KI Intellect line of classroom furniture works to eliminate that experience for today's students. By increasing the ergonomic performance of classroom furniture, KI hopes to reduce the "fidget factor" and increase students' ability to learn.

While ergonomics were a key goal of this line, functionality was equally important—the furniture had to be strong enough to withstand the rough usage it was bound to receive while lightweight enough to be moved easily, even by children. Because it was intended for the preschool through adult school market, it had to be flexible enough to work for a wide variety of body sizes and types. It had to be nestable and stackable; it also had to be adaptable to today's high-tech classroom, with accommodations made for keyboards, mousepads, and wires. And visually, because classroom furniture isn't replaced very often, "it had to be simple and clean and kind of timeless," says Scott Bosman, an industrial designer at KI.

Initial sketches included a wide array of ideas for chair and leg configurations. Making the seat and back out of one large piece of plastic turned out to be less cost-effective than separating the two parts. Bending the legs so they crossed under the seat and screwing the shell directly onto the frame proved weaker as well as less distinctive than other solutions.

The designers also brainstormed ways to make the system adjustable in size, but that idea was rejected when market research revealed that once the furniture was sized, it was never changed. Says Bosman, "Why have all these exposed holes and a butchered-up look when you can have just one size that fits, and make four sizes? And costwise, it came out that we could do that."

Early in the process, marketing requested that the design team add the option of a personal bin—a book box that slid out of the desk so students could easily access their own supplies. Design took this idea a few steps further by imagining a lid for the box so that it could serve as a lap desk as well. In the end, the lap desk concept wasn't pursued, but the storage bin was. The drawer holding the book box can also serve as a keyboard tray, further improving the functionality of the desk. The addition of built-in wrist rests and field-installable mousepads adds both functionality and ergonomics to the desk.

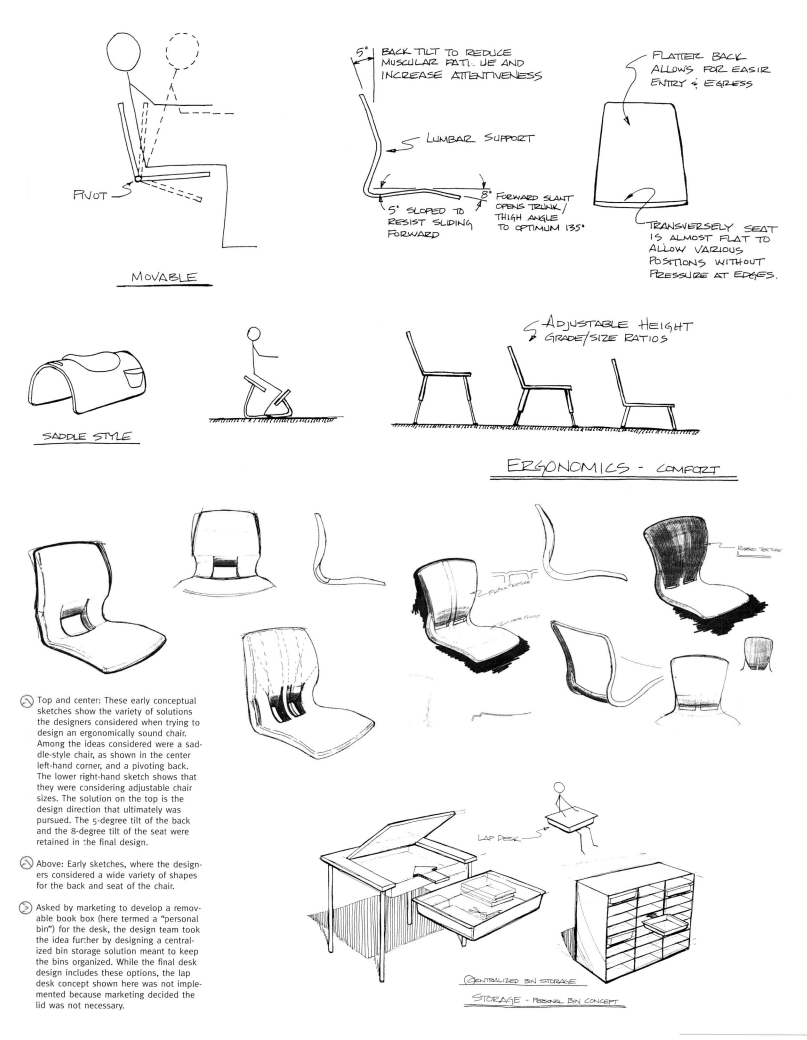

PIVOT

MOVABLE

5° BACK TILT TO REDUCE MUSCULAR FATIGUE AND INCREASE ATTENTIVENESS

LUMBAR SUPPORT

5° SLOPED TO RESIST SLIDING FORWARD

8° FORWARD SLANT OPENS TRUNK / THIGH ANGLE TO OPTIMUM 135°

FLATTER BACK ALLOWS FOR EASIER ENTRY & EGRESS

TRANSVERSELY SEAT IS ALMOST FLAT TO ALLOW VARIOUS POSITIONS WITHOUT PRESSURE AT EDGES.

SADDLE STYLE

ADJUSTABLE HEIGHT GRADE/SIZE RATIOS

ERGONOMICS - COMFORT

RIBBED TEXTURE

Top and center: These early conceptual sketches show the variety of solutions the designers considered when trying to design an ergonomically sound chair. Among the ideas considered were a saddle-style chair, as shown in the center left-hand corner, and a pivoting back. The lower right-hand sketch shows that they were considering adjustable chair sizes. The solution on the top is the design direction that ultimately was pursued. The 5-degree tilt of the back and the 8-degree tilt of the seat were retained in the final design.

Above: Early sketches, where the designers considered a wide variety of shapes for the back and seat of the chair.

Asked by marketing to develop a removable book box (here termed a "personal bin") for the desk, the design team took the idea further by designing a centralized bin storage solution meant to keep the bins organized. While the final desk design includes these options, the lap desk concept shown here was not implemented because marketing decided the lid was not necessary.

LAP DESK

CENTRALIZED BIN STORAGE

STORAGE - PERSONAL BIN CONCEPT

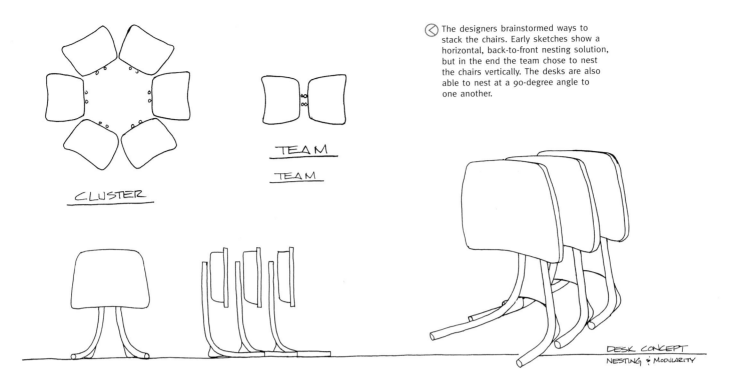

CLUSTER

TEAM

TEAM

The designers brainstormed ways to stack the chairs. Early sketches show a horizontal, back-to-front nesting solution, but in the end the team chose to nest the chairs vertically. The desks are also able to nest at a 90-degree angle to one another.

DESK CONCEPT
NESTING & MODULARITY

Stackability was another important requirement for the system; the chairs had to stack at least six high. But initial prototypes would not stack. It turned out that the crossbar, which had been positioned across the back two legs of the chair to ensure stability, prevented the chairs from stacking properly. The team discovered that moving up the crossbar enabled the chairs to stack without sacrificing stability.

Mobility was another important requirement for the furniture. Handles on the back of the chairs were designed to make it easier for students and cleaning staff alike to move them while giving students a place to hang personal items. The handle was originally nylon, but when testing showed that more strength was needed, a tougher grade of nylon was substituted.

The floor glides were also designed to ensure the mobility of the chairs and desks. The glides in the back are nylon, which slides easily, while the glides in the front are polyethylene, which is stickier; as a result, the chairs and desks slide smoothly when pulled yet grip when stationary. In testing, the glides worked well; however, some issues arose with marketing, so the designers developed customer-specific materials that are easily adaptable to the glide.

While the line was in the prototyping stage, Metaphase Design Group was brought in to give guidance on the ergonomic features and functionality of the product line. Bryce Rutter, founder and CEO of Metaphase, compares the ergonomics of classroom furniture to that of office furniture: "We don't have the luxury that we have in office chair programs, where there's room for springs and cylinders and all kinds of adjustments; we've got to find a solution that really integrates what we call passive ergonomics, where the chair is scaled and has some flexure in the way in which it's designed that would make it seem like it is a high-quality task chair for the student."

Though the budget didn't allow for extensive user testing, Metaphase's team included experts in industrial design, kinesiology, and physical ergonomics. Among their recommendations was to modify the front curve of the desk to fit the curvature of the body. Says Rutter, "It's a lot more sympathetic and inviting for the child to get into their work and get into it in a comfortable way." The team also recommended modifying the waterfall edge on the front of the seat; increasing the radius of the edge to make it softer would reduce pressure on legs, keeping them from falling asleep. Likewise, the edge in the book box was eased for greater comfort when a keyboard was in use. The geometry of the relative distance between the seat back and the seat pan was closely scrutinized and changed to improve both the comfort and the posture of students. More clearance was recommended for the back handle on the chair to suit the larger, stronger hands of cleaning staff. Metaphase passed these recommendations along to the design and engineering team, marking up prototypes and passing along drawing files showing cross sections of the chair. Engineering then modified the molding tools and produced a new prototype for Metaphase to evaluate.

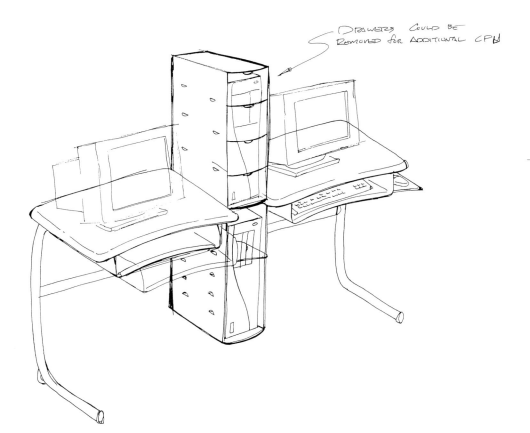

DRAWERS COULD BE
REMOVED FOR ADDITIONAL CPU

Top left: An early concept for CPU shelving for the computer desks; due to lack of demand, this concept was never implemented.

Top right: Illustrations like these helped Metaphase Design Group analyze the ergonomics of the chair's seat pan and of the distance between the seat and the back relative to the shape of the pelvic bone of a child.

The final version of the chair can stack up to six high—one of the original requirements set out for the design team.

Throughout the process, the furniture underwent KI's rigorous safety testing. When the furniture was close to production, prototypes were beta-tested in classrooms near the company's headquarters in Wisconsin. KI got feedback on the furniture from students and staff, and the schools got a discount on the furniture.

Early in the process, the team had agreed on ABS plastic for the seat and back—to provide both strength and flexure—and elliptical steel tubing for the legs. But during manufacture, KI discovered that high-quality, cost-effective manufacturing was more difficult to source than expected. The seats and backs of the chairs produced by KI's vendor in Poland were marred by white marks; KI eventually bought the mold and produced the ABS parts in-house. The team invested in an expensive bending machine, but it required a lot of fine-tuning before it would produce what the team envisioned. Welding the cantilevered seat to the frame took a lot of trial and error, too. "It was done by hand in the beginning," says Bosman, "but the welds just weren't looking like we wanted them to, so we finally got a robot that would do it very well, and it visually looks very nice and is very strong."

The team's attention to detail has paid off. As Rutter says, "It's all these little details that really convert the experience from just another chair into, 'Wow, I really like this, this is nice stuff,' which has resulted in astronomical sales for KI in this category."

Cachet Chair
Plush, ergonomically correct **chairs are** now standard at most desks. But **how many** of us spend all our time at our **desks?** With the large amount of time **most office** workers

The two versions of the Cachet chair: the four-leg stacking version and the five-star-based swivel chair on casters. The chair is available both with upholstery and without (as shown here).

spend in conference rooms, training facilities, auditoriums, and other common areas, Steelcase Inc. could see that there was a need for an ergonomically—and economically—sound chair for the rest of an employee's day.

So when Peter Jon Pearce of Pearce Research and Design—an industrial designer who has worked extensively with space frame structures, playing a role in the designs of Chicago's Navy Pier and Tucson's Biosphere—approached Steelcase with a chair design that met their requirements for an all-purpose office chair, they agreed to work with him to refine his initial concept. "He came to us with a fairly complete idea, at least conceptually," says Bruce Smith, manager of design for Steelcase. "Our role in this was to help clarify a lot of that vision, to make it work from a functional standpoint, an operational standpoint, in terms of production, and from a market standpoint, in terms of form and cost."

Pearce had hit on the idea of achieving a comfortable design by using what he terms a "balanced action-rocker mechanism," which allows individuals to gently recline as the seat flexes and which relies on physics to let individuals find a position that suits them without having to adjust the chair manually. Crucial to this concept was the notion of using advanced polymer materials throughout the chair's construction. Compared to the metal framework used in the construction of most chairs, a polymer construction would weigh less; it would also allow the chair to conform to the user's body, making it more comfortable.

Pearce initially conceived of the construction as entailing a shell-type base in a single-shot mold. Smith describes the original concept: "If you can imagine the structure of a chair beam formed out of a skin that was a constant $\frac{1}{8}$ inch (3 mm) thick, if it could be formed in a particular way, you would not only have strength but you'd have thinness and lightness, and when you want a high-density stacking chair, thinness is very important."

Pearce constructed initial concepts in wire and wood and, along with computer and paper sketches and a model, presented his initial design to the Steelcase design team. At their request, he went on to develop full-scale prototypes, to explore both the aesthetics and the practicalities of the chair's form. "We are a prolific model-building organization here, especially when it comes to seating," says Smith. "Nothing can replace actually seeing a physical piece, something you can walk around full-scale, because chairs are just so sculptural."

⊗ Pearce used this first scale model—only 6 or 8 inches (16 or 20 cm) tall—to present the initial concept to Steelcase.

⊗ After his initial consultation with Steelcase, Pearce made this second aluminum prototype to refine pivot positioning in the chair. For the following nine months, as Pearce continued to work on the Cachet chair, he sat in this prototype to prove to himself that the surfaces were comfortable and that the pivot points worked.

The first scale model led to two discoveries. The first was that Pearce was less restricted than he had thought in locating the pivots required by the chair's action-rocker mechanism, which freed up design possibilities he had not considered. The second was that the shell-style frame he had envisioned would be hard to manufacture.

Another wave of modeling helped the team revise and refine the locations of the pivots. The team also decided to replace the leaf spring mechanism they had been using to achieve the chair's rocking action with an elastomeric torsion spring, or rubber pack. The rubber pack was not only quieter than the leaf spring mechanism; it also performed better and was more durable. Says Smith, "It's literally going to last the entire life of the chair without any change."

During the next generation of proof-of-principle modeling, the team discovered that the chair's seat and back surfaces required very specific contouring to be comfortable. Early design concepts were driven by the choice of single-shot processing as the manufacture system for the product. The process would require a vertical flow channel in both the back and the seat to allow the material to flow to the outer seat structure. However, including this channel in the design constrained compliance and restricted the team's design choices. Design and engineering worked together closely to choose a manufacturing process better suited to the product's needs. In the end, they chose two-shot polypropylene and glass-filled polypropylene for the seat and back to achieve strength, stiffness, and compliance.

Concurrently, the team built half-scale models to explore the aesthetic possibilities of the chair. Some of the chairs explored what Smith calls the "skin structure" concept, while others explored a more stick-built direction, which is what the team pursued in the end. Smith says of this phase, "This really is a testimony to our passion for modeling and seeing these things physically." The first model that Pearce presented to Steelcase was closer in appearance to the final chair than many of the models that followed. Smith notes, "That's the amazing thing about product design and development—it's an iterative process, and you learn a lot of things along the way, and like a lot of things in life, sometimes your first ideas are the best. But it's important to go down those paths to find what really works."

Integral throughout the design process was the 3-D database the team had developed at the start of the project. The ProE modeling enabled the team to predict how changes in the design would affect the material flow mold; some base designs were rejected when the team found they couldn't be manufactured properly.

The end result was a chair that, because it's made essentially out of one material, is 99 percent recyclable. Moreover, the chair follows through on Pearce's original concept—a chair where no unseen structures or mechanics are responsible for its performance— while being comfortable with or without its optional upholstery.

The four-leg side chair was designed to be stackable.

These half-scale stereolithographed models were developed concurrently with the full-scale models to further explore the aesthetic details of the chair. The chair on the far right and the chair second from the left explore Pearce's idea of a skin structure; the chair second from the right was designed by Smith "using [Pearce's] constraints, but with a different language." The chair on the left was designed by Pearce, using more of a stick-built language rather than a skin structure; the team ended up choosing this one for the final design.

Below: This full-scale version of the model helped convince the team to eliminate the skin structure concept as an option, as the molding it required was too thick, negating one of the goals for the chair's design—creating a high-density stacking chair.

Bottom: This functional prototype was developed by the engineering group concurrently with the half-scale stereolithography (SLA) models.

Bottom right: "The slats seen here are molded in polypropylene, and the lid on the mold is lifted, the bottom of the mold is rotated to a different position, the new lid is put on it, and then the outside rim is molded, and then gas assisted," says Smith.

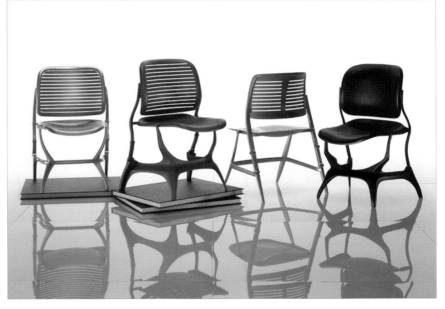

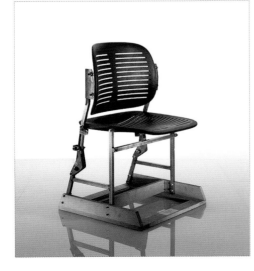

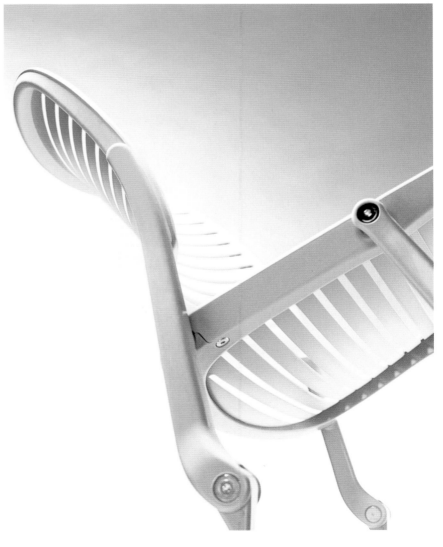

Wharton Lectern

Wharton Lectern The **quality** of the next speech you hear may not be due solely to the **public speaking** skills of the **presenter** but to the **high-tech** innovations built into the lectern.

The Wharton Lectern's Creston control panel allows the presenter to operate every aspect of the presentation environment directly from the lectern, including lights, blinds, and projection screens and cameras.

When the Wharton School of Business at the University of Pennsylvania was looking for 60 lecterns that would be both a signature mark and the educational technology nerve center for its new Jon M. Huntsman Hall, not just any lectern would do—but time was of the essence, as the move-in date was fast approaching.

The Wharton School researched available lecterns and found that none incorporated the attributes they desired—height adjustment, expandable surfaces, and electronic/data capabilities. They took their concerns to Krueger International (KI). The design firm didn't produce this type of product at the time, but they were known to address specific customer needs, especially in the area of one of its core markets, furniture for the education market.

Wharton turned the project over to KI, which initiated discussions with the customer to identify general and specific criteria before developing initial concepts. At that point, KI enlisted the help of Aaron DeJule, an industrial design consultant, for brainstorming and initial concepts.

"Initially, the concepts were somewhat boxy because of the technology equipment and surface space requirements," says Lon Seidl, senior project manager. Designers proposed using semi-transparent and perforated materials to make the lectern appear lighter and smaller, two features desired by Wharton. The recommended materials—a mix of frosted acrylic, sculpted and powder-coated aluminum, perforated steel, and fiberglass—were approved, and designers went back to the drawing board to come up with ideas for new shapes.

Using input provided by the Wharton team and creative problem solving, designers developed a new set of shapes that reflected current thinking and directly addressed the issues of height adjustment and how best to conceal the high-tech hardware.

Stability and strength were the next considerations. These, in turn, dictated the shape of the foot. "Some initial concepts took on shieldlike forms, but they were abandoned in favor of a more interactive and a less defensive posture. The common thread was that all of the forms were much more slender than traditional lecterns," says Seidl. "Ultimately, the more organic shape was selected. It was stately yet approachable."

Finally, a direction was chosen, but now the move-in date was only eight months away. Timing was critical. Designers built electronic, form core, and real material models and shared them with Wharton over the next three months. During this period, designers made changes and alterations, specifically to the slope of the surface, which was thought to be too steep, and overall size, which was deemed too large. Designers incorporated details of

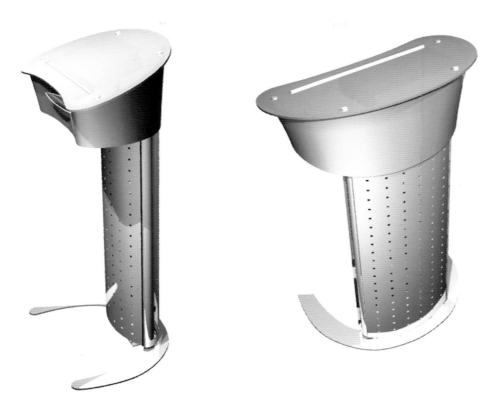

 Renderings show the use of 18-gauge perforated sheet steel. The bottom shroud can be slid upward to allow limited access to the wiring that connects the lectern to a floorbox.

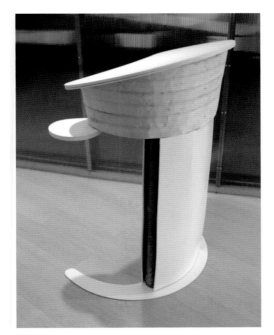

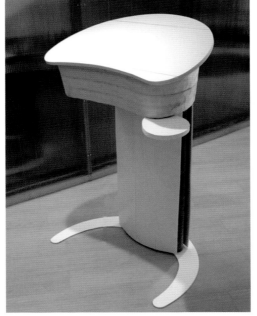

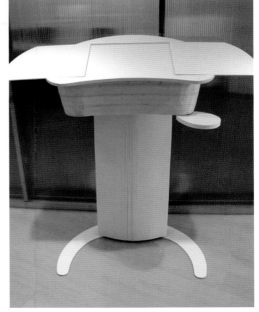

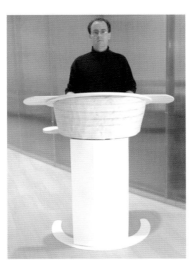

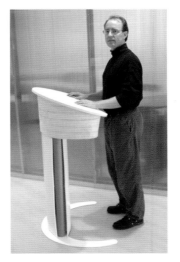

Early mock-ups were made of electronic, form core, and real material to test height adjustability, stability, and other criteria.

components and internal mechanisms into the computer model. One month later, a final prototype was delivered for review, receiving high marks from the professors. It wasn't long before Wharton formally approved the lectern and the team began the final engineering development of the product.

To help speed the entire process and make communicating as efficient as possible, the teams at KI and Wharton shared notes, images, and 3-D models from an extranet site established by KI at the outset. "Basic ergonomic conditions such as the height adjustment range, top angle, activation, and location of controls were studied and shared digitally. The two teams rapidly resolved most of the open design issues," says Seidl.

"The design team had their hands full, as there was now less than five months to ship the first order. All aspects of the product design were influenced by the short timeline. Low volume and fast turnaround required the use of materials that could be readily machined, formed, or laid up by hand, yet were elegant enough to be at the head of the class."

Next, designers looked into alternative materials and production methods. "The 3-D CAD geometry was used extensively for the creation of flat patterns for steel parts, cutting negative mold patters for the fiberglass basin, and direct machining of the aluminum components," explains Seidl. "In addition, the team was able to leverage components and techniques from two existing adjustable table product lines."

These steps all saved time, allowing the product to come together smoothly the first time—"with only a couple of minor tweaks," says Seidl. That was good news. The first order shipped on time, and the lecterns were installed for the fall 2002 semester.

"Product development can be done in many ways, from customer-driven to exploratory brainstorming," adds Seidl. "Initially, this project was thought be a substantial investment of development time while not necessarily fitting with the product development efforts already underway that would have to be put on hold. Eventually, the universality of the solution broadened our horizons. The product is a mainstream offering that embodies all the latest technologies in a stunning visual presence. Be open to the possibilities."

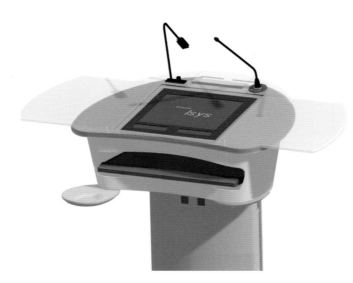

⟨ The frosted acrylic top has two recessed doors that slide open to expose a touch-screen control panel that operates every aspect of the presentation environment, or a laptop.

⟨ The top has built-in extensions to accommodate the speaker's notes or other supporting materials. The basin of the lectern is constructed of fiberglass and painted to match metal components. It supports the acrylic top and houses the control panel and the keyboard tray; it also functions as the technology well for the adjustment motor and controller.

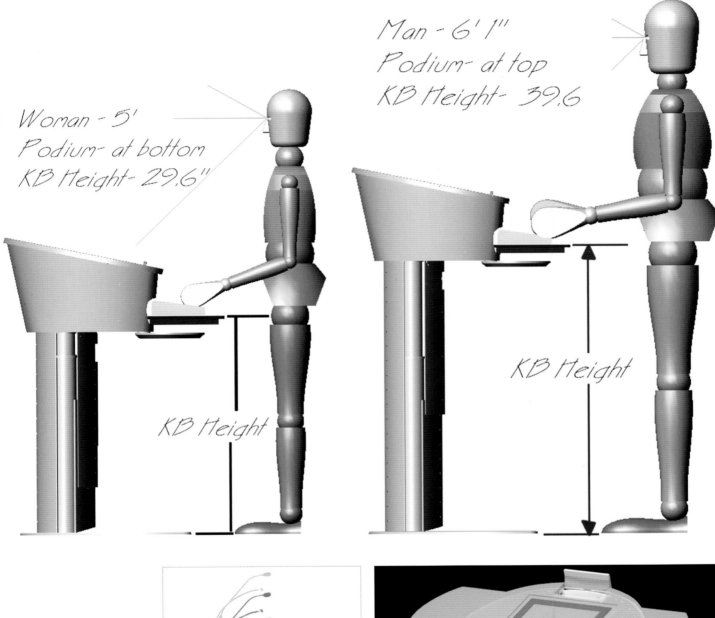

Woman - 5'
Podium- at bottom
KB Height- 29.6"

KB Height

Man - 6' 1"
Podium- at top
KB Height- 39.6

KB Height

⊘ Top: The adjustability of the lectern's height was a key design element. The presenter has to touch only one button to raise or lower the lectern between a range of 37 inches (94 cm) and 47 inches (119 cm).

⊘ Above: The speaker can easily adjust the gooseneck microphone and light for individual preference.

⊘ Right: The lectern was designed so that speakers could access their LAN, surf the Web, or access the hard drive of their personal laptop.

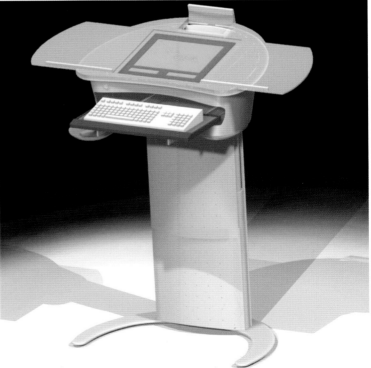

The **HP Workstation zx6000** was **created** when the Hewlett-Packard Company **needed** a new line of products to go with the **introduction** of a new chip from Intel, the **Itanium chip**. The company tasked **Lunar Design** with the job.

⊗ The upright orientation minimizes the time required for servicing; the alternative is having to remove all the access panels and turning the unit on its side. To perform basic servicing tasks such as memory and expansion upgrades, customers can remove the side panels of the HP Workstation zx6000 without tools, and the hard drives are hot swap accessible without removing access panels.

⊗ In developing concepts, designers created a story using people, products, and artifacts to give likely users a personality. "This combination of imagery creates a demographic caricature of who might be using this product and the experience they desire. The goal is to have the form of the concept communicate the desired personality," says Max Yoshimoto, vice president of design at Lunar Design.

⊗ Opposite top: Designers created a series of concepts and matched each with a fictional potential user with a scenario of preferred features and characteristics. "Part of how we describe a concept is to try to attach an idea with a few words and attach a personality to the concept as well, like a small demographic," says Yoshimoto.

⊗ Opposite bottom: Here is a preliminary take at developing different personalities for one of the concepts presented. In this scenario, designers also show preliminary thumbnails to support the imagery.

The mission: create a workstation for the computer-aided engineering (CAE), life sciences visualization, scientific research, government/military, software development, digital content creation (DCC), and mechanical computer-aided design (MCAD) markets. While users would range from creative animators to engineers, the station was to be designed primarily for aerospace and mechanical engineers—people who demand a system that is powerful, fast, sophisticated, stable, and robust.

Among designers' goals was easy transformation from racked graphics workstation to deskside unit. It was also important that the design language be applied to other HP workstations of different size.

Using software programs such as Alias and Vellum, designers set to work. Not unlike other design teams, this task force began by thoroughly analyzing the customer. However, while identifying concepts, they actually identified customers and developed fictional scenarios of likely users along with profiles of their needs, likes, and dislikes, which they matched to each concept. From there, they developed sketches, mock-ups, and CAD models, keeping them matched to the personalities they developed.

"As the new product had to use an existing-rack mount enclosure, and none of the components within it could be rearranged, the design team decided to treat the existing enclosure as a performance-driven black computing engine," says Max Yoshimoto, vice president of design. "User-accessible components such as the hot swappable hard drives and CD door were left as is, with a raw yet functional feel. Contrasting silver metallic side panels

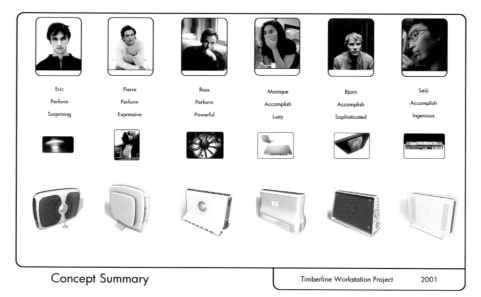

Concept Summary Timberline Workstation Project 2001

Automotive Designer [USA]

Ross

Perform

Gesture
Expression
Empress

Powerful

"Front grill"

Create a hollow area to encapsulate the "engine", need to add side vents

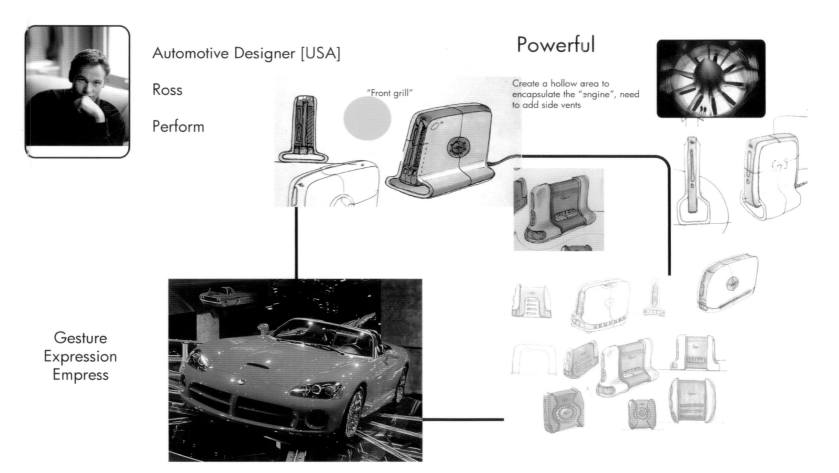

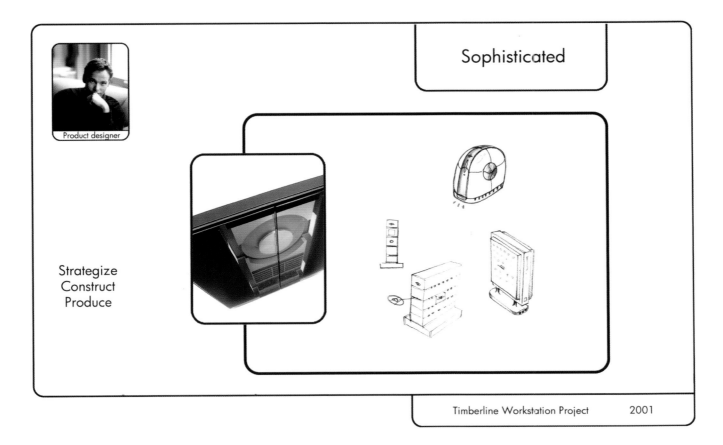

Sophisticated

Product designer

Strategize
Construct
Produce

Timberline Workstation Project 2001

were introduced to the design for an element of sophistication and to reinforce the messages of speed and power. The side panels lift the engine off the ground to provide proper ventilation. They also give the product more presence and importance."

Ultimately, the concept chosen featured an upright orientation that is easily serviced without tools or having to turn the unit on its side. To perform basic servicing tasks such as memory and expansion upgrades, customers simply remove the side panels of the HP Workstation zx6000 without tools. The hard drives are hot swap accessible without removing access panels.

The operating procedure is quite simple, too. The user connects the power cord to an outlet, connects the network cable, and powers up the machine, at which point the operating system software and application software take over.

"The HP zx6000 is designed to be flexible. It can be used as a single-unit deskside system or as a multiple-unit system in a rack mount configuration. The side panel design also helps highlight how easy it is to repurpose a rack-mount unit into a deskside unit. It is ideal for users who need racked graphics workstations

or who require cluster nodes that can later be redeployed as deskside units," says Yoshimoto. Lunar Design has heard that customers have been very pleased with the product's design.

"Most products have but one life and then are either recycled or end up in a landfill. Giving the product a second life by repurposing it from a rack-mount unit to a deskside unit has a positive impact on society by extending the usage of resources in the product," says Yoshimoto.

What did Yoshimoto and the rest of the design team learn from this experience? "Don't think that ideas are too wild, and don't make assumptions. Show some wild, pushy ideas along with ones that are more grounded," he says. "This tends to open the discussion and keep people on their toes."

"Have a clear sense of why your designs—wild or mild—are noteworthy. Create emotion, reason, and meaning behind a design. Because it looks cool is just makeup or a nice haircut; the effect is pretty light and wears off quickly. Enhance and expose the product's personality by telling a complete story, and when you tell that story, know who your audience is."

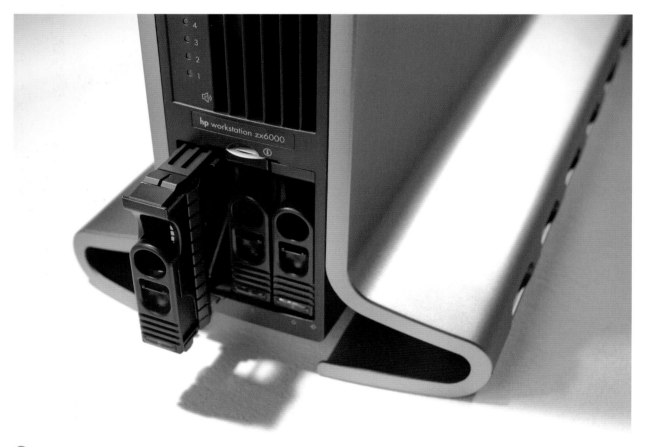

A close-up of the HP Workstation zx6000 drive.

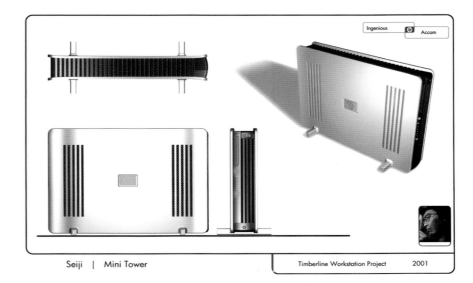

⊘ This concept, developed for the fictional Ross, an automotive product designer, is based on a selected demographic and personality. His concept was liked by the client and is shown here in further development.

Ross Timberline Workstation Project 2001

⊘ Ultimately, the concept developed for Ross was chosen as the final direction, but before it was granted final approval, it competed against an alternative concept, developed in parallel for Seiji, which also featured an upright workstation.

Seiji | Mini Tower Timberline Workstation Project 2001

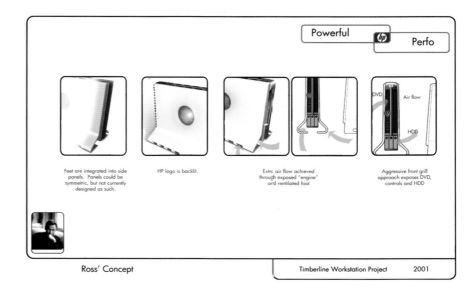

Feet are integrated into side panels. Panels could be symmetric, but not currently designed as such.

HP logo is backlit.

Extra air flow achieved through exposed "engine" and ventilated foot

Aggressive front grill approach exposes DVD, controls and HDD

⊘ These sketches further develop Ross' concept and describe how the forms provide solutions for the technical requirements of the project.

Ross' Concept Timberline Workstation Project 2001

The **Spider table** and Accessories for Herman Miller

is easily assembled in just **15 minutes** with only six Phillips screws and a **screwdriver**. More important, for **less than $500**, a start-up business can set up a **workstation** with accessories that **looks professional**.

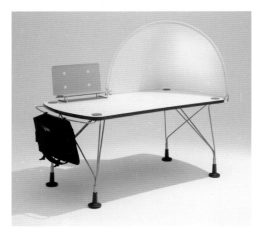

⊗ Lightweight legs and disk-shaped feet allow for 3 inches (8 cm) of height adjustability. They make gliding easy for office reconfiguration and individualized table height. The metal rod tool bar is good for hanging everything from umbrellas to laptop bags to purses to blazers. Herman Miller also supplies an attachable bag that can be used for daily active file storage.

That was the goal when Herman Miller, a manufacturer of office furniture, asked ECCO Design to create a reasonably priced, high-performance desk that would fill a major gap for start-up businesses headed by young and hip buyers.

"The idea for Spider originated from observing the number of start-up companies with little capital that needed creative design solutions for their diverse needs of office privacy, mobility, and personalized space," says Eric Chan, president of ECCO Design. "Spider is a big step forward from corporate desk systems that have little character, are immobile, and take a great deal of time and money to obtain. This new tool allows individuals to challenge the traditional furniture status quo of corporate-dominated style, function, and price."

Of course, that also posed designers' biggest challenge: how best to offer innovative and highly functional solutions for young, spontaneous users while keeping the prices low and affordable. With that in mind, designers embarked on the project. The first step was to conduct a project download with the client. Then, they did in-depth research, including site visits, interviews, online investigation and surveys, and extrapolation, to understand the market and key problems. With research in hand, they started brainstorming and developing sketches of table ideas.

These sketches explored different tabletops, keeping in mind the client's priorities—that the desk provide storage, cable management, cable function, and independent form and structure. Likewise, designers explored various accessories in hand sketches as well as how the table legs would fold to facilitate portability.

With dozens of hand sketches completed, designers created scale mock-ups, which they refined before putting the design into 3-D CAD modeling. With client approval, they created full-size mock-up to test structural schemes, of which there were multiple iterations. Ultimately, they had their final creation—a simple, streamlined desk that met all the client's criteria and then some.

The desktop cover acts like a giant picture frame. Users can personalize their table by placing photos, art, wallpaper, or whatever else they want beneath the free-floating plastic sheet indexed between the four corner caps. An ample document stand snaps onto the table to hold books, CDs, and documents upright. Pens and files nestle beneath.

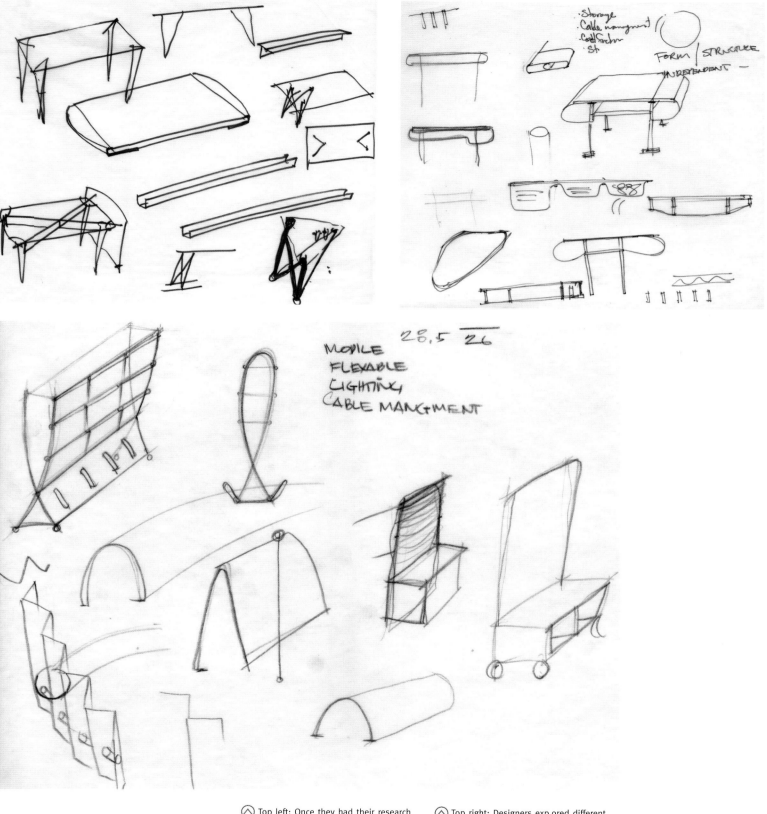

Top left: Once they had their research in hand, designers played around with rough sketches of various table ideas.

Above: Mobility, flexibility, and cable management were treated as accessories in this sketch, which also explored lighting.

Top right: Designers explored different tabletops, keeping in mind that the client wanted a desk that provided storage, cable management, cable function, and independent form and structure.

"Spider's corner screen adds just enough privacy to hide both a monitor and wandering eyes," says Chan. Monitor cables easily tuck under the elastic canopy, creating free-form cable management. Slightly transparent, the screen retains that big loftlike space start-ups desire. With just one Velcro closure, it is easy to remove and wash.

The Spider and its accessories can be ordered online and shipped door to door in about a week. "This new and innovative approach is backed by a smart product that offers not only essential features but also great performance and flexibility," says Chan.

"Spider is a democratizing piece that everyone can afford and feel good using, whether they are the company owner or the intern," he adds. "For under $500, a young firm can set up a complete workstation with accessories."

Does Chan offer any advice for the design intern? "Conceive of the fantastic and make it feasible, or conceive of the feasible and make it fantastic," he says. "Either of these may be the right approach, depending on the endeavor. It pays to know in advance which to pursue. In this case, with a tight time frame for production and an aggressive price target, it was wise to use the tried-and-true affordable methods and materials—then push the limits for a surprising result."

⊽ This sketch includes sample storage and easily hidden computer cable chaos, but the concept still required refinement.

⊳ Opposite top: Designers sketched various leg shapes before hitting on the final structure, which is shown here.

⊳ Opposite bottom left: The legs attach to the underside of table with the help of a tabletop cap. All totaled, the Spider table is assembled with only six Phillips screws.

⊳ Opposite bottom right: A sketch of the final concept aptly illustrates the table's simplicity and details, including all accessories, legs, and points of attachment.

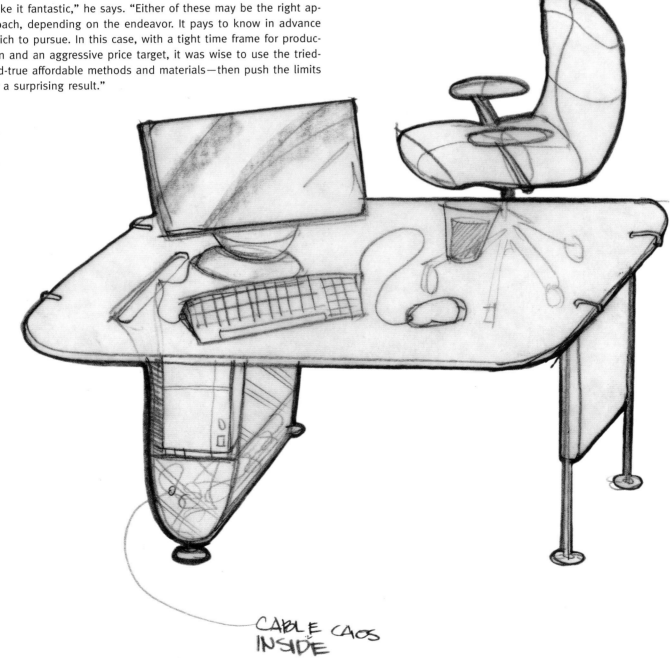

CABLE CAOS INSIDE

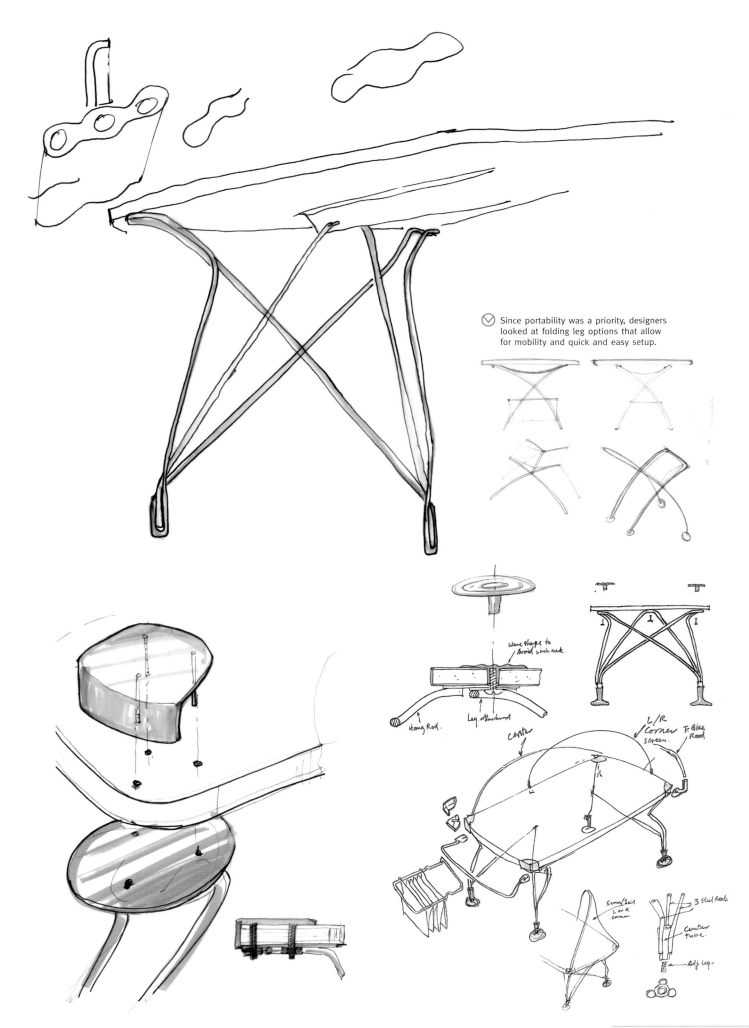

Since portability was a priority, designers looked at folding leg options that allow for mobility and quick and easy setup.

Wave shape to avoid sink mark.

Hang Rod.

Leg. Attachment.

center

L/R Corner screen.

F. Glass Rod

Screen/Sail L or R corner.

3 Stud Rods

Center tube.

Adj. Leg.

IBM Transnote

What if your **notepad** were **as smart as** your laptop computer? **That was the idea** behind IBM's **TransNote,** a device that immediately **digitizes** notes taken on paper, with all the **functionality** that implies.

⬥ The TransNote follows in the footsteps of the ThinkPad, both in its use of ThinkPad brand colors and in the way its simple exterior opens to reveal a surprise.

⬥ Opposite top: In these early concept sketches, the design team attempted to fit the TransNote into the clamshell form factor IBM had established with the ThinkPad; all of these ideas were rejected when the team realized they were too complicated for users.

⬥ Opposite bottom: This sketch reveals some of the details behind the TransNote's configuration. The right side shows how the display is positioned over the TransNote's keyboard; the left side shows the unique Z-shape of the TransNote, which allows the user to view only one side of the TransNote while protecting the other side.

John Karidis, an IBM Distinguished Engineer, says the idea behind the TransNote was "to use the paper for what it's good for, which is quick and natural expression and sketches, but to add the value of the computer, which is organizing, searching, communicating, image sending and storing, and retrieving." When users open the TransNote, all they see is the LED touchscreen and a pad of paper. While there is a keyboard underneath the screen if needed, users are meant to interact with the TransNote primarily through the pen—making the device an ideal companion at meetings, where the clicking of a keyboard might be distracting. Notes, sketches, and forms can be shared instantaneously by printing copies or emailing them.

The TransNote evolved from two existing IBM products. The CrossPad, which IBM developed with A.T. Cross, allowed users, with the help of a special pen and pad, to make handwritten notes digital. However, the fact that it was a peripheral device made its use less than seamless: If users wanted to email a sketch during a meeting, they would have to bring their computers, hook up their CrossPad to the computer, and download the information before they could proceed. Ron Smith, project manager for the IBM Corporate Strategic Design Program, says, "All along, we had the idea that there was some way to marry the computer world and this digitized paper world together into one thing that would be in itself a little bit greater than the individual pieces." IBM had already designed the ThinkPad, an early version of a laptop computer, so combining it with the CrossPad was a natural fit.

Extensive user research identified a list of things the new product had to do well: easy note taking, storage, and retrieval; easy sharing of handwritten information; simplification of personal information management; and automation of paper-based forms. These goals were the benchmark of all further research and development; if a feature was proposed that did not support these objectives, it was discarded. Says Smith, "One thing that's always a danger with any computer product is that there's so many things that you can make it do that it's quite easy to achieve doing none of them very well." Two primary user groups were targeted: note-takers and graphic-intensive users such as architects, journalists, designers, lawyers, and engineers; and business users who fill out forms regularly in the line of work, such as members of the pharmaceutical, insurance, and real estate industries.

Research had shown that users wanted a pad of paper no smaller than $8 \frac{1}{2}$ x 11 inches (21.5 x 28 cm) to write on. Coincidentally, that size matched the clamshell shape and size characteristic of IBM's ThinkPad, so many of the initial explorations of the team, both in sketches and prototypes, explored concepts based on that form

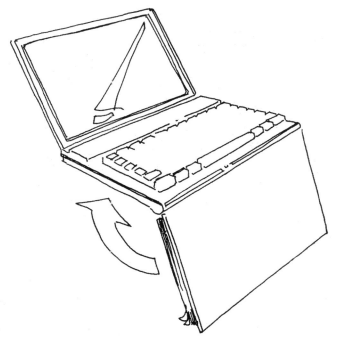

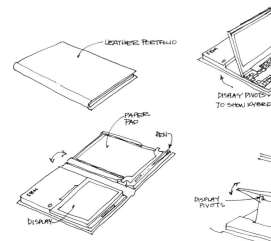

LEATHER PORTFOLIO

PAPER PAD

PEN

DISPLAY

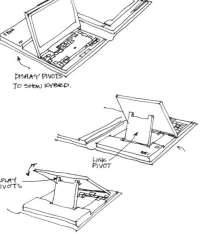

DISPLAY PIVOTS TO SHOW KYBRD.

LINK PIVOT

DISPLAY PIVOTS

factor. But while that was the easiest design to do, it wouldn't be the easiest product to use. Says Karidis, "We stopped and said, look, the user cannot be required to rotate things or do a lot of reconfiguration to switch modes. The keyboard has to be accessible without rotation. The paper has to be vertically oriented in its normal mode, and we have to figure out a way to put all that stuff together without it being too big or too thick." That meant the computer and the pad would have to be side by side—and that meant the computer side would have to be shrunk. A display 10.4 inches (26 cm) wide, plus an optimized keyboard of the same width, was the smallest the team felt they could go and still have a workable device.

With the width of both sides of the TransNote defined, just a small vertical strip down the left-hand side of the digitizer remained for both the electronics and the user interface. To keep everything on the computer side no thicker than $\frac{3}{4}$ inch (2 cm), the designers set the display directly on top of the keyboard and put all of the thicker components, like the battery and disk drive, toward the back of the left-hand side. In addition to keeping the device thin, this configuration also de-emphasized the importance of the keyboard. Users have the option to use an onscreen keyboard, if they have a small amount of text to type in, or they can pull out the screen and type on a traditional keyboard if necessary. This configuration also allows users to use the TransNote in a group setting without imposing the physical barrier of a screen between themselves and others—an important benefit in cultures where imposing such a physical barrier is considered rude. The arm required by this configuration allowed the team to add a feature that enables users to rotate the screen.

Once the team had settled on the configuration, a new problem appeared: Clearly, the TransNote would still be too large to use on an airplane and in similar situations. In such settings, users would have to fold the TransNote in half, which would either rub the computer side against the table or crumple the paper. Says Smith, "It was going to be a major obstacle to using this product

if we didn't come up with a good solution for that." After creating dozens of cardboard models, the team finally hit on a concept that worked: By integrating a unique soft cover into the hinge and adding two other hinge locations, the IBM team created a solution that would allow users to follow their natural instinct to stack one side on top of the other rather than to fold the TransNote in half.

Another discovery was that the TransNote would be difficult for left-handed users to negotiate. For this market in particular, that was a problem. "Five percent of the general population is left-handed, but 10 or 15 percent of the creative and artistic population—those who might be interested in sketching—is left-handed," says Karidis. It was clear that a reversed version of the product was necessary.

The TransNote hardware was not the only area of concern for the team; its proprietary InkManager Pro software was equally important to the product's usability. The product was so new and different that, according to Smith, "It really required a lot of participation and buy-in from different areas, including the software guys really believing in the product and trying to understand what it would be like physically to use the thing." The team closely analyzed the various ways that people organize their notes so they could understand what features would be valuable to users. The software team also kept the four main goals of the product in mind and discarded or minimized features—such as handwriting recognition—that couldn't be done well enough or that didn't relate to the product's core aims. To help users find the notes they were looking for, the software enabled users to get a thumbnail view of their documents, long before Windows included such a feature. Other features, such as the feature which allowed the user to organize their notes into folders, proved to be more problematic, and rollout of the product was delayed until the team felt the software successfully achieved the goals they had for the product.

This image of the TransNote's proprietary InkManager Pro software demonstrates its ability to allow users to search by keyword and organize their notes in folders.

In the end, the TransNote didn't meet with the market success IBM expected: Just as the product was released there was a downturn in the economy; the vertical markets IBM had targeted were hit hard and, thus, were unwilling to invest in new technology. But there were collateral benefits to the project. Says Karidis, "We learned a lot about customers' usage and requirements and issues around tablet-oriented computing. It's one of the reasons why to date IBM is not selling a tablet PC. It is a niche market, but a very large number of people is going after that market, and so based on our understanding of the marketplace, we're watching and waiting." Smith adds, "I have to really applaud IBM for taking the risk to develop this."

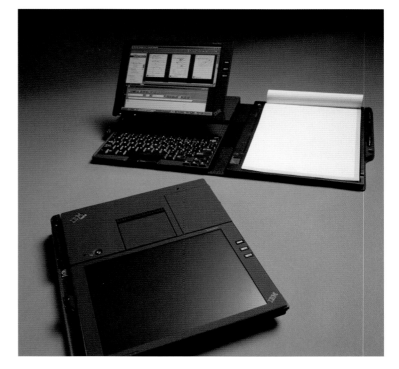

⊘ ⊘ The many faces of the TransNote: right, closed and opened, with the display up; below, when the user first opens the TransNote; below right, with only the writing side visible.

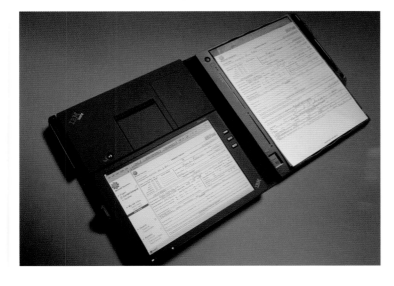

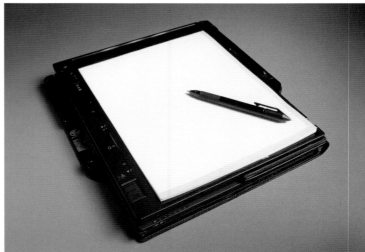

⊘ The arm on the screen of the TransNote allows users to easily share the display with others.

All photos—Jimmy Williams Productions

IBM NetVista X41 What do you get when you take the "desktop" out of "desktop computer"? You get IBM's NetVista X41, a personal computer that, through its revolutionary design, doesn't require a desktop.

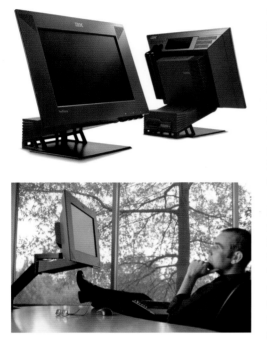

The integrated flat-screen computer, which gives consumers the choice of arm-mounting or desktop placement, was IBM's response to requests from customers to develop a computer for placement in a variety of previously unthought-of spaces. Traditional personal computer designs were not well-suited for highly space-constrained work environments such as hotel registration desks, bank teller counters, and work cubicles; additionally, they were not optimized for sharing information in the highly dynamic and collaborative work environments common today. IBM saw the need for a space-saving, easily serviced, and ergonomically sound computer, and a team convened with a mission: to create a design that would revolutionize not only the way a computer looked but also how and where people could use it.

IBM enlisted the help of world-renowned designer Richard Sapper, who also designed IBM's first ThinkPad, and started to rethink the idea of the desktop computer. One of the first priorities of the team was to hide the technological components of the computer. "We felt that people weren't really interested in looking at their computer," says David Hill, director of design for IBM's personal computing division. "They were more interested in the experience of *using* a computer, which is really primarily all about the screen, so our idea from the beginning was to make the computer appear as though it was only a display."

The NetVista X41 in both its arm-mounted and desktop versions. Paired with a cordless keyboard and mouse, it offers a uniquely convenient and freeing user experience.

What the user would see was not the team's only concern; how the user would use the machine was also at the top of their minds. Having the CD-ROM/DVD drive at the front of the system was a design concept that can be seen even in the earliest sketches. "The idea of hiding everything and making it invisible yet having everything you need right at your fingertips was really the core concept of the actual physical configuration," says John Swansey, senior industrial designer for IBM.

To brainstorm how to configure the interior to take up the smallest possible space, the team took the physical volumetrics of the core internal components and, on pieces of paper on a light table, moved them around until they hit on a configuration that would work on both technical and design levels. Says Swansey, "In our team-based, cross-disciplinary group that was doing the development, we had very close interaction with the marketing department, engineers, and mechanical and electrical experts that could let us configure those components exactly the way that would best support the user experience we were trying to create." The team identified an innovative configuration in which the system board, option cards, and hard drive were placed directly behind the screen, allowing them to jettison the separate box for those components that was standard in most computers at that time.

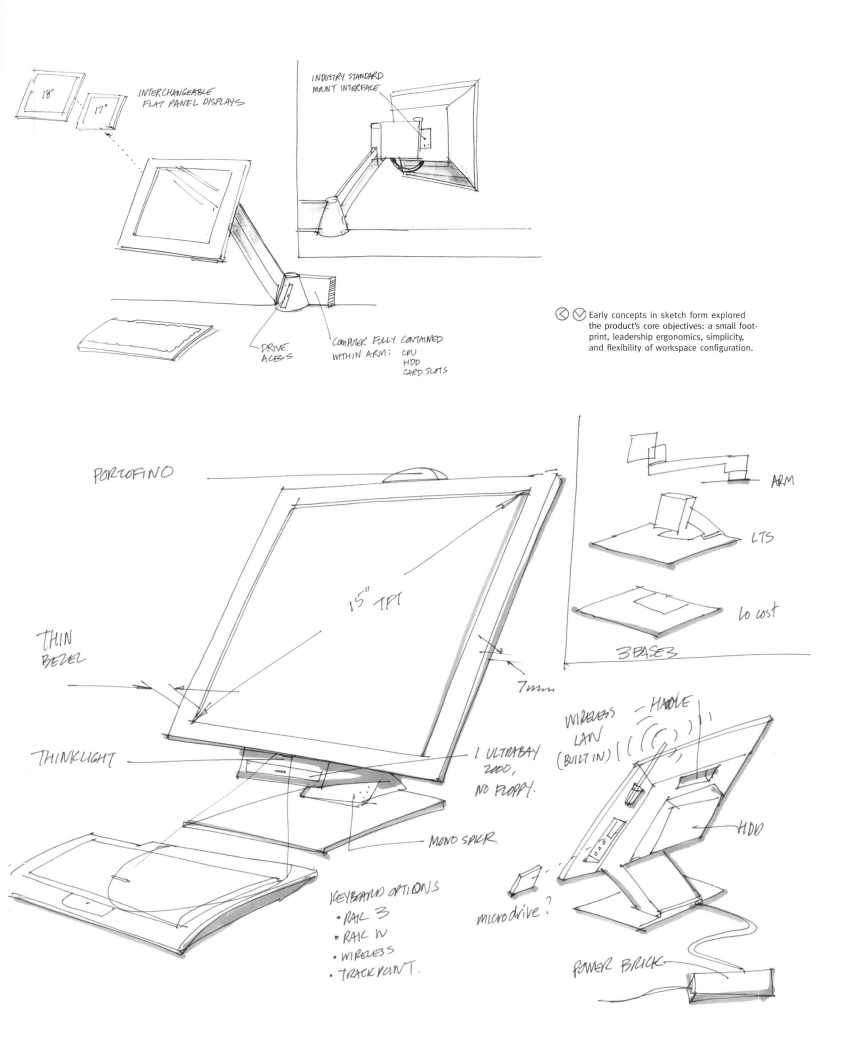

18" 17"

INTERCHANGEABLE
FLAT PANEL DISPLAYS

INDUSTRY STANDARD
MOUNT INTERFACE

DRIVE
ACCESS

COMPUTER FULLY CONTAINED
WITHIN ARM: CPU
 HDD
 CARD SLOTS

Early concepts in sketch form explored the product's core objectives: a small footprint, leadership ergonomics, simplicity, and flexibility of workspace configuration.

PORTOFINO

15" TFT

THIN
BEZEL

THINKLIGHT

7mm

1 ULTRABAY
2000,
NO FLOPPY.

MONO SPKR.

KEYBOARD OPTIONS
• RAIL 3
• RAIL IV
• WIRELESS
• TRACKPOINT.

ARM

LTS

Lo cost

3 BASES

WIRELESS
LAN
(BUILT IN)

HANDLE

HDD

microdrive?

POWER BRICK

Sapper worked closely with the IBM team from his studio in Milan and was instrumental in devising the computer's bold geometric form. Advancing his goal of creating a "floating" computer that gave the screen the highest priority, he sketched a number of designs that followed through on that idea. One concept featured a removable base that was called the Eiffel Tower base because of its lightness and openness; another featured a counterbalanced arm. Both of these ideas were selected for further development and user testing.

Testing revealed that users were sharply divided between those who preferred the arm-mounted design and those who preferred a free-standing design. More low-tech users preferred the plug-and-play aspect of the free-standing model, while larger businesses with technical support staff preferred the elegant, space-saving design of the arm-mounted version. As a result, the team decided to offer the arm-mounting mechanism as a separately sold accessory, so consumers can choose the configuration that best suits their needs.

Midway through the process, the team was asked to integrate the latest, highest-performance processors, and as a result had to reconfigure the internal components to allow for a larger processor and a larger cooling mechanism. While this change could have been disruptive, the IBM team was able to react quickly because the changes were kept within what Swansey calls a "very tight loop" of design and engineering. Hill says of the design team, "We had our finger on the pulse of everything that was going on and were active in all of the decisions."

Numerous models and prototypes followed, all designed to handle the new technical demands while keeping the computer as quiet as possible. The end result was the finlike design, complete with air slots surrounding the back of the monitor and the component case, that can be seen on the back of the final product; Hill thinks that the team turned a negative into a positive by translating these technical demands into a design that was a visual manifestation of the power of the computer. The look of the back of this computer was particularly critical, since it often would be placed facing business users' clients.

Other features of the computer required fine-tuning during prototyping. Says Swansey, "The arm took a fair amount of engineering to make sure it was strong enough to withstand movement and that it could be adjusted to balance properly at any height the user chose." The team also worked hard to make sure the design looked integrated but that the rear cover could be removed without tools for easy access to the computer components; however, the shape and pressure of the latch mechanism used to make that happen required several iterations before the team was satisfied.

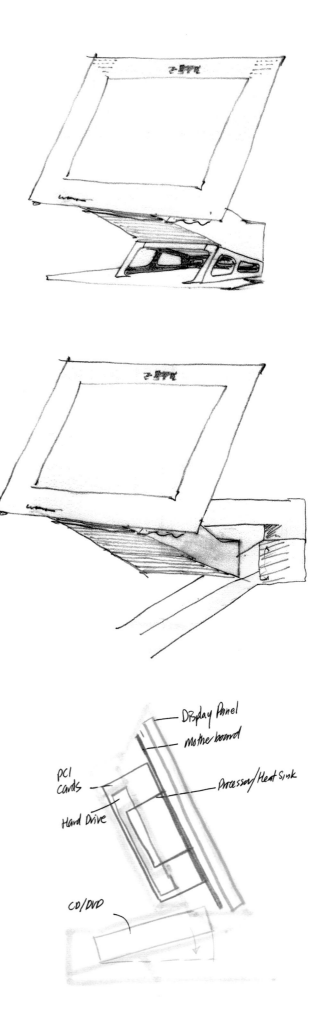

⊘ Early Richard Sapper concept sketches. One shows a proposal for the removable Eiffel Tower base, whose openings emphasize a sense of lightness; the other envisions the computer mounted on an arm.

⊘ A sketch showing some of the early thinking behind the arrangement of the computer's internal components. This compact and innovative configuration conceals most of the elements behind the display panel but places the CD/DVD drive where it is most accessible. The close-fitting external contours enabled by this arrangement create a slim and distinctive profile.

Display Panel
Mother board
PCI cards
Processor/Heat Sink
Hard Drive
CD/DVD

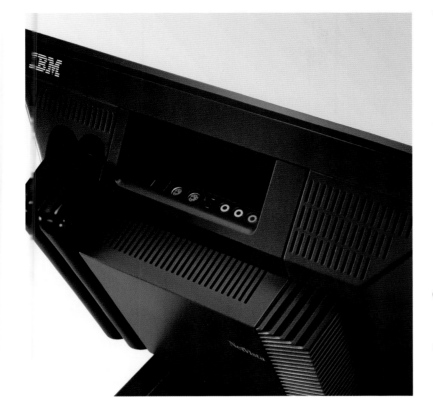

While the NetVista X41 was a successful product at the time of its release in 2001, IBM has decided to discontinue its line of all-in-one computers with flat screens, for two reasons. First, the increased size, speed, and cooling requirements of processors has made it increasingly difficult to configure both processor and cooling mechanism in such a small space. The team also received feedback after the product's release that some customers wanted to be able to preserve their investment in the flat-panel screen, and an integrated product doesn't allow for that. For the moment, IBM products with flat-panel displays and a smaller computer size are able to deliver a similar user experience while allowing customers to upgrade as needed. However, IBM has not abandoned the idea of an all-in-one flat-screen computer entirely. Since IBM's design process is, according to Hill, "very iterative, very customer-focused, getting customer feedback, modifying products, and making them better and better," the company remains open to whatever customers might demand in the future.

◁ Final detail of the top rear showing cooling air exits, convenience jacks for headphones, retractable handle, and black cylindrical covers over the expansion card slots.

▽ The range of motion possible with the optional arm permits the X41 to be shared by two users and accommodates both sitting and standing use positions. A touchscreen option facilitates stand-up use.

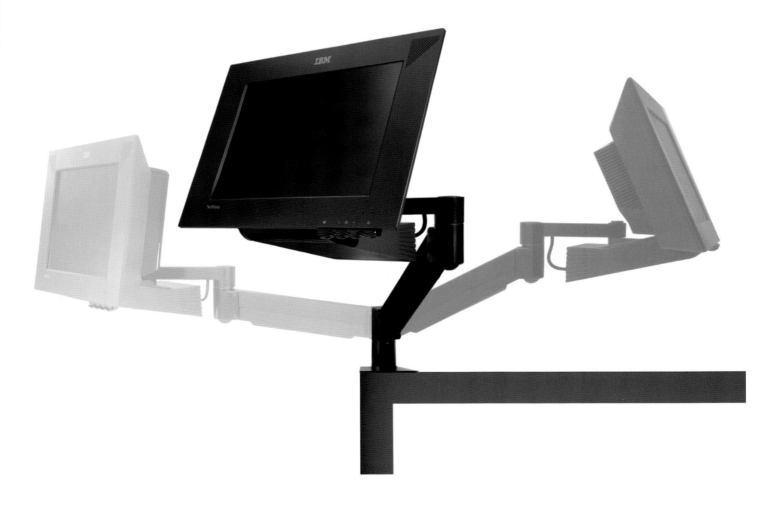

Labtec Desk Microphones Verse 504 and 514

They stand only 8 **inches** (20 cm) **high**, but the diminutive **Desk Microphones** pack a **mighty punch**, especially in terms of their **high-end** design versus **low price point.**

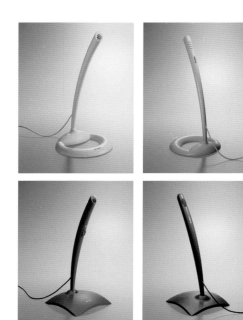

⊘ Demand outpaced supply for both the Labtec 504 (top left and right) and 514 products, however the higher-end 514 premium product did surprisingly well.

Labtec, their manufacturer, wanted to take advantage of the growing market for desktop microphones used with personal computers for Internet telephony and for software applications that support voice recording or voice recognition. However, to do so, it needed to replace an existing desktop model that looked dated and appeared too similar to competing products with something new and more eye-catching.

"Desktop PC microphones had been around for awhile, but momentum had been growing in the year leading up to this program," says Steve Rodden, partner, Fiori product design. "Labtec knew that they had an opportunity to capitalize on these trends, but they also knew that they needed an improved product to take advantage of increasing demand." Labtec assigned the job to Fiori and stated their two priorities: Get it done fast, and make sure the cost of the new product was no more than the current one.

"When we began, we established some priorities of our own, first, this is a simple product, let's keep it simple in both function and design. Second, this may be a low cost product, but low cost doesn't have to mean low design. Let's demonstrate that great design doesn't have to add cost to a product," says Rodden.

Designers began the process by deciding on one-word attributes they wanted to communicate through the design. Rodden remembers that "*simple* was obvious; *valuable* was an attribute to balance the product's low cost; *natural* because we felt that nature was missing on the desktop; *personal* because the product would be in close proximity to the person using it; and *striking* to capture the attention of people walking by a store shelf.

"While the schedule was tight, and it may have seemed frivolous, taking ample time to debate, discuss, and document what we wanted to achieve in this product was critical in proving both fuel and guidance for the design that followed," Rodden says.

The brainstorming process came next. Four to six designers sketched together around a large table but worked individually. Afterward, the group discussed each concept and offered opinions on its promise and how it might be refined. "The work was collective and unselfish. Many of the ideas were taken up and refined by someone other than the originator. We continued the process of developing form concepts over the course of about a week and a half," says Rodden.

With almost 100 concepts to choose from, designers narrowed the field by grouping similar concepts using the attributes they had defined earlier. Next, they prepared hand-sculpted foam models and 2-D orthographic renderings of each of six selected concepts

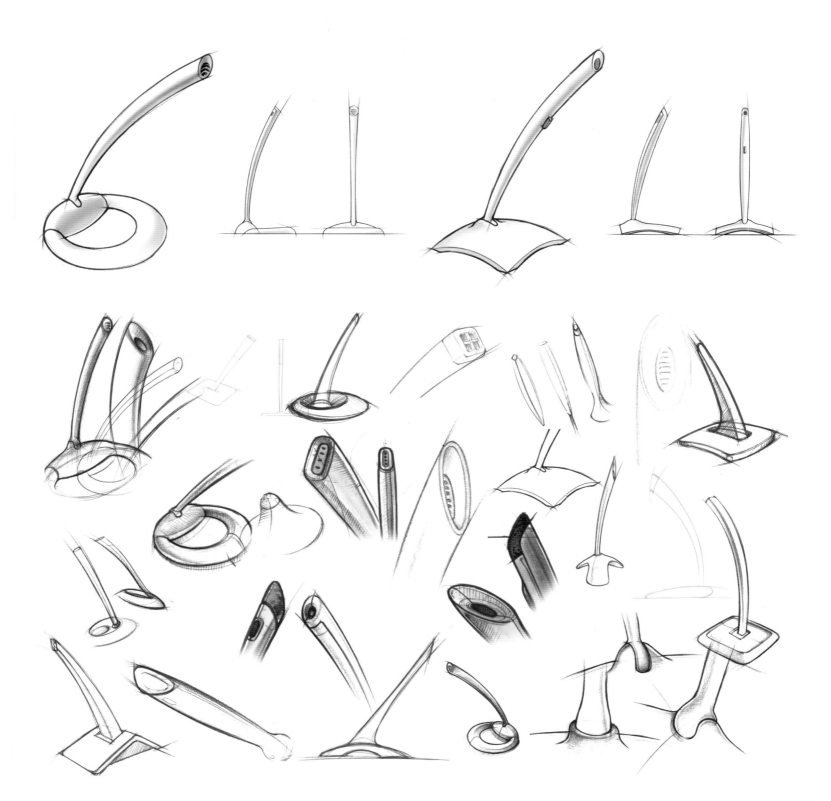

⬦ Top: Labtec liked two of the initial concepts presented, both utilizing tall, elegant, slender booms and distinctive bases.

⬦ Bottom: During the brainstorm phase, designers produced almost 100 possibilities. They narrowed the field by grouping similar concepts using the attributes they had defined early in the program. Interestingly, a majority of the concepts selected had strong influences in nature. "This attribute became increasingly compelling to us as we moved through the process. Product design inspired by nature is nothing new, but with this product, we felt that we had a unique opportunity to stay true to natural inspirations," says Chris Valentine, a designer with Fiori.

for presentation to the client. They also included a construction diagram for each concept that outlined the probable method of molding and assembling the product. "This step was important in demonstrating that each concept could be produced," says Rodden. "This enabled the client to focus on the design of each concept without concern for its feasibility."

During the review, Labtec gravitated to two of the concepts, both utilizing tall, elegant, slender booms and distinctive bases. "After much discussion, evaluation, and debate, the client still couldn't decide which of the concepts to move forward with. They were absolutely in love with both," remembers Rodden. "With the tight schedule, we had planned to narrow to a single concept in this review, but because of the impasse, we agreed to carry both concepts forward in the next phase of refinement."

Next, designers refined the details. "With products so simple and forms so pure, the details become even more important," says Rodden. "We spent the next week developing and evaluating countless options for each facet of the product. We worried over each parting line location and trajectory, agonized over vent shape and spacing, and argued over the perfect pivot."

In the next client review, Labtec still could not decide on which of the two concepts to pursue, so once again, designers kept working on both. "Both clearly had enormous potential, but each represented a different take on the attributes—one was more playful, the other more sophisticated. In the midst of the discussion, someone suggested producing both," says Rodden.

Labtec liked the idea and conducted a quick market study, concluding that there was an opportunity to offer two microphones, one priced at about $10.00 and the other at $15.00. Adding two microphones to the line would require a significant and unplanned investment, but Labtec decided to move forward with both concepts.

"With the higher-end model to be priced with a 50 percent premium, we needed to draw a clear value distinction between the two products," explains Rodden. "We used the more sophisticated form for the higher-end version. We applied a darker, richer color to this model and added a mute control. While we added only pennies of additional cost, combining advanced form, color, and a new feature were plenty to communicate its place at the top of the line. We used the more playful form for the lower-end model. We developed a much lighter color for this model, a color that was consistent with other PC peripherals of the day."

The products, named the Labtec Verse 504 and 514 microphones, were an immediate hit. Retailers offered new space for these products, and demand outpaced supply. "The program demonstrated that exceptional design and quality don't have to reside in the realm of high-priced products only," says Rodden. "It was design almost entirely that differentiated these new products from those of competitive products—dramatic design differentiation that led to Labtec dominating the category."

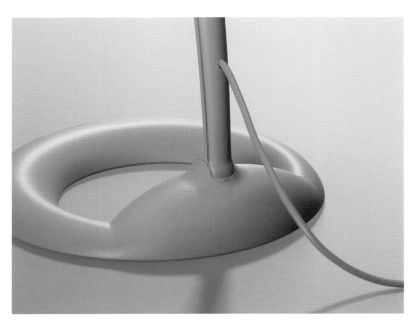

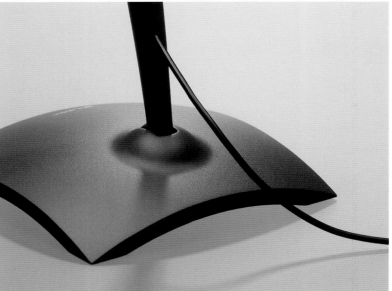

Labtec decided to pursue both concepts—one of which was more playful and the other more sophisticated, as shown in this comparison of their bases.

The Labtec Verse 504 and 514 desktop microphones were differentiated by small details and their colors. The 514 model was thought have a more sophisticated form, so it became the higher-end version. Designers thought it needed a darker, richer color.

Designers added a mute control to the higher-end version, as it would command a premium price.

The Treo 270 Smart Phone is, indeed, smart. It is a **mobile communicator** that includes a **cellular phone**, wireless access to **email and Web browsing**, and a Palm OS personal **organizer**, all in one small **hand-held** device.

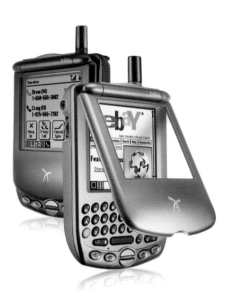

⊘ The Handspring Treo 270 is a full-color communicator that seamlessly integrates a mobile phone, a Palm OS organizer, and wireless applications like email, short messaging, and Internet browsing in one device. And it's an amazingly small communicator even with a built-in, backlit QWERTY keyboard and vivid color screen. Now text and graphics are crisper and more readable. Plus, Web browsing, photos, and games are more fun in color. The keyboard makes data entry and one-handed navigation a breeze. You can even look up a number and dial it with just one hand.

Jeff Hawkins, chief product officer and chairman of Handspring as well as founder of palmOne, met a financial analyst at a road show who dumped a phone, Palm Organizer, and Blackberry email device out of her purse and asked Hawkins, "Please fix this! I need one device that allows me to manage my life on the road!"

That incident propelled the project. The Handspring team focused on the user interface and the integration of phone and organizer, while the IDEO product design team focused on the product architecture, hardware, and industrial design.

"The market need was the clear driver in this case, but the product timing was facilitated both by evolving small form factor telecommunications technology (especially digital cellular networks) and The new demographics of an increasingly mobile workforce," says Peter Skillman, director of product design at Handspring.

Keyboard usability at a small scale was the biggest challenge. "We had to make the product as small as possible so it was iconically a phone, but still enable full email and keyboard usability," says Skillman. "Doing this meant building the smallest keyboard ever made. What's wonderfully counterintuitive here is that making the keyboard smaller is better. Compared to a traditional organizer, you can type with one hand and look up an address in three steps rather than two hands requiring six or more steps. At the same time, the IDEO team did a great job making the aesthetics discreet and professional, hiding the complex keyboard when the flip lid is closed."

The IDEO and Handspring teams together made hundreds of sketches and built more than 50 prototypes using Pro Engineer, Photoshop, and various custom user-interface bucks (nonfunctional form factor devices with a cable connected to a PC.) Each prototype was designed to validate a particular question such as product architecture, form factor, keyboard usability, or form. "These models were carried into meetings, worn in pockets, and treated like they were real," Skillman says. "This process helped validate user interface questions like lid integration with call answering functionality and test the overall portability of the product against social and personal expectations of scale and aesthetics."

⬡ ⬡ Designers created more than fifty proto-types, some of which are shown here, that were carried into meetings, worn in pockets, and treated as if they were the real thing.

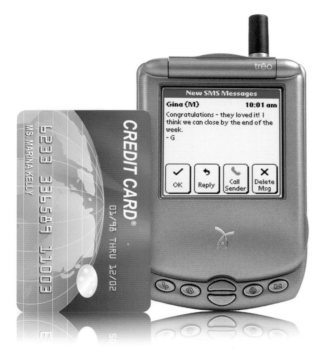

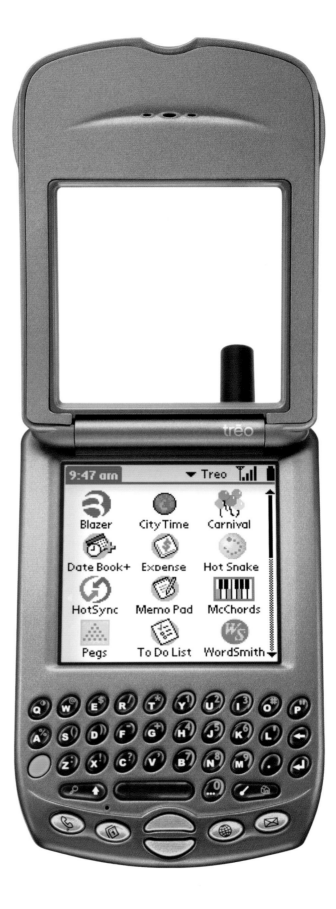

⊗ Top: The clear flip-up display cover protects the screen when stored while proving quick access to information such as emails, caller ID, and more. When flipped open, the speaker in the cover acts as the phone's earpiece or a speaker phone for hands-free and conference calling.

⊗ Above: The Treo's small size makes integrating this products with one's life effortless.

⊘ Right: In the familiar flip-phone configuration, the phone is opened to make a call, but the flip cover contains a transparent window to allow one-handed browsing of the phone book, date book, text messages, or Web pages using the jog rocker on the side.

Working side by side with Handspring's in-house development group, the multidisciplinary design team at IDEO delivered the finished product in a highly compressed time schedule, going from concept to completion in just six months. "The goal just has to be clear from the beginning," remembers Skillman. "Jeff Hawkins declared, 'We are building a phone first.' That forced the teams to take big risks on product and keyboard size we never would have taken otherwise."

In the end, the product solved the common problem among the wired workers of the world—having to juggle multiple devices. "People carrying two or more devices is a common sight, and just as common is their fervent wish that all their devices be combined into one."

"Listen to and observe frustrations that people express every day," says Skillman. "These things are easily overlooked, but buried here are opportunities to lead, build lasting businesses, and enable better communication."

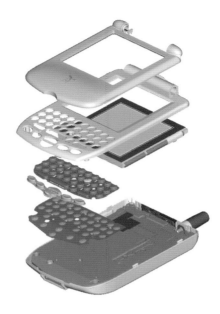

⊘ Right: An exploded view of the Treo 270.

⊘ Bottom right: The Treo 270 has a pen that tucks neatly away in a pocket next to the antenna.

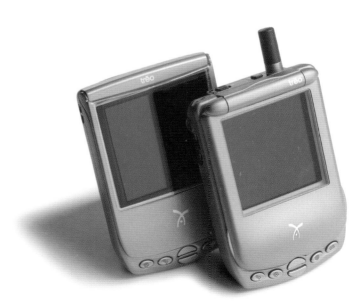

Terabeam 7200 Optical Transceiver—Elliptica If you feel like everything today **moves** at the **speed** of light, you **may very** well be **right**.

⊗ Terabeam 7200 Optical Transceiver—Elliptica

⊘ Opposite top left and right: When designers mapped Terabeam's competitive products on axes ranging from "contemporary to outdated" and "extreme to traditional," they could see clearly where they wanted their new product to be. "Although the product can be described as a simple laser, we did not want consumers to be intimidated by having this product in their office," says Brady Olason.

⊘ Opposite middle left and right: Designers created mood boards labeled "crisp tech" and "soft tech" to communicate the differences in how the technical product could be portrayed. After discussions with the client, they agreed that the soft-tech approach would set the product apart from its competitors and fit with the brand image created in the second generation of the optical transceiver product.

⊘ Opposite bottom left and right: In the concept exploration phase, a team of three designers began sketching concepts for the optical transceiver head and the mounting solution. After about two and a half weeks, designers selected three sketch directions to develop.

The so-called information superhighway connects cities around the world via a high-speed fiber-optic network that provides tremendous bandwidth and enables large amounts of data to be transmitted at extremely high speeds. However, just as car and truck traffic gets heavier and slower as it approaches a city, so does data on the information superhighway.

"Copper wire in the existing infrastructure is slow, and the cost of laying new fiber-optic cable under city streets is high, not to mention the bureaucratic red tape," says Brady Olason, senior designer at Teague, which developed the Terabeam 7200 Optical Transceiver, a revolutionary technology that eliminates the information bottleneck by using lasers to transmit and receive data. Place a Terabeam 7200 near a window, plug it in, align it with another unit in a building across town, and you've established high-speed data link, extending the optical network into the city and providing fiber-optic speed and bandwidth to customers. "The Terabeam system is robust, and it remains unaffected by atmospheric conditions. It can best be described as fiber-optic cable without the cable," says Olason.

The hardware that establishes this high-bandwidth data link is a device called an Elliptica, which is used at both the provider and the customer site. The idea of the system came from Elliptica's predecessor, a successful product "that helped the company secure half a billion dollars in funding, build out networks across the nation, as well as being honored with multiple international design awards. The assignment was simply stated: 'Top this,'" says Olason.

Part of the challenge was making the new device much smaller than its predecessor. The first two iterations, while successful, were large and required a mounting stand, which ate up valuable floor space. The first Terabeam Optical Transceiver was more than 24 inches (61 cm) in diameter and approximately 6 inches (15 cm) thick. The second generation was smaller, but it was still approximately 18 inches (46 cm) in diameter.

Working with Terabeam, Teague's design team dug into their five-phase design process: (1) design research, (2) concept exploration, (3) concept development, (4) concept refinement, and (5) implementation.

During the first phase, designers examined competitive products, creating a visual map of competitors along axes labeled "contemporary to outdated" and "extreme to traditional." "By mapping the products on these axes, we were able to communicate with Terabeam and understand where they saw their new product placed relative to the competitors," says Olason.

At this stage, designers also created mood boards labeled "crisp tech" and "soft tech" to communicate the differences in how the technical product could be portrayed. Crisp-tech products focus on small footprint, sharp details, and a strong materials story,

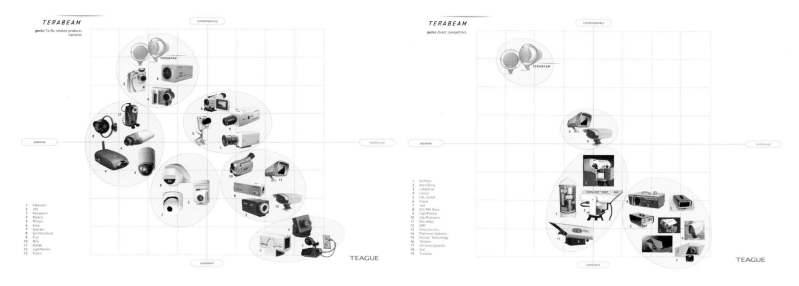

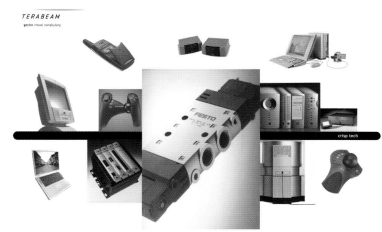

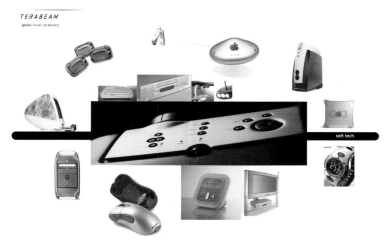

BLUE LINE
REPRESENTS
CABLE PATH
TO POWER SUPPLY
ON FLOOR

while soft-tech products focus on an integrated form that is broken up graphically with materials and colors to highlight innovation, features, or ergonomics, emphasizing a human aspect that appeals to the end user. The designers ultimately agreed that the soft-tech approach would set Terabeam apart from its competitors and fit with the brand image created in the second generation of the optical transceiver product.

In the concept exploration phase, a team of three designers sketched concepts for the optical transceiver head and the mounting solution. "It was important to understand how we could achieve a high-design look and feel for the mounting solution at a cost-effective price," Olason says. "We researched security cameras to better understand what mounted technology boxes look like. There were concerns that the new product might be perceived as a security camera, and we wanted to understand how to avoid this connotation."

In the next phase, concept development, designers chose three of the sketches and started giving each a visual design while considering the mechanical complexity of the mounting solution. They worked closely with Terabeam so that they would fully understand how the development of the optical assembly would affect packaging size, access for service, and installation and setup of the unit. Ultimately, they presented three CAD models to the client so Terabem could choose the direction for further development.

With the final direction in hand, designers focused on refining the key design details. "At this point, Terabeam had created a detailed database of the optical assembly package, and we were working with their accurate database files to generate all the exterior parts," remembers Olason. "Our goal was to create a detailed CAD model of all critical exterior industrial design elements that would be visible to the end user. We agreed to deliver a shelled CAD file with part breaks and accurate surfacing to their engineering team to use as a starting point for the detailed part design."

Teague consulted on industrial design issues that arose after the files were delivered. When there were problems with mounting location, ventilation, thermal issues, and assembly, Terabeam consulted with Teague to find the best solution.

Throughout the process, designers wrestled with numerous challenges, including ensuring the device could be mounted to a wall or ceiling to achieve any view out the window and that it be adjustable, simple, and cost-effective.

In the end, designers achieve their goals. This third-generation product came in at a reduced-to-package size of 12 x 14 x 12 inches (30 cm x 36 cm x 30 cm)—a fraction of the size of its predecessors—which enabled it to be mounted fairly discreetly.

"Creating a successful technical product requires an intense and intimate collaboration between the design consultant and the client's in-house design team," says Olason. "As individual entities, we can each create strong work, but collaboration produces great work."

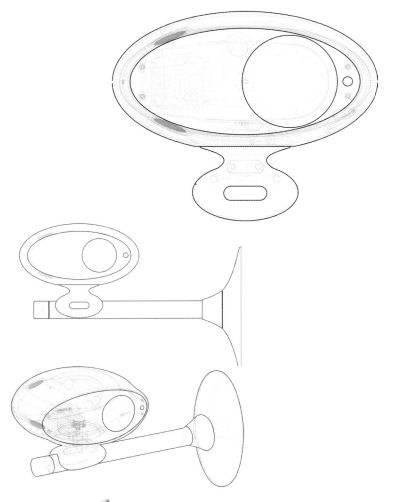

⊘ Line art of the final product shows a straight-on and angled front view of the head of the product, mounted and not mounted. These images represent the final design direction that went to production.

⊘ In the concept development phase, designers created three preliminary CAD models to communicate the form development of the product around the optical assembly and presented them to Terabeam for review. Terabeam selected one model for the final round of refinement.

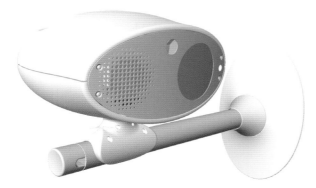

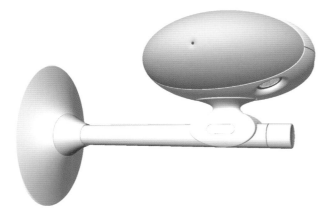

⌃ In the concept refinement phase, designers finalized the exterior surfacing, generated vent details, resolved the LED location, resolved assembly steps and manufacturing issues, and decided on the color scheme. Then, the completed files were given to Terabeam's product development team to begin the detailed mechanical part design.

⌃ Rendered images of the product just prior to going to production. "Teague not only contributed to the final industrial design approach but also built the CAD database in Solidworks that was used by Terabeam to create the final tooling database. Many consultants preach that they have a seamless process with their clients, but this was truly such a case. Teague handed off final ID CAD data for Terabeam's engineering team to implement," says Brady Olason, senior designer.

The **Logitech** Pocket Digital Camera's compact **size** is its **best asset**. Half the battle in **photography** is being at the **right place** at the right **time** with a camera.

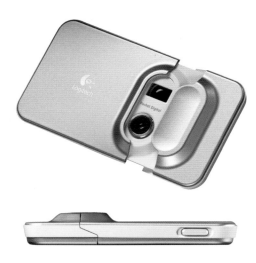

⊗ Top: The Logitech Pocket Digital Camera, featuring SMaL's ultraslim photo technology, uses design to set itself apart from the competition.

⊗ Above: The incredibly compact design allows users to keep the camera with them at all times so they never miss a shot.

This battle is frequently lost, though, because even "portable" cameras are often too big to fit in a pocket or small purse— meaning most of us are caught without a camera when the right time comes.

Likewise, half the battle of product design is coming up with the right product at the right time. When Logitech saw SMaL's ultra-slim photo technology at the International Consumer Electronics Show in 2001, they knew the time was right for an inexpensive, point-and-shoot digital camera that people could carry everywhere. Though SMaL had presented their own camera using this technology and Fuji had already licensed the technology, Logitech thought they could produce a sleeker, more sophisticated product than SMaL's camera and beat Fuji to market, so Logitech licensed the technology and asked IDEO to develop the camera.

Because they knew they would be using the same technology as their competitors, Logitech identified design as their leverage on the product. According to Rico Zörkendörfer, IDEO's project manager and designer of the camera, "One reason they gave me so much freedom is because they said that this is something that has to be completely driven by design and if people don't look at it and say this is something I want to have, then we've failed." Because the team had only six weeks to produce a final design, only four designs were presented, and none of the designs were user-tested during the product development phase. Zörkendörfer and IDEO had worked with Logitech before, so the client trusted them with this streamlined design process.

"From the get-go, Logitech wanted to highlight the thinness of the camera," says Zörkendörfer. As a result, the team immediately chose aluminum as their material of choice because of its thinness and durability, and it had the same sleek, polished look as their design inspiration for the camera—metal credit card holders. Early on, the team decided that to keep costs down and to preserve the simplicity of the camera, it would not feature a LCD screen, a feature included on most digital cameras. While Zörkendörfer originally hesitated about this, he points out, "Before we had digital cameras, that's how we took pictures—we didn't have a chance to review them."

"The original thought was that we'd create something that was completely flat when it was off and had a lens pop out when turned on. That lens mechanism was where we put most of our effort," says Zörkendörfer. Getting the lens mechanism correct was especially crucial because the distance had to be constant between the lens and the chip in the back that would record the image; if the distance were slightly off, then picture quality would suffer.

Concept A

Key features
Lens and viewfinder are fully protected when camera is not in use
Approx. thickness 9 - 10 mm when closed
Push/push mechanism exposes viewfinder/lens mount
Outer camera metal housing is extruded and machined

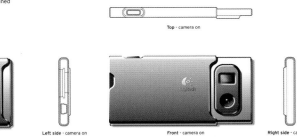
Top - camera on

Front - camera off

Left side - camera on

Front - camera on

Right side - camera on

Rear - camera off

Rear - camera on

Concept B

Key features
Lens and front viewfinder are fully protected when camera is not in use
Approx. thickness 8.5 - 9 mm when closed
One motion sliding door exposes and extends viewfinder/lens mount
Outer camera metal housings are stamped and mounted to a center
plastic frame
Stamped grip feature

Front - camera off

Top - camera on

Rear

Left side - camera off

Front - camera on

Right side - camera on

Bottom - camera on

Concept C

Key features
Lens and viewfinder are fully protected when camera is not in use
Sliding door exposes fixed viewfinder and lens
Approx. thickness 11 mm with fixed lens and viewfinder
Outer camera metal housings are stamped and mounted to a center
plastic or metal frame

Top - camera on

Front - camera off

Left side - camera on

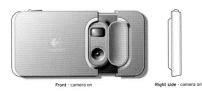
Front - camera on

Right side - camera on

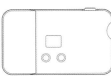
Rear - camera off

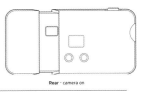
Rear - camera on

◁ While the flat designs were aesthetically pleasing and emphasized the thinness of the camera, cost and time restraints precluded the development of the retractable lens shown at the top and center. The initial design concept on the bottom—the only one with a lens that did not retract— was ultimately chosen for refinement.

Only one of the original concepts featured a lens that didn't retract, so that design was chosen for refinement because, given the short time frame, it would be the easiest to produce quickly, inexpensively, and successfully. There were aesthetic advantages to this choice too, according to Zörkendörfer: "Given that the form was so radically new compared to what was out there, I wanted to have something that had some elements that picked up on traditional camera features, and I thought the bump in the front with the integrated grip is reminiscent of older cameras that had a sliding mechanism."

After the design was chosen, refinement came mostly in the form of "tons of work that went into noodling, getting the thickness right—literally, we're talking about half a millimeter here and there, making sure everything fit inside," remembers Zörkendörfer. Foam models were created to make sure the measurements were accurate as well as to get a sense of how well the user interface worked on this small scale.

The designer originally planned for some areas, such as the grip area in front of the lens and the inserts, to be polished aluminum. "We wanted to put highlights on the camera, especially around the lens," says Zörkendörfer. "It turned out, though, that in production, it was really hard to do. The samples weren't turning out like we wanted, so we went with a somewhat untouched finish—the standard anodized aluminum finish." The final product was made of stamped brushed-aluminum sheet bonded to an injection-molded polycarbonate frame.

According to IDEO, the product launch was well-timed—the Logitech Digital Camera kicked off the compact digital camera subcategory before mainstream camera makers developed their own models. The novelty of the item gained Logitech entry into press outlets usually closed to technology firms, such as ads in fashion magazines, gift bags for award shows and celebrity sporting events, and plugs on the TV entertainment program *Extra*—entry Logitech hopes to exploit with future products.

Zörkendörfer expresses satisfaction with the project. Because of the short design cycle, he says, "The original design intent wasn't diluted at all." He likes the product so much, in fact, he carries one with him every day. "It's a piece of technology that completely disappears on your body," he says. "I have some really great, surprising pictures that I normally wouldn't have had because I wouldn't have brought a camera. It becomes like your wallet; you carry it around all the time, and that's the beauty of it."

⊘ Since the camera was so small, the scale and placement of all the features in relationship to one another was crucial. Many iterations, and a number of foam models, were created to get a sense of how these details would work on such a small scale. However, the demands of the photo technology restricted Zörkendörfer's freedom when designing the interface.

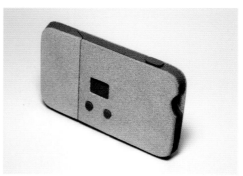

Rear—camera off

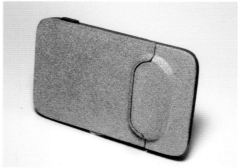

Front—camera off

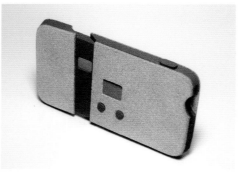

Rear—camera on

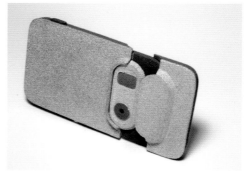

Front—camera on

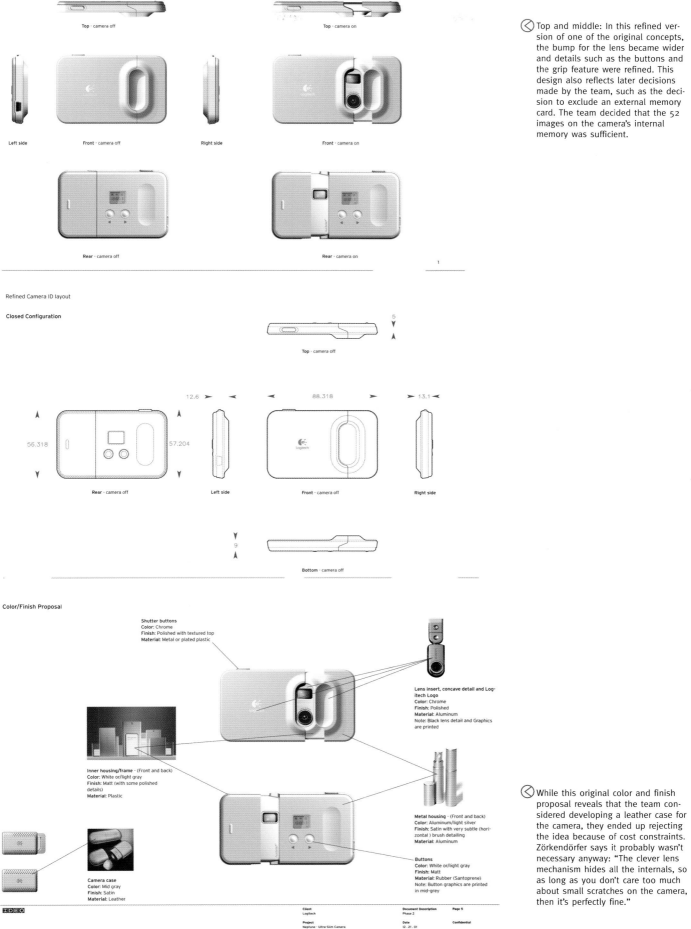

Top - camera off

Top - camera on

Left side

Front - camera off

Right side

Front - camera on

Rear - camera off

Rear - camera on

Refined Camera ID layout

Closed Configuration

Top - camera off

Rear - camera off

Left side

Front - camera off

Right side

Bottom - camera off

Color/Finish Proposal

Shutter buttons
Color: Chrome
Finish: Polished with textured top
Material: Metal or plated plastic

Lens insert, concave detail and Logitech Logo
Color: Chrome
Finish: Polished
Material: Aluminum
Note: Black lens detail and Graphics are printed

Inner housing/frame - (Front and back)
Color: White or/light gray
Finish: Matt (with some polished details)
Material: Plastic

Metal housing - (Front and back)
Color: Aluminum/light silver
Finish: Satin with very subtle (horizontal) brush detailing
Material: Aluminum

Buttons
Color: White or/light gray
Finish: Matt
Material: Rubber (Santoprene)
Note: Button graphics are printed in mid-grey

Camera case
Color: Mid gray
Finish: Satin
Material: Leather

IDEO

Client	Document Description	Page 5
Logitech	Phase 2	
Project	Date	Confidential
Neptune - Ultra-Slim Camera	12 . 21 . 01	

Top and middle: In this refined version of one of the original concepts, the bump for the lens became wider and details such as the buttons and the grip feature were refined. This design also reflects later decisions made by the team, such as the decision to exclude an external memory card. The team decided that the 52 images on the camera's internal memory was sufficient.

While this original color and finish proposal reveals that the team considered developing a leather case for the camera, they ended up rejecting the idea because of cost constraints. Zörkendörfer says it probably wasn't necessary anyway: "The clever lens mechanism hides all the internals, so as long as you don't care too much about small scratches on the camera, then it's perfectly fine."

Motorola NFL Headset, Generation II

Motorola NFL Headset, Generation II When **Motorola** first became sponsors of the **National Football League** (NFL) in 1999, they asked Herbst LaZar Bell (HLB)—a **product design** firm they had **worked** with since the 1970s—to design a headset for the **head coaches** that featured the **Motorola** logo.

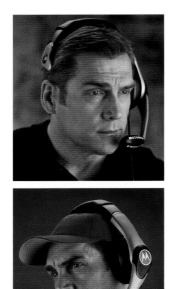

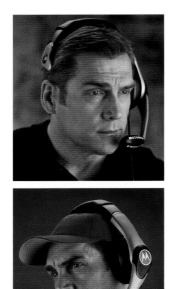 Though other venues have wanted to purchase it, the Motorola NFL headset is exclusive to the NFL; only 1800 units are produced per year. The headset can be manufactured in single or dual ear-cup configurations; the single ear-cup configuration can be worn on the right or left side.

The first generation had to be done within a very short period, so HLB didn't have time to refashion the headset from the ground up, and the headset they ended up with for that season was fairly traditional. When the following season rolled around, Motorola decided that they were missing an opportunity: Coaches are highly visible to millions of fans every week. Moreover, their status as team commander-in-chief carries a cachet that is hard to beat. "How could you have a more positive product placement than a commander marshalling his army down the field using technology to succeed?" asks Mark Dziersk, vice president, design at HLB. Motorola asked HLB to create a new version of the headset that made the most of this visibility by prominently featuring their logo on a new, higher-tech headset.

The team at HLB faced a long list of requirements for the headset: It had to feature the logo in a way that would cut through the clutter of the competing visuals of the TV sports environment and that would be easy to read from a variety of camera angles. Visually, the headset had to reference Motorola's consumer line. As Howard Kavinsky, director of corporate design strategy for HLB, says, "Ultimately, the goal was for consumers to see these products on the heads of head coaches and link them to [Motorola's] consumer products, so that consumers who see the headset on TV and then walk into a retail establishment and see a product that's similar will buy it." The headsets also had to work for their toughest clients—the coaches themselves.

The HLB team was already aware of some of what the coaches would require. They knew the headset had to be sturdy enough to survive what they called "the Ditka test"—referring to Coach Mike Ditka's habit of tearing off his headset and slamming it on the ground. The headset also had to make the coaches look good. And since they would be wearing the headsets for over three hours at a stretch, comfort was key.

HLB began by brainstorming a number of concept sketches and then narrowing their ideas to a group of more refined concepts. These concepts were presented one on one to the coaches during a meeting in Atlanta, where HLB discovered that the coaches preferred a rugged design to a futuristic or sleek design. "With any technology, you have to be careful about how you move people forward, and in this case they were extremely particular about how advanced-looking this was going to be," says Dziersk. While many of the concepts HLB presented featured a yoke that wrapped around the back of the head—allowing one more placement of the Motorola logo—the coaches felt the configuration

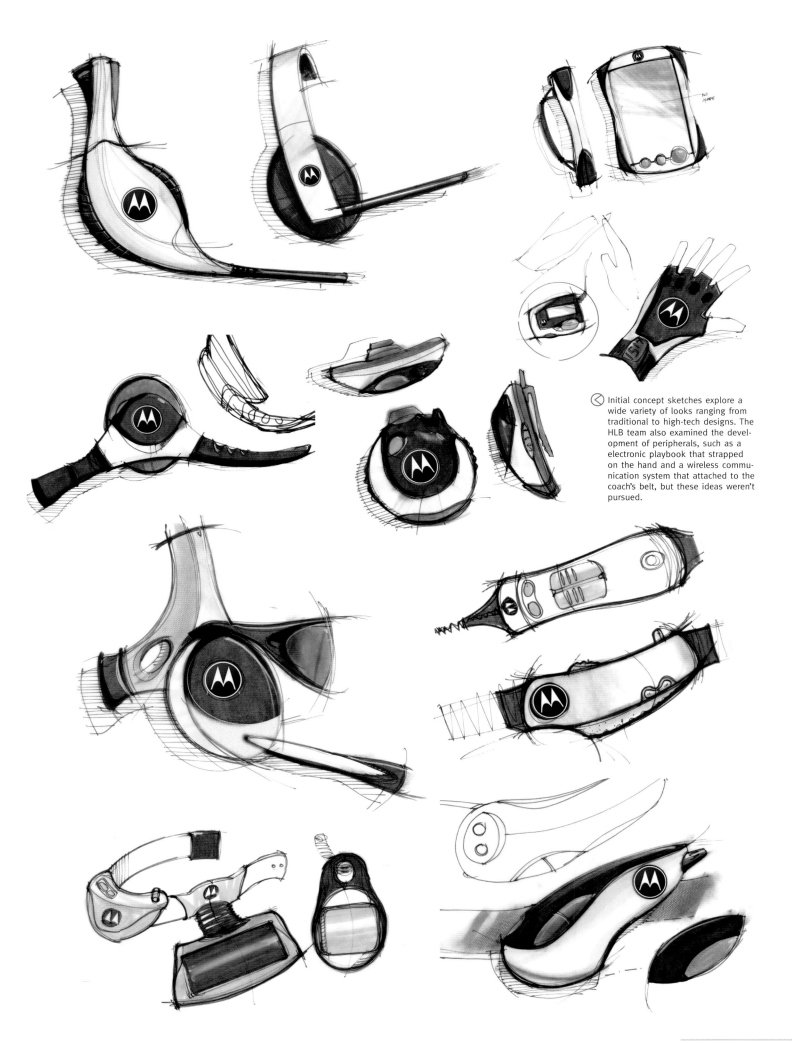

Initial concept sketches explore a wide variety of looks ranging from traditional to high-tech designs. The HLB team also examined the development of peripherals, such as a electronic playbook that strapped on the hand and a wireless communication system that attached to the coach's belt, but these ideas weren't pursued.

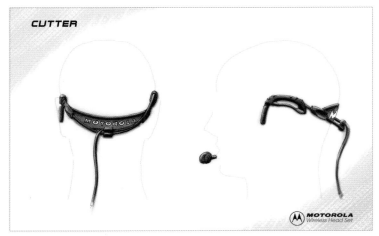
CUTTER

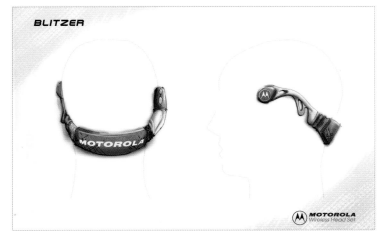
BLITZER

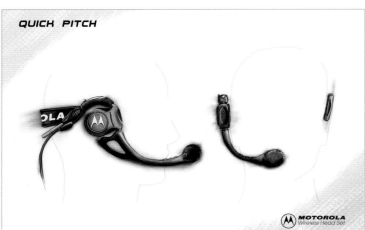
QUICK PITCH

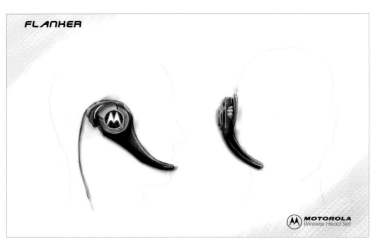
FLANKER

More refined concept sketches were presented to the coaches. The team explored a number of variations on a configuration where the yoke of the headset wrapped around the back of the head rather than the top, to allow for one more logo placement. The coaches expressed concern about the security of the headset in that configuration, especially when hats or sunglasses were removed. The style of some of these early concepts was considered too futuristic and not rugged enough by the coaches.

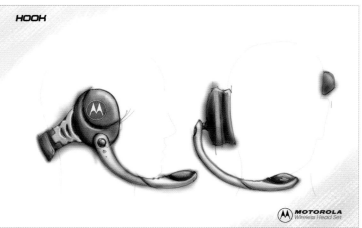
HOOK

A wide variety of shapes and colors were contemplated for the ear-cup. The HLB design team worked to find a shape that felt comfortable and blocked out noise well. A larger version of the ear-cup ended up working better for these purposes; to counteract the cup's size and to make it less visible, the designers chose to make it black.

would not be secure. The coaches also wanted a large mouthpiece, to prevent the other coaches from lipreading when they were calling a play.

The team at HLB also did qualitative research centering around the impressions and opinions of the fans themselves. Fans were asked for their comments on the look of the previous headset, on Motorola, and on their game-viewing experiences.

All of this research informed the CAD and foam modeling that followed. Using the first generation of the headset as a starting point—as research had shown that it would serve both coaches and fans better not to go too far with the second generation—the designers looked for ways to improve both aesthetics and functionality. To prevent lipreading and to take into account the fact that coaches might remove their headsets up to 100 times during a game (almost always grabbing the headset by the boom), the designers made the new boom more substantial. The mouthpiece was overmolded with Sandoprene TPE to give it a tactile grip. The microphone boom was coated with elastomer, which is easy to bend and twist, allowing the coaches to adjust the placement of the microphone. Using automotive and high-end consumer products as their inspiration, HLB added a metallicized finish to the polycarbonate yoke of the headset; this finish—similar to that used in some of Motorola's phones—imparts a sense of quality and sophistication and ensures that the headset looks good on television.

The first generation of the headset had attached the boom to a conventional set of headphones. The redesign more seamlessly integrated the boom with the rest of the headset, attaching the boom to the yoke instead of to the ear-cup. Both the yoke and the boom are metallicized, creating a sweep from the yoke to the microphone and giving the headset a streamlined look.

The ergonomics of the headset were carefully examined. For comfort, removable foam temple supports were added to the yoke. The headset was designed to rise from the top of the wearer's head, allowing air to flow and reducing pressure on the top of the head. When it turned out that a larger version of the ear-cup would be more ergonomic, the designers specified that it be black, to call less attention to it.

Research had shown that, while some of the coaches preferred a dual ear-cup version, others preferred a single ear-cup configuration, so the headset was designed for easy manufacture of either. For maximum flexibility for the coaches as well as ease of inventory for the teams, the single-cup version of the headset was designed to be reversible, allowing the coach to position the ear-cup on either side. This feature meant that the mouthpiece had to have two logos on it to ensure visibility in either configuration; the designers had to carefully scrutinize the logo placement to ensure that both logos wouldn't be visible at the same time. The pivot mechanism of the boom also required extra thought: a full 360-degree rotation, done several times, would damage the wires, so a mechanical stop prevents the full rotation.

Did HLB's efforts pay off? Dziersk thinks so, and the proof is in the recognizability of the headset. "We've been making products for forty-two years, and especially with men, when you mention that product, everybody knows what it is." Kavinsky calls the campaign "one of the most successful invisible Motorola marketing campaigns that the company has launched." The headset will continue to be featured weekly before millions of fans for the length of Motorola's sponsorship. The headset has even gone on to pass a real-life Ditka test: it still worked after Coach Ditka threw the headset down in frustration during a game—perhaps the ultimate testament to the product.

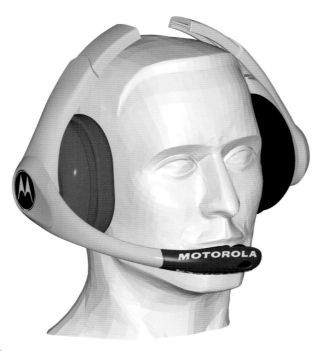

Three-dimensional CAD modeling of a human head was used to help the designers visualize the interaction of the ear-cups and microphone as well as the fit of the headset.

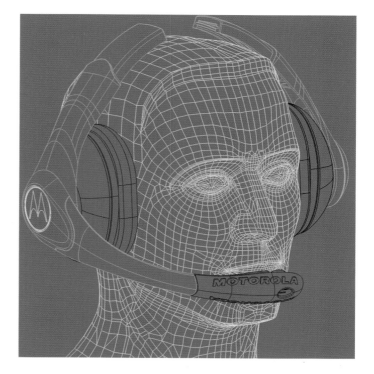

Maxim Sport Safety Eye Gear

Eyewear makes a **big fashion** statement, and the same is true of protective **eye gear**. There is no need to wear bulky, **uncomfortable** goggles when **instead** you can wear Maxim Sport **Safety Eye Gear**.

These glasses are a part of the Maxim series of safety eyewear developed by Insight Product Development LLC for the Aearo Company. The product line shares parts, such as the lens, to reduce production costs while still providing different looks, adjustability, and comfort features from model to model.

The market called for this product. "The need for companies to encourage their employees to wear safety gear has sparked on-going development in the safety eyewear business. Current safety eyewear designs aim to increase a user's comfort," says James McGee, industrial designer, Insight Product Development. "As a general rule, if comfort increases, users are less bothered and less likely to remove their safety gear, thus increasing compliance. Durability is also important; the longer the eyewear stays usable, the less pairs per employee the company will have to purchase over time. Safety eyewear must meet these needs while appearing to be comfortable, durable, and safe. Often the purchase of safety eyewear is made on appearance alone."

When Aearo sought Insight's help to develop a family of eyewear with shared parts that explored a range of features and styles, the primary challenge was to achieve the goals within the stated budget. "In the world of safety eyewear, cost reigns supreme. The benefit of each aspect or feature added to a pair of safety glasses is measured against its cost," says McGee. "Development and production costs are compared with an added feature's ability to improve compliance, comfort, durability, safety, and sales. Adjustability and aesthetics are weighed against part or piece count. Creating eyewear with less adjustment yet achieving a level of comfort similar or superior to other products in the Maxim series was a big challenge."

⊘ The Maxim Sport brings together a variety of features to create a functional, affordable, and stylish pair of safety eyewear. The glasses are both comfortable and sporty in appearance, which helps increase user compliance. In addition, the eyewear meets and exceeds safety standards while being reasonably priced.

AEARO COMPANY INSIGHT PRODUCT DEVELOPEMT

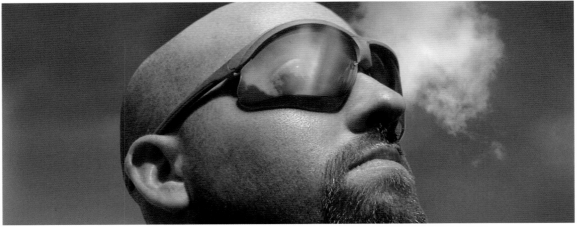

AOSAFETY MAXIM™ SPORT

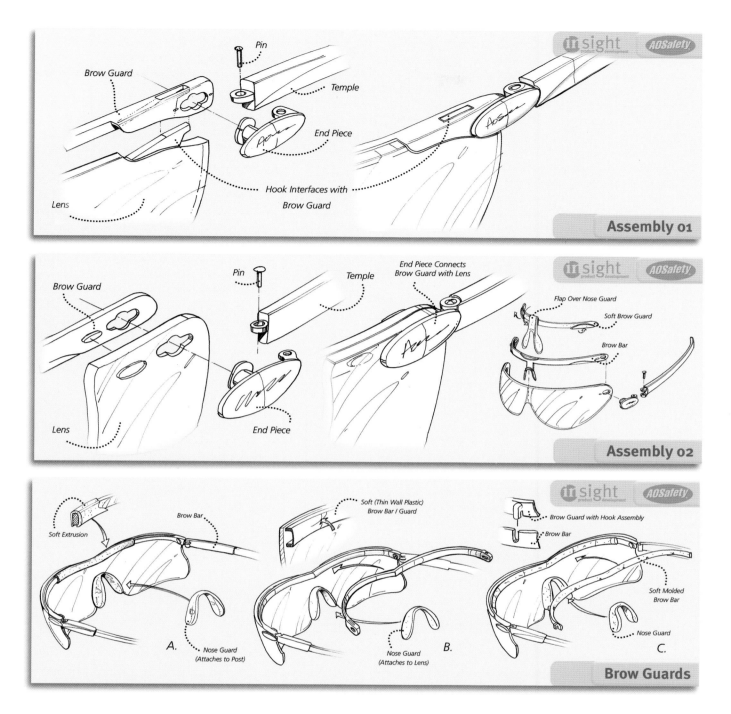

Assembly 01

- Pin
- Brow Guard
- Temple
- End Piece
- Hook Interfaces with Brow Guard
- Lens

Assembly 02

- Brow Guard
- Pin
- End Piece Connects Brow Guard with Lens
- Temple
- Flap Over Nose Guard
- Soft Brow Guard
- Brow Bar
- Lens
- End Piece

Brow Guards

- Soft Extrusion
- Brow Bar
- Soft (Thin Wall Plastic) Brow Bar / Guard
- Brow Guard with Hook Assembly
- Brow Bar
- Soft Molded Brow Bar
- Nose Guard
- A.
- Nose Guard (Attaches to Post)
- B.
- Nose Guard (Attaches to Lens)
- C.

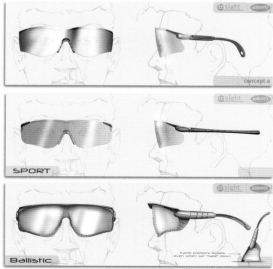

concept a

SPORT

Ballistic

Early on, the Insight team created rapid prototypes to evaluate and tweak every curve, tangent line, and surface to minimize stress and friction points and improve overall fit and feel. They tackled the project by leveraging previous research and brainstorming experiences with Aearo to help form a list of features that could potentially add value to a new series of eyewear. Next, the design team explored three concepts for the line—a traditional look, an athletic-inspired look, and a rugged style. "Even at this early stage, the team worked closely with Aearo and our own engineers to conceptualize how these concepts could be made," remembers McGee.

Even though the concepts were in the early stages of design, members of Insight and Aearo's product team worked out the details of manufacturing them.

Designers explored three concepts for the new line: a traditional look, an athletic-inspired look, and a rugged look.

Soon, concepts turned into something much more concrete, an actual product they named the Maxim Sport. While most of the Insight designers' work on this product seems quite tight from even the earliest concepts, they typically begin with loose sketches and quickly move into 2-D CAD and PhotoShop. With this completed, they presented the client with concepts for a range of looks. "The end of this phase resulted in a concept development presentation in which we showed a variety of possible looks. During the presentation the design team discussed the pros and cons of particular concepts based on aesthetics and manufacturing," McGee says. "With this information, Insight and the client decided which direction to pursue."

Aearo chose to go with concept two, which featured two-tone materials that made the eyewear look a little more expensive than average safety glasses. "They found the form athletic-looking but not too aggressive to dissuade older demographics," says McGee. With the client's decision in hand, Insight began refining the design, taking into account the concerns and feedback they received from Aearo's marketing and engineering people.

Their chief concern: making the Maxim Sport visually distinct from other Maxim products. As the designers refined the design, they tweaked the concept and decided to put the nosepiece in front of the lens, creating a two-lens appearance instead of the traditional monolens commonly seen in most inexpensive safety eyewear.

Once Aearo approved this modification, it was time to build prototypes so they could see the product in three dimensions. "During this phase, it was key to constantly reference human factors and safety specifications. This was a highly iterative process," recalls McGee. "Insight produced prototypes and then tested them

out. The team evaluated each one on fit and finish, while Aearo ran a variety of tests and offered their own engineering, marketing, and production concerns. We made adjustments and repeated the process."

Next, Insight's engineers and designers worked closely with Aearo to create robust 3-D geometry that met all production concerns while maintaining design intent. Finally, everything was as it should be.

In the end, the Maxim Sport design brings together a variety of features to create a functional, affordable, and stylish pair of safety eyewear. Its electrometric browguard and temple accents provide comfort and impact absorption while creating a color and texture break. The nose section provides a visual break, creating a two-piece lens appearance while serving as a mount for the universal-fit nosebridge. The wraparound temple pieces grip the head firmly without needing mechanical adjustment. The patented lightweight dual-aspheric plano lens reduces visual distortion. "The sum of these elements establishes a comfortable feeling and athletic inspired eye gear that helps increase user compliance and meets and exceeds safety standards while maintaining a reasonable price point," says McGee.

"Sometimes, it's one great big idea that gets you a good design. Sometimes, it's the sum of many well-implemented small ideas that gets you a good design," he adds. "The Maxim Sport is the result of a big goal supported by lots of small ideas. Every little detail was painstakingly revisited and refined by consultant and client, researcher, designer, and engineer to turn out a well-designed, well-engineered, and well-executed product. Its success is in the details."

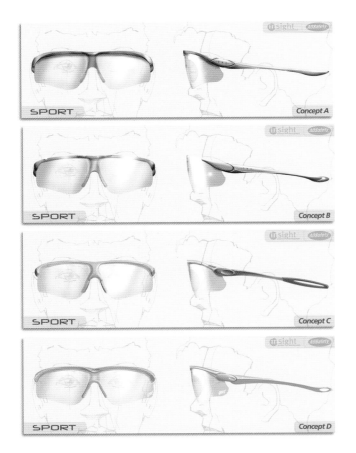

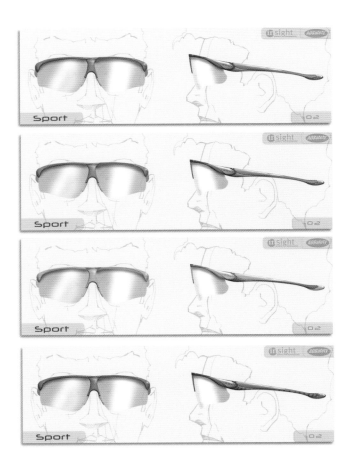

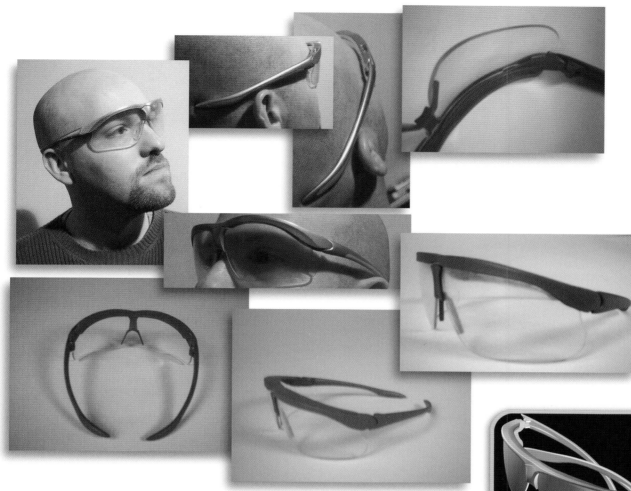

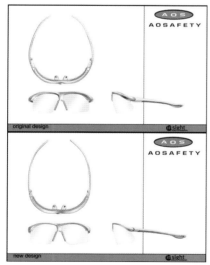

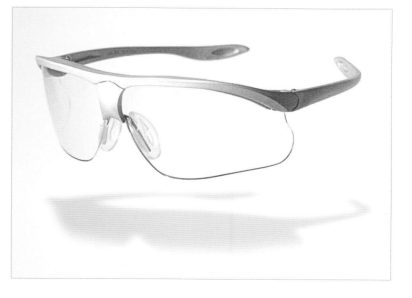

◁ Opposite left: Insight presented Aearo with four initial concepts for the Maxim Sport, and together they discussed the pros and cons of each and decided which concept to pursue.

◁ Opposite right: To set the Maxim Sport apart visually from other Maxim products, designers chose to place the nose-piece in front of the lens, creating a two-lens appearance that departs from the traditional monolens commonly seen in inexpensive safety eyewear.

△ Top: Insight's designers build several prototypes, each of which was tested thoroughly by Insight and Aearo, resulting in adjustments that were made before the process was repeated yet again.

△ ▷ Above and right: With the prototype finalized, Insight's engineers and designers worked with Aearo to create 3-D geometry that met all production concerns while remaining true to the original design.

CDI Dial Torque Wrench Why **redesign** a product when the **current version** of the product has **80 percent** of the **North American** market?

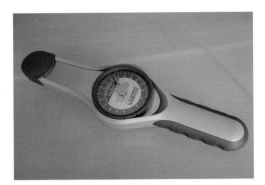

○ CDI's dial torque wrench, shown in their company's color, light blue; models distributed by CDI's clients are made in the clients' colors instead.

▽ The previous dial torque wrench, designed in house at CDI 30 years ago. Its uncomfortable handle and passé look made it overdue for an update.

That was the question when Consolidated Devices Incorporated, a subsidiary of Snap-on Tools, approached Tor Petterson Associates (TPA) and asked them to redesign their CDI dial torque wrench.

Despite the success of the product, a specialized industrial tool used in precision assembly and in inspections where breakaway torque is measured, customers had been complaining about the grip for years. "It didn't have any sort of comfortable grip at all; it was just kind of a square block," says Charles Davis, principal and managing director of TPA. Moreover, both the client—who had designed the product in house 30 years earlier—and its customers felt that the design needed to be updated for today's market. Finally, the product in its original form was expensive to produce, relying as it did on technologies such as aluminum castings and flat plate stamping that require extensive machining and finishing.

Spurred by these factors, CDI reviewed competitors' products and discovered that most of them were also overdue for a design update, and they realized that a redesign would help them keep their place as a market leader. CDI's further research with its customers revealed additional functional requirements for the redesign, such as protection for the dial and head and high measurement accuracy.

Armed with this set of requirements, the design team at TPA started to brainstorm the look and construction of the wrench. Some early concepts had the feel of a precision instrument, while others had the rugged appearance of a tool. A design that found a happy medium between these two extremes ended up being chosen by the client. However, as Davis says, "They still weren't happy with the handle designs. We explored several directions on different grips, because that was something they really wanted to pay attention to."

At this stage, construction of the wrench was still being debated. "We were playing with covering the entire unit in plastic versus exposing metal, bending the metal, in order to get the ears to protect the dial," says Davis.

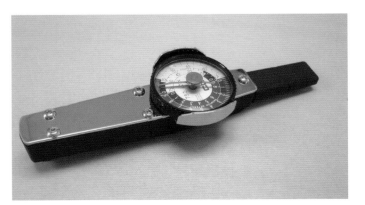

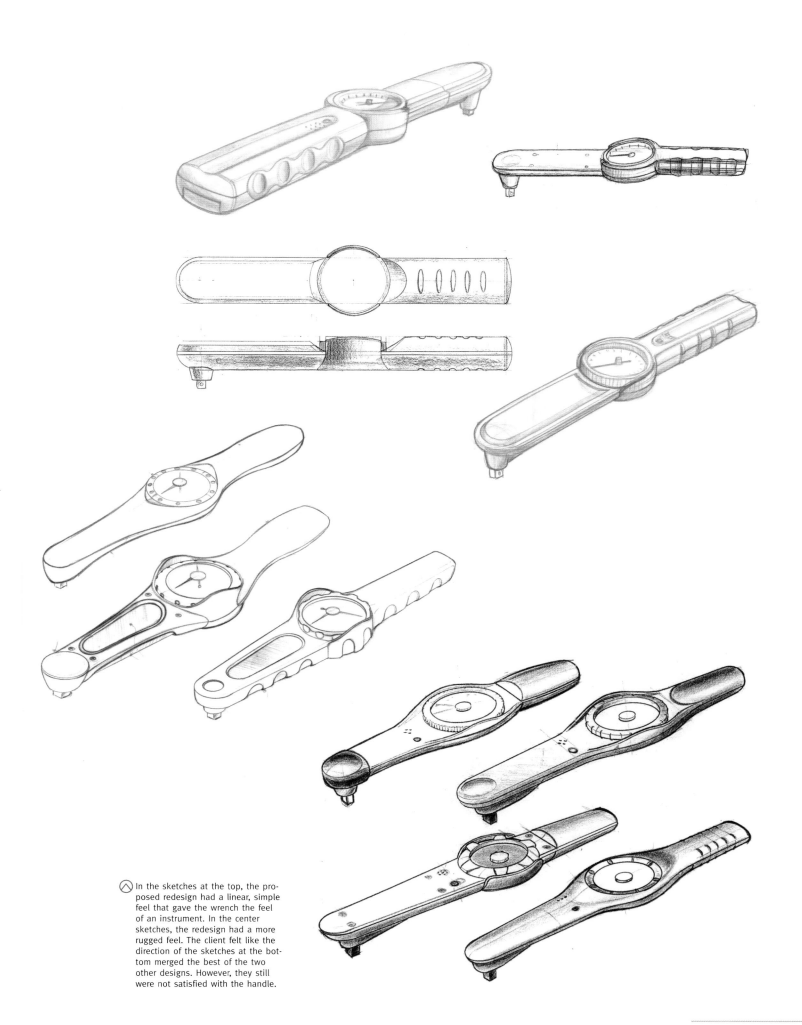

In the sketches at the top, the proposed redesign had a linear, simple feel that gave the wrench the feel of an instrument. In the center sketches, the redesign had a more rugged feel. The client felt like the direction of the sketches at the bottom merged the best of the two other designs. However, they still were not satisfied with the handle.

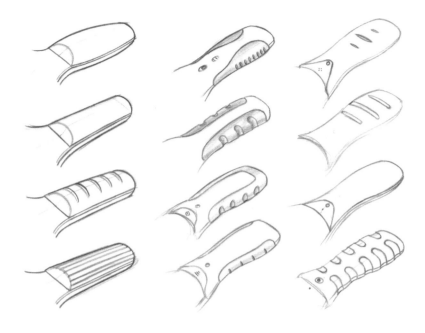

One thing was certain: Whatever material was chosen, it had to be very strong and stiff to avoid affecting the tool's measurements. "It was interesting for me to learn how sensitive a little dial like this would be to the up-and-down flexing of the housing and how, if you crank on this thing, you're not really putting true linear force to it because of the way it goes at an angle," says Davis. "So we spent a lot of time doing structural analysis, just to make it stiff enough so that it wouldn't throw off the accuracy."

The concept of an impact-modified polycarbonate housing and a press-formed steel skeleton—bent into an upside-down U-shaped channel for structural integrity—won out for a variety of reasons. First, it was less expensive to produce than the aluminum casting and chrome-plated steel that had originally been contemplated, but it still provided the stiffness needed to ensure that the tool's measurements were accurate. The plastic exterior allowed for comfortable handling of the tool; it also made it possible for CDI to produce the wrench in the colors of their customers, expanding the market for private brand sales. Says Davis, "It was really an important sales tool, to be able to show them that it looks like their wrench already. It allows CDI to sell a lot more product than they could if the wrenches were just black and silver."

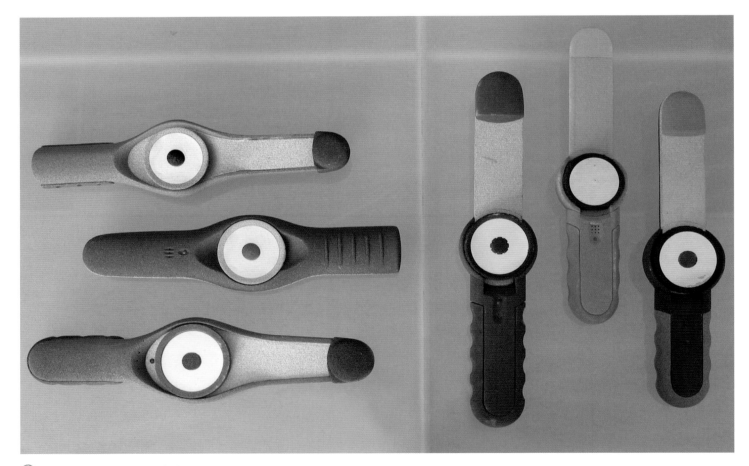

⬡ Top: These sketches show the further development of the handle that was requested by the client.

⬡ Above: When CDI was presented with these foam models of the wrench, they preferred the look of the model on the left, but they preferred the handles on the right. "It was an unusual design process because we went in so many directions and then merged a couple of them," says Davis. "The final result was better than either of the two originals."

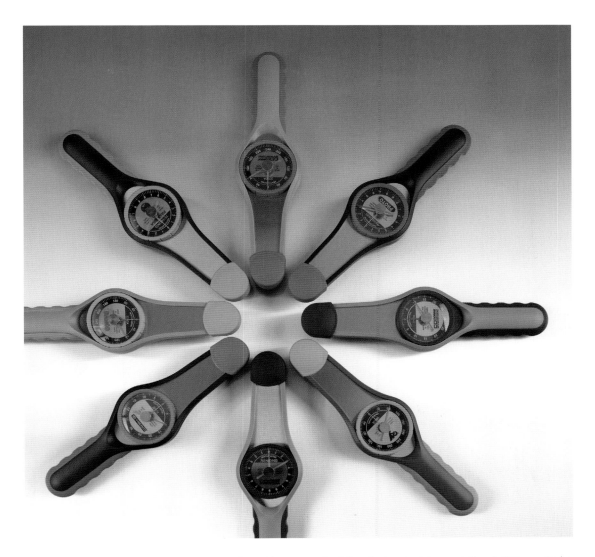

Once the concept of the design had been defined, TPA created a 3-D SolidWorks model of it and made stereolithographed models from the 3-D data. Several prototypes were then created out of silicone molds; these prototypes were cast in a variety of client colors, which were then shown to (and heartily approved by) CDI's customers.

While it would have been difficult for CDI to increase its North American market share by very much, its redesigned product was able to create new markets for CDI. The increase in private sales that resulted from the redesign helped CDI increase its world market share from 30 percent to 50 percent while reducing manufacturing costs and satisfying the needs of its customers—proving that even for products that dominate their niche, there's always room for improvement.

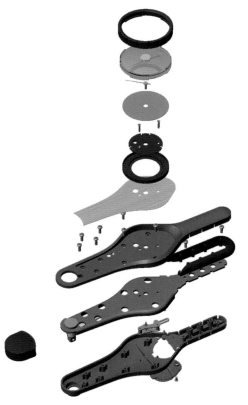

⊗ In this CAD rendering, the details of the assembly have been refined.

⊗ Instead of using testing and focus groups to judge whether the wrench would be a success, CDI took prototypes like these out to customers, who had driven the redesign in the first place. The customers responded favorably, giving CDI the confidence to go ahead with production of the redesign.

John Deere Spin-Steer Technology Lawn Tractor For many people, **mowing** the lawn is a **time-consuming** chore; even if you own a **tractor**, the lack of maneuverability

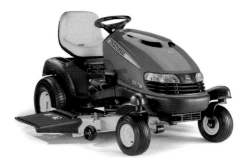

The John-Deere Spin-Steer Technology Lawn Tractor is the first tractor to combine the maneuverability of a zero-turn-radius tractor with the look and feel of a lawn tractor.

of the traditional consumer models means that you'll have to go back and trim the edges after you're done. But what if you could marry the usability of a traditional lawn tractor with the maneuverability of a professional-grade, zero-turn-radius (ZTR) tractor?

That's just what John Deere did with its Spin-Steer Technology Lawn Tractor—a tractor that aims to make lawn care more fun and less time-consuming than ever before.

John Deere worked closely with Henry Dreyfuss Associates (HDA), an industrial design firm with whom they have a long relationship, to consider how this new breed of tractor would fit visually into the John Deere heritage. William Crookes, partner at HDA, describes one of the biggest issues they faced: "How close does this have to be to the traditional agricultural or lawn and garden product in appearance? The function of the vehicle is identical, but the operation is considerably different, so what you want to do is create a design that conveys that notion but is still in the family of John Deere tractors."

To achieve this, the designers began by looking at the concept from a consumer's point of view. They test-drove lawn tractors and traditional ZTR mowers and quickly agreed on one point: This model would have to have a steering wheel. Crookes observes, "You'll notice that quite a number of the commercial operators have lever-operated configurations, and users have the time to spend to learn how to use it, but if you were to just jump on the seat and go out and mow, you'd find yourself a little frustrated."

Adding a steering wheel had a ripple effect on the rest of the design, starting with the transmission. ZTR mowers are propelled by two separate motor systems, one for each side of the vehicle. These units, since they operate separately and at different efficiencies, can be difficult to operate in a straight line or tight turn situation, and the steering wheel—by taking away the refinements of operation possible with the lever controls traditional for ZTR mowers—would compound the problem. John Deere worked with their transmission supplier to develop a new drive system where both systems were contained in one case.

The steering wheel would signal to consumers that this tractor would operate like their car, but that wasn't the case; when reversing a ZTR tractor, turning the wheel to the left means the front—not the rear—of the machine goes to the left. The team felt that confounding the consumer's expectations of how the mower would work would undermine their goal of designing a user-friendly vehicle. They developed a reverse logic system that automatically switches the steering to react as a consumer expects it will. Since this would head off possible operator mistakes that could have resulted from standard ZTR operation, it was also a built-in safety feature of the tractor.

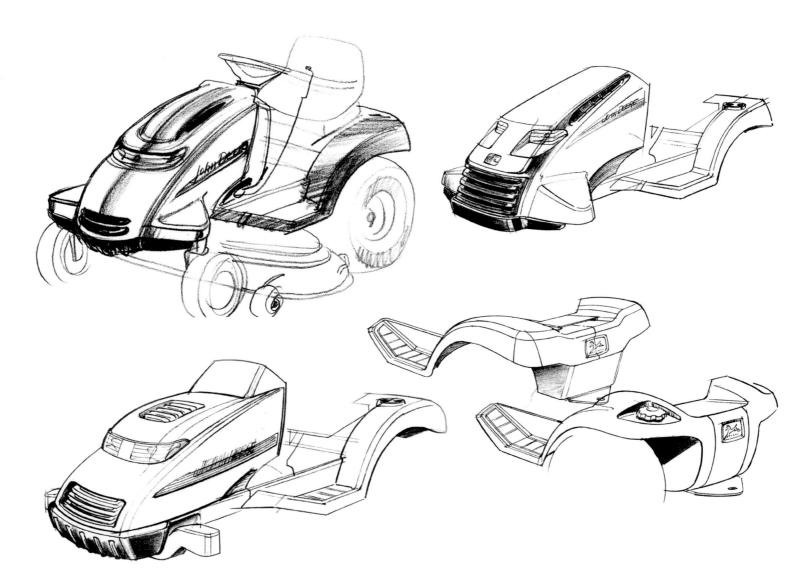

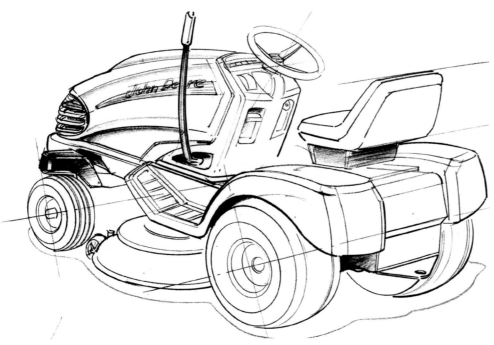

⬡ Top left: In this early sketch, the team established a basic concept for a tractor that fit the John Deere heritage look while incorporating the new features of this model, including the unique physical relationship among the wheels, tires, seat, and operator required by the zero-turn-radius concept. The original concept features a large area built into the hood that was meant to hide the wheel action; this was abandoned in later sketches.

⬡ Top right: The team decided to tool the injection-molded grill separately from the hood to give the tractor the trademark John Deere appearance.

⬡ Middle left: This sketch imagines the wheel coverings as separate from the hood rather than integrated with it. To integrate support for the steering column without enlarging the entire hood, the height of a smaller area in the back of the hood was increased.

⬡ Middle right: This sketch plays with the possible functions of this part, which merges the fender covering and tow board. The top version also includes a fuel tank, making use of the double-walled nature of the rotomolded part.

⬡ Bottom: More details of both the rear of the vehicle and the instrument panel are being decided here: The sketch imagines an instrument panel that mirrors the form of existing models, to save costs, while integrating details specific to this model, such as the lift lever that controls the elevation of the mowing deck.

Another change that resulted from the team's desire to make a ZTR tractor fit into a consumer line was the position of the engine. The engines of typical ZTR tractors are behind the operator, but the team moved the engine of this model up front to match the design of other consumer tractors. In response, the rest of the tractor was reconfigured to redistribute weight to the back of the tractor to keep it balanced.

Throughout the HDA process, the designers had to consider how every change would affect the look of the machine and to balance the need for the tractor to fit in visually with the rest of the John Deere line and the need for it to work well for the user. For instance, the rectangular shape of a traditional Deere vehicle was abandoned for a sleek, rounded shape designed to increase visibility and to reflect the nimbleness of the tractor's movement. Atypical wraparound headlights were also planned to provide the additional light to the side needed on a tractor that can pivot.

To compensate for the new design elements required by the tractor's functionalities, the design team looked to cultivate other visual cues that would signal this tractor's place in the John Deere family. Color—specifically, a careful application of the traditional John Deere green and yellow—was one of the key ways they chose to do that. Complicating this strategy, however, was the plan to use plastic for areas traditionally manufactured in sheet metal, such as in the rear fenders. There were a number of practical reasons for this choice: Plastic is both more cost-effective and more durable, especially in areas that might be scraped by rocks or rosebushes. But it can be difficult to rotomold colors accurately, a problem that only increases as the tractor is exposed to the elements. Says Crookes, "Ultraviolet exposure and aging of the part causes the color to shift. When it appears alongside an adjacent green material, you'll see a mismatch between those two colors that increases with time." The HDA designers carefully planned so that green rotomolded parts didn't abut green injection-molded parts, while maintaining the proper balance of green and yellow that would give this tractor the characteristic John Deere appearance.

The steering wheel, which had been identified as the model's signature feature, was given special attention by the design team: It is coinjected and overmolded in a three-barrel, 1,000-ton molding machine; the subwheel is polypropylene that is coinjected with a blowing agent and then overmolded with a softer green material, providing users with a comfortable grip.

In the end, as with other well-designed products, the seamless incorporation of technology in the tractor might go unnoticed by users—but an experience that had been a chore for them has now become a delight.

⊘ Top: To help them visualize the correct proportions of green, yellow, and black on the tractor, the design team produced this illustration; the white area at the rear of the tractor can be overlaid with any of these colors. Since rotomolded parts tend to be black, the team needed to decide which parts had to be rotomolded and to plan the rest of the color scheme around that.

⊘ Middle: With this sketch, the design team attempted to redistribute the balance of colors by splitting the rear into two parts so that one part could be green and the other black, and by making the rotomolded part above the wheel green. In the end, however, the rotomolded parts above the wheels had to be black to prevent problems matching the rotomolded green to other green parts of the tractor.

⊘ Bottom: The HDA design team responded to the new information they had from John Deere about the cooling and exhaust requirements of the engine by adding large air vents on the top of the hood. This design allows for the air to come in from the top and out the front, as the John Deere engineers now planned.

⊘ Above left: Toward the end of the design process, the CAD modeling got very specific about where the outside surfaces are relative to the internal package.

⊘ Above right: A 3-D CAD model of the tractor in a close-to-final version.

⊘ This first build of the product was used for advertising and market research purposes and was presented to focus groups. To keep costs down, the team decided to eliminate the part that covered the front wheels, but the focus groups thought that the tractor looked unfinished without the covering.

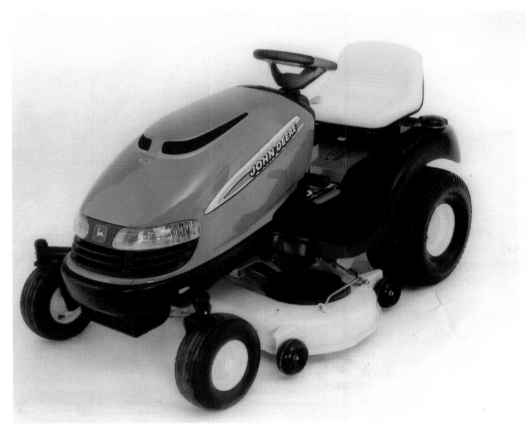

The Water-Gate We all know the **fable** of the **little boy** who put his finger in a hole in a dike and **saved** his town from a **flood**.

⊘ The final version of the Water-Gate in action. An undeployed version is shown rolled up next to inventor Daniel Déry; smaller versions of the Water-Gate, when rolled up, can be carried on a person's back.

In the real world, rescue workers trying to save buildings from flooding need a lot more than a finger—they need hundreds (or thousands) of sandbags, a time-consuming and costly solution.

Until now: MegaSecur's Water-Gate has turned the fable into a reality by making it possible for a single person to stop a flood in minutes. The system consists of a polyethylene tarp covered in PVC; a barrier system on the edge of the polyethylene sheet is designed to catch the water as it flows, unfurling and activating the system. As Jacques Lauzon, sales manager for MegaSecur, describes the ingenious principle behind the design, "It's the water that stops the water."

As with many other great inventions, the idea came to its creator in a flash of inspiration. Daniel Déry, an award-winning industrial designer and inventor, was watching video footage of floods of the Red River in Winnipeg, Ontario, Canada. "He was amazed at how much labor had to be put in to erect those sandbag dikes, and all the water that was running through the sandbags, and he thought, 'We've got to have a better way of doing this,'" says Lauzon. Déry had an idea: If he joined a series of plastic bags together, maybe the water would fill up the bags and stop its own flow. He quickly sketched a plastic barrier featuring a number of vertical and horizontal partitions, with a floating device on top, and set out to test this idea with simple miniature prototypes.

After the inspiration, the perspiration: Déry spent over a year experimenting with the construction of the miniature prototypes before getting to a full-scale working prototype. Though initial prototypes proved he was on the right track, he continued to refine the construction and choice of materials for the barrier, trying various weights and kinds of plastic, fabric, and tarp before settling on polyethylene.

The first full-scale prototype was a success, but Déry wondered if the design could be simplified; eliminating the multiple vertical partitions would decrease the weight of the barrier and make it cheaper and quicker to produce. Simplifying it would also make it more rugged, as fewer joins mean fewer opportunities for tears or leakage. Déry tested a second prototype with this simplified design and was delighted to discover that it worked.

So far, the prototypes had primarily been tested on small brooks near MegaSecur's headquarters in Victoriaville, 130 miles (209 km) east of Montreal. With Déry's first test of the prototype on asphalt, he discovered that the barrier—now crafted out of polyethylene—was too slick to stay down on this relatively smooth surface. To prevent the barrier from sliding with the first onslaught of water, metal anchoring and sandbags were required—a solution that was far from desirable, since eliminating the need for sandbags was one of the goals of the barrier. Further prototypes revealed that coating the polyethylene in PVC gave the barrier sufficient traction to adhere to asphalt or concrete, eliminating the need for the anchor system.

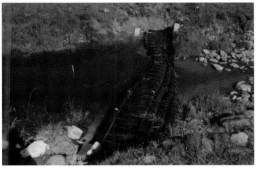

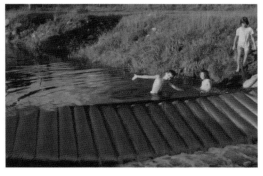

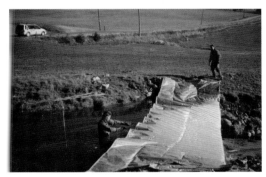

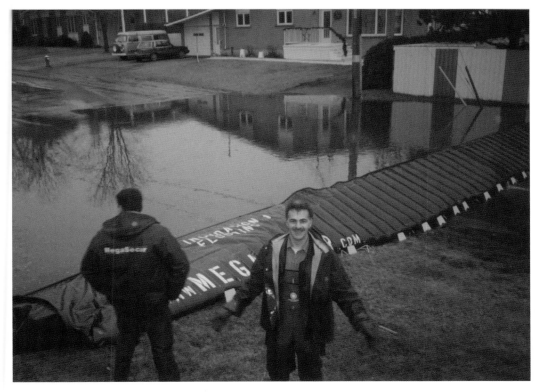

Above left: After several miniature prototypes were tested, this first full-size version was developed.

Above center: In this second prototype, Déry tested (and proved correct) his idea that partitioning once vertically would be as effective as a design that was partitioned multiple times, while simplifying the device and cutting costs.

Above right: The first full version of the product.

Middle left: Déry created a 5-foot (1.5 m) barrier and tested it live; this version of the barrier was a simple polyethylene version.

Middle right: In this first test on asphalt pavement, the barrier didn't have the stability it showed on natural terrain; Déry then created metal anchoring to help the barrier stick to the ground.

Bottom: In the first full launch of the improved version of the Water-Gate, it proved effective when a water reservoir was opened; Déry is shown here overseeing the launch.

With the basic elements of the barrier in place, Déry began thinking of additional features for the Water-Gate. To expand capacity, he worked on devising a system to join two or more Water-Gates together. At first he tried a system of laces, but he couldn't make this system watertight. In the end, Velcro proved a fast and effective way to join multiple barriers.

Déry also began development of a diverter that could be used to prevent overflow or in any situation (for instance, in agricultural applications) where water needs to be diverted from a wet area to a dry area. The final version features a floating pull-out drawer that, when anchored with a rock, can be used to aim and stabilize the diverter.

Déry and his company continue to refine and develop the product; currently, the maximum height of a Water-Gate is $6\frac{1}{2}$ feet (2 m), but MegaSecur is working toward increasing its size, with an ultimate goal of creating a 16-foot (5 m) barrier. The product's width can be customized; so can its color (agricultural and forestry clients prefer green, while yellow is standard for construction and emergency use). The company sells a version of the Water-Gate that is not covered by PVC at about a third of the cost of the standard version; while this version is primarily bought by homeowners protecting their houses from flooding, even they generally prefer to invest in the standard version, which is more rugged and reusable.

MegaSecur also continues to explore new applications and markets for the product. "It's amazing—every time we go out there, we find another use for it," says Lauzon. In addition to its use in flood prevention, the product is used by construction workers to enable them to work in wet areas without producing polluting sediments; firefighters use it both to store water in preparation for oncoming forest fires and to protect forests and buildings. Some squad cars now carry the device to help contain toxic spills. It is being used in New Zealand to protect beaches from erosion. A 6-inch (15 cm) version is being marketed to fire departments as a way to keep them from damaging property with water while they're fighting a fire, while a version $6\frac{1}{2}$ feet (2 m) high and 385 feet (117 m) long is being used to back up the hydroreservoir in Panama.

Lauzon stresses the astonishing laborsaving capabilities of the Water-Gate: "The biggest thing to remember is the time of installation for this barrier—there's nothing in the world that can touch it right now. If I went head to head with somebody that's got to install 770 sandbags, you would have to put at least 50 people on the job and it would still take them 10 times the time that I would." In a crisis, saving time means more than just saving money: "It's a fast-reacting product, it can save lives, and one of these days that's what's going to happen," predicts Lauzon.

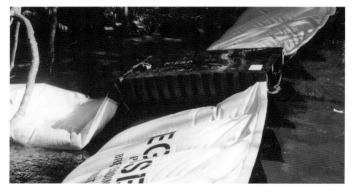

⊗ Top: Déry continued to refine the product, here testing whether he could attach two barriers of different heights.

⊗ Middle: A year and a half later, the same experiment was conducted at the same spot with a refined version of the product; this version had a new color and a simpler method of attachment for different barriers. This version used a PVC coating on the polyethylene to give the system traction, rendering metal anchors unnecessary.

⊗ Bottom: Contractors had asked for a version of the product with a diverter that would enable them to direct water elsewhere. This photo shows Déry's solution: He placed a semi tube on the barrier and attached a long tunnel to the tube.

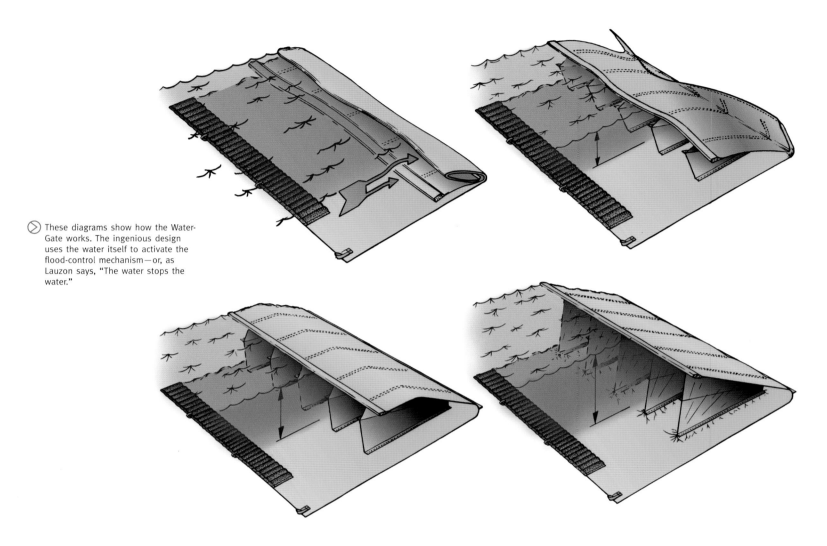

These diagrams show how the Water-Gate works. The ingenious design uses the water itself to activate the flood-control mechanism—or, as Lauzon says, "The water stops the water."

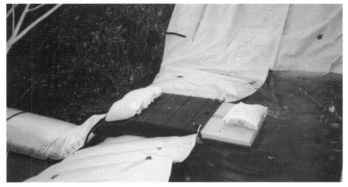

Above: The completed diverter.

Right: When a brook flooded near MegaSecur's headquarters in Victoriaville, Canada, the Water-Gate was able to protect the house of a woman who had not evacuated in time. The Water-Gate protected the house, which remained dry, for 54 hours; the local news broadcasted the scene.

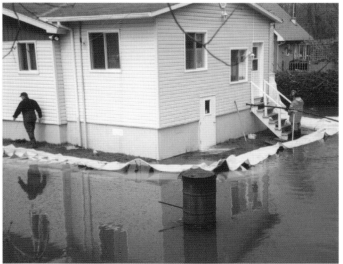

The **Watercone** is a simple, **functional**, and innovative **solution** to one of the most **basic needs** in developing countries—the need for **drinking water**.

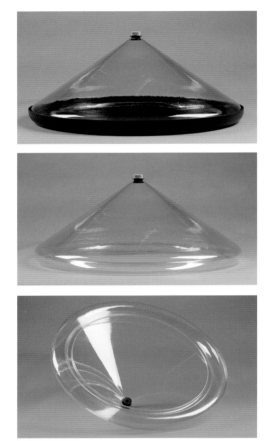

The Watercone is a simple device that uses a combination of solar energy and condensation to produce potable, drinking water.

This simple product provides anyone an independent, inexpensive, and mobile solar means to create potable water by condensation in, what is quite simply, a solar still.

After making several trips around the world and becoming aware of the global water problem, Stephan Augustin, a designer at BMW AG, felt a social responsibility to create a simple, highly utilitarian, solar-powered seawater desalination apparatus that could be manufactured cheaply. "For ecological, economical, geographical, and/or political reasons, 50 percent (2.5 billion) of the world's population has no access to clean, potable water and sanitation," says Augustin, who set his mind to doing whatever he could to minimize this problem.

His primary challenge lay in how to go about producing such a product while keeping it inexpensive enough to produce through mass production. He knew it could comprise no more than two pieces and that there was no predecessor to follow; there was no comparable product on the market. Dedicating himself to the job, Augustin started work on the project in 1998 by experimenting with solar desalination. All of his work on this project was done in the evenings, weekends, and holidays in addition to his regular job at BMW.

He began by experimenting with evaporation and condensation using a simple upside-down pyramid, a common device in desert survival. The problem here was that one-third of the condensation formed at the outer wall and ran into the sand. Moreover, the lightweight, plastic foil device wasn't wind resistant.

In February 2001, Augustin had a breakthrough idea in terms of the shape of the Watercone. A simple wooden tool was used to test the idea of a cone outfitted with a screw-cap spout at the tip and an inward circular collecting trough at the base. This cone was made out of two pieces that were glued together. While promising, the piece burst and dirt collected at its inner edge, which wasn't satisfactory.

In the fall of that year, Augustin contacted a company in Germany which was willing to develop the idea. "We began to think about several production methods that could be much cheaper than vacuum forming, which needs lots of manpower," he says. "We looked at different types of blow molding, especially for PET bottles, which already have a screw-cap spout at the tip, but all the manufacturers rejected [our proposal] because of geometrical and physical reasons. Then, we had the genius idea for a vacuum tool that allowed us to make the cone out of one piece."

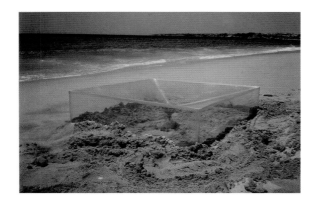

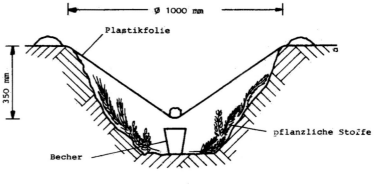

Desert Survival Still

(Labels in diagram: Ø 1000 mm, Plastikfolie, 350 mm, pflanzliche Stoffe, Becher)

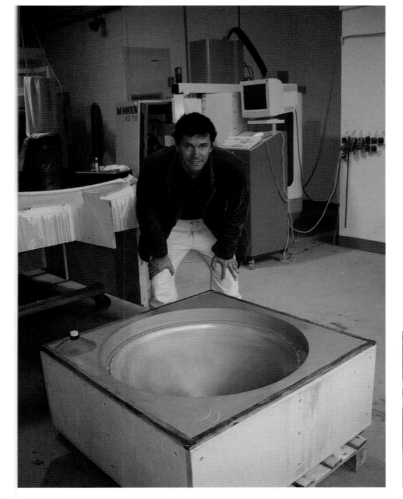

⊗ Above left: Initial experiments with evaporation and condensation were conducted in the desert.

⊗ Above right: The desert tests had problems: The condensation that formed ran back into the sand, and the plastic foil device wasn't wind-resistant. Nevertheless, the tests yielded important information that was used as the design evolved.

⊗ A prototype of the vacuum tool used to make the device.

⊗ The first units were made—conical, self-supporting, and stable devices made from transparent, thermo-formable polycarbonate outfitted with a screw-cap spout at the tip and an inward circular collecting trough at the base.

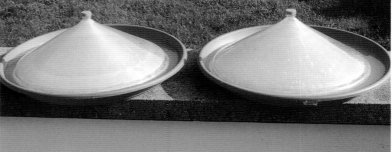

In spring 2002, construction began on a prototype vacuum tool. Later that summer, the first working products came out of this tool "after lots of failures because the material was stretched so much at the outer trough areas that it came out as a thin foil," Augustin says. "After about 100 tests, we found the right temperature and airspeed to get a perfect result."

Winter 2002 brought a license agreement with that same company to produce and distribute the product, and in spring 2003, Bayer AG, Leverkusen became the supplier and partner for the polycarbonate, Makrolon, which was the primary material.

"As we had no PR and headcount budget, the company we were working with and I were using international awards and press reports about this product resourcefully and abundantly to increase public awareness about the global water situation and our innovative product to get manufacturing and distribution started—and it worked!" says Augustin.

"There is a big potential for innovations that fulfill humanitarian, ecological, and economical aspects in one product...and I hope concern for humanity is the next new trend."

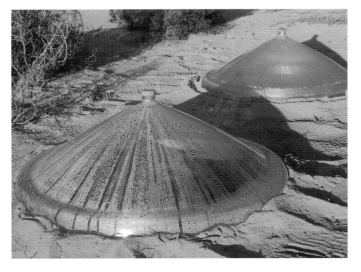

⟩ Top: The revised device was tested again under desert conditions.

⟩ The evaporated water condenses in the form of droplets on the inner wall of the cone. These droplets trickle down the inner wall into a circular trough at the inner base of the cone.

⟨ The Watercone works by a combination of solar activity, condensation, and evaporation. In short, it is a solar still.

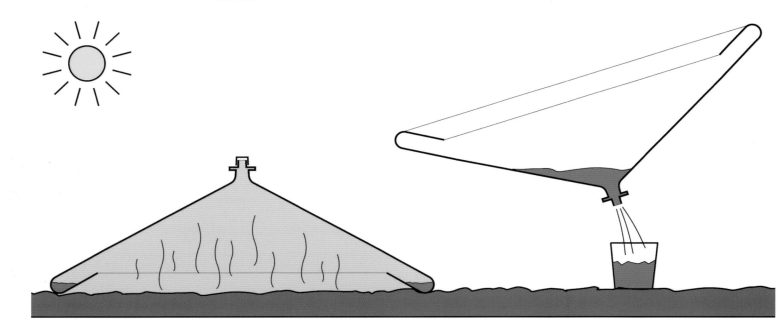

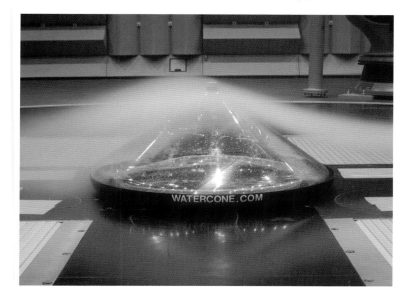

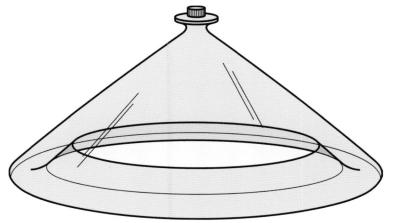

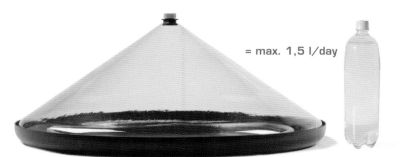

= max. 1,5 l/day

⊗ Top: Tests were run to ensure that the device would be wind resistant. Here it is withstanding winds of 34 miles (55 km) per hour.

⊗ Above: By unscrewing the cap at the tip of the cone and turning the cone upside down, one can empty the potable water gathered in the trough directly into a drinking device.

⊗ Top right: To use the Watercone, simply pour salty or brackish water into the pan. Float the Watercone on top. The black pan absorbs the sunlight and heats the water to support evaporation.

⊘ Right: The Watercone has proven to be tremendously successful at creating drinking water from condensation and solar energy, and in fact, can produce as much as 1.5 liters of water a day.

Dutch Boy Twist & Pour Paint Container The design of the paint can has been an industry standard for more than 100 years, but longevity doesn't necessarily mean perfection.

A pourable plastic paint container provided numerous advantages over the traditional metal can, yet the industry resisted.

However, when anything has been around that long, changes are bound to be resisted. The paint industry was no different when John Nottingham and John Spirk, principals of Nottingham-Spirk Design Associates, Inc., suggested improvements in paint can design.

Let's face it, there isn't a consumer around who enjoys using a metal paint can. It requires a tool to open it and a hammer to close it. The metal handle digs into your palm. The paint's difficult to pour and inevitably runs down the entire can, messes up the label, and must be wiped down to store. When it's time to touch up your paint job, you find that the can has rusted and particles of dried paint are floating on top of what would otherwise be perfectly usable paint. Why, again, has the can been the mainstay for 100 years?

The team at Nottingham-Spirk didn't have the answer to that question, but they did have revolutionary solutions to offer. "Overcoming 100 years of inertia in paint packaging posed serious challenges. It seemed that everyone in the paint trade could only think of reasons why a plastic, pourable container wouldn't work," says Nottingham. "There were issues of fitting existing shakers in retail stores, stacking in warehouses, filling line equipment, and perceived drop test concerns."

Since the paint industry is complex, the design team opted to partner with a large paint manufacturer rather than develop the product independently. They approached the Sherwin-Williams Company, which owns brands such as Dutch Boy, Pratt & Lambert, and Martin Senour in addition to the Sherwin-Williams brand. They pitched their idea and showed prototypes to Chris Connor, the new CEO of Sherwin-Williams, in early 2000, and the project was given the go-ahead.

At first, the team met with plenty of naysayers who touted all the reasons why the new packaging concept would not work. Nottingham and Spirk needed a champion and found one in Adam Chafe, the leader of Sherwin-Williams' team and now vice president of marketing for the company. "He had an open mind and could sense the potential consumer demand if the two development teams could overcome the inevitable obstacles in the creative process," says Spirk.

The design team began by studying the life cycle of the paint can from manufacturing to the filling lines, from the warehouse to the store, through the tinting process to the ride home and eventual storage, disposal, or recycling. Early brainstorming concepts ran the gamut from "mild to wild," exploring round and square shapes and a variety of product features.

Next, the designers researched consumers' reaction to a new container. "It has been recognized that the key decision makers and product drivers have been consistently changing in the last 10 years. In particular, more women are making décor decisions and actually taking part in painting. These consumers are more

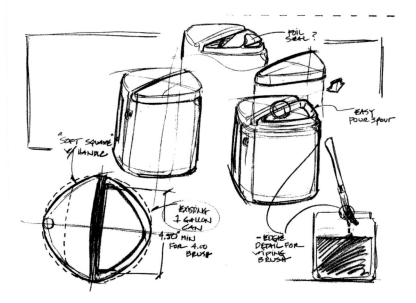

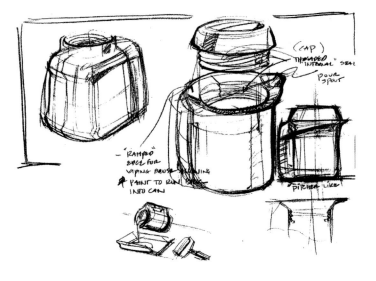

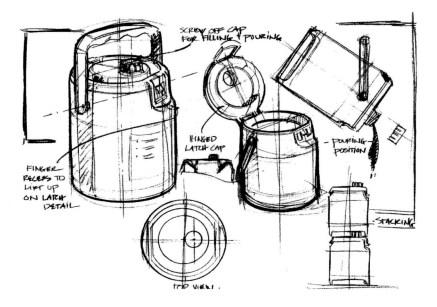

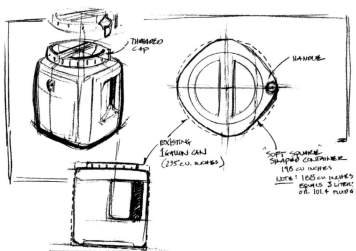

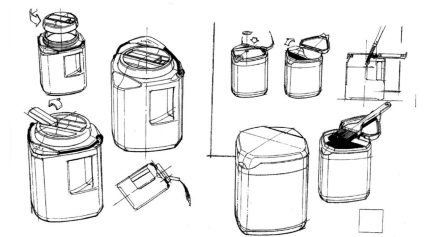

Early sketches ran the gamut from "mild to wild" concepts that played with a variety of shapes. The constants were the easy-pour spout and easy carrying handle.

The idea of the threaded screw cap wasn't a part of the concept from the beginning. Designers played around with the idea of several product openings to find the one that provided the easiest method of pouring.

demanding of ease-of-use and neatness of do-it-yourself projects, being used to liquid laundry detergent bottles and other convenient household packages," says Nottingham.

"One of the early constraints we imposed on the project was to stay within the standard gallon can footprint so that warehouse and retail shelves wouldn't need to be changed," Spirk remembers. "By making the container square, we were able to buy free space in the corners to make room for a hole-through side handle. In this case, we had to test how tight the corners could be within bold molding parameters. We also challenged ourselves to connect the plastic bail handle to fit within the footprint."

Aside from the merchandising issues, designers had to maximize the screw-threaded opening to fit a standard 4-inch (10 cm) brush while accommodating a flow-back, pourable feature. This was done using an injection-molded insert. The lugs on the lid were positioned diagonally across the corners, staying within the footprint and allowing for thumb leverage while holding the side handle. The stepped lid allows for nesting in the underside of another container for stacking and also provides a smaller diameter for gripping while twisting off the lid.

The design seemed to be coming together as the negatives were eliminated one by one. Finally, the time was right to take the container to a series of focus groups, who compared it to the standard metal paint can. "The overwhelmingly positive reaction to the plastic pourable can gave us the impetus to continue to tackle the distribution system," says Nottingham.

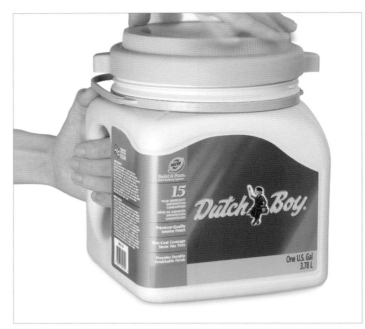

The threaded opening had to be large enough to accommodate a standard 4-inch (10 cm) paintbrush.

Top and middle: Designers used a Finite Element Analysis program to help maximize the container's structure while using a minimum amount of material.

Bottom: Designers finessed the product design in Pro/Engineer.

Far left: A product rendering as a whole and exploded show how the chosen design goes together.

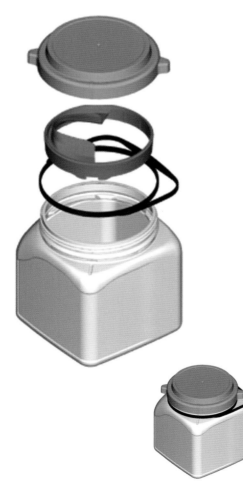

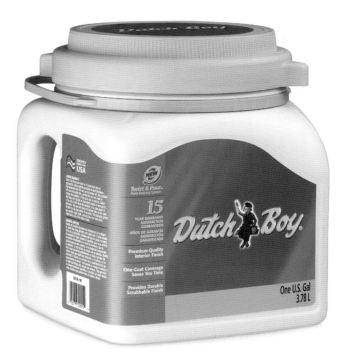

Store shaking machines had to be outfitted with square inserts, paint filling lines had to be converted to the square plastic containers, and warehouse shelving and pallets had to be configured for the new package. "The trade and distribution concerns have been met and exceeded," says Spirk. "For instance, the store tinting process has improved. Opening and closing when adding the tint is not only faster, but also the flat sides of the container provided more complete mixing of the tinted color."

Another advantage proved to be the new can's square shape. The container requires less shelf space because it doesn't have side ears for the bail handle. Retailers can place 14 linear facings of the new container on store shelves, one more than was possible with the round can. "The flat front face also produced a strong visual effect for merchandising. In a drop test, the plastic container actually bounced and fared better than the metal," Nottingham adds.

The container was launched as part of the Dutch Boy brand in July 2002. Since then, the number of retail outlets that carry the brand has tripled. In addition, the container is being distributed throughout Sherwin-Williams paint stores. According to Adam Chafe, "Sales are far exceeding our expectations."

⊗ Top: The square shape of the new container accommodates 14 linear facings in the same area previous occupied by 13 metal gallon cans.

⊗ Above: While observing the habits of consumers using metal paint cans, the design team noticed that men typically hold the metal bail with one hand and pivot the can from the bottom with the other hand to pour, while women tend to hold both sides of the can and pour by pivoting their wrists. To provide a more secure grip and pouring experience for both sexes, designers added a side handle to the container.

⊗ The easy-pour spout couldn't be neater. It includes a built-in lip for wiping excess paint from the brush, and it won't rust or dent like typical paint cans.

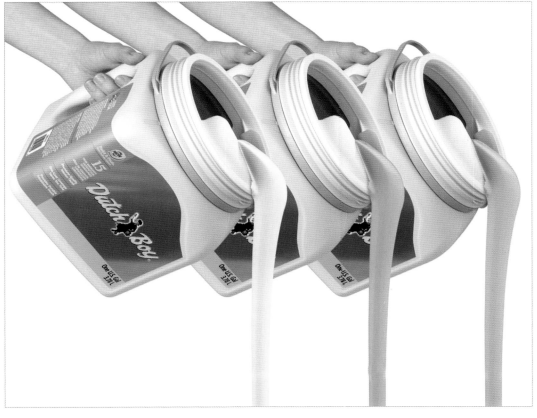

Handy Paint Pail

Mark Bergman had **an idea** for a paint pail that would take some of the **hassle** out of an unpleasant **chore**—it would provide a place to wipe off the **paintbrush** or to place it, it would be **comfortable** to hold,

The main container of the Handy Paint Pail is composed of two parts, an injection-molded polypropylene bucket and an injection-molded flexible PVC top ring and strap. A ceramic magnet functions as a brush holder.

Opposite: These sketches resulted from half a day of brainstorming by Worrell's design team. They explore the idea of a plastic lid with a hole in it meant for swiping off extra paint and holding the brush. Some of the sketches also show the early idea of an accordion-shaped flexing handle.

and it would be easy to clean. He went to Worrell Design with preliminary sketches and asked them to refine and produce his product. Bob Worrell, president, says, "This was an entrepreneur who had an idea, and there's enough of us here that do DIY home projects anyway that we understood what was going on, and could do this very quickly and very simply."

Since turnaround had to be quick, as Bergman's budget for the product was limited, the designers at Worrell Design spent only half a day coming up with sketches that refined the original idea. The client's original concept was a cup with a separate, rounded lid made of the same injected molded polypropylene planned for the cup; it would have a hole on the top that could be used both to hold the brush and to wipe paint off it. The team had an alternate idea: a design that featured an edge and handle made of thermoplastic rubber, which is an injection-moldable material with a soft durometer; the material would give the product a distinct look and make the handle more flexible.

To keep the handle flexible, early sketches also considered a handle with an accordion-like flexing mechanism on top, but the team ended up favoring the idea of an adjustable strap, which gives users the ability not only to adjust it to their own hand size but also to attach it to a ladder or any other convenient place. The team decided to take both Bergman's idea and their variation into modeling to see which one they all preferred.

Worrell points out that, given the time and budget limitations on this project, they skipped the solid modeling that their designers would usually do in Alias or Rhino, and instead went straight into engineering, where the engineers built a ProE solid model based on the sketches. "If we give the engineers a database out of our Alias system, the engineers cannot actually work productively on that database—they have to almost redraw it," says Worrell. And that would have taken time the client couldn't afford to pay for.

Once solid modeling was complete, stereolithography models were made. The designers then built temporary mold boxes from room temperature vulcanizing, a process that can be used to build prototypes quickly, and used the master parts to create a mold. From the mold, the team made urethane prototypes, which the engineers examined to be sure the parts fit together properly.

In the end, Worrell Design's variation on Bergman's idea won out; it was felt that Bergman's version would be too rigid to work with the wide variety of sizes and shapes of brushes that users employ. The thermoplastic rubber of Worrell's version had other advantages, too. "That particular part allowed for a lot more utility in

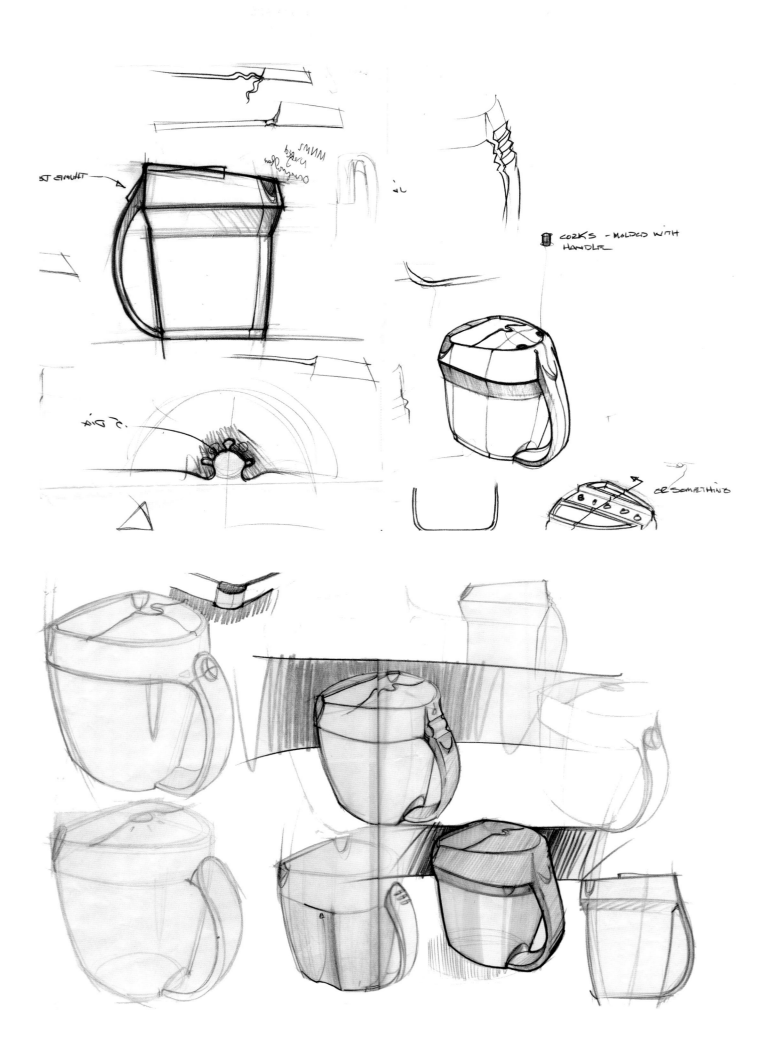

CORKS - MOLDED WITH HANDLE

or SOMETHING

that it created a distinct aesthetic image, and we could color it differently than the rest of the bucket; it acted as a paint drip edge, and it allowed and accommodated different hand sizes," says Worrell.

Since the idea of a rigid dome over the pail opening had been rejected, the team came up with another way to hold a brush conveniently within reach of the user: the simple addition of a magnet inside the rim of the pail to hold the brush clear of the paint. The magnet has a metal back with a lip; the magnet slides into a slot near the handle, where the metal lip holds it in place.

The engineers then put together drafting documents for the molders. While not strictly necessary—molders can work from ProE documents—Worrell feels that providing better detail ensures the quality of the products the molders produce. "We produced the line art as a quality tool. That helps the client approve and verify that what they got from the molder was in fact accurate," says Worrell. Bergman approved the design, and the molder asked for minor refinements to make the design more efficient to produce.

Bergman ended up striking a deal with a local molder to produce the product. Color was decided by Bergman and the molder; Bergman had decided that he wanted the colors to be neutral be-

cause of the variety of hues of paint that might go in the pail. The part for the handle and lip went to a darker gray to distinguish it from the rest of the pail and to avoid color-matching problems that may have resulted from the lip and the cup being made from different materials.

Small local hardware stores started carrying the Handy Paint Pail, then larger chains; sales took off when Home Depot began carrying it, and since then, sales have zoomed into the hundreds of thousands. Says Worrell, "Who would have thought that you'd want to pour paint out of a can into another bucket that you have to clean up, but it's so comfortable, and it's such a simple idea, that it just really caught on."

Mark Bergman wasn't the first entrepreneur Worrell Design has worked with, and he probably won't be the last: Worrell feels that working with start-up companies as well as corporate clients "keeps us on our toes and fresh." But there's a special excitement in working with entrepreneurs. Says Worrell, "The business we're in is creating people's futures. It's an exhilarating idea. There's a lot of promises inherent in what we do of wealth and excitement, and whenever we do concept sketches or drawings or models, it's like Christmas—you can't open the package fast enough."

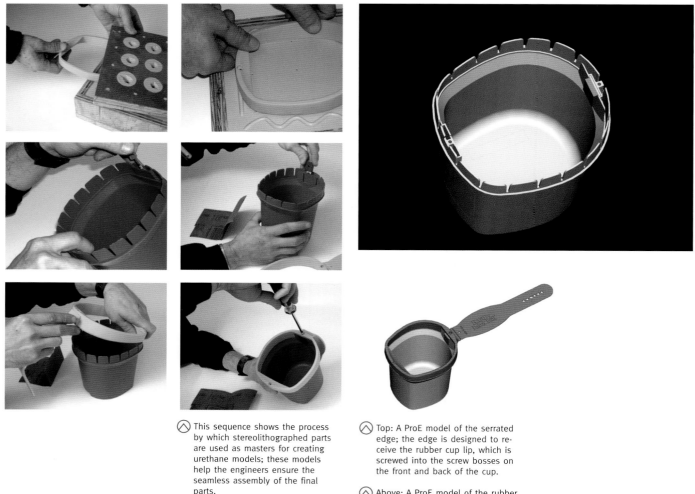

⬙ This sequence shows the process by which stereolithographed parts are used as masters for creating urethane models; these models help the engineers ensure the seamless assembly of the final parts.

⬙ Top: A ProE model of the serrated edge; the edge is designed to receive the rubber cup lip, which is screwed into the screw bosses on the front and back of the cup.

⬙ Above: A ProE model of the rubber cup lip and its adjustable strap handle, here attached to the serrated edge of the cup.

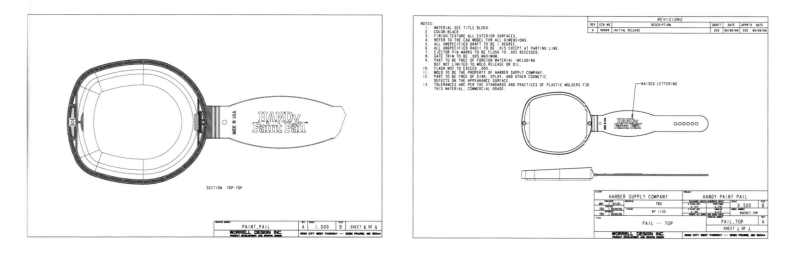

NOTES:
1. MATERIAL: SEE TITLE BLOCK.
2. COLOR: BLACK.
3. FINISH: TEXTURE ALL EXTERIOR SURFACES.
4. REFER TO THE CAD MODEL FOR ALL DIMENSIONS.
5. ALL UNSPECIFIED DRAFT TO BE 1 DEGREE.
6. ALL UNSPECIFIED RADII TO BE .015 EXCEPT AT PARTING LINE.
7. EJECTOR PIN MARKS TO BE FLUSH TO .005 RECESSED.
8. GATE TRIM TO BE .005 MAXIMUM.
9. PART TO BE FREE OF FOREIGN MATERIAL INCLUDING
 BUT NOT LIMITED TO MOLD RELEASE OR OIL.
10. FLASH NOT TO EXCEED .005.
11. MOLD TO BE THE PROPERTY OF HARBER SUPPLY COMPANY.
12. PART TO BE FREE OF SINK, SPLAY, AND OTHER COSMETIC
 DEFECTS ON THE APPEARANCE SURFACE.
13. TOLERANCES ARE PER THE STANDARDS AND PRACTICES OF PLASTIC MOLDERS FOR
 THIS MATERIAL, COMMERCIAL GRADE.

—RAISED LETTERING

Though ProE modeling is sufficient for the molder to work from, Bob Worrell believes that architectural blueprints like these help ensure the quality of the products the molder produces.

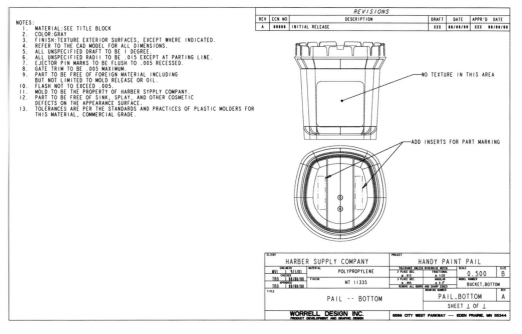

NOTES:
1. MATERIAL: SEE TITLE BLOCK
2. COLOR: GRAY
3. FINISH: TEXTURE EXTERIOR SURFACES, EXCEPT WHERE INDICATED.
4. REFER TO THE CAD MODEL FOR ALL DIMENSIONS.
5. ALL UNSPECIFIED DRAFT TO BE 1 DEGREE.
6. ALL UNSPECIFIED RADII TO BE .015 EXCEPT AT PARTING LINE.
7. EJECTOR PIN MARKS TO BE FLUSH TO .005 RECESSED.
8. GATE TRIM TO BE .005 MAXIMUM.
9. PART TO BE FREE OF FOREIGN MATERIAL INCLUDING
 BUT NOT LIMITED TO MOLD RELEASE OR OIL.
10. FLASH NOT TO EXCEED .005.
11. MOLD TO BE THE PROPERTY OF HARBER SYPPLY COMPANY.
12. PART TO BE FREE OF SINK, SPLAY, AND OTHER COSMETIC
 DEFECTS ON THE APPEARANCE SURFACE.
13. TOLERANCES ARE PER THE STANDARDS AND PRACTICES OF PLASTIC MOLDERS FOR
 THIS MATERIAL, COMMERCIAL GRADE.

—NO TEXTURE IN THIS AREA

—ADD INSERTS FOR PART MARKING

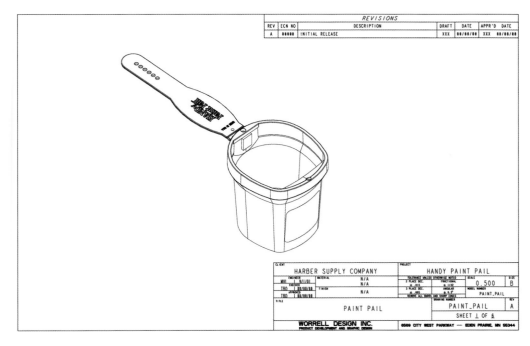

Master Lock Titanium Series Home and Yard Padlocks

Can **brand awareness** be a **double-edged** sword? It can indeed, **when** used against you by your **competition**.

The Titanium Series Home and Yard Padlock, like other locks in the Titanium series, features an ABS/rubber bumper to protect the lock from rust as well as to prevent the padlock from scratching whatever it protects. The interior of the lock is primarily zinc and brass, so it won't corrode.

That's precisely what happened to Master Lock. After decades as leader of the padlock market, and with over 90 percent brand awareness, Master Lock was starting to see its market share dwindle because of cheap knockoff products that confused consumers into thinking they were high-quality Master Locks—and buying them instead of the real thing. In the face of the pricing pressure they were receiving from mass-merchant customers such as Wal-Mart and Home Depot, Master Lock had to make a decision.

"Master Lock came to us saying, is there a design solution to this business problem that we have?" says Harry West, vice president of strategy and innovation at Design Continuum. "One way to deal with low-cost foreign competition is simply to lower your prices, but of course the downside of that is it reduces the value of your company. So the question was, was there some way through design to maintain Master Lock's share, or even grow their share, and not have to lower their prices?"

To answer that, Design Continuum researched the padlock category to see where Master Lock's leverage might be; in doing so, they identified three major issues that the brand would have to address. First, they found out that, while the average person has a lot of padlocks, no one spends much time thinking about them. Second, people had trouble finding them in stores; padlocks are generally located in the hardware aisle, but that's not where people looked for them. Finally, people couldn't distinguish between the Master Lock brand and the knockoffs. These initial findings led to what West calls an "epiphany" about the product: It wasn't the padlocks that were important to people, it was what the padlocks protected. This revelation led to the team's strategy for the design: "It had to do more than just be a good security device, it also had to fit into the fabric of consumer's lives in a way that the current padlock did not," says West.

To find a way to do that with the product's redesign, Design Continuum sought to answer two questions: What did consumers think about security, and where did consumers use locks? To answer the first question, the team conducted focus groups and interviews; in doing so, they discovered that most people believe that locks are broken into with bolt cutters. A lock where less shackle is exposed would appear more secure to consumers—and would give Master Lock a competitive advantage. The team also discovered that people were reluctant to lock up outdoor equipment because the prominent display of locks signaled mistrust of one's neighbors—indicating that there could be a demand for locks without the archetypal lock appearance.

To answer the second question, the team identified the primary areas consumers used padlocks and decided that they needed to target each of these areas—beginning with the home and yard and automotive categories—with products designed specifically for them.

Left: This early sketch was where the concept of the Master Lock Titanium series began. West describes this first concept as "sort of like a padlock, but a padlock like you've never seen before."

Right: A more refined version of the original sketch.

Early line drawings explored different notions of bumper shape and of how the keyhole would be covered; all featured a lock mechanism that was front and center, and all featured a shank that was minimally exposed.

⊘ Further sketches continued to explore bumper configurations as well as a variety of color applications.

⊘ An early color illustration of the lock with the plastic configuration retained in the final version.

INTEGRAL SLIDER
TEXTURED STRIP

Armed with this research, Design Continuum's team of consumer researchers, business analysts, and designers began brainstorming solutions to Master Lock's business—and design—problem. This led to a simple line sketch and a simple concept: Says West, "We wanted to make one core product that would be what we called Swatchifiable [a reference to the famous line of watches]—it's basically all the same product, but with an application of color and texture you make the user see it as a completely different product. We wanted to take that notion and apply it to padlocks." This concept would allow Design Continuum to target a number of consumer areas while keeping manufacturing simple and cost-effective. Even in the initial sketch, the lock also managed to address some consumer concerns: The front-facing lock was easier for users to reach; the small amount of exposed shank looked secure; and the shape was graceful and unobtrusive.

The team had hit on a rubber bumper as their vehicle for "Swatchifying" the lock; not only did the bumper allow Design Continuum to tailor the look of the lock for a number of different uses, it also added value for the consumer. It also protected the lock from rust, it prevented the objects that were being protected by the lock from being scratched by it, and it protected users' hands from cold and heat. Further sketches refined the shape of the bumper itself as well as how the lock mechanism would be protected by it.

The team fashioned various appearance models out of foam and plastic and showed them to consumers. Consumers said they liked it, but for the team, actions spoke louder than words: "As they were talking, they always had it in their hand," says West. "There's something about the form that people wanted to pick up and hold, and that made us confident that we were going in the right direction." The team then built and gave working models to consumers to test; their response to both the form and the feel of the lock was positive.

To help refine the look of each line, the design team created separate image boards for the home and yard and automotive lines; inspired by the boards, the team created new appearance models for each line, and then went back to consumers with the image boards and the appearance models. When challenged to match the home and yard model to the home and yard image board and the automotive model to the automotive image board, consumers could do it right away—and the design team knew they were on the right track.

At this point, Design Continuum started to tweak the design for manufacturing. The cylinder of the locks came from Master Lock, but Design Continuum's engineers were responsible for the rest of the lock design. While they were refining the design to minimize manufacturing costs, they were also putting it through the standard security tests that a padlock has to pass. West describes this phase as "a fairly lengthy, iterative process whereby, as designers, we can see the difference, but consumers I think really cannot see the difference."

By designing a new breed of padlock, Design Continuum was successful in getting Master Lock's products out of the hardware aisle; mass merchants like Target and Wal-Mart now spread Master Lock products throughout their stores. Says West, "If you want to get your products into another part of the store, you have to make them so they don't look like hardware; when they looked like hardware, that's where they were put." In some stores, this has resulted in double-digit sales gains for Master Lock.

But West has a different way to measure success: "I think the best way of looking at success is not product by product but by the total story that all of those products together tell the consumer. The story they tell here is that Master Lock is now innovating, and in a category where there's basically been no innovation for decades." That innovation has paid off; the Titanium Series has a utility patent and several design patents, meaning that knockoffs of the product can no longer be sold in the United States. Moreover, as West says, "We took that category and we made some absolutely beautiful products."

⊗ This model of the Titanium Series Home and Yard Lock is very close to the final design for the lock.

⊘ These appearance models experimented with different configurations and colors of the plastic bumper. "Ninety-five percent of the cost is in the stuff other than the plastic bumper," says West. "The plastic bumper changes the context, so the one on the left is appropriate for an automotive application and the one on the right is appropriate for a more professional series application, like a building yard."

Soft Edge Ruler When was the last time you saw the **beauty** in the ruler that lies in your **desk drawer**? If it is your typical **ruler**, you probably **didn't** even realize you **had it until** you look for it and was **missing**.

However, if you had a Soft Edge ruler, you wouldn't only notice it; it would command your attention. "It was designed to be so much more than just a desktop ruler," says Eric Chan, president, ECCO Design, Inc. "It was created efficiently and economically for precise functionality by taking full advantage of the material from which it is made. Soft Edge's lyrical and curvilinear gesture is a reflection not only of the inherent precision of a ruler but of our hands, our bodies, and the landscape of our desks."

It is obvious that Chan sees beauty in everyday objects that don't necessarily possess a beauty of their own—that is, until a designer takes a look at them from another perspective. The idea came from a "need for poetry, simplicity, and beauty in our everyday objects," he says. "Simple poetry in everyday objects was missing in the high-tech work environment. In the digital information age, many of our desktop products have become sterile, full of buttons, screens, and clicks. The goal was to design something beautiful, with beauty lying in the natural form of the object."

The market wasn't demanding the Soft Edge ruler, but Chan felt that it was crying out silently for one. So he and his team went to work on a design for a different ruler, a ruler with a twist—literally.

"While most rulers are have hard edges and are rectilinear, physically reflecting their metaphorical purpose—to measure within a straight Cartesian world—Soft Edge was designed with another focus—to improve user experience and function while remaining precise," he says.

The design began as a sketch, and from that designers made paper and cardboard models. "We went back and forth between the sketches and models to find the right overall shape and the desirable curve and bend of the handle," Chan remembers."

The team used Ashlar-Vellum and Illustrator 9.0, along with Prisma colored pencils, paper, and cut cardboard to design the product. "While technology helped in the design process, it was not the only tool used," Chan is quick to point out. They experimented with the material, using a single sheet of stainless steel, and continued to make models.

The primary challenge Chan identified was creating the right fold and turn of the handle. "We wanted to maximize the ergonomics of the product while using the minimum amount of stainless steel material," he says.

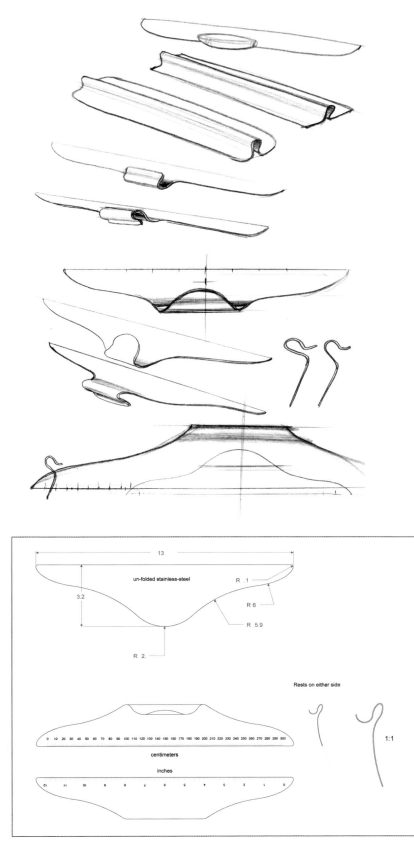

The design called for the Soft Edge to be stamped from a single sheet of stainless steel. Leftover material is recycled. The sheet is polished to remove imperfections. Precise logos are laser-etched, and measurements are silk-screened. The parts are bent in steel tool dies.

After a lot of tweaking, designers achieved the right fold and, in the end, the ruler, stamped from a flat sheet, delicately curls up for an easy grasp while easily flipping over to reveal both inches and centimeters. "Its curved and angled surface makes viewing easier as well," Chan says. "It achieves subtle beauty through the marriage of a high degree of industrial process informed with user sensitivity and lifestyle."

Because the Soft Edge is bent from a single sheet of metal, the product cost the client little to produce, yet it still reflects a high degree of quality and craftsmanship. "The perceived value is much higher than actual manufacturing cost, so the client gained a high sales margin," Chan says, noting that the suggest retail price is $14.00.

The ruler is durable and rustproof, user friendly, and elegant, and because of these things, Chan says that it will likely never be discarded. However, if it is, it is fully recyclable.

"Its soft, undulating form allows it to blend into a multitude of environments, from a CEO's desktop to a secretary's reception table. As a desktop object, Soft Edge communicates functional beauty and a passion for work. It negates the more commonly sought attributes of status. The ruler is a simple reminder of our bodies; it is a permanent tool much needed in our temporal technologically burdened lives."

What is the most outstanding feature of this product? Its simplicity. "A powerful design can come from a very simple material. The foundation of design is to provoke internal emotions and to show the emotional expression of the creator. Challenge simple, everyday objects and elevate them to a higher ground," says Chan. "I learned that poetry and technology could actually coexist, even in a ruler. Perhaps especially in a ruler. That poetry rules over technology."

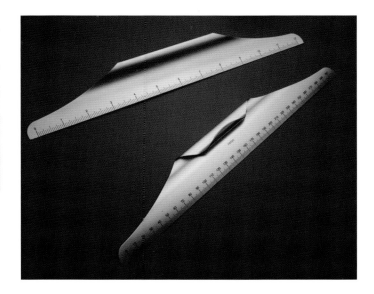

Top: Designers tackled the Soft Edge ruler by creating a variety of sketches that took the traditional straightedge ruler to more poetic realm.

Middle: The team used technology daily but also relied on Prisma colored pencils, paper, and cut cardboard to design the product.

Bottom: This diagram shows the unfolded stainless steel, the degree of the fold, and how the inch and centimeter marks will be laser-etched on the stainless steel.

Although the fold proved the most challenging aspect of the project, designers overcame the problem. As a result, the ruler, made from a single sheet of stainless steel, delicately curls up for an easy grasp while easily flipping over to reveal both inches and centimeters.

The Rabbit Corkscrew We **never** really **pay** much **attention** to a corkscrew—that is, unless it **doesn't** **work**, which is **frequently** the **case**.

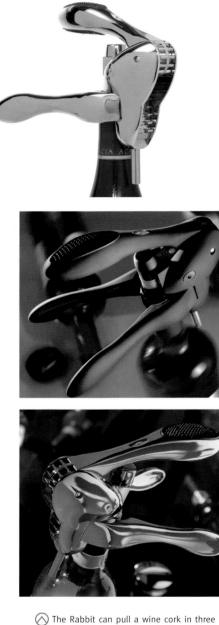

The Rabbit can pull a wine cork in three seconds. To use, simply remove the foil cap with a knife or foil cutter. Raise the corkscrew by bringing the top handle forward. Position the corkscrew over the cork and grip the top of the bottle with the gripping handles. Insert the corkscrew into the cork by bringing the top handle up and back. Remove the cork by bringing the top handle forward and down. To release the cork from the corkscrew, bring the top handle up and back. Then, grip the cork with the gripping handles and bring the handle forward and down. The entire process takes only five to six seconds.

It's a little-known fact that the lever-action corkscrew was invented in the 1970s by Texas oilman/inventor Herb Allen, who made his fortune creating many innovations in oil drilling and spent years developing the lever mechanism for a corkscrew. He tried to sell his invention without much success. Upon his death, his estate sold the company, Hallen, to French cookware manufacturer Le Creuset, which named his invention the LeverPull professional corkscrew and sold it for $140 to high-end specialty shops.

In 1997, Le Creuset sued Metrokane, based in New York, for manufacturing a self-pull corkscrew with a faucet handle. It looked different than Le Creuset's product but used a Teflon coating, which violated the patent, and the case was settled out of court. During the process, Metrokane's marketing director and co-owner, Bob Larimer, discovered that the patent on the Lever-Pull was due to expire in 1999. He remembered meeting Ed Kilduff, a 27-year-old designer who had already designed many housewares products for companies like OXO and EKCO and had just started Pollen Design in New York with Dean Chapman, an English designer.

"At first, the plan was to simply reshape it, make it in China, and sell it for $70, half the price of ScrewPull," says Kilduff. "But I convinced Bob to spend a bit more on the materials and beautiful packaging."

Kilduff broke the project down into three phases: concept sketches, design/model, and mechanical drawing. "After choosing one of the concepts from the drawing phase, I tried to match that sketch while building the model. I had the drawing pinned up at my studio, constantly looking at it for reference," remembers Kilduff. "After painting and assembling the prototype, I remember showing it to my girlfriend, who said, 'It's really nice, but it looks like a rabbit!' I was not very happy about that. I wanted it to look like a corkscrew, not an animal."

The whole process from first meeting to finished prototype took three weeks. The next day, Kilduff presented the prototype to Metrokane. "They loved it! But I reluctantly told them that it looked like a rabbit," says Kilduff. "A lightbulb went off in Bob's head—people would associate it with speed. Bob was an advertising and marketing mogul who had created many famous TV campaigns. He sold his worldwide agency in 1982 before starting Metrokane. So we tried to make it look *more* like a rabbit by using a rubber spray on the body that would simulate the furry feel of hair and a rubber grip pad on the handle. We also moved the pivot axle to the place where the eye would be."

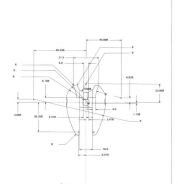

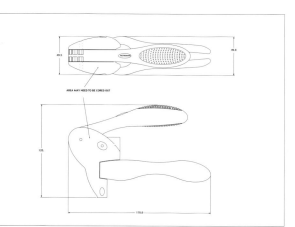

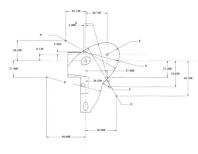

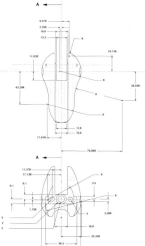

MATERIAL: TRANSLUCENT POLYCARBONATE
COLOR: TBD
SCALE 1:1
MAIN UNIT

METROKANE				
rabbit corkscrew				MET-001
EK		1 OF 1	1:1	12/20/97
VELLUM 2.70D			001	

◈ Above: An early mechanical drawing makes it easy to see how the corkscrew got its name, Rabbit. To enhance the look, designers moved the pivot axel to the place where the rabbit's eye would be.

◈ Below: As part of Kilduff's research, he had to measure various sizes of wine bottles.

◈ Right: Pollen Design also got involved in creating the packaging for the product.

Kilduff sent the drawings off to Metrokane's factory in China, which had about two years to perfect it until the patent was due to expire.

The Rabbit was finally introduced at the Housewares show in January in 2000 and was successful at the suggested retail price of $80. In early 2003, Metrokane sold its millionth Rabbit. Metrokane went from $3 million in annual sales to $20 million in 2002. The line consists of about 30 products and is growing. "The Rabbit was my first design project for Pollen Design," Kilduff says. "We were lucky to have a great client that let us design the product, packaging, graphics, identity, advertising, and so on. Because this product took two years to hit the market, we've learned to be patient and focused.

"I've learned that being a successful designer is really about forming a tight bond with your client. You will have to earn their trust—in which they will invest hundreds of thousands of dollars based on your decision making and recommendations."

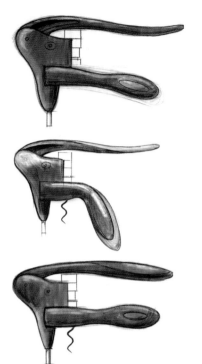

○ Ed Kilduff created several sketches of the new lever-pull corkscrew in the first phase of the project.

▽ Kilduff pinned this sketch of the concept chosen by the client on the wall in his studio and worked from it to build the first prototype.

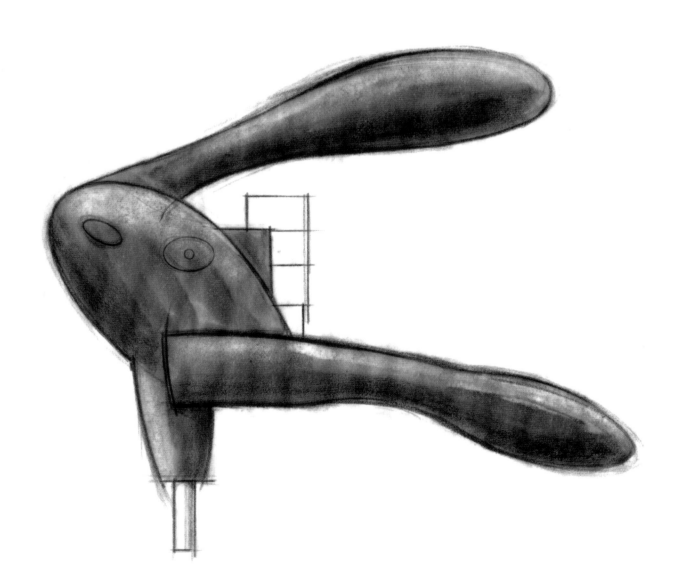

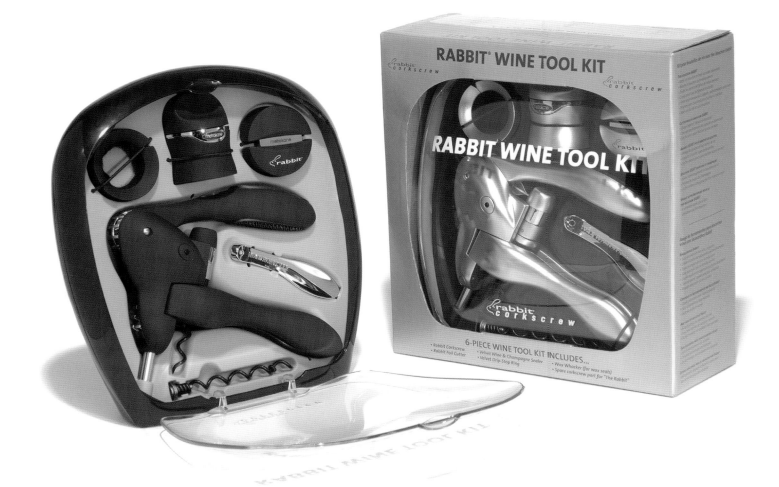

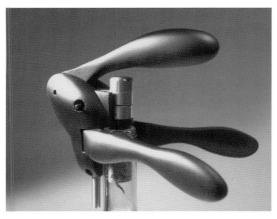

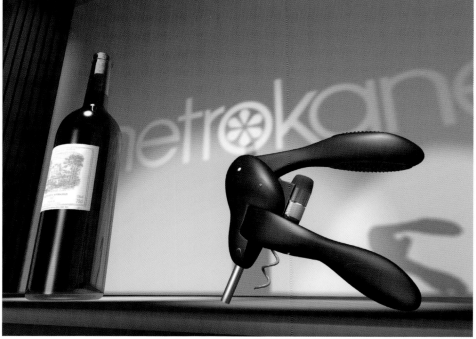

⊘ Top: Kilduff also designed the Rabbit Hutch, a Lucite case that holds the Rabbit Corkscrew and the Rabbit Foil Cutter. The Rabbit is available in black and silver.

⊘ Above: After building the first prototype, Kilduff's girlfriend commented that it looked like a rabbit. Embarrassed at first by the resemblance, Kilduff and the client found that it worked in their favor.

⊘ To make the corkscrew look more like a rabbit, a rubber spray was applied to the body to simulate a furry feel, and a rubber grip pad was added to the handle.

Malden Mills Polartec Heat Blanket Who doesn't enjoy snuggling beneath a toasty warm blanket on a cold night?

The wireless remote control clips onto the blanket so that you don't lose it in the night.

Altitude's brainstorming process is where designers indulge in blue-sky thinking. They consider related products and get as broad as possible in that first initial conceptualization.

Of late, however, concerns about large electrical fields, high voltage, and the dangers to pets and children caused by electric blankets are pushing many people to shiver beneath a pile of ordinary blankets and comforters.

Malden Mills, a textile company, felt the time was right to develop its own heat blanket and tapped Altitude for its design expertise. One of the initial challenges designers encountered was the price point versus feature set. "Since Malden Mills had never developed a product before, we had to work through what their needs were and what that would cost them," says Heather Andrus, Altitude's engineering director. "One of the first decisions we made was that the blanket would have a wireless remote control. It was an expensive option, but they knew about it up front so it was calculated into the necessary price point. That did add a significant amount of cost, but it gave us a lot of options."

A secondary challenge was deciding how the blanket would be powered. Most blankets require high voltage and produce a significant electric field. "It was important that it be a low-voltage product, so that kids wouldn't be hurt and pets could chew on it and still be safe. It took a lot of design to incorporate this feature, but safety was a priority at the outset," says Andrus.

Designers approached this project like they do any other—with a brainstorming session where "we get as blue-sky as possible," says Andrus. They consider related products and get as broad as possible in that first initial conceptualization. "Some ideas may not be practical, but there will be a spark of an idea. It is really an opportunity to not have any boundaries on the problem," Andrus says.

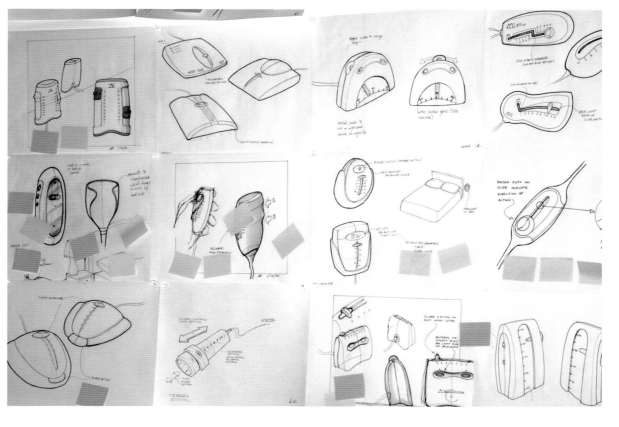

Ideas resulting from the brainstorming may not be practical, but designers usually find plenty of gems among them. These early sketches explored how the remote, the transformer, and the blanket might look.

Designers may present as many as 30 concepts to the client to make sure they are on the same page. From these, two, three, or four concepts are selected. In this case, the concept in the center of this layout was one that ultimately was pursued.

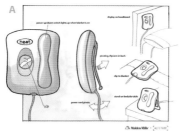

A

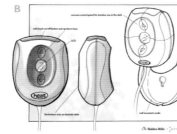

B

C

D

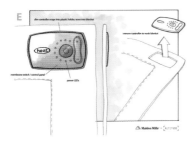

E

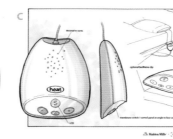

F

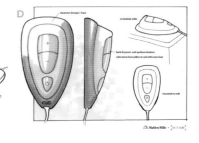

G

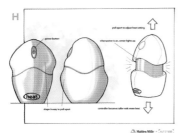

H

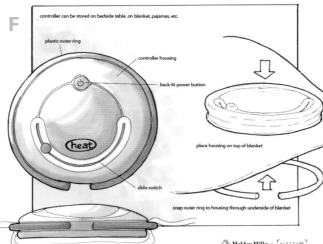

I

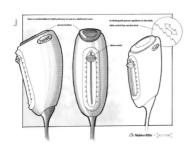

J

K

L

M

The result was plenty of sound ideas, and Altitude took as many as 30 quick sketches to the client to discuss. "This helps us get on the same page as the client," Andrus explains. "Some ideas may not be feasible, but this approach allows us to say what we think is important. Then we'll select two, three, or four concepts."

In the case of the heat blanket, a lot of early exploration centered around the remote control. Designers wanted to understand how a user would interact with it at night. Users had to be able to adjust it without turning on the light.

In early sketches, they explored the feasibility of using a round or elliptical controller and produced prototypes for testing. They wanted to see how the remote would "live" in its actual environment. Since it was not tethered to a cord, how would a user find it at night? The answer: It could be clipped to the blanket, sheets, or the user's pajamas. Designers walked through usage scenarios with both models, evaluating the intuitiveness of the controls and the feel of the remote in the hand. Feedback revealed that the elliptical controller was difficult to orient in the dark, whereas users could approach the round remote from any direction. Designers also found that they didn't need the power button, which just added an unnecessary level of complexity. The results drove the decision to pursue the round unit.

Creating the transformer was another challenge. Safety was the primary objective. Since the blanket uses very low power, designers needed a transformer that could turn the voltage from the wall into something safe. "The transformer ended up being big next to the remote," says Andrus. You don't want a lot of electronic stuff cluttering up a bedroom, so the question became, where do you put the transformer to get it out of the way? Designers did their research and developed an inconspicuous transformer with vents on top to keep the unit cool to the touch.

The last component to consider was the blanket itself. While most blankets have threaded through the fabric a heavy wire that delivers the heat, designers opted to weave tiny wires, no thicker than thread, through the Polartec fleece so that it looks and feels like any other fleece blanket. "We run very small amounts of power through the wires, which makes for a much safer product," says Andrus. In fact, the voltage is so low that a dog can chew on the blanket, get it wet, and still be completely safe.

It took eight months to complete this project and, when it was done, the result was an electric blanket that is cozy, soft, warm, and safe. "It is really important to think about everything early on," says Andrus. "In the middle of the process, we went through a number of iterations thinking about the safety of the blanket, which affected the usage scenario. Very early on there are a lot of trade-offs. The team has to know what all the factors are and rate their importance. The team must be in agreement on the priorities for the product. You need to have a cohesive view of all the implications of each decision that you make."

Designers explored developing a round and an elliptical controller, but user testing found that the round controller was easier to orient in the dark, so it was chosen over the elliptical shape for further development.

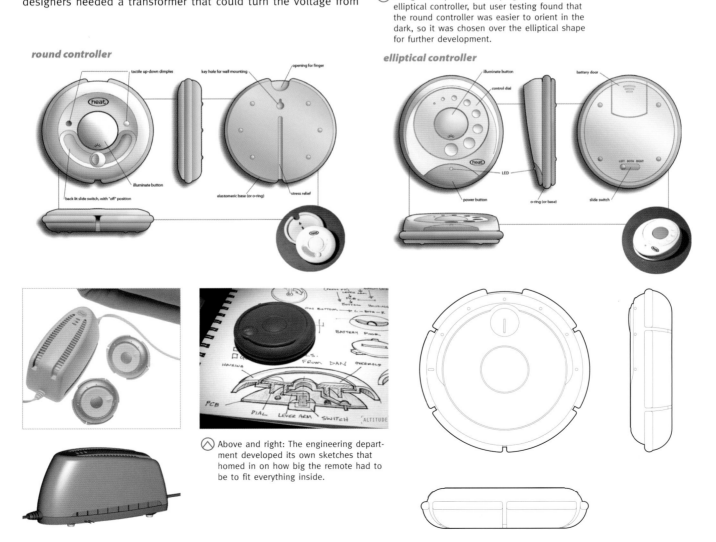

round controller

elliptical controller

Above and right: The engineering department developed its own sketches that homed in on how big the remote had to be to fit everything inside.

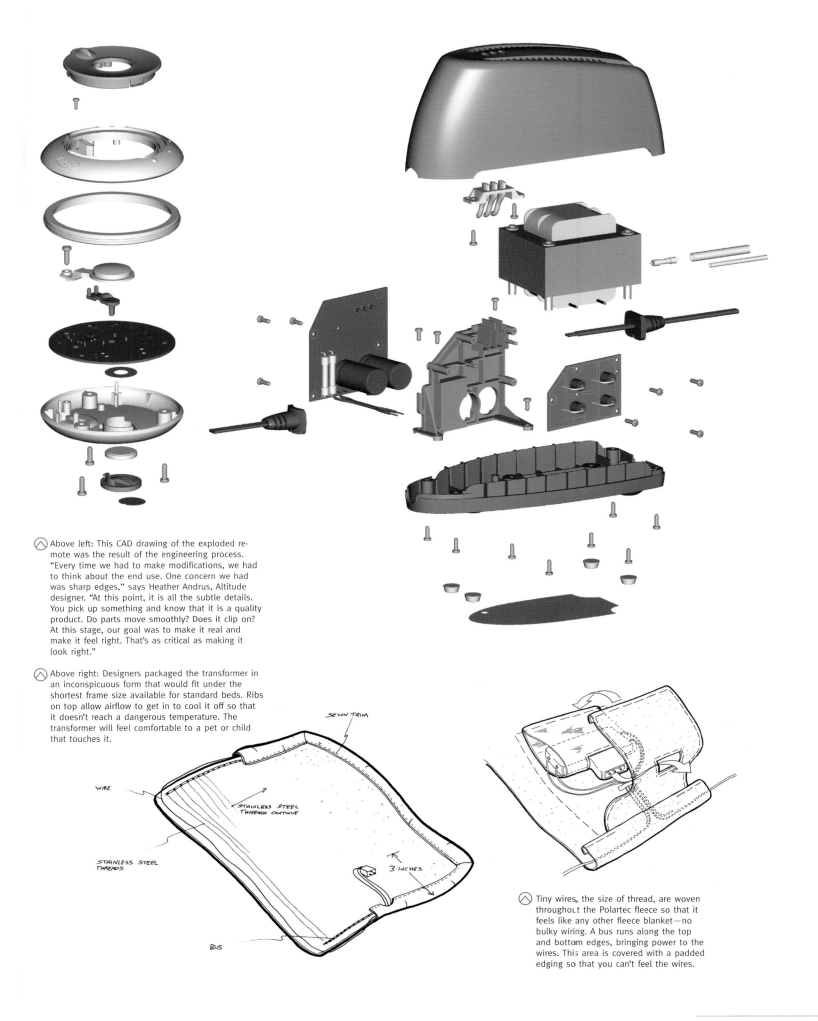

⬦ Above left: This CAD drawing of the exploded re-
mote was the result of the engineering process.
"Every time we had to make modifications, we had
to think about the end use. One concern we had
was sharp edges," says Heather Andrus, Altitude
designer. "At this point, it is all the subtle details.
You pick up something and know that it is a quality
product. Do parts move smoothly? Does it clip on?
At this stage, our goal was to make it real and
make it feel right. That's as critical as making it
look right."

⬦ Above right: Designers packaged the transformer in
an inconspicuous form that would fit under the
shortest frame size available for standard beds. Ribs
on top allow airflow to get in to cool it off so that
it doesn't reach a dangerous temperature. The
transformer will feel comfortable to a pet or child
that touches it.

SEWN TRIM

WIRE

STAINLESS STEEL
THREADS CONTINUE

STAINLESS STEEL
THREADS

3-INCHES

BUS

⬦ Tiny wires, the size of thread, are woven
throughout the Polartec fleece so that it
feels like any other fleece blanket—no
bulky wiring. A bus runs along the top
and bottom edges, bringing power to the
wires. This area is covered with a padded
edging so that you can't feel the wires.

Duet Fabric Care System

Doing the **laundry** has never topped **anyone's** list of favorite **household chores**, but with the advent of **Whirlpool's** Duet Fabric Care System, there **certainly** won't be as much grumbling about the **job**.

⬙ Early sketches homed in on the key requirements of the new fabric care system. It had to have the largest opening into the wash drum in the industry, the highest possible position for the wash drum to make loading and unloading simple, and a detergent dispenser that is robust and easy to use.

⬙ Bottom left: This rendering details the control, which is tailored for the person who wants to wash clothes as quickly as possible as well as for the person who wants to modify the process to exact personal preferences.

⬙ Bottom right: Designers' goals were to tie all the features desired into a consumer-friendly, easy-to-care-for, attractive, aesthetically pleasing design.

Consumers clamoring for a front-loading laundry system that provides greater water and energy efficiency, ease of use, and gentler handling of laundry items prompted Whirlpool's fabric care marketing department to propose the idea for the Whirlpool Duet Fabric Care System.

"One of the main challenges for this project, from a design perspective, was to coordinate all of the consumer requirements," says Mark Baldwin, category lead for Whirlpool Global Consumer Design. "These requirements included the largest opening into the wash drum in the industry, the highest possible position for the wash drum to make loading and unloading simple, and a detergent dispenser that is robust and easy to use. In addition, the desire was for a control tailored for both the person who wants to wash clothes as quickly as possible and the person who wants to modify the process to exact personal preferences. Finally, we had to tie all of these together in a consumer-friendly, easy-to-care-for, attractive aesthetic design."

During the first phase of the project, designers created hand sketches that tried to take into account not only all of the consumer requirements but also the manufacturing and marketing requirements. A cross-functional team was established right from the start that included design, marketing, engineering, and manufacturing. From there, using ProEngineer software, designers embarked on phase two, which included moving the sketches into the 3-D CAD system. "This allowed us to see very quickly if the direction we were working on was feasible or not," says Baldwin.

In phase three, designers went to consumers one on one to gather specific feedback on several concepts. During the fourth phase, designers used the consumer input to further refine the concepts, narrowing the field to two, both of which were built as mock-ups.

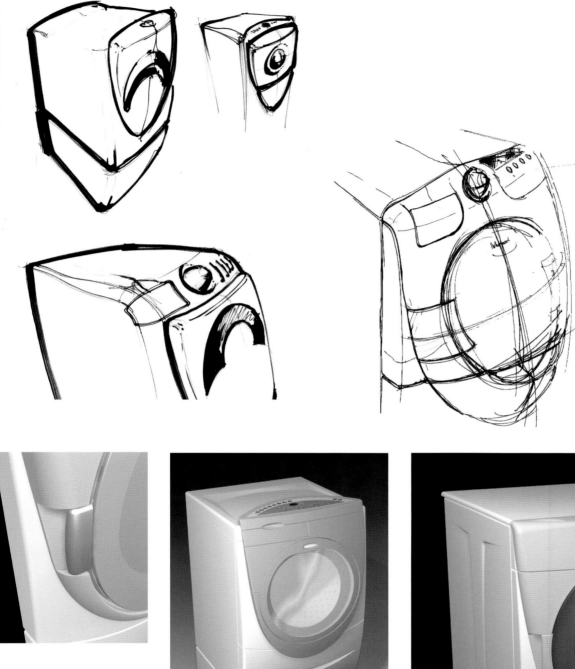

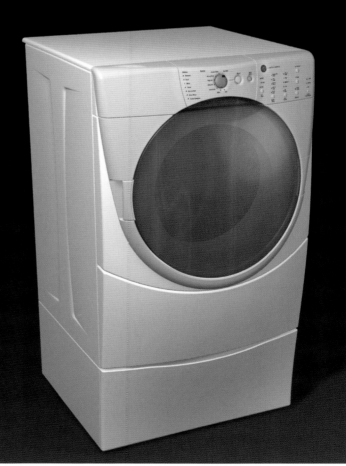

◇ Top: In early hand sketches, designers tried to take into account not only all of the consumer requirements but also the manufacturing and marketing requirements.

◇ Above and right: Designers wanted to ◇ get the sketches into their 3-D CAD system as soon as possible because it could tell them right away if what they were creating was feasible.

"At this point we were heavily involved with engineering to confirm that the design directions that we were proposing were feasible and manufacturable," says Baldwin. "Extensive usability studies were conducted at this and in other phases to ensure a consistent and pleasant experience for the consumer with the product."

In phase five, designers conducted quantitative design research with their mockups as well as competing products. At this point, they also researched color choices with consumers to determine the correct palette for the Duet system.

Throughout the latter portion of the project, designers continued to work closely with engineering to finalize extraneous details. The intent was to bring the design to fruition in the most efficient manner possible while following all of the details right into production.

"This product is unique in a number of ways," says Baldwin. "The design, forms, and colors help reinforce the whole concept of laundry—clean, fresh, and new. The combination of forms and color help give the user the feeling that the product is gentle on clothes and is a superior performer.

"To create a winning product takes more than just looking at the design aspects of a product; you must integrate holistically all of the disciplines, including engineering, manufacturing, human factors, marketing, and business. When all of these work together, you can achieve new milestones in design," says Baldwin.

"The main thing I learned from this project was that a dedicated team of people working together toward one goal and thinking outside of the box can break longstanding paradigms of design."

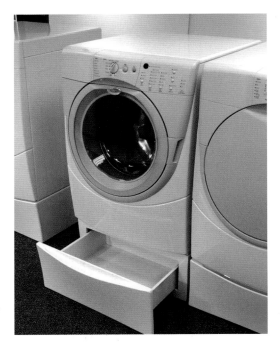

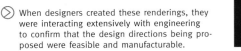

⊘ Designers worked directly with consumers and used their feedback to further refine the design. This rendering shows how the machine looks with an optional pedestal that raises the unit by 12 inches (30 cm) and functions as a storage area for detergent or other items.

⊗ When designers created these renderings, they were interacting extensively with engineering to confirm that the design directions being proposed were feasible and manufacturable.

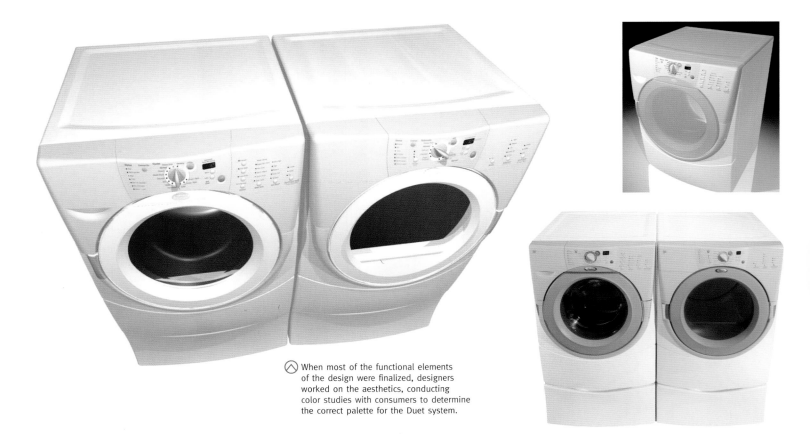

⊘ When most of the functional elements of the design were finalized, designers worked on the aesthetics, conducting color studies with consumers to determine the correct palette for the Duet system.

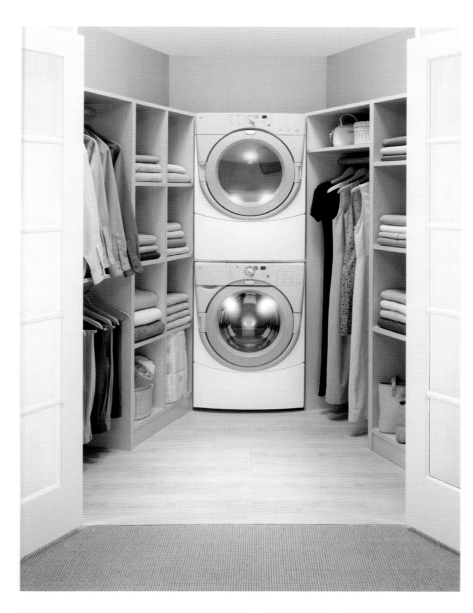

◁ The Duet system is stackable and designed to fit in with existing furnishings, whether in a laundry room or a closet.

▽ Bottom left: The cabinet, including the customizable front panel, is stamped steel with a combination of highly durable paint and porcelain finishes. The front body panels and the outer door are molded from engineering polymers with a fine texture. The control panel graphics are pad printed using high performance inks.

▽ Below: The Duet Fabric Care System not only looks good but is efficient, too. The washer uses 67 percent less water than conventional washers do—only 15.8 gallons (60 L) of water per load compared to the usual 40 to 45 gallons (150 to 170 L) in top loaders. It also uses 68 percent less energy than conventional washers, saving the consumer as much as $120 a year.

Photographs used with permission from Whirlpool Corporation.

Wolf Convection Oven Line Your **mission:** to design a complete line of **ovens** and cooktops from the **ground up**— a total of **18** products must be **designed** and **engineered** in a mere 16 **months**.

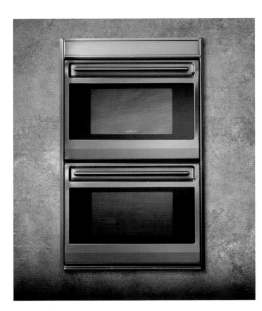

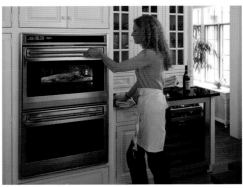

The Wolf line of convection ovens, owned by Sub-Zero, lives up to the quality and performance the Sub-Zero line of refrigeration is known for.

And these can't be just any ovens—you're designing this new line for a high-end manufacturer with high expectations. Are you up to the challenge?

Jerome Caruso was, when Sub-Zero Freezer Company, Inc., a maker of high-end refrigeration units, decided to enter the cookware business. Spurred by consumer demand—consumers loved their aesthetically and technically advanced Sub-Zero refrigeration units and wanted a complete Sub-Zero kitchen—Sub-Zero bought Wolf Appliance Company and hired Jerome Caruso Design, Inc., to design the new line from the ground up, with engineering assistance from Arthur D. Little in Boston. But this wasn't a new challenge for Caruso—over the previous 20 years he had almost singlehandedly designed everything in Sub-Zero's refrigeration line, so Sub-Zero felt confident trusting him with their new line.

Caruso began by thinking about how he would translate the qualities he already knew were important to Sub-Zero into the new line of cookware. Sub-Zero is known as a pioneer in built-in refrigeration, so Caruso examined how he could apply that to cooking appliances. "I believe sense of purpose is very important in maintaining a long-term success in a company's philosophy, and that was of course to blend or integrate the units into the kitchen," says Caruso. "I examined what was on the market, and of course I saw these flat designs with handles sticking out and a lack of integrity with the kitchen, so the first approach was to design the door and control panel."

From market surveys, Caruso already knew there would be two oven widths, a 30-inch (76 cm) and a 36-inch (91 cm) model. He also knew that an important objective for the ovens was to have a larger interior capacity than other ovens of the same width. To make that possible, Caruso decided to design a horizontal control panel and worked to fit the controls on the panel in a way that was both aesthetically appealing and intuitive to use. Caruso designed as many as 50 variations, which were presented on a computer to focus groups comprising consumers, kitchen designers, and architects. With input from these focus groups as well as from the team at Arthur D. Little, Caruso was able to finalize the layout.

Caruso also worked to implement another of his ideas for the control panel—having it revolve at the touch of a button to hide the display, further integrating the oven seamlessly into its environment. The idea was presented to focus groups, who responded enthusiastically, so Caruso and Arthur D. Little added this to the list of features they wanted to incorporate. Caruso also recessed the door handle to avoid projecting it into the room.

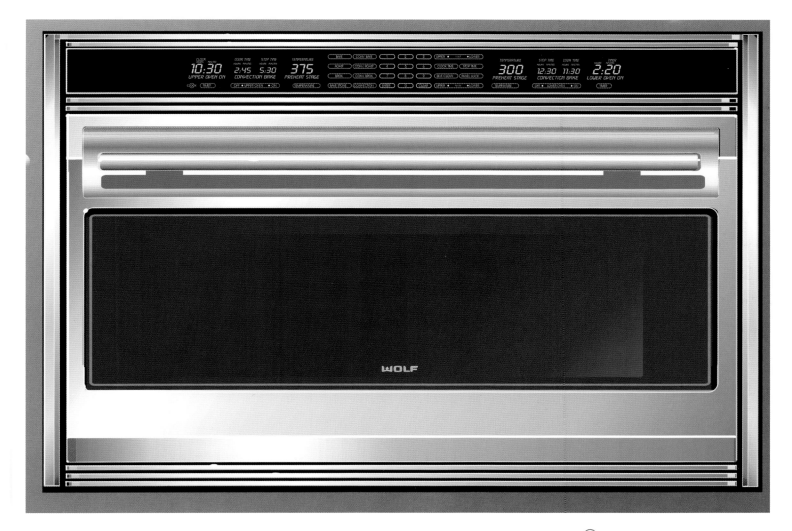

Control panels like this one at top were shown on a computer to consumer and commercial customers in order to test usability; the computer rendering at bottom shows the panel in the context of the entire oven.

Arthur D. Little had benchmarked the top European makes of oven—such as Gaggenau and Miele—with the objective of meeting or exceeding the functioning of these state-of-the-art ovens. The engineering team developed a new system of convection cooking that utilized two fans (mirroring the dual compressors in the Sub-Zero refrigeration units); the fans were controlled by a microprocessor chip that turned them on and off at intervals to keep the oven's temperature constant overall and consistent within the unit.

Meanwhile, Caruso worked on adding features to the ovens that would make them more ergonomic. When the oven door is opened, the bottom rack glides onto rails on the door and can be easily pulled out farther, making the handling of larger items easier and safer. The round door handles rotate in the user's hand when opening or closing the door. A hydraulic cylinder in the door creates a soft landing, even when the door is released abruptly. Caruso likens Sub-Zero's attention to detail to that of another client, Herman Miller: "Both have a way of focusing on details and things they believe matter in the marketplace. In both cases, ergonomics is a very important feature."

Since fit and finish is another important trademark of Sub-Zero that Caruso aimed to bring to the Wolf line of ovens, the oven door was designed so it could be inset, making it flush with the kitchen counters. The beveled, tinted glass on the door of all units has a graphic pattern that matches all the other Wolf products, giving continuity to the design of the line. The glass control panel is bonded on the back with capacity-switch film, tinted to change the color of the vacuum-fluorescent display to a proprietary blue-green. Feedback from additional focus groups, where CNC (Computerized Numerical Control) aluminum appearance models were presented, led Caruso to explore finishes beyond the traditional stainless steel. He added two finishes: platinum (wherein stainless steel is lightly sandblasted; the resulting finish doesn't show fingerprints) and carbon (a black, brushed stainless steel).

Manufacturing the Wolf line proved as challenging as designing it had been: When Sub-Zero was not able to buy a manufacturing plant that met their specifications, they built their own 350,000-square-foot (32,500 sq m) plant and hired a staff of 75 to get it up and running. Most of the parts and materials were sourced locally in Wisconsin; says Caruso, "If you visit the Sub-Zero plant, it's delightful, because you can see raw steel coming in one door and finished units going out the other." Sub-Zero envisioned their Wolf plant operating in the same way, with the same degree of quality control that such centralization allows.

This quality control was necessary for the manufacture of the Wolf line, many of whose parts were composed of deep-drawn, stamped stainless steel: "When you deep draw stainless steel, it's critical where you get that steel from to stretch it into these shapes," says Caruso. Among the biggest manufacturing challenges were the stamping of the recessed door handle and keeping both door and handle insulated and cool to the touch, even through the self-cleaning process, where temperatures can reach up to 900°F (482°C). Manufacturing the rotating panel proved challenging too, but the new staff was up to the task.

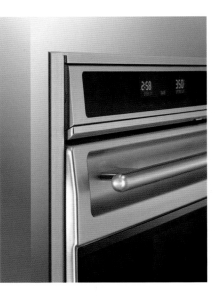

Details of one of the finished ovens show the revolving control panel in action. The control panel is a clamshell—two die-cast aluminum parts finished to match the finish of the oven. Also visible is the recessed handle of the oven; the handle rotates in the user's hand when he or she is opening and closing the oven door.

In the end, manufacturing of the line—which had expanded from the original goal of 18 to 25 products—began 28 months after design had begun. Caruso credits his accomplishment to two factors. In his eyes, the leanness of his operation was a boon: "One person was an advantage—I didn't have to discuss it with anybody else except my client, and an awful lot of decisions were made in a very short time on my computer under my direction only." His long relationship with his client, and the trust they put in him, not only saved time but also added to the quality of the final design. "I felt that what has been done for Sub-Zero throughout the years has been quite distinctive, and I thought it was necessary that this be a criterion for the ovens, that they not look like anybody else's," says Caruso. "I think they kept adding to it, to my surprise, in saying, go there, do it, and make it distinctive, and carry it to the top of the line."

⊘ A dual-fan convection system was invented for this line of ovens to maintain evenness of temperature. The interior is porcelainized to a rich blue—a proprietary color that contrasts with the speckled gray of many other self-cleaning ovens.

⊘ The bottom rack glides onto the door of the oven, making the handling of larger items easier and safer.

sōk Overflowing Bath A long, **hot soak** in a bath is one of life's **simple pleasures**, or so it would seem. In **practice**, we all know the **difficulty** of keeping **submerged** and warm,

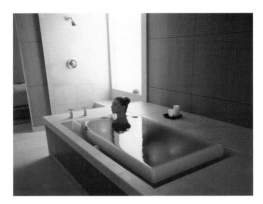

⊘ The sōk overflowing bath provides a relaxing alternative to a whirlpool.

and of keeping the bath at a constant temperature—not so simple, after all. That is, until the introduction of the sōk overflowing bath.

This reinvention of the soaking bath uses an overflow channel to recirculate water, creating a waterfall effect that soothes and engages the bather. While the water is recirculated, it is filtered and heated, so bathwater stays warm and clean; the recirculation also creates a natural effervescence that is more low-key than that created by a whirlpool.

"The initial idea of the bath came to us because, listening to our customers, we were hearing that people could not get a bath deep enough to keep them warm and to give them a really deep soak," says Carter Thomas of Kohler Co. Consumers also wanted a new experience—a bath that would be visually interesting, quiet, restful, and reminiscent of bathing outside. Adds Thomas, "Obviously, they didn't say, I want something that overflows into a channel and has color—we had to discern that." The bath also fit into Kohler's strategy of marketing the concept of a home spa—a dedicated area in the house similar to a home gym or home theater—to give new interest to an overlooked category and to provide interior designers with a more engaging product to offer their customers.

The team came up with a number of concepts for a soaking bath; the bath that mimicked some of the qualities of an infinity pool was the one the team chose to develop. After initial brainstorming, Kohler quickly went into crude modeling of the bath in cardboard and plywood. "We're a very hands-on organization where we go right to the three-dimensional very quickly, and then we may follow up with the computer work," says Thomas, "because ultimately the experience is what we're after here, and you really can't get that from the computer."

The rough prototypes were used to get an idea of what the size and shape of the bath would be, how many people it would hold comfortably, and how the depth felt. The data was adjusted and put into the computer model; then, the team built a rough model that would hold water. This model did not yet have pumps or motors; it was simply used so the team could evaluate the experience of the bath itself.

In evaluating this experience, the team had help from Kohler's human factors lab, which has access to a database of information about employees throughout the company. Employees were called and asked to spend half a day in the lab evaluating the bath. "The different sizes of people and the different volumes and

⊘ This model enabled users to evaluate the experience of sitting in the tub; Kohler was able to draw on its own employees to test the sōk, both without water and with it.

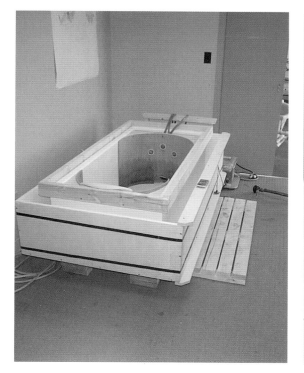

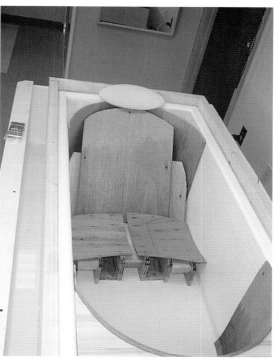

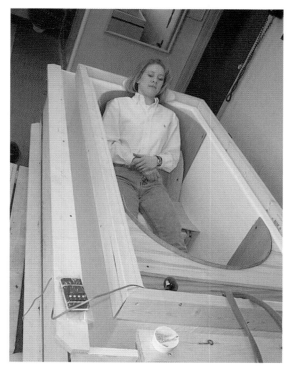

the way people feel in different vessels of water surrounding them can be quite interesting," says Thomas. The team put that feedback into a third set of models, which now had detailing close to what the team wanted for the final design as well as working electronics.

From this testing, the team learned that the speed with which bathers entered the bath was a big variable in the proper functioning of the channel overflow. If bathers got in quickly, there was a good chance that the resulting water displacement wouldn't be caught by the channel and instead would end up on the floor. "We tried to go wide and shallow with the overflow channel, but that just did not work," says Thomas. "We had to go deep and narrow to make sure the water would stay in the channel, go down to the bottom of the channel, curl up on itself, and then stay in there and not ramp back out." The overflow channel also affected another of the team's primary objectives: keeping the bath quiet. The height the water fell from the interior well into the overflow channel turned out to make a big difference in the noise level of the bath, so the team had to take that factor into account when refining the overflow channel.

Every change in a crucial element—the size of the pump, the volume of water contained in the bath, the size and shape of the overflow channel—affected all the others, and more adjustments had to be made to the rest of the design. As Thomas puts it, "These variables are all interdependent, and if you change one of them, the applecart really gets upset." At the same time, the design had to allow for a wide variation in one of the most crucial variables—the person using the bath, a factor that affects both the volume and the speed of the water displacement.

One of the biggest challenges facing the team was perfecting the manufacture of the product. The chosen material—fiberglass-reinforced plastic (commonly used in the manufacture of boats)—had many advantages: It allowed for high-strength, thin, cross-sectioned parts, which were necessary to allow room for the electrical components contained within the walls of the bath; it could be crafted with the precise geometrical detailing necessary to make the overflow channel work; and it allowed for a colorful and highly durable surface. There was one major drawback, however: The choice of this material meant Kohler would have to reinstitute manufacturing processes that they had not performed in years. The team was worried that it might be difficult to get right, especially on a product where precise manufacture was critical to success.

Because of Kohler's unfamiliarity with the material and the intricacy of the overflow channel mechanism, the team decided to set up an independent manufacturing cell at their headquarters in Wisconsin and do a small prototype run, much as the auto industry does. They brought up personnel from their manufacturing facility in Texas to assist. In doing so, they particularly wanted to prove two parts of the process—that the water would sheet out sharply and consistently into the overflow channel, and that the manufacture cycle time would be as planned. The manufacture is a complex, multistep process—the bathing well and the overflow channel are cured, demolded, and trimmed separately, and then bonded together with high-strength methacrylate structural adhesive and reinforced by support brackets—so it was critical that the timing of each step could be predicted accurately.

In the test run, the team found out that all the assumptions they had made in CAD modeling were correct—the prototypes did indeed work as envisioned, and they could be manufactured within the range of time the team had predicted. "Everyone on the team and also executive management breathed a huge sigh of relief," says Thomas. "We were confident about it before, but I think until you actually see that part come off a prototype line, you don't really know what you have." The prototypes—fewer than a half-dozen in all—were then sent to a packaging lab so packaging and shipping specifics could be determined.

The sōk overflowing bath was an immediate hit with consumers— while the sales team had projected a sales goal of just 100 units in the first seven months of release, at the end of that time they had sold quadruple that number, putting them close to surpassing their third-year sales projections. A year after its initial release, Kohler added chromatherapy, which allowed users to enhance their bathing experience with a variety of colored lights; this feature had been planned from the start, but the team didn't have time to incorporate it into the product's first incarnation.

⬡ An early version of the overflow channel (left) was too wide and shallow to enable the recirculation to work as the team had envisioned; the final version (right) was deeper and narrower.

⬡ The sōk was designed to be flexible enough to be easily incorporated in any style of room, whether traditional or contemporary.

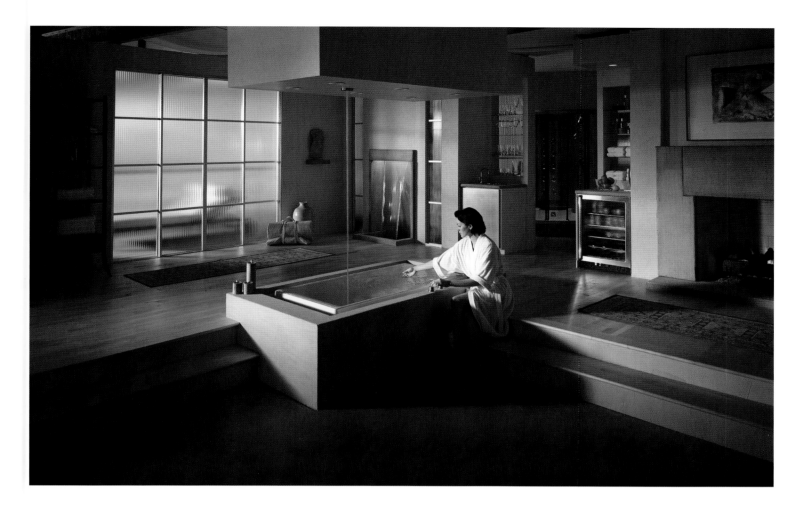

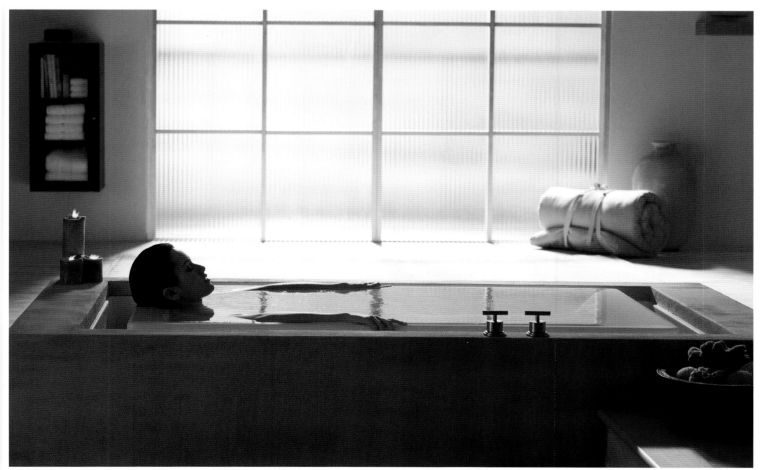

New Century Maytag Neptune Washer When the first version of the **Maytag Neptune** washer was **released** in 1997, it featured a **number** of progressive **design** and performance features:

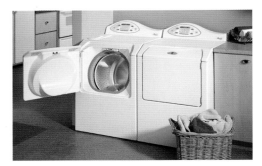

The New Century Maytag Neptune saves energy—while saving clothes from wear and tear and user guesswork.

It saved energy and cleaned clothes gently, and its patented cabinet design allowed better access and visibility into the units.

Nevertheless, the original design still featured mainstream elements such as a control panel with pushbuttons and a timer. When it came time to redesign the washer—in a version dubbed the New Century Neptune—Maytag knew there was room for improvement. Says Steve Schober, manager of industrial design, laundry, for Maytag, "We realized we needed to make sure that we were providing the user with enough information; we wanted to do better for consumers in terms of giving them what they needed to understand the complexities of the machine, and one way would be the control system." Testing revealed that users didn't like that the unit itself didn't feature instructions on how to do laundry and that they had to rely on the user pamphlet or their box of detergent for help. "With the New Century Neptune, the goal was to provide users with a lot more comprehensive information at the touch of their fingers," says Schober.

The user interface team—which consisted of representatives from research and development, marketing, product testing, survey research, service, and industrial design—brainstormed ways that a redesigned control screen could benefit users. They used Macromedia Director to test various concepts before deciding to develop a touchscreen that would allow users to touch the letter their stain began with, find the stain, and select it. This feature, called the "Stain Brain," would include 55 kinds of stain that the washer would be programmed to handle. Owners would also be able to customize the settings to include "Favorites": types of laundry loads they did often.

The overall goal of the redesign was to incorporate these new features and maximize consumer appeal while maintaining the integrity of the design. Since the new controls took up much less space in the control console, Schober and his team were given more latitude with its shape than they'd had in the previous model.

Schober began sketching ideas for a reshaped panel. Previously, Maytag's design of the Admiral had featured a wave shape that began in the washer's fascia and that continued to the dryer; says Schober, "We actually found out that it caused a little bit of a boost in sales of the dryers, because people wanted the matching dryer." This fact, along with Maytag's goal of developing laundry systems that could be moved out of the basement and into a family's living space, informed the design team's earliest sketches of the New Century model. Other areas that received attention in the sketches included the shape of the door and of the detergent dispenser. Another early concept for the design was eliminating the traditional back panel for the control system, instead placing the controls on the door of the machine.

△ Top right: This early sketch for the Neptune featured the flow the Maytag team was looking for; however, that the design limited the flexibility of placement—the washer would have to be to the left of the dryer for the design to work—was seen as a drawback, and the idea wasn't pursued.

△ Top left: An early concept sketch of the control panel.

△ Above: To address internal concerns that a dip in the back panel of the washer might not be desirable to consumers trying to hide flaws in their laundry area, this playful sketch imagines a vase in that spot.

▷ Right: These more refined computer illustrations show the wavelike shape of the control panel as well as the reshaping of the detergent dispenser.

The team chose four early concepts to develop and fashioned appearance models out of existing Neptune models that they modified with carved, primed, and painted Styrofoam; they used Bondo putty to reshape the door handle. The models were presented internally and to consumers; consumers rejected the model with the controls on the door as a bit too progressive but liked the wave shapes of the other consoles. They also approved of the new door design, which featured a swelled handle on the top that both carried out the flowing design of the control panel and allowed the door to be reversible. Based on the consumer research as well as internal feedback, the team chose to explore a snail-shaped control panel as well as a back panel that flowed in an arc from the washer to the dryer. "The idea is that you could set a bunch of them together in a store, or just two together, and show a bit more of the dynamics of the design and a more sweeping, flowing feeling than a plain rectangular box has," says Schober.

The design team began rethinking the shape and configuration of the control panel with this snail shape, with a smaller screen, in mind. Complicating matters was the fact that two versions of the Neptune were planned—a higher-priced version with an LCD control panel and a lower-priced version with an LED control panel. Says Schober of the LED control panel design, "That posed quite a few more problems from a design standpoint. We had to have so many functions—as many functions as we had on regular rotary knob controlled or pushbutton controlled units—that it was hard to fit everything into the small area." Designing for the LCD control panel was equally challenging, but for different reasons. While Schober had originally envisioned the LCD display screens to feature wavy lines that mirrored the wavy lines of the control panel and door, the low resolution of the LCD screen restricted him to straight lines. He envisioned color in the LCD, as well as movies that showed the washing action, but those ideas were ultimately too expensive. One new feature that did make the cut was a display showing the number of minutes left in the cycle; no longer would users have to squint at a pointer on a dial and try to guess how far they were into a cycle.

According to Schober, no fewer than 50 layouts of the control panel were presented to the interface group, which evaluated both form and content of the screens. Usability was closely scrutinized; even the wording used on the interface had to be changed due to copyright issues.

Another area of the unit that was redesigned for both visual and practical reasons was the detergent dispenser, which was reshaped to reflect the waves and swells of the control panel and the door. User testing had shown that the dispenser lid on the original model was difficult to open, particularly as users often opened the lid with their left hands. The team attempted to address this with a spring-loaded lid, but users weren't impressed by this feature, so the team instead opted for a simpler solution, restyling the lid with a better grip area.

⊘ Top: This early model features a square control panel; internally, the team decided that the square panel wasn't big enough—especially as the same design had to work for the LED control panel, which required more space—and that it didn't complement the flowing lines of the design.

⊘ Middle and bottom: These early appearance models were presented both internally and to consumers.

⊘ Left: When designing the Neptune's LCD display, the designers had to map out a complicated array of controls. Some early designs featured wavy lines in the display, to carry out the organic lines of the washer, but the design was constrained by the limits of the low-resolution LCD screen. In the final design for the LCD display, the waves were replaced with straight lines.

⊘ Right: An image of the LCD screen in its final form.

⊘ These final versions of the LCD (top) and LED (middle and bottom) control panels show the design team's attention to detail in following through on the organic lines of the rest of the washer, even in the button design and layout.

⊘ The medallions featured on the washer were designed to mirror the shape of the control panel.

The medallion on the door panel was redesigned to reflect the shape of the control panel, and a new medallion was created for the control console. Says Schober, "I got some ribbing for this from engineering, who tries to cut every penny out of the unit that they can, but it really was something that was favorable to the consumer."

The new control panel was designed to lock into the plastic console, as the conventional version had; the only difference was that the new version had fewer parts to snap in, thus simplifying manufacture. The ease of assembly that had been designed into the newer Neptune meant it was easier to service too; repair personnel could easily unscrew and take apart the control panel when needed. In the end, while the Maytag team added innumerable features to the New Century Neptune, the engineering and design incurred no additional factory costs.

By designing a washer with both beauty and brains, Maytag was able to maintain its position as leader of the high-end laundry category. But Maytag refuses to rest on its laurels: A redesign of the New Century Neptune is already in the works.

Birkenstock Footprints: The Architect Collection

When **fuseproject**, a San Francisco **design** studio, created a **"learning shoe"** for the "Design Afoot" show

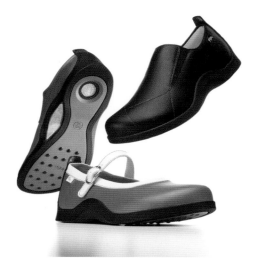

Designers paid homage to Birkenstock's history of green design and quality manufacturing by creating "branded windows." These clear, biodegradable windows reveal the interior of the shoe and allow a peek at the sole's cork-latex technology.

Opposite top left: This is the concept shoe that started it all. Created by fuseproject for the San Francisco Museum of Modern Art, this "learning" shoe is embedded with a chip that collects data about the ergonomic needs of the wearer. Birkenstock liked the idea and asked fuseproject to develop its Birkenstock Footprints: The Architect Collection.

Opposite top middle: The insoles, which are part of Birkenstock heritage, are made out of a mixture of cork and latex that affords comfort and creates a distinctive look. Designers started with this base and reshaped it in 3-D, adding new front and heel padding made of biodegradable gel.

Opposite top right and center: Designers sculpted the sole to lighten its mass and to create a more dynamic and modern silhouette. The overall result is a more fitted, sporty, and elegant shoe with a modern, urban attitude.

at the San Francisco Museum of Modern Art, it had no idea that it would catch the attention of Birkenstock, a company that had been manufacturing comfort shoes for 232 years.

Fuseproject's concept shoe "learns" its wearer's ergonomic needs through a reactive sole embedded with a chip that collects data about the wearer's feet and walking style. This information is stored on the chip and, when removed, can be used to customize the wearer's next model.

This kind of thinking appealed to Birkenstock, which tasked fuseproject with developing a new line—Footprints: The Architect Collection, which would bring their key brand attributes of comfort, green design, recyclability, and sustainable manufacturing to a new generation and specifically, appeal to the new urbanite consumer without betraying the brand's heritage.

"The primary challenge was to go beyond—basically invent—a new direction while staying true to the history and the principles of the brand," says Yves Behar, founder and principal of fuseproject. "We had to blend the existing technology and fit with new comfort features and a new design direction." Specifically, while the new line had to respect the traditional wide fit of the Birkenstock brand, Behar wanted a design that lightened the visual bulk of the shoe and made it distinctively different from Birkenstock's other styles. At the same time, designers had to ensure that the new assemblies and manufacturing techniques would be feasible within European Union and German labor and environmental standards.

The team started working on the shoe, "designing from the inside out, which is not the typical way that shoes are designed," Behar says. Throughout the process, designers asked, Can comfort be elegant and modern? Can green design go beyond the aesthetic clichés of green design?"

"Our approach to these challenges was to introduce innovation to the brand by adapting new recyclable technologies, creating new comfort features, and presenting these with a stylish, fashion-forward look," says Behar.

They began by reshaping the insole in 3-D and adding comfort and stabilizing features like the heel pad and front pad, using a renewable mixture of recycled cork and natural rubber lined with natural vegetable-died suede. A recessed, biodegradable polyurethane techno gel was integrated with the insole to provide added shock absorption, comfort, and stability.

Next, designers sculpted the sole to lighten its mass and to create a more dynamic and modern silhouette. "While the original wide fit of the Birkenstock offering was respected, the new design is fluidly sculpted around the insole, minimizing extra material and making the shoe appear more sleek and the mass visually lighter," says Behar.

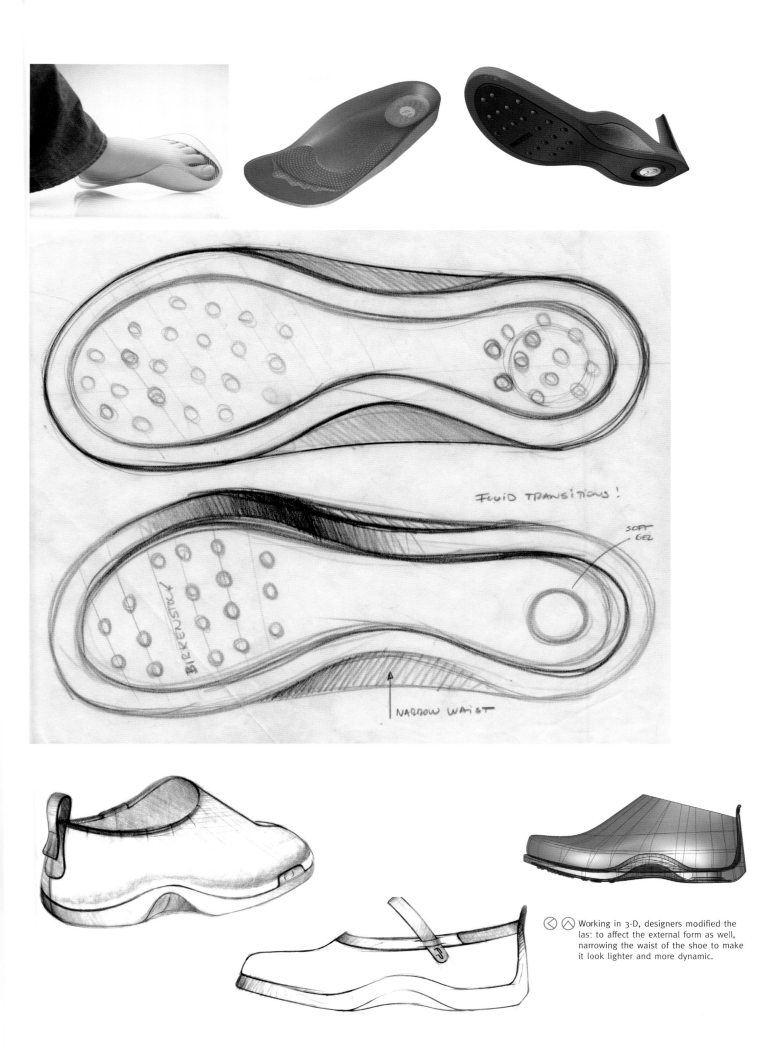

FLUID TRANSITIONS!

SOFT GEL

BIRKENSTOCK

NARROW WAIST

⊘ ⊘ Working in 3-D, designers modified the last to affect the external form as well, narrowing the waist of the shoe to make it look lighter and more dynamic.

Color scheme Fluid W

Designers mixed up materials, playing around with leathers, elastic, and neoprene. Color choices include a range of existing Birkenstock colors and new colors whose bright, affirmative look is also elegant.

Sole	details	stitch	lining	upper
PANTONE Cool Gray 8	PANTONE 360	PANTONE 360	FAYTEX 2000 PANTONE 579	PANTONE 579

Custom Color
Nappa Gold

Sole	details	stitch	lining	upper
PANTONE 445	PANTONE 445	PANTONE 445	FAYTEX 2000 PANTONE 467	PANTONE 467

Lana
Nappa Gold

Sole	details	stitch	lining	upper
WHITE	WHITE	PANTONE 200	FAYTEX 2000 PANTONE 200	PANTONE 200

Cherry
Nappa Gold

Sole	details	stitch	lining	upper
WHITE	WHITE	PANTONE 298	FAYTEX 2000 PANTONE 298	PANTONE 298

Custom Color
Nappa Gold

Color scheme Architect W

Sole	details	stitch	lining	upper
WHITE	PANTONE 200	PANTONE 200	FAYTEX 2000 PANTONE 200	PANTONE 467

Lana
Nappa Gold

Sole	details	stitch	lining	upper
PANTONE 5743	PANTONE 583	PANTONE 583	Dri-lex Aero Spacer 684 PANTONE 583	PANTONE 5757

Custom Color
Nappa Gold

Sole	details	stitch	lining	upper
WHITE	PANTONE 297S	PANTONE 297S	FAYTEX 2000 PANTONE 297S	PANTONE Cool Gray 9

Ramarro
Capretto Gold

Color scheme Fluid M

Sole	details	stitch	lining	upper
PANTONE 445	PANTONE 432	PANTONE 200	Dri-lex Aero Spacer 624 PANTONE 200	PANTONE 417

Rana
Nappa Gold

Sole	details	stitch	lining	upper
PANTONE 467	PANTONE 145	PANTONE 200	Dri-lex Aero Spacer 624 PANTONE 145	PANTONE 1615

Lombrico
Capretto Gold

Sole	details	stitch	lining	upper
PANTONE Cool Gray 8	PANTONE Cool Gray 8	PANTONE 200	Dri-lex Aero Spacer 624 PANTONE 200	PANTONE 467

Donnola
Nappa Gold

They modified the last to affect the form on the outside as well. "The main constraint is that Birkenstock is mainly a wide shoe that allows for as much room as possible for your foot and toes inside the shoe," says Behar. "We were able to design it to narrow the waist of the shoe and create aesthetics that broke it down in shape. The result is that it looked a lot lighter and a lot more dynamic."

For the uppers, designers created different end-use styles, some of which are quite simple and mix materials including leather, elastic, and neoprene. The look is comfortable but also streamlined. Color studies were done with the range of colors that Birkenstock had been using. "We went with new colors that are very modern but not considered completely loud. The result is a new brightness and affirmative look that the colors give to the brand while being somewhat elegant," says Behar.

Fuseproject's work didn't stop there. While the shoe was complete, they continued to work on the project, going so far as to develop its logo and the balance of the branding materials including merchandisers and point-of-purchase materials. They even orchestrated the product's launch.

From start to finish, the entire project took more than two years, but the wait was worth it. The new Birkenstock Footprints line has introduced a new generation of customers to the company's philosophy of green design and comfort. New customer comments have been along the lines of "I never thought I would be wearing Birkenstocks," while the pool of traditional Birkenstock customers, a loyal asset, have been reenergized by the company's innovations.

"I learned how powerful design can be with respect to supporting brand evolution and change," says Behar. "Even though we started from an industrial design standpoint, we carried it through all the other aspects of the Footprints brand. That is what makes fuseproject quite unusual. We integrate the brand strategy, and we are able to do a version of industrial design that includes and considers all of the aspects and all of the touchpoints that a consumer will experience about the brands we work with."

⊘ Top and middle: Unlike most product design studios, fuseproject did not end their involvement with Birkenstock Footprints with the final manufacturing designs; the firm also created the new line's logo and all of its branding. "The logo represents a fluid continuum, simply expressing the circular element of Birkenstock's ecological product and company principle," says Yves Behar, designer. The mark appears on all Footprints product, packaging, point-of-purchase, and collateral materials and serves to distinguish the Footprints line without alienating the Birkenstock tradition.

⊗ The display fuseproject created for the Birkenstock Footprints: The Architect Collection.

While the **expression** might be **"ladies first,"** in the world of **sports** apparel and **accessories**, the situation has often been **anything but**.

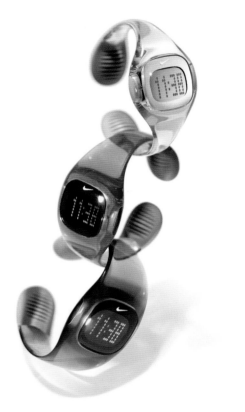

From top to bottom: The small, medium, and large versions of the Presto Digital Bracelet. The silhouette of each size is unique, both for aesthetic reasons and for practical ones—it makes it easier at the retail level for both clerks and customers to differentiate between sizes quickly.

In the past, Nike has been no different: As Scott Wilson, creative director for Nike's Timing and Monitoring business, observes, "In our timing business, we essentially have all men's watches. When we did a women's watch, we would take a men's watch, scale it down a little bit, color it a more feminine color, and say that's a women's watch." But then Nike introduced the Presto shoe—a revolutionary concept in athletic footwear. The Presto shoes came in sizes small, medium, and large rather than being sized numerically, and many styles had no laces. They were supremely comfortable, lightweight, and wearable.

When the Presto shoe became a $400 million phenomenon, Nike saw the opportunity to tap into a market hungry for products specifically designed for the active-life consumer. Nike decided to take the qualities that made the Presto shoe such a success (especially with women)—its retro yet futuristic styling and its lightweight and comfortable construction—and translate them into other categories to create a Presto collection. Wilson saw this as an opportunity to create an alternative choice for the active woman by designing a sport watch specifically for her. In addition to being comfortable, the watch needed to possess the same sense of duality as that of the original Presto shoe—a quality that made the shoe as appropriate for a night on the town as it was for the gym.

The timing division started brainstorming ideas for a Presto watch; they considered a wide variety of strap styles, including sweatbands and elastic cords, but had difficulty finding a strap that a wearer would forget she had on. Wilson realized that sunglasses aren't felt by their wearers and took further inspiration from the lightweight nylon Nike's own sunglasses are made of.

The team began exploring the notion of a concept that they called a C-bracelet, a bangle shaped like a C that would slip on and off easily. Initial sketches explored having the opening of the bracelet at any number of points on the wrist, and the team went pretty far in exploring a form factor where the opening of the bracelet was on the side of the wrist. But having the opening at the center underside of the wrist turned out to be the most logical choice—the two indentations of the wrist would serve as natural resting points for the ends of the bracelet, avoiding the wearer's carpal tunnel. This shape was also deemed more secure than having the opening on the side, which the team felt would more easily be caught on something.

For the ends of the bracelet, Wilson took another cue from eyewear and planned on rubberized fins to provide grip as well as a sport-influenced aesthetic. "Nike is a little sensitive to the f-word: which is fashion," says Wilson. "We know it's going to be bought by a lot of people as a fashion watch, but—and this goes for any Nike product—the designs that do the best are the ones that are

> Right: Two inspirations for the Presto Digital Bracelet: the Presto shoe and a lightweight pair of Nike sunglasses.

> Below: Early on, a variety of styles of C-bracelet were considered.

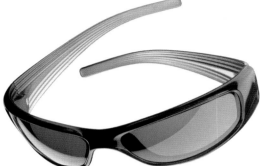

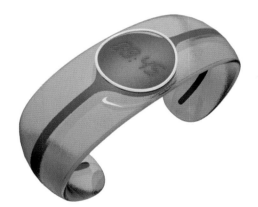

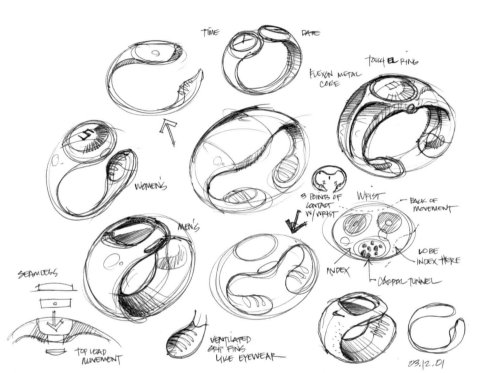

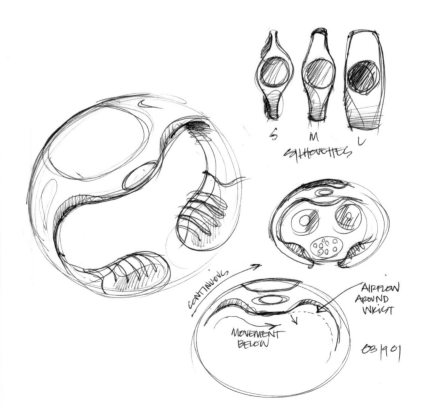

> One of the first ideas for a C-bracelet was to use a memory metal (called Flexon), which was being used in a new line of Nike eyewear. The idea was to cover with a polyurethane skin, but this was rejected because of its cost and because of the possibility of it popping out of the skin and injuring the wearer. But the team liked, and cultivated, the seamlessness and sleekness of this design.

> When Wilson realized that a bracelet with an opening at the bottom of the wrist would be well placed to avoid the wearer's carpal tunnel, he developed this more detailed sketch to explore the possibilities of the concept.

performance-inspired." To aid in the flow of air between the wrist and the bracelet—another performance-inspired detail—a bump on the underside of the watch face provides a third point of contact on the wrist.

Early in the process, the team had settled on a sleek, seamless style for the watch and contemplated a variety of materials that would aid in achieving that. Memory metal coated in polyurethane was considered but was rejected because of its cost; also, the metal was at risk for popping through the polyurethane. Amorphous, or liquid, metal would look sleek but would easily be shattered when overstressed. In the end, a custom polymer was chosen for the initial line; this polymer, as with that used in eyewear, responds to the user's body heat, allowing the watch to gradually mold to the user's body over time for a more comfortable fit. The polymer also allows for a wider array of colors and special styling—such as back-painting, hand decoration and embellishment, and laser etching—than polyurethane, allowing for easy customization.

In keeping with the simplicity and ease of use they wanted for the watch, the designers thought of combining a digital timepiece with an analog-style dial for adjustment. "The great thing about analog watches is that you really don't need a manual, because everybody knows how to adjust an analog watch," says Wilson. But Timex held a patent on the idea, so the designers worked instead on developing a digital watch that was simple and intuitive to use. The final model features a two-button interface: The button on the left sets the watch to one of its three modes—time, date, and chronograph; the button on the right lights up the numerals and, when held down, changes the watch settings. With its scoreboard-inspired font and the odometer action of the numerals as they change, the watch face underlines the influence of sport on the bracelet.

⊗ A number of models were created to help the team determine the best size and shape for the watch. The black models in the back of this photo are wax printouts; the white models in the middle are SLS, which are sturdier than SLA models and can be flexed; the clear models in front are cast urethane, and the model front and center was a prototype made by Nike's vendor, Seiko.

⊗ The team also considered spring steel, but rejected it because it wasn't lightweight or aesthetically appropriate.

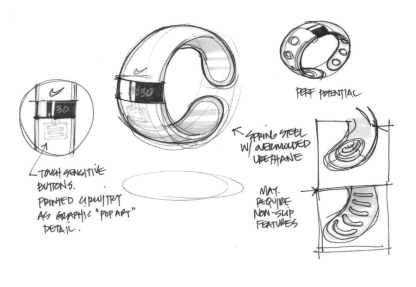

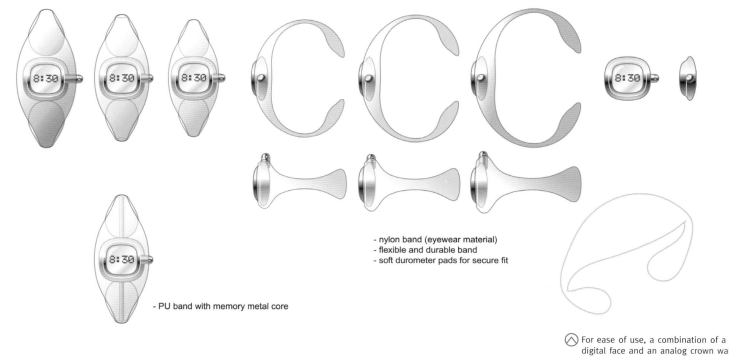

- nylon band (eyewear material)
- flexible and durable band
- soft durometer pads for secure fit

- PU band with memory metal core

⊗ For ease of use, a combination of a digital face and an analog crown was considered, but the idea was rejected because of patent issues.

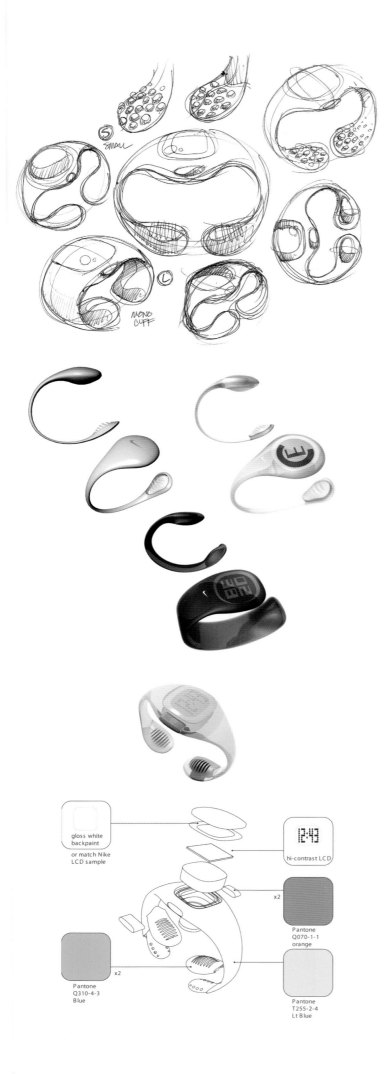

To determine the best sizes and shapes, the designers created wax models, then SLS models that had flexing properties similar to that of custom polymer used for the watch. Nike's sports research lab assisted by researching fit and sizing across the widest variety of people and providing the team with relevant sizing data. Finally, working prototypes were created by Nike's vendor, Seiko. Throughout the process, the Nike team eschewed focus groups, and even the feedback they received from their sales reps (a majority of whom are male, and thus not the primary market for this watch) proved unreliable. Instead, the team relied largely on Nike's consumer, immersive, and trend research—as well as their own design instincts—to shape the product.

Keeping the seamless styling of the watch proved to be one of the designers' biggest challenges, especially because Nike expects their watches to have a high degree of water resistance. To keep the watch's face seamless, the designers had originally planned for it to be loaded from the back, but in that way compromised water resistance. The designers then had to plan for front-loading while still keeping the sleek look they were shooting for—even for the back, which Wilson points out is sleeker than the backs of most watches. "You have to dive in deep. I think one of the things we do at Nike, especially in our tech group, is design inside out with the vendors, and we rearrange components and challenge construction techniques, and we look at how to shave a quarter-millimeter out of here and there," says Wilson. "It's a lot different than watch companies who just throw an Illustrator sketch over to Asia and get the watch made." The watch's seamlessness is further cultivated by the snap-fit assembly designed into it as well as by the hand-polishing each unit receives to eliminate parting lines.

This attention to detail has paid off for Nike: In an industry where selling 50,000 to 100,000 watches is considered phenomenal, over a million Presto digital bracelets were sold in its first year. Nike has continued to explore extensions to the line, including an analog version. Out of the 60 styles and 180 SKUs Nike has in the timing area, the Presto accounts for over 40 percent of their business. "You'd think, in an industry where everything's been done, that there would be no more open segments," says Wilson. "We realized that this is a big opportunity, and we've seen it with the success of the watch now. Women think, wow, that was designed for me."

Top: Various stylings were considered for the rubberized pads at the end of the watch, but in the end, a fin shape was chosen both because it satisfied the design team from an aesthetic standpoint and because it could be tooled seamlessly.

Middle: Further studies of the concept of a bracelet with an opening on the side of the wrist rather than underneath it; the illustration [above left] is a form factor study, while the illustrations [above right and left] are the male and female versions. While the team felt this concept had a distinctive Nike style, they were concerned that it wouldn't be as secure on the wrist as it would be if the opening were underneath the wrist.

An exploded view of the near-to-final watch. The construction allows for a wide array of color combinations; colors can be specified to match colors in other areas of the Presto line.

gloss white backpaint or match Nike LCD sample

hi-contrast LCD

12:43

x2

Pantone Q070-1-1 orange

x2

Pantone Q310-4-3 Blue

Pantone T255-2-4 Lt Blue

First Years Comfort Care Baby Products Designed in the face of **daunting** challenges, the **First Years** Comfort Care product line features the **easiest-to-use**, safest, and most **innovative** baby care **products** on the market, **combining** adult and **infant ergonomics** in a single shape.

"Baby care is stressful, especially for first-time parents who are afraid of hurting their newborn. Tiny fingernails need trimming. Soft skulls need washing. Delicate hair needs brushing. Early teething needs soothing. Baby's temperature needs to be taken many ways. Medicine needs to be delivered, and mucus needs to be removed. All these tasks need to be performed with tools that present a design paradox: They must be large enough for the parent to operate yet small enough to accommodate a baby," says Anthony Pannozzo, director of design, Herbst LaZar Bell, Inc.

The market and parents demanded a product like this one. Taking care of babies doesn't need to be made more difficult than it already is by clumsy, ill-made products. To be successful, designers knew that they had to deliver the features most needed by parents and childcare experts alike.

"Every parent of an infant or toddler knows how difficult it is to take their temperature, clip their nails, or remove mucus from a stuffy nose—in fact, research indicates that many parents dread this task," says Pannozzo. "That's why we shaped and sized these products for adults to hold securely and comfortably and why we used materials that ensure a steadfast, sure grip. The ease of use and the safety of these products was the number-one focus, because taking care of a baby can be much easier and calming for baby when a parent feels at ease."

Interestingly, it wasn't the products themselves that provided the biggest challenge to designers; it was the time frame they were given. The entire project was done inside of four weeks. "The

⊗ Oral hygiene starts before the first tooth comes in, and the Comfort Care Gum & Toothbrush Set covers oral needs from newborn to toddler. The set includes a fingertip toothbrush that slips comfortably on an adult finger to access hard-to-reach areas. The infant and toddler brushes are ergonomically designed to fit easily into adult hands, while toddlers will love the feature that shows them how much toothpaste to use on their toothbrush.

⊗ The early sketches all show placement of overmolding to ensure a sure grip on everything from the toothbrush to the hairbrush.

⊗ Below right: Early sketches of three toothbrushes that progress as the child grows place them in a suction cup base.

FROSTED TRANSLUCENT FINISH

TPE OVERMOLD GRIP

SUCTION CUP BASE IS USED FOR ALL 3 PRODUCTS THROUGH ORAL CARE SEQUENCE

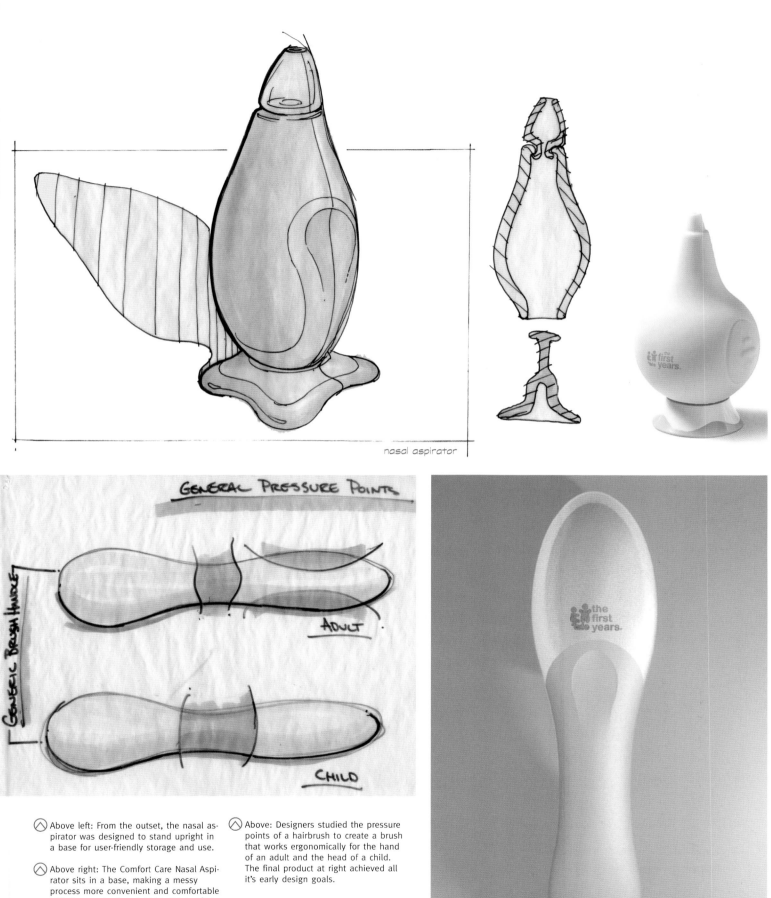

nasal aspirator

GENERAL PRESSURE POINTS

GENERIC BRUSH HANDLE

ADULT

CHILD

⊗ Above left: From the outset, the nasal aspirator was designed to stand upright in a base for user-friendly storage and use.

⊗ Above right: The Comfort Care Nasal Aspirator sits in a base, making a messy process more convenient and comfortable with its easy-to-rinse interior. Its comfort tip only reaches as far as it is comfortable for baby. Bulb grip guides on the side ensure the right compression and suction to make it easy on the baby.

⊗ Above: Designers studied the pressure points of a hairbrush to create a brush that works ergonomically for the hand of an adult and the head of a child. The final product at right achieved all it's early design goals.

toughest part of this project was definitely the time frame. We had to collect all the data we needed, generate ideas, and find the areas in which we could be innovate without being gimmicky," recalls Pannozzo.

Given the short timetable, designers had to condense their normal process and take shortcuts wherever they could without compromising the product. "We had to be far more subjective than objective in our research," says Pannozzo. As a result, while designers spoke with childcare experts to obtain input, they didn't go from city to city conducting focus groups. There was no time. Instead, the designers assigned to the project were those with children in the target age groups. "We didn't have a lot of time to observe parents and how they took care of their children, so in order to get what we needed, we made sure that the designers on the team had young children. We learned first-hand the frustrations parents had taking care of young children."

They solicited feedback from the team of designers/parents and worked with childcare experts to identify features that would aid parents in performing routine tasks. Many features, such as the

temperature alerts on the thermometers, the removable base of the nasal aspirator for inside cleaning, and the magnifying lens on the nail clippers, were the direct result of input from the designers themselves and childcare experts.

Next, the designers identified a list of parental anxieties rooted in the fear of hurting a child. "Then we brainstormed around them to find ways to reduce that anxiety and, as important, create the perception that the product would take away that anxiety," says Pannozzo.

They brainstormed with words first, then sketches. "We created a language for most of these products," he says. They also jumped into color studies right away, earlier than they usually do, to find wellness colors. "From the sketches, they took the designs into CAD. We rarely build hand models anymore," says Pannozzo. "Once we had scale and ergonomics correct, we sent our files to China.

"Early reports reveal that sales have been through the roof in just a few short weeks since market introduction, far exceeding the

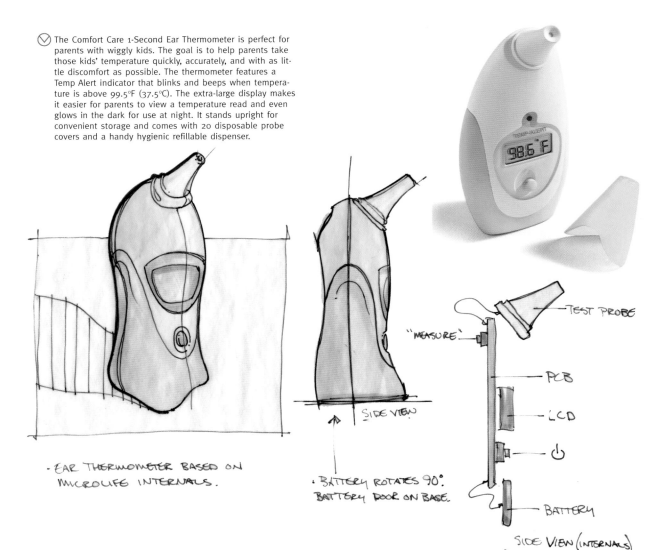

The Comfort Care 1-Second Ear Thermometer is perfect for parents with wiggly kids. The goal is to help parents take those kids' temperature quickly, accurately, and with as little discomfort as possible. The thermometer features a Temp Alert indicator that blinks and beeps when temperature is above 99.5°F (37.5°C). The extra-large display makes it easier for parents to view a temperature read and even glows in the dark for use at night. It stands upright for convenient storage and comes with 20 disposable probe covers and a handy hygienic refillable dispenser.

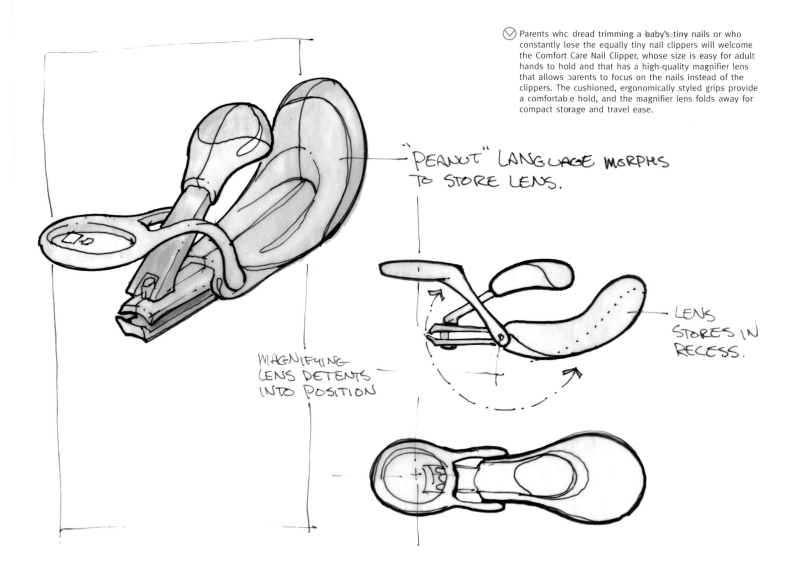

"PEANUT" LANGUAGE MORPHS TO STORE LENS.

MAGNIFYING LENS DETENTS INTO POSITION

LENS STORES IN RECESS.

client's initial projections," says Pannozzo. In the end, not only did the client benefit from the design, but Pannozzo and his team benefited, too, in an unexpected way. "I learned that we could do really good work in less time than I thought. I imagine any designer wants what feels like a sufficient amount of time to explore and solve problems, but after you've been doing this for 10 years, it is surprising what you are able to accomplish when you don't have the luxury of time and the ability to play by the book. You make decisions based on previous research efforts and previous projects when you did have the time.

"The First Years products were probably one of the best products we've ever done, and the irony is we did it without having the time frame we're accustomed to."

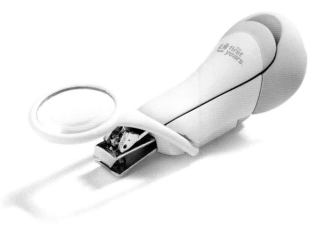

Perfect Portions Getting **infants and toddlers** to eat can be **among** the most rewarding and **frustrating** ventures a **parent** undertakes.

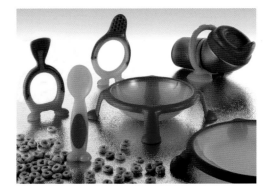

Interviews with parents helped designers accommodate their needs, such as products that were portable and easy to clean. Left to right: 3 Step Spoons, Friendly Feet Bowl, Helping Handlers Starter Cup, and Friendly Feet Plate.

Training infants and then toddlers to transition from liquids and purees to solid foods eaten by hand—and eventually with utensils—isn't as easy as it looks.

Dorel Design & Development (Safety 1st) asked Dot Studio to create a series of sketches for a line of infant-to-toddler tableware consisting of bowls, plates, and utensils. They liked what they saw; Wayne Marcus' sketches were engaging, and the client asked that the ideas be developed further—but not before they researched the interaction between parents and children in their homes during mealtime.

"Parents know the challenges of helping babies and small children learn the skills they need to eat on their own. They are also painfully aware of the problems associated with measuring, mixing, storing, pouring, and transporting their child's food and preparation gear," says Wayne Marcus, formerly the principal of Dot Studio, Inc., which designed the Perfect Portions product line, and now the design director at Product Ventures Ltd.

The researchers examined the types of feeding products that were used, how parents and children used the products and their preferences, dislikes, frustrations, and desires with respect to the feeding process. "Traditionally, the infant and toddler feeding product category has included basic items intended to function across broad age ranges," says Marcus. "This has resulted in products that may work well for one stage but not for another. The existing market presented an excellent opportunity for innovation."

The findings pinpointed four distinct feeding stages: birth to six months, when infants derive their nourishment primarily from liquids via a bottle or nursing; four to twelve months, when solids are introduced; six to eighteen months, when children begin learning to feed themselves; and twelve to thirty-six months, when toddlers begin using utensils.

The consensus was that the feeding products on the market failed to give children the features they need at each stage while addressing measuring, spilling, storage, portability, and other requirements of parents. Equally important, "Dorel wanted products that children would find endearing—that would be fun to see, touch, and use," says Marcus. "In addition, the products had to appeal to parents. Dorel sought a refreshing offering in a marketplace overcome with licensed cartoon characters and unappealing aesthetics.

"A rapid flurry of sketches was faxed back and forth during the following weeks as the two companies worked together to identify the balance of style, form, fun, and function that would result in a successful product line," Marcus adds. "From the very start of the project, Dorel's design management knew it wanted the personality and character of simplified human forms to be the unifying stylistic element of the product line. It was up to Dot

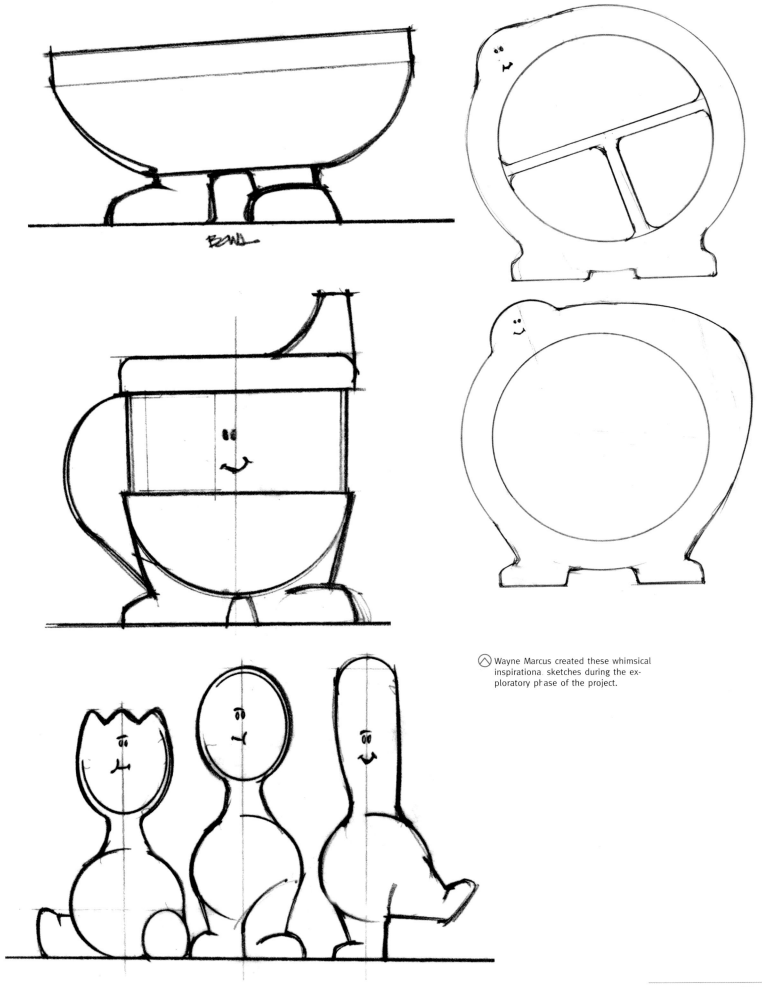

Wayne Marcus created these whimsical inspirational sketches during the exploratory phase of the project.

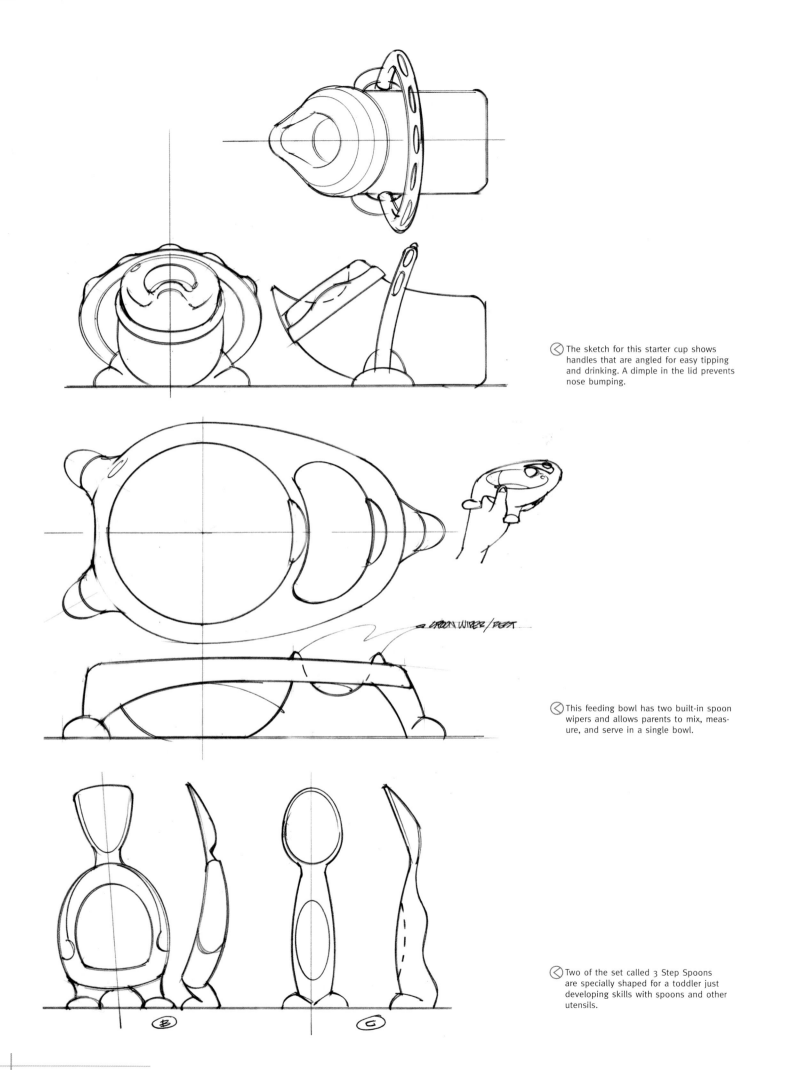

The sketch for this starter cup shows handles that are angled for easy tipping and drinking. A dimple in the lid prevents nose bumping.

This feeding bowl has two built-in spoon wipers and allows parents to mix, measure, and serve in a single bowl.

Two of the set called 3 Step Spoons are specially shaped for a toddler just developing skills with spoons and other utensils.

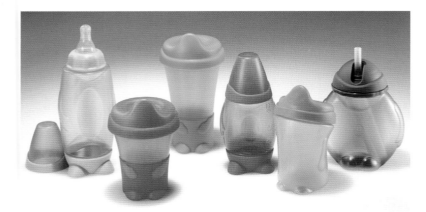

Studio to find the right balance of abstraction and literal interpretation that would work well with the functionality of these useful objects."

Dot Studio used quick clay and foam board mock-ups to transform their sketches into rough 3-D. Since everything from the utensils to the bowls, cups, and plates took on a whimsical personality and even body parts, designers explored several styles of legs, feet, arms, and tummies through this process until the right look and feel was captured.

At this time, designers had to decide where they would place overmolded thermoplastic elastomer on injection-molded polypropylene and blow-molded polyethylene to ensure a good grip in an often wet and slippery environment. Finally, they produced a series of orthographic drawings to document the designs for subsequent detailed product development, models, and prototypes. "With significant development support by Velocity Product Development and expert sculpting by Danebroch Studios, the animated character of Dot Studio's original sketches and orthographic drawings remained virtually intact throughout," says Marcus.

The completed line, finished just 11 months after the project was launched, boasts a rainbow of colors and eye-popping designs with real kid appeal and all the features weary parents want, too. They include easy-to-read measurement calibrations, built-in spoon rests, and easy-to-hold shapes, and are made of slip-resistant materials.

For Marcus, the most challenging aspect of this project was capturing the appropriate balance of fun and function. "Too much silliness or overt saccharine cuteness would overshadow and devalue the innovative and well-researched functional benefits of the product line. Conversely, an overly functional or clinical appearance would neither be relevant to the category nor possess much kid appeal.

"I was reminded of how clear client vision, fast decision making, and rapid, open dialog between client and consultant is critical for achieving success within a severely compressed schedule," he continues. "It was also personally rewarding to have had the opportunity to explore and harmonize so many shapes, textures, and combinations of materials."

In short, these utensils for the young at heart are just perfect.

⊘ Top: The Perfect Portions cups are designed to help children master the art of drinking from a cup. Used as a system, the product line transitions a child through the bottle-feeding stage, the sippy cup, and, finally, to drinking with a straw.

⊘ Second: Left to right: The Mix & Measure Bowl allows parents to measure ingredients and mix them in a single bowl with sturdy feet that won't slide or tip. A set of three Pack-a-Bowls makes it easy for parents to take a meal on the go.

⊘ Third: Left to right: Friendly Feet Plate, Jar Topper with Feeding Spoon, Second Chance Bowl.

⊘ Bottom: Left to right, back row: Friendly Fit Toddler Fork and Spoon, Stay Clean Travel Spoons, and Feeding Spoons (three sizes).

All photos Jay Carlson
All sketches Wayne Marcus

Evenflo Triumph Convetible Car Seat

The function of some products is **so vital** that few people give **much thought** to how they look. **Infant** car seats are a **good example**:

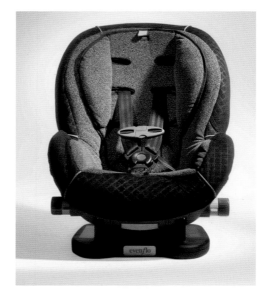

The Evenflo Triumph convertible car seat has a number of features that enhance ease of use for parents; designed to accommodate children from 5 to 40 pounds (2.2 to 18 kg), it converts from rear-facing for small children to front-facing for older children.

Parents are so focused on protecting their children that they have long taken for granted the minimal aesthetics of many of the products offered in this category. When Evenflo approached IDEO with the idea of developing a convertible car seat (as well as a booster seat), IDEO aimed to change that—to use aesthetics and brand identity, as well as increased usability, to distinguish the product in a category that seemed to overlook these qualities. That was the idea behind the development of the Evenflo Triumph convertible car seat.

IDEO began with extensive research conducted by their human factors lab. Annetta Papadopoulos, senior mechanical engineer at IDEO, describes the role of human factors research at her company: "We're not really trying to validate problems in the market per se, we're just looking for inspiration of what problems there are to solve, and maybe different ways to go about solving them." IDEO's human factors team observed parents buying and installing car seats and went to schools to watch parents loading and unloading their children. While this aspect of their research turned out to be touchier than anticipated—parents were suspicious of the strangers following them and observing their interactions with their children—it proved invaluable to IDEO in highlighting both parents' and children's relationships with car seats. The team was able to observe the difficulty most parents had installing car seats properly—a key safety issue. The team also observed that, to adjust the harnesses on some car seats—for instance, to allow extra room when the child was wearing a bulky coat—the car seats had to be completely uninstalled; parents often avoided the adjustment hassle by leaving the straps a little loose—another safety issue. Watching parents buying a car seat and then having to unpack it in the parking lot of the store just to fit it in their car spurred the designers to rethink the car seat's packaging.

Armed with this initial research, the design team began to create sketches with points of view that emphasized various aspects of the product. "We had this array of drawings going from very maternal at one end and moving through minimal, and then by the time we got to the other end it was very rugged and athletic," says Frank Friedman, senior industrial designer at IDEO. Reaction from parents to these illustrations, coupled with the work of the

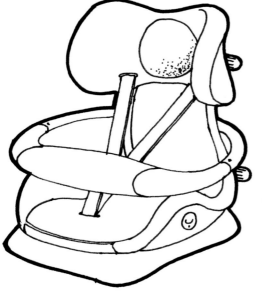

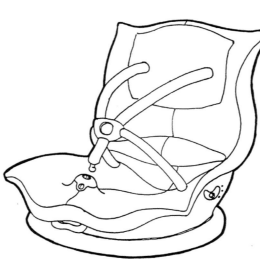

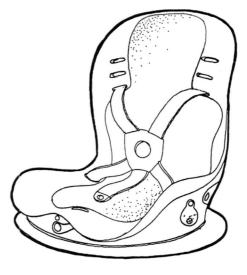

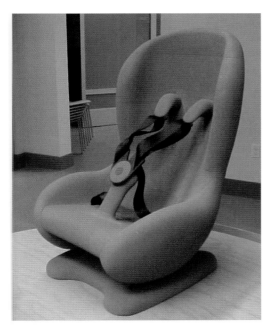

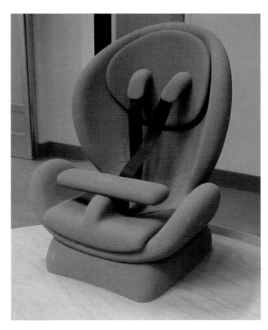

These sketches explored pushing various goals of the product further. The sketch at left is meant to envelop the child; the headrest wraps around the child's head and the body wraps up, cradling the child. The middle sketch emphasizes the comfort aspect of the product and has a more pillowlike quality. The sketch at right emphasizes giving users feedback as to whether the seat is latched in correctly and includes an LED display to help with that.

To explore aesthetic and functional directions, the IDEO team crafted these foam models. The model at top left had the enveloping look they wanted the car seat to have but was too large across the base; the top right model was closer to the scale they wanted. The third model at lower left was deemed more appropriate for the booster seat the IDEO team was also developing for Evenflo, since research revealed that older children preferred a more open configuration. All models featured a sleekly finished back, lower right. The team decided to pursue a merger of the best qualities of the models at top left and right.

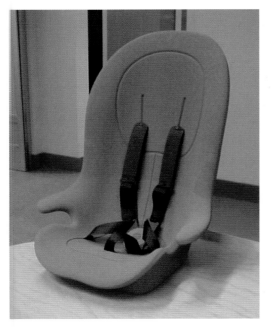

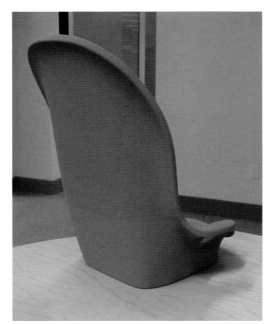

human factors lab, helped the team compile a list of what they called "big ideas" that would shape the car seat's design.

Obviously, the car seat had to keep the child safe, but it also had to make its safety apparent visually. Papadopoulos says, "Parents perceive that their children are quite fragile at that age, and that was a big element in how happy they would be with that seat." Another big idea was "comfort for contentment": Parents want their children to be comfortable so they will be contented. Since car seats are often improperly installed and used, the team wanted to simplify installation and to build in feedback to help parents know whether or not the seat was properly secured. The seat had to be large enough to hold a child but not so big that it took over the car. Visually, the designers aimed for a unique look and a strong brand identity, to distinguish it from other car seats. Finally, keeping in mind that the car seat would sometimes face backward in the vehicle, the designers wanted the outside of the unit to look as finished as the interior—something they knew would distinguish their car seat from others on the market, which often have exposed ribs on the back.

Feedback from the sketches helped the team prioritize the importance of these ideas: Safety and envelopment of the child were parents' first priority; comfort followed closely. High-tech features that were contemplated for the product—such as an LED display giving parents feedback on whether they had installed it correctly—were jettisoned because parents didn't see the need for them.

Armed with this information, the designers proceeded to create more refined sketches and foam models of concepts shaped by these ideas. All the models incorporated an idea the IDEO team knew would distinguish their car seat from the competition: The team decided to turn the traditional car seat structure inside out, internalizing the ribs and allowing a finished surface on the back of the seat. Not only would this improve the appearance of the seat, it also would prevent damage to the vehicle interior.

Three concepts were implemented. One version was deemed not enveloping enough for an infant and was instead considered appropriate for the booster seat IDEO was also developing for Even-flo. Another version had the enveloping feel the team was seeking but was larger across the base than they wanted; the third version was of the scale they wanted, but its appearance wasn't cozy enough. The designers chose to merge the best qualities of these two versions in the next iteration of modeling. Achieving a proper balance between a seat wide enough to be comfortable for a growing child but narrow enough to allow two car seats to fit side by side in the back seat (a necessary consideration, since children are now riding in car seats longer, so families are now more likely to include more than one child that is riding in a car seat) was a thorny problem for IDEO, requiring a number of iterations before the team was satisfied.

IDEO continued to explore additional features, many of which revolved around the harness system. The team worked to build flexibility into the system so that parents wouldn't have to uninstall the car seat simply to adjust the harness. They developed a system where a knob allows parents to easily tighten and loosen the harness, increasing both the child's safety and comfort and the parents' convenience. They also developed a memory feature that snaps the harness back to its original position after it has been loosened, minimizing the need for continual manual adjustment of straps. They considered a system that would use numbers to help parents track and remember settings for their child, or for any other children they might transport, but the team decided that this had little utility for the average parent. A detail that did make it into the final product was a system where colors were used to signal when the buckle was secured properly. The team continued to consider both lap bars and five-point harnesses, but in the end, Evenflo felt that the five-point harness system was lower-risk and perceived as safer by parents.

At this point in the process, IDEO presented the final model to Evenflo, who took over the final design and engineering. During the presentation, however, the IDEO team got a surprise: Evenflo commented that the seat was now too small. Evenflo went on to enlarge the seat; they also took over the engineering of the harness system and the reclining of the seat as well as the final choice of fabrics.

The result of all this effort was a car seat that is both easy to use and easy on the eyes, and that still meets or exceeds every safety standard—proof positive that safety and style can indeed coexist.

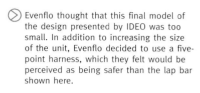

Evenflo thought that this final model of the design presented by IDEO was too small. In addition to increasing the size of the unit, Evenflo decided to use a five-point harness, which they felt would be perceived as being safer than the lap bar shown here.

This illustration shows a version of the design that uses numbers to help parents track the fIt of the harness; this idea was felt to be not useful enough for most parents.

East3 Thoughtcaster Are **video games** the cause of **attention disorders**, or could they be their **cure?**

The East3 Thoughtcaster at rest on its base station. Not only does the base station receive EEG signals from the helmet and transmit it to the computer software, it also serves as a safe and convenient place to keep the helmet when not in use.

A photo of the original NASA-developed technology in use by a child. Says Montague, "It was an interesting process to start with that laboratory set of wires and electronics and convert it to something that a kid would actually be willing to put on and parents would be willing to pay for."

While East3 doesn't claim their Thoughtcaster—which uses a video game interface to train children to concentrate—is a permanent cure for these disorders, it does believe its product can help minimize the problem and alleviate the need for treatment with drugs.

The Thoughtcaster system has three components: a wireless helmet, a base station, and computer software. The base station is connected to the computer, and the helmet, through a system of sensors, reads the child's electroencephalogram (EEG) and transmits the brainwaves to the base station, allowing the child to play the computer game hands free; when the child is able to concentrate on the game, he wins.

The technology used in the Thoughtcaster was originally developed by NASA's Langley Research Center to train pilots to extend their attention span. East3 saw the application this technology could have in aiding children with attention deficit disorders and licensed it for this purpose. They then approached BOLT, an industrial design and research firm based in Charlotte, North Carolina, and New York City to help them develop the product.

In its original form, the technology was bulky and laden with wires, and it required a trained technician to set up and use. BOLT's challenge was to develop a product suitable for the consumer market—wireless, easy to set up, compatible with a home computer (to which it would be attached), and, most of all, appealing both to its young users and their parents. East3 would provide electrical engineering and software expertise, while BOLT would research and design the product, with additional engineering assistance provided by its strategic partner, Spark Engineering.

Researching the target market was the first step in the product development process. The client was already in contact with doctors and other clinical organizations specializing in attention disorders, and through these venues had access to a sample of boys in the target age range (ages six to twelve) who were affected with attention issues. A team from BOLT went into the homes of over 30 of these boys and interviewed them and their parents. Since the technology requires systematic and repeated use to be effective, it had to appeal to the users—or as Monty Montague, principal of BOLT, says, "We wanted to make sure that we did something that at least wasn't uncool, and if possible, was cool, so they might actually want to wear it for a while and they might tolerate it after the 38th time." BOLT also videotaped and photographed the subjects' homes to better understand how the product might be integrated into its use environment.

The team knew that the final product would have to be some sort of headpiece, since the proprietary technology used sensors to pick up and transmit brainwaves from the scalp. As Montague points out, "The interesting thing about the heads of kids is that they're all over the map in terms of size and shape." BOLT's in-

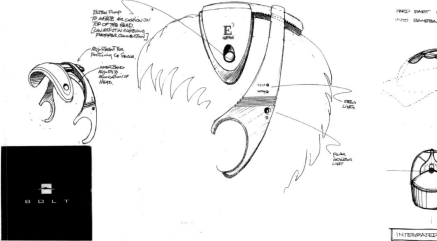

BUTTON PUMP
TO INFLATE AIR CUSHION ON
TOP OF THE HEAD.
(CAN ASSIST IN ACHIEVING
PROPER CONNECTION)

E³
GEMINI

ADJUSTMENT FOR
POSITIONING THE SENSOR

INNER BAND
ADJUSTS FOR
ELONGATION OF
HEAD.

STATUS
LIGHTS

POWER
INDICATOR
LIGHT

BOLT

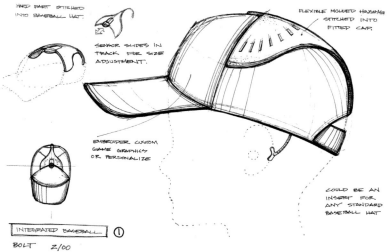

HARD PART STITCHED
INTO BASEBALL HAT.

FLEXIBLE MOLDED HOUSING
STITCHED INTO
FITTED CAP.

SENSOR SLIDES IN
TRACK FOR SIZE
ADJUSTMENT.

EMBROIDER CUSTOM
GAME GRAPHICS
OR PERSONALIZE

COULD BE AN
INSERT FOR
ANY STANDARD
BASEBALL HAT

INTEGRATED BASEBALL ①

BOLT 2/00

THIN, FLEXIBLE CONTOURED
SHELL. DOES NOT HAVE
THICKNESS LIKE A
BIKE HELMET (LOWER
PROFILE / FORM FIT)

VISOR PIVOTS TO
POSITION SENSOR

OPTIONAL SPEAKER ARM

USE SNAP IN PADS
TO ADJUST SIZE.

ADJUSTABLE
STRAP

BIKE HELMET

BOLT 2/00

SMALL CAP BILL

MOTO X / SKI GOGGLE
STRAP WITH CUSTOM
EMBROIDERY GRAPHICS
(DIFFERENT GAMES)

EAST3

BATTERY /
TRANSMITTER

GOGGLE / VISOR ⑬

BOLT 2/00

⊗ Above: Sketches of some of the f rst
concepts the BOLT team came up with,
including the earliest version of the hel-
met style that became the final design
for the Thoughtcaster.

⊗ An example of the research BOLT did on
children's head sizes.

90

house research department put together an anthropometric database of kids' head sizes. For the product to work properly, says Montague, "the sensors had to be located on a specific spot on the head, and that specific spot changes as the head grows—that is, the location of the spot relative to the shape of the head changes. We needed only specific dimensions of the head to work this thing out, so we collected those that we needed."

Armed with this research, the creative process began. The team started with roughly 20 concepts, and through internal and client review narrowed this group to six or eight concepts, which the team then developed into more detailed illustrations. BOLT took these illustrations back to the children and their parents for in-depth one-on-one interviews; they also did additional testing via focus groups.

BOLT's research helped the designers focus on what the end-user wanted. "We weren't trying to create our own visual statement," says Montague. "We were trying to think about what a young person might find appealing and come up with ideas that would meet that need, which is a tough thing to do."

BOLT's team also had to keep in mind the opinions of the parents, who would be paying for the product. Early designs that were considered included an earphone and a baseball cap, but in both cases, parents had reasons to resist the concepts. "You always get conflicting information, and we definitely had that," says Montague. "Some of the kids thought the baseball cap was great, but the parents said, 'Well, I'm not going to spend $900 for a baseball cap,' and that's what it was going to cost." The parents had other concerns about the earphone concept, according to Montague: "The earphone looked like it could fall off, and even though we felt confident that we could design it so that it would not fall off, parents were still nervous."

In the end, the helmet concept was deemed to best satisfy the needs of both parents and kids; it was sturdy and substantial enough to allay the fears of parents while still appealing to children. "It had a little bit of familiarity to the kids, a little bit of a bicycle helmet look to it, and that's why they liked it," says Montague. "And most of the kids who have this problem are males; it was kind of a warrior helmet look, a cool thing for a boy."

Based on this feedback, they narrowed the concept list to two and started to make foam models. These were taken back to the children, who evaluated the look, feel, and fit of the helmet. The team used ProE to make further refinements in the design and to create a rapid prototype.

Throughout the design process, engineering was being done concurrently. "A complex set of engineering issues had to be dealt with," says Montague. "We didn't want it to become this big thing, we wanted it to be svelte and to hug the head. We were able to move things around within the confines of the spaces of those yellow and blue plastic helmet pieces and tailor it to a fairly small, compact size."

Once the design team had selected the helmet concept, the choice of materials fell into place quickly. Since they knew the helmet had to be lightweight yet electronic, injection-molded construction was a given. The team explored a number of plastics and chose ABS plastic because they felt it would be strong

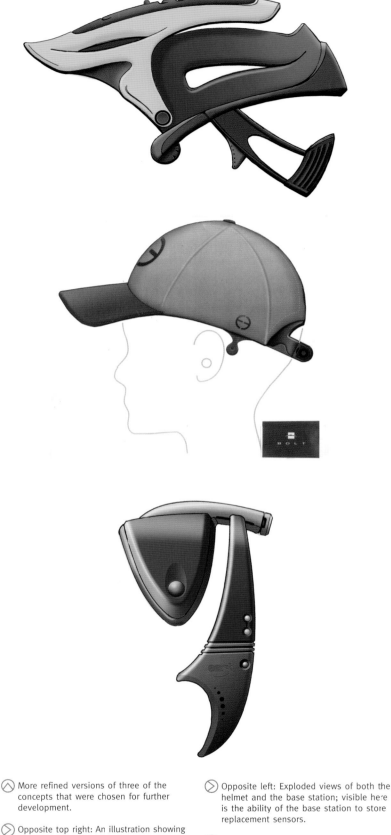

⌃ More refined versions of three of the concepts that were chosen for further development.

⌄ Opposite top right: An illustration showing where the three groups of sensors, consisting of seven filaments each, are placed on the scalp. While other neurofeedback systems use single-use sensors that rely on messy conductive gel applied by a technician, this proprietary system of sensors uses filaments that are similar to the tip of a felt pen; when sensors no longer provide the required signal strength, they can be replaced.

⌄ Opposite left: Exploded views of both the helmet and the base station; visible here is the ability of the base station to store replacement sensors.

⌄ Opposite bottom: An image comparing the CNC (Computerized Numerical Control) machine foam model—a process where a programmer used CAD data to program a machine tool to cut a model—(back) and the rapid prototype (middle) to the final product (front).

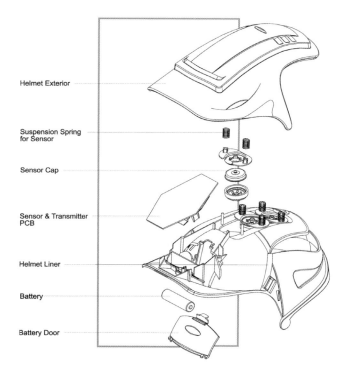

Helmet Exterior

Suspension Spring
for Sensor

Sensor Cap

Sensor & Transmitter
PCB

Helmet Liner

Battery

Battery Door

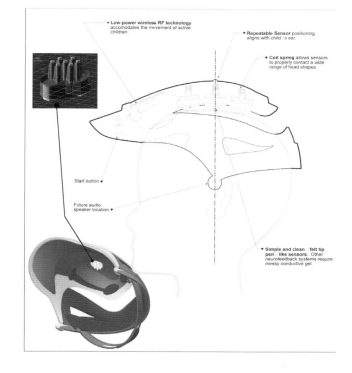

• Low-power wireless RF technology
accomodates the movement of active
children

• Repeatable Sensor positioning
aligns with child's ear.

• Coil spring allows sensors
to properly contact a wide
range of head shapes.

Start button •

Future audio
speaker location •

• Simple and clean felt tip
pen-like sensors. Other
neurofeedback systems require
messy conductive gel.

Base Station Lid

Extra Sensor
Storage
Compartment

LEDs

Outer

Shield

Receiver / Processor PCB

Bottom Housing

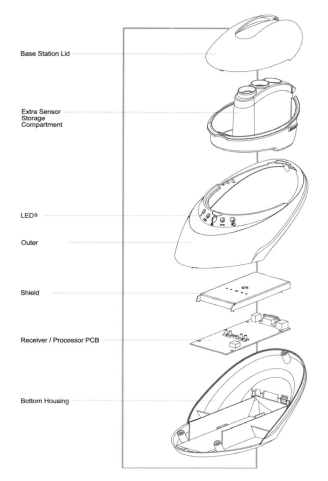

enough to withstand the rough treatment of its users. BOLT helped their client find a molder and went to Asia to supervise the toolmaker during the production process.

To address the issue of head size variation, BOLT designed an adjustable strap on the back of the helmet with a molded rubber grip on the back under the cranium and pads on the front and sides. On-screen prompts from the software alert the technician to make adjustments when necessary—the software is able to gauge this when it stops getting a reading from the helmet. Other ways to customize the helmet for various head sizes were explored—including removable Velcro pads, a strap that runs radially around the head, and an under-the-chin strap—but the final choice was the most comfortable and unobtrusive.

While the product was in final production, the client decided to reorient its marketing focus to clinics and schools rather than in the home. Though no official explanation was given to BOLT, Montague believes that the client recognized that for the product to work, a technician would need to make sure it was being used correctly and consistently. Montague thinks that their extensive end-user testing made this change almost irrelevant to the product design; BOLT had research that proved its user market approved of the product and could benefit from it, and that was all that mattered to the purchaser, whether parent or clinic.

In the end, BOLT was not only able to design, engineer, and test a complex product in 10 months, it also was able to get its young audience excited by something that was good for them—no small feat indeed, as any parent can attest.

Joey Clamp & Cutter The process of **cutting and clamping** a newborn's **umbilical** cord has **changed** very little since the **introduction** of the Hollister clamp years and years **ago**.

The Joey Clamp & Cutter comes in a variety of colors, which aids in identifying infants in multiple births and provides a cute keepsake for parents to save in their baby book.

This narrow device, with its hard-to-handle alligator-type clamps, requires disposable surgical cutting tools to use. It also requires more than one hand to complete the procedure while safely supporting a wet, slippery, and wiggling infant. Putting it on can be time-consuming, particularly at a multiple birth where time is critical. There's also the concern of blood spray. The Hollister clamp can produce elevated pressures inside the umbilical cord that can result in a biohazardous blood spray when the cord is cut. Finally, the baby goes home with the Hollister clamp in place until it falls off with the umbilical remnant and is discarded along with the diapers.

Dr. Richard Watson, chief medical director of Maternus Medical, figured the time was right for something better. He invented the Joey Clamp & Cutter, which he took to Design Edge, Inc., to design. "It is a single, integrated device that replaced three separate instruments required for cutting and clamping a newborn's umbilical cord. It performs both the surgical cutting and clamping procedure in one single-handed action while attaching a friendly koala character to clamp the newborn's navel," says Philip Leung, senior industrial designer at Design Edge. Moreover, it is simple enough for physicians, midwives, and even unskilled birthing partners who participate in the birthing experience to use.

"The client, a new obstetric products company, saw an opportunity to resolve these issues with a cost-effective, ergonomically feasible, and visually captivating design. This new company's objective is to use effective design to not only meet the cost and functional needs of physicians and hospitals but to also address and enhance the experience of the newborn child and its family," adds Leung. "Using an outside design consultancy instead of a specialized medical design consultancy gave us a unique perspective and a fresh new look at things. Building the product not only around the doctor but the end user, the newborn, allowed us to create a strong, recognizable identity and brand for the client."

As work on the project began at Design Edge, designers proceeded with two mandates from Watson. The device had to be an improvement in terms of safety and ease of operation, and it needed to be mom friendly. With their charter, designers embarked on their own research, performing competitive product searches and subject matter searches, watching nursing videos, reading delivery brochures, and reviewing literature to ascertain the pros and cons of the new device versus the commonly used Hollister clamp.

Opposite: Dozens of concept ideas came out of the first round of sketches.

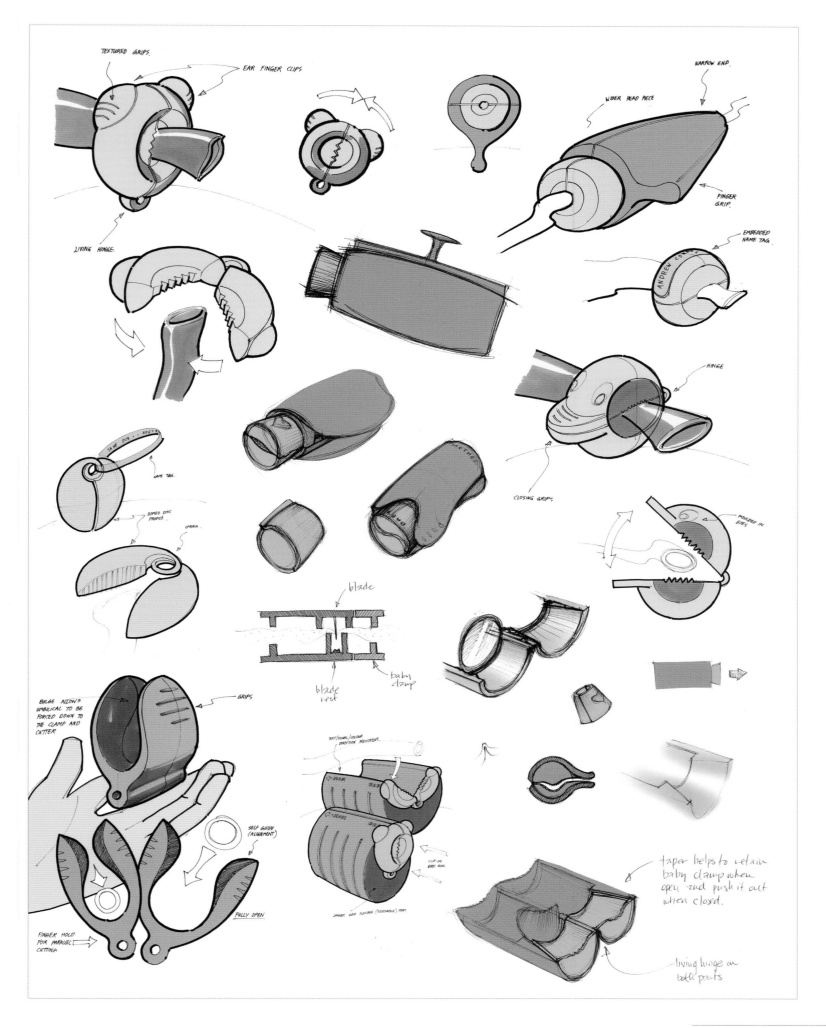

TEXTURED GRIPS.

EAR FINGER CLIPS

NARROW END.

WIDER HEAD PIECE

FINGER GRIP.

LIVING HINGE.

EMBEDDED NAME TAG

ANDREW CORK

HINGE

NAME TAG.

DOMED DISC PROFILE

SPRING

CLOSING GRIPS.

MOULDED IN EYES

blade

baby clamp

blade rest

BULGE ALLOWS UMBILICAL TO BE FORCED DOWN TO THE CLAMP AND CUTTER

GRIPS

SELF GUIDE (ALIGNMENT)

TEXT/VISUAL/COLOUR DIRECTION INDICATOR

CLIP-ON BABY RING

taper helps to retain baby clamp when open and push it out when closed.

FINGER MOLD FOR PARALLEL CUTTING

PULLY OPEN

LARGER GRIP FLEXIBLE (SQUISABLE) FOAM

living hinge on both parts

Next, they did usability studies. "We created several rough mock-ups to simulate the size and action of an all-in-one clamp and cutter system to create a use model. How would it be held? How much pressure would be needed to close? How would you separate the clamp? Would it self-eject? and so on," says Leung. Designers performed end-user tests using a weighted baby doll with a rope as its umbilical cord. They quickly concluded that the device had to be simple, straightforward, and require just one hand. "We delivered dozens of babies at Design Edge," says Leung of their testing, "and created a number of prototypes to get a sense of how users would navigate their way around the umbilical cord, newborn, and clamp. The challenge was to cater to just about every way in which a newborn can be delivered."

The testing led to brainstorming sessions, both internal and with the client, that inspired idea sketches for how the device might work. Eventually, as sketches for the belly clamp evolved, the one part of the system the baby would keep became more oval and took on the face of a smiling baby koala—a joey. The designers continued to refine the sketches, developing and expanding on earlier ideas in detailed sketches and CAD.

Now came the hard part: narrowing the directions. They continued to build in more detail, working in Alias and ProE for prototyping, and ultimately readied the selected concept to go into mechanical design by refining the design based on tooling issues. They made more prototypes, and the client finalized the choice. Now that the design was final, the Joey was submitted it for Food and Drug Administration (FDA) and patent approvals.

"The Joey clamp design affords an unexpected emotive element to an otherwise clinical device," says Leung. Moreover, it "is proactive; it reduced by five times blood exposures in the delivery environment by shielding the blood spray inside the housing of the maternal clamp."

What advice would Leung give to design students? "Question the obvious! Not only were we able to satisfy the needs of the doctor but also to enhance the experience of the parents....The project created unique challenges that only a lot of user testing and mechanical testing were able to solve," he adds. "The Joey functions better than previously accepted systems and methods. It allows more people of varying experience to use it safely. It also happens to make people smile."

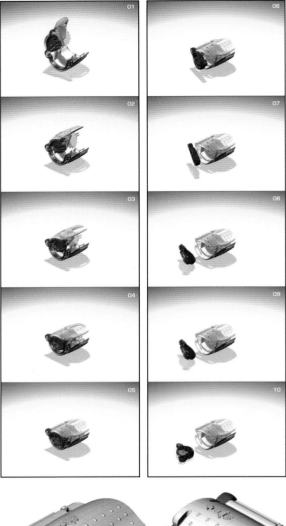

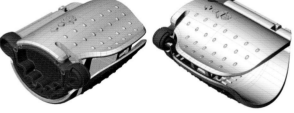

⊗ Top: This animation sequence shows the motion and closure steps of the final design.

⊗ Above: The final direction was chosen and then created as a 3-D shaded wireframe model.

⊗ A 2-D drawing made from the 3-D database submitted for FDA approval.

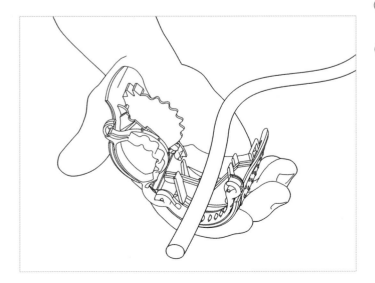

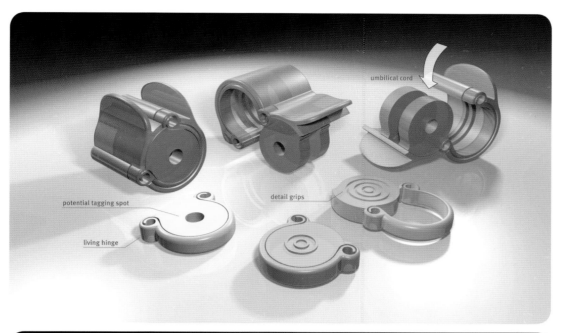

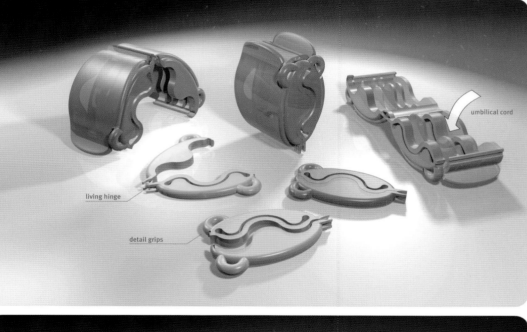

User testing consisted of designers employing a weighted baby doll with a rope as its umbilical card and a mocked-up clamp.

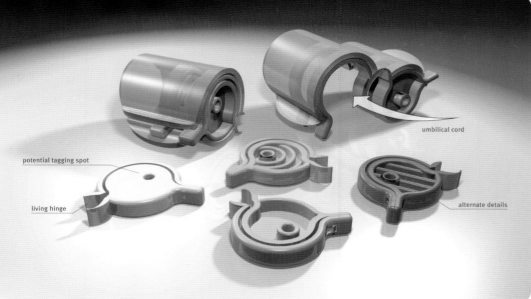

At last, the design team and the client narrowed the field to three leading directions, each of which was refined in Alias.

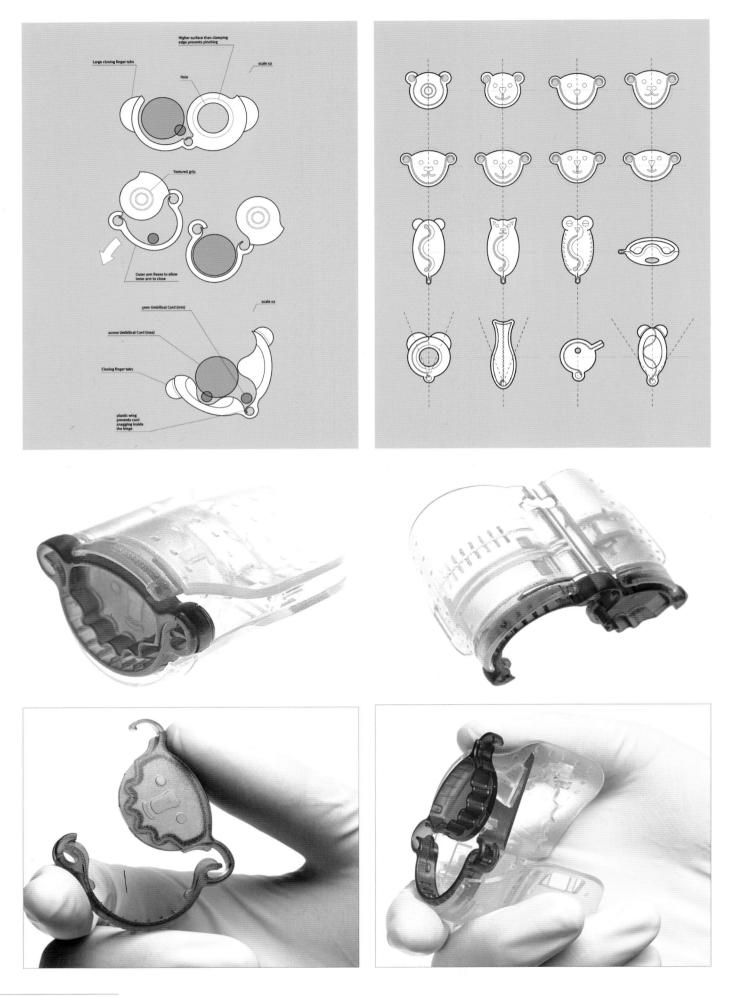

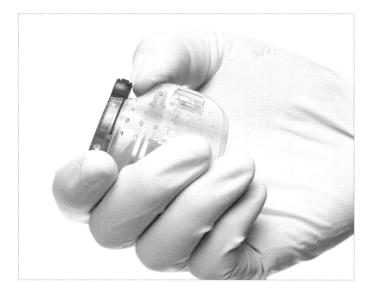

⊗ Top: The Joey Clamp & Cutter is designed for easy, one-handed operaticn.

⊗ Above: The commonly used Follister clamp alongside the Joey Clamp & Cutter.

⊗ Left: "The simple, endearing face (of the Joey) has become the brand statement for Maternus Medical as well as a great marketing hook for their flagship product," says Philip Leung, senior industrial designer at Design Edge, Inc. "What is mom going say—'No, I'd prefer the ugly clothespin on my baby, please'?"

⊗ Opposite top: When designers refined the concepts, the belly clamp, the one part of the system the baby would keep, took on an oval shape and the face of a smiling baby koala—a joey.

⊗ Opposite middle and bottom left: When the umbilical cord is aligned in the v-shaped groove, the clamp can be closed shut, confirmed by two audible snaps. Once closed, the infant clamp can be ejected by pushing on the ears, leaving the Joey Clamp on the newborn.

⊗ Opposite bottom right: The blade is contained within the housing of the maternal clamp, protecting the doctor from potential injury. The blade remains attached to the placenta side of the cord.

SpeedBlocks Head Immobilizer In the world of health care, where the **technological advances** of the past **50 years** have been **dazzling**, some areas remain surprisingly **low-tech**.

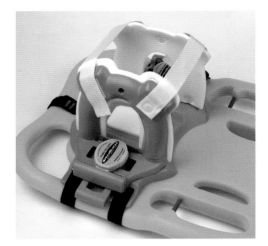

⊘ The SpeedBlocks Head Immobilizer, shown attached to a backboard, immobilizes patients suspected of having spinal injuries.

⊘ Even in this first model, the basic concept of the structure—a universal base that can attach to any type of backboard, with plastic blocks to hold the head—is apparent.

Take the area of head immobilization: Only 20 years ago, emergency medical technicians (EMTs) were still placing sandbags on either side of the head to immobilize patients suspected of having incurred a spinal injury. This inelegant solution didn't always achieve the desired result—the bags were so heavy that if the patient had to be held sideways on the backboard, the bags often moved the patient's head. The vinyl-coated foam blocks that became popular in the 1980s were a step forward—they were at least light enough not to move the head when the patient was moved—but they had other problems: They were easily punctured, and their straps and buckles were hard to keep clean, but they were too expensive to be thrown away. So in 1989, Laerdal Medical Corporation's design team introduced a cheap, disposable system called the Stifneck HeadBed; this system effectively immobilized patients, but because it was made of corrugated cardboard, many EMTs remained unconvinced of its effectiveness and stuck with the foam blocks.

Laerdal, a world leader in creating products for the EMT and paramedic community, saw a need for a head immobilization product that was easier to keep clean than the foam blocks and that had a more convincingly sturdy appearance than the HeadBed, but that was still cheap enough to discard when needed. Says Jim Traut, director of design and development for Laerdal, "The idea was to give them something that could be reused on multiple patients until they did get into a really serious accident that was very traumatic; then, when the product got very messy, it would be inexpensive enough that they could throw it out if they wanted to." This was similar to the way EMTs used extrication collars, another product in Laerdal's line of spine immobilization products, so Laerdal thought EMTs would be receptive to the idea.

Further research—through focus groups, field studies, and close examination of videotapes of EMTs on the job—uncovered a number of other requirements for the product. It had to be quick and easy to use in the field, since time, obviously, is of the essence for EMTs. The product would have to be attachable to a variety

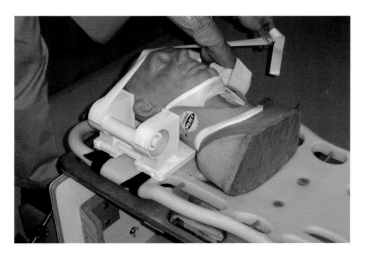

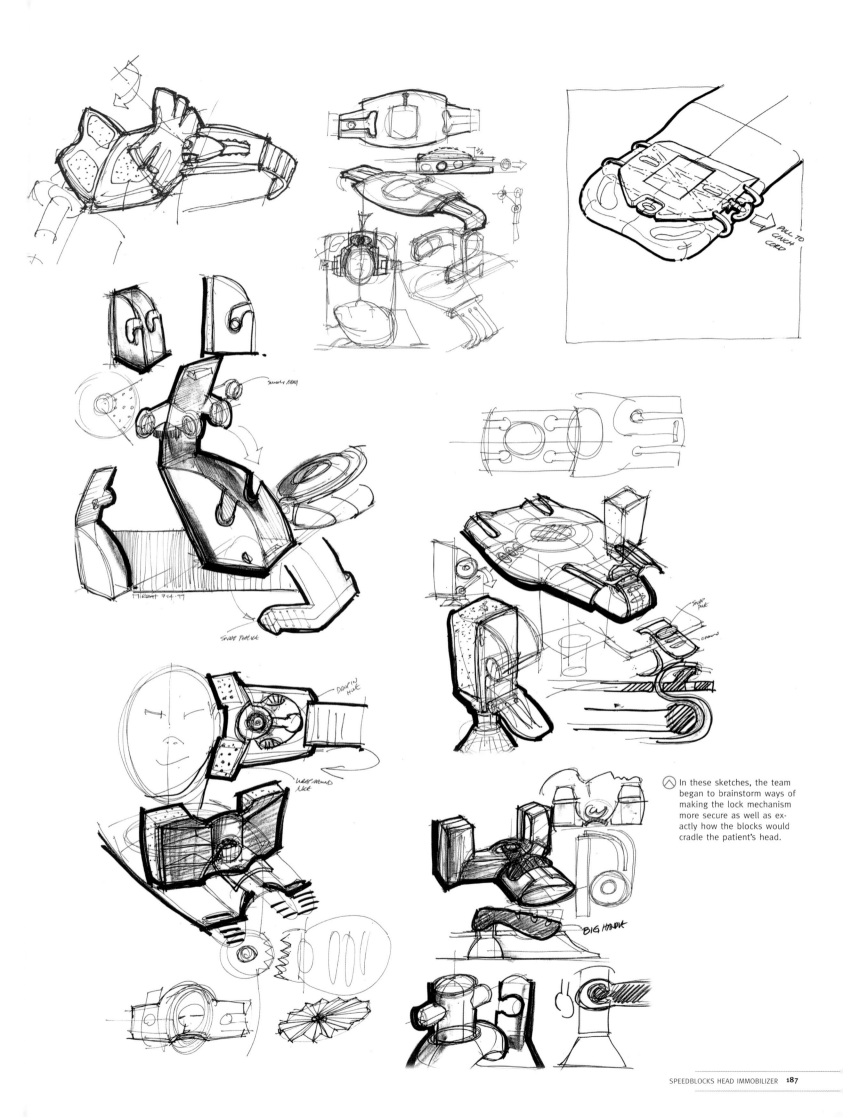

In these sketches, the team began to brainstorm ways of making the lock mechanism more secure as well as exactly how the blocks would cradle the patient's head.

of styles of backboards, as backboards are not standardized. Ideally, the product would be of open enough construction to give doctors physical and verbal access to the patient and to not interfere with x-rays. It had to be easily cleaned and stored, and flexible enough to be used on a two-year-old child or a helmeted motorcyclist. Most importantly, of course, it had to immobilize the patient's head, even if the patient was disoriented and struggling.

Early in the process, the team experimented with ways to attach blocks directly to the board. "We looked at things that stuck down, that were permanent changes to these backboards, like a panel that you would adhesively bond to the board that contained some kind of detail that you could attach the blocks to," says Traut, "and they all didn't work for some reason, or it was asking too much of the customer to make permanent modifications to their boards." At this point, the designers decided that the most practical structure for the product would be a universal base that could be affixed to any size or style of backboard, with a pair of blocks to cradle the head. For the material, Laerdal chose the same injection-molded plastic they used on the extrication collars. They knew the plastic would be strong and easy to clean; moreover, because they already purchased the material, they were able to take advantage of volume discounts from their suppliers.

Once the basic architecture of the system was decided, the team worked on attaching the blocks to the base. At this point, because Laerdal's team didn't include engineers, they enlisted the help of Machineart Corex to devise a mechanism that would lock the blocks to the base quickly, securely, and in three axes of motion. The system had to be secure, yet flexible enough to adjust to different sizes and shapes of heads; devising a system that could do that, yet not use Velcro (which is difficult to keep sterile), was a challenge.

The team also worked on structuring the blocks so they didn't interfere with x-rays. "We bought a bunch of children's toys and took them to the vet," says Traut, "and had him x-ray these toys to get an idea of how the shapes of these plastic products—the wall thicknesses and transitions and shapes—showed up on x-ray, and we used what we learned from that to shape the product in ways that we knew wouldn't show up on x-ray."

⊘ In this later model, the team kept the base and block concept but started refining the strapping mechanism used for the head. Through trying this model out on team members, they discovered that its straight-across strapping mechanism was not as effective as a slanted mechanism.

Later models were used to adjust the fit of the device to a wide variety of patients. Through trial and error, the team discovered that straps that slanted across the patient's face at an angle were more effective in holding a patient secure in the device than straps that went straight across. Because patients may spend hours in a device such as this one awaiting evaluation or treatment, comfort was also a high priority, especially because an ill-fitting device can cause secondary injuries that can mask the very trauma physicians are looking out for in this kind of patient.

The team also tried to address the need of EMTs to save space in ambulances; they developed a model in which the blocks folded down for better storage, but feedback from EMTs indicated that saving time in the field was a higher priority for them than saving space. It was also difficult to develop a foldable block mechanism that was as stable as one that didn't fold, so the designers abandoned this concept.

Having decided on the basic shape and structure of the device, the design team started to refine it. They made stereolithography models, and from them made molds and cast fully functioning prototypes out of urethane. These prototypes were once again fitted onto a wide variety of people, and comfort was checked; load-testing with mannequins was done in a lab to ensure the product wouldn't flex under pressure.

⊘ The team explored the concept of a head immobilizer that folded to save space on a crowded ambulance. Ultimately, the idea was rejected because feedback in the field from EMTs was that speed of use was more important to them than saving space, so any additional assembly would be undesirable; the team also had trouble ensuring the stability of this concept in action.

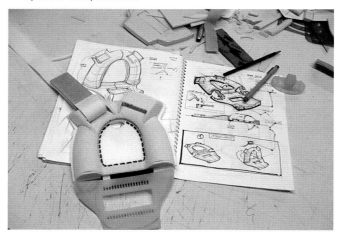

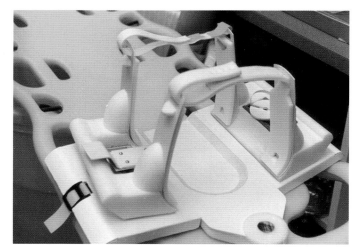

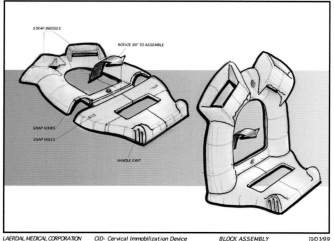

LAERDAL MEDICAL CORPORATION CID- Cervical Immobilization Device BLOCK ASSEMBLY 11/01/99

Two final prototypes were field tested, and the feedback the team got was surprising. Though the cost of the SpeedBlocks system was significantly less than that of reusable immobilizers, it looked like such a high-quality product that EMTs had a difficult time accepting the disposability of the system. Says Traut, "What we heard from a lot of people was that they wanted us to make the pads and straps replaceable, so they had the option of throwing the whole thing out if they wanted to or just throwing out the pads and cleaning the plastic parts." Not only did this solution further lower the cost per use of the product, it also reduced the amount of material waste associated with the product by an average of over 80 percent compared to disposable head immobilizers.

In a field study done with SpeedBlocks after its release, the reactions of the EMTs were resoundingly positive. They immediately appreciated the gap that SpeedBlocks filled in the market and commended its simplicity of use and ease of cleaning. "When they try it for themselves, they're almost surprised by how well it works in terms of immobilization," says Traut, "because it looks fairly minimal, and it doesn't have a big, hefty structure, which is what they're used to with these gigantic foam blocks." Now that SpeedBlocks has gained a foothold in the market, Laerdal is examining extending the line to include backboards with integral SpeedBlocks mounting slots.

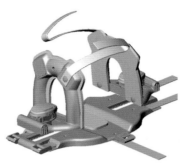

◇ Top: This photograph shows field testing; note that the patient is also wearing an extrication collar, the Laerdal product that gave the team the idea of using plastic to manufacture SpeedBlocks. The field testing confirmed the security of the lock mechanism and the ease of use and cleaning, but the team discovered that their customers preferred the option of disposable pads and straps.

◇ An exploded view of the final product, which shows the blocks separated from the base. Though the yellow board shown here is Laerdal's own model, the base can be strapped to any kind of backboard ahead of time.

◇ Above left: The team tested the comfort and efficacy of the arch mechanism on a wide spectrum of people, trying to find the construction that suited the largest number of people; they also wanted to align the hole with patients' ears, if possible, which would aid physicians both in diagnosing trauma and communicating with patients.

◇ Above right: A CAD model of one of the final prototypes.

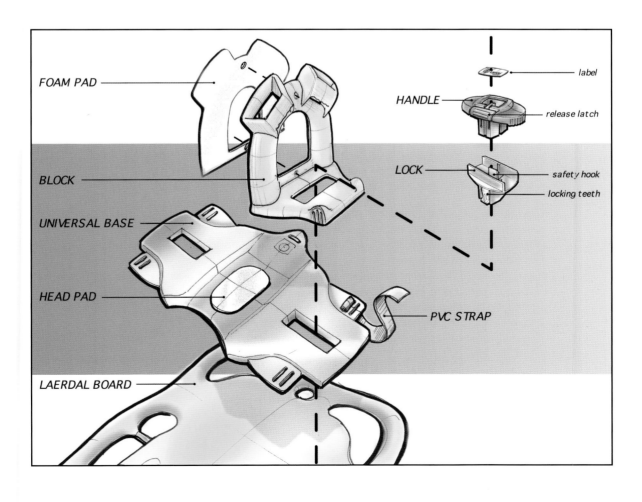

FOAM PAD

BLOCK

UNIVERSAL BASE

HEAD PAD

LAERDAL BOARD

HANDLE — release latch

label

LOCK — safety hook — locking teeth

PVC STRAP

IV House UltraDressing

IV House UltraDressing Most people would rank a **hospital** stay as one of their most disliked and **feared** experiences, and one of the most **unpleasant** aspects of this unpleasant **experience** would have to be **getting stuck** with a needle.

⬡ Top: The plastic dome-shaped IV House UltraDressing has ventilation holes and a flange to which the fabric dressing is ultrasonically welded. Rutter says that though the design of the device looks simple, "If you took the last five years of all the products that we've had through here, maybe 100 products, I'd say that this dressing would be in the top five most complicated products we've worked on."

⬡ Above: The fabric dressing is designed to fit either hand and, as a result, possesses two thumbholes.

⬦ Opposite top: This concept utilizes a covered adhesive patch but involves a flap that turned out to have no good landing.

⬦ Opposite bottom: This sketch is an early exploration in the use of thin Velcro strips, which later were replaced with a single patch.

"There's been enough research to show that we've got a needle-phobic society," says Bryce Rutter, founder and CEO of Metaphase Design Group, "and the last thing that people want is to be pricked with a needle numerous times when they're in the hospital." Because needles are so feared, patients often pick at their intravenous site, dislodging the needle. But studies have shown that increasing needle dwell time increases the effectiveness of a patient's treatment—and reduces the length and cost of the hospital stay.

After years of watching nurses construct makeshift IV covers out of plastic cups and tape, Lisa Vallino, an IV therapy nurse herself, saw the need for a product that protected intravenous sites; along with her mother, Betty Rozier, she started IV House, a company founded to market a polyethylene dome that did just that. But after seven years, sales had plateaued. The founders of IV House recognized the problems associated with the use of tape to attach the product to patients—it prevented easy visual access to the site and caused trauma to some patients—and they knew that if they could provide a way to attach the product to the site without tape, they could improve both the product's quality and its sales. They approached Metaphase Design Group and asked them to come up with a simple, elegant attachment system for the dome that would allow access to the site while holding the dome securely enough that it would not come loose and knock out the catheter or get twisted. Keeping the number of product SKUs (stock keeping units) to a minimum was another goal. "One of the issues that we know is important to hospitals is simplicity in purchasing," says Rutter, "and the last thing they want to do is buy into a solution where they have to have 13 different sizes to fit all the different people."

Over the next several months, Metaphase began intensive research into the anthropometrics of the hand, trying to determine where and how hands varied in size. And since the product was intended for everyone from pediatric patients to morbidly obese adults, the team discovered that variation was wide indeed. "We know from the leading experts in handheld products that the one-size-fits-all paradigm is a really tough one to solve," comments Rutter. Complicating matters was the fact that the device would have to work on both left and right hands.

The design team sketched a number of initial ideas, including using die-cut tabs on the dome and affixing it with adjustable straps, and wrapping a utility strap around the middle and ring fingers to hold the dome tightly onto the hand. But these solutions weren't simple enough—additional straps and lock mechanisms would both complicate use of the product and drive up manufacturing costs. This product was intended to be a disposable, not high-end, product, so in the end, Metaphase ended up

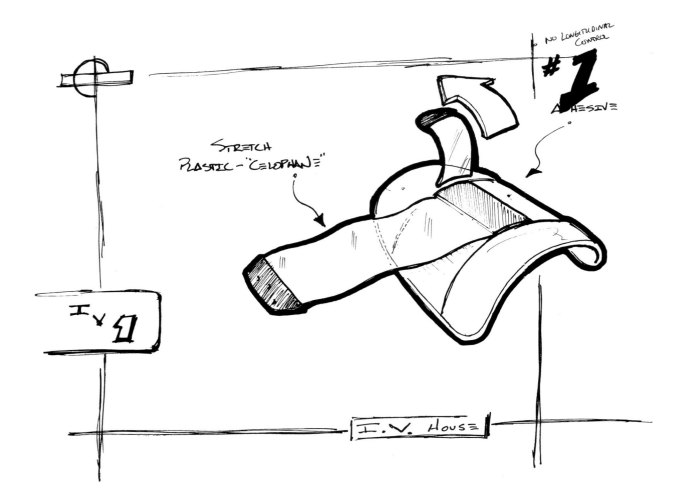

NO LONGITUDINAL CONTROL

#1

ADHESIVE

STRETCH PLASTIC - "CELOPHANE"

I. V. HOUSE

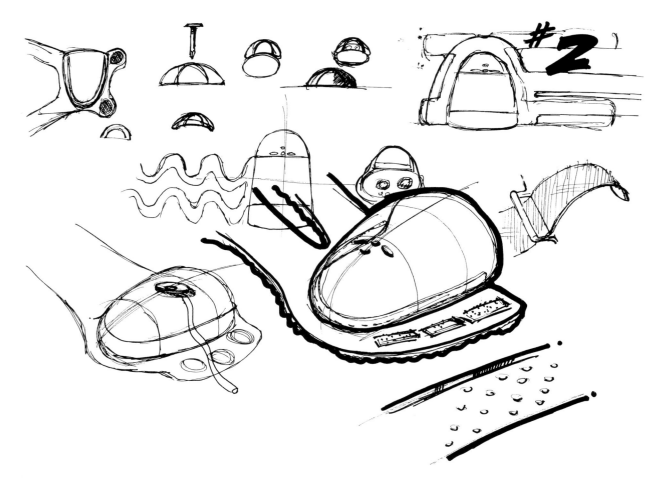

#2

primarily exploring the idea of affixing the dome with an elastic fabric joined by Velcro. The give of the fabric would, the team hoped, accommodate hands of a wide variety of sizes while coddling patients and making them feel secure.

Now came the tough part: determining the correct combination of shape and material to fit as many sizes as possible. "The most ticklish part of this whole process was working in parallel with the anthropometry and the ergonomics of the product and trying to address the materials that we could use," says Rutter. There were a lot of requirements for the material: It had to be soft but have a bit of traction, so it wouldn't slip off; it couldn't cause allergic reactions, so latex was eliminated as a possibility; it had to have enough stretch memory that it could withstand the four to eight times a day a nurse might open and close the device without losing its shape; it had to be able to withstand the die-cutting process. To cut costs, the team wanted to use Velcro on only one side on the fabric—"when you're looking at a disposable product, a tenth of a cent matters enormously," says Rutter—so they also wanted a fabric that Velcro could attach to.

At the same time, the team was trying to determine the best pattern for the material. They had decided to use the thumb as an anchor to keep the device from rotating and as a vertex for sizing the product, but determining exactly where, and what size, the die-cuts where the thumb would go through the fabric should be, as well as the shape of the pattern itself, was a challenge. Accommodating various hand sizes was one thing; accommodating hands alternately in use and at rest also meant the same hand might change shape a number of times. And not only did the device have to fit properly, the dome had to be centered properly over the vein, and the size and placement of the die-cut hole directly affected that. According to Rutter, the team went through at least 50 prototypes. "Every time we'd change a material, all the fit factor elements would have to be in total readjusted because now the stretch factor would be different, it would be different in the warp and the weave of the product, it may have more or less traction."

Prototypes were tested on hands of all shapes and sizes. In the end, one size didn't fit all: The minimum number of sizes that would work for all the targeted patients was four. For upper-arm sites, an alternative dressing pattern was designed with integral notches in 1-inch (3 cm) increments along its length to provide easy cut-to-length cues for nurses. The fabric that was ultimately chosen was made of 60 percent Tyvek, 30 percent nylon, and 10 percent Lycra, possessing 100 percent stretch in one direction.

The device passed its initial small-scale testing, but when a larger-scale clinical study was done, the team discovered that having Velcro on only one side of the dressing wasn't secure enough. "If it fails on a small percentage, that's unacceptable; it's got to be 100 percent successful," says Rutter. The additional Velcro was added to the device.

Ensuring that the sizing system was easy for hospitals to implement, and for nurses to use, was key to the product's success. Metaphase decided that offering a starter kit for the program that contained the various sizes in proportions that corresponded to the size breakdown of the population would give hospitals a painless entry point into the system. The team also carefully assessed the needs of nurses, the actual user population. The product's sizing system and usage had to be immediate and intuitive because nurses are highly stressed—as Rutter says, "Every moment of their day, they're late." They don't have time to read directions, and they don't have a tape measure, so the team devised a chart that allows nurses to measure the patient directly from the package. The labels on the product that indicate size match the standard sizing colors in the vascular access industry.

The UltraDressing has been a successful product for IV House. In the first year after its introduction, national sales increased 15 percent over sales of the previous version. Moreover, with this device and with others like it, Rutter believes that design has the power to make a positive contribution to the quality of patients' lives. "The reason why people are coming to us in the health care domain is because there is an emerging awareness that we can't treat humans as animals," says Rutter. "We need to be able to be much more sympathetic with the psychology of health care and we also can, through good, intelligent design, develop products that alleviate a lot of the stress." IV House founder Lisa Vallino speaks with pride about the value of her product: "I did it for nurses, and I did it for patients—especially pediatric patients, as a way to make medical care less frightening to them. But geriatric patients can benefit, too. In fact, it's hard to imagine any patient who wouldn't benefit from an IV House dressing."

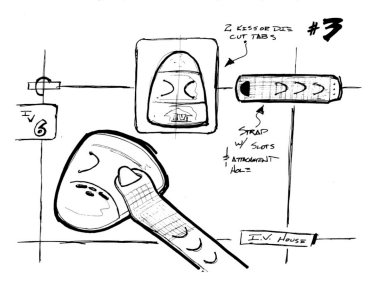

◁ Here, the team explores the use of a keyhole fastener system, which added wingtips that ended up doing a poor job of retaining the strap.

▷ Opposite top: In this sketch, the Metaphase design team considers the benefits of twin straps designed to better follow the surface of the hand. They later discovered that they could achieve the same effect with a simpler single strap of high-stretch fabric.

▷ Opposite bottom: This sketch explores the use of a clear paper-backed sterile pack; the paper back provides an excellent billboard for product use graphics and branding.

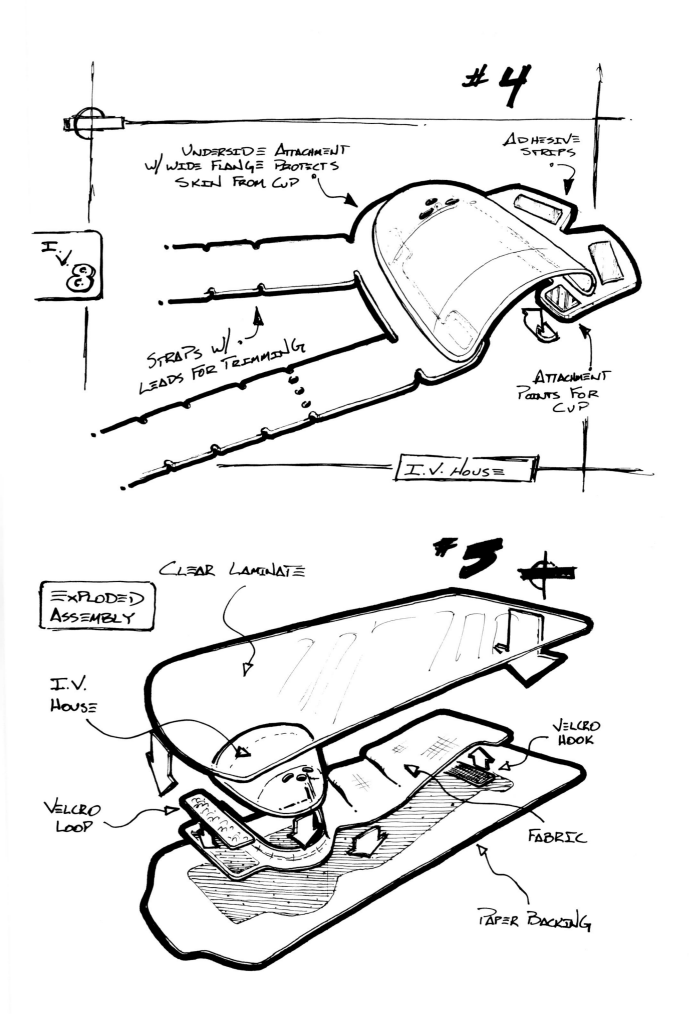

4

UNDERSIDE ATTACHMENT
w/ WIDE FLANGE PROTECTS
SKIN FROM CUP

ADHESIVE
STRIPS

I.V.
C.C.

STRAPS w/
LEADS FOR TRIMMING

ATTACHMENT
POINTS FOR
CUP

I.V. HOUSE

5

CLEAR LAMINATE

EXPLODED
ASSEMBLY

I.V.
HOUSE

VELCRO
HOOK

VELCRO
LOOP

FABRIC

PAPER BACKING

SenseWear Armband and Innerview Software "Most of us know more about **what's** going on in our **cars** than in our **bodies**.

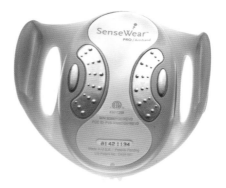

The dashboard displays data about fuel, oil, engine temperature, even when the vehicle is due for a checkup. That's what we're hoping to do for the body," says Astro Teller, CEO of BodyMedia, Inc.

That kind of thinking gave rise to the SenseWear Armband. Chris Kasabach, vice president of industrial and mechanical design for BodyMedia, Inc., which designed the product, describes it as "the first multisensor body monitor for collecting clinically accurate energy expenditure (calorie burning), sleep quality, and activity states (such as walking, driving or watching TV) in a free-living environment."

⟁ The SenseWear armband, which is a wearable computer, is worn on a part of the body where skin-touching wearble monitors have never occupied—the upper arm.

⟁ SenseWear, worn on the upper arm, collects clinically accurate caloric burn and sleep data from the wearer whether he or she is working out in a gym, jogging, or sitting at a computer.

SenseWear produces a physiological documentary of the wearer, providing researchers with a continuous and accurate view of the body over as many as five days. The information SenseWear collects is wirelessly communicated to BodyMedia's Web-based Innerview software. "Because SenseWear works outside the lab, problems such as insomnia, weight gain, and obesity can be viewed in the context of lifestyle patterns, permitting new insights previously impossible in conventional lab settings," says Kasabach.

BodyMedia recognized that existing physiological monitors were limited, notably because of the lack of attention paid to how the monitors are worn on the body and the limited ability of single-sensor devices to collect data and present information. That, together with "the increased desire for medical professionals and individuals with health concerns to better monitor and understand the body and the coming of age of several technologies and systems" led to the development of the produced, says Kasabach. The technological advances included decreased size and cost of key hardware and sensing technologies, maturing artificial intelligence capabilities, and improved materials, manufacturing processes, and design software. In addition, the designers capitalized on a proprietary body-mapping system, first presented at the International Symposium on Wearable Computing (ISWC) in 1998, for determining the best locations for wearing and sensing.

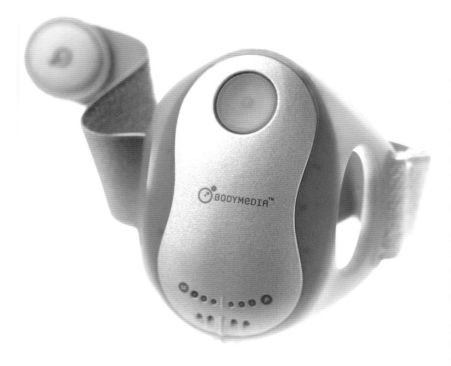

Recognizing that the time was right for this revolutionary product, designers tackled the job head on. They began by translating market requirements into a "preferred experience."

"The team conceived what the ideal process of using the product should be, given the constraints set up by the market requirements," says Kasabach. "The SenseWear Armband is a wearable computer and medical device in one, but both of these categories carry heavy perceptual stigmas. The challenge was to build a system that was as advanced as the newest wearable computer and as accurate as a clinical medical device while feeling like neither. The challenge was to design a wearable accessory that would be inviting even if it didn't do anything."

Specifically, designers had to find a way to collect clinically accurate caloric burn and sleep data from an extremely diverse range of adult body types in all environments. Moreover, the device—to be effective—had to be comfortable enough to wear for an extended period.

Until the advent of BodyMedia's SenseWear, body monitors were far from comfortable, so it was the design team's top priority to make wearing the sensor as comfortable as wearing a watch. "This was an enormous challenge, as SenseWear's technology is much larger than a watch movement," Kasabach says, who wanted the act of data collection to "feel less like a medical experience and more like a self-discovery experience."

With these objectives in mind, designers developed concepts and played around with the options of making the system largely textile-based or molded. The textile approach presented performance problems involving moisture, oils, odor absorption, and long-term cleaning. Designers spent considerable time selecting materials and processes to make the armband hypoallergenic, small, comfortable, and durable—using, among other materials, surgical-grade hypoallergenic stainless steel, FDA-approved polyester, and UV-stabilized thermoplastic urethane, along with a custom-developed, latex-free nylon-polyester blend for the adjustable strap. Together, these features made the SenseWear water resistant and easy to clean.

⊘ The SenseWear Armband is the first multisensor body monitor for collecting clinically accurate energy expenditure (calorie burning), sleep quality, and activity states (such as walking, driving or watching TV) in a free-living environment.

⊘ The information SenseWear collects is wirelessly communicated to BodyMedia's Web-based Innerview software.

⊘ Sense maps, which show the best locations for accurate free-living sensing, were analyzed by designers choosing where to place the body sensor.

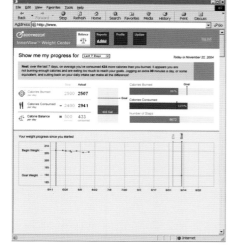

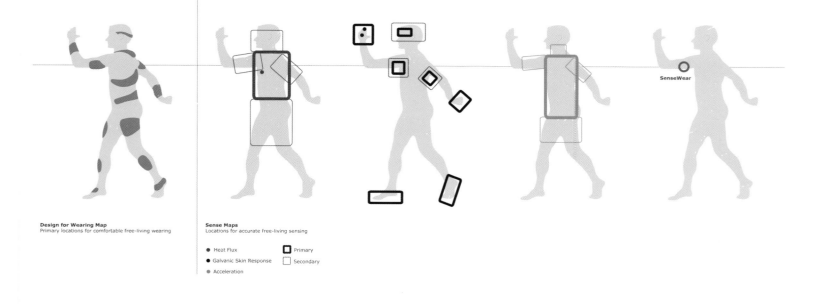

Design for Wearing Map
Primary locations for comfortable free-living wearing

Sense Maps
Locations for accurate free-living sensing

● Heat Flux ▢ Primary

● Galvanic Skin Response ▢ Secondary

● Acceleration

Where the sensor was placed on the body was an all-important factor in determining comfort and ease of use, so designers chose to position the SenseWear on the upper arm—a new location for skin-touching wearable monitors. They developed custom, skin-sensitive elastic capable of fitting a wide range of arm sizes and compositions. Numerous design studies were generated to define the topology of the product's underside for maximizing sensor-to-skin contact and minimizing pressure and heat buildup.

Next, designers collected hours and hours of data on wearers of different sizes in diverse conditions to provide the informatics team with enough input to develop algorithms that intelligently translated the raw sensor data into useful information. During this data collection phase, the SenseWear armband and a medical gold-standard product were tested simultaneously on users to validate SenseWear's accuracy.

Once the design was finalized, a part file and detailed drawing were created for each part. Designers relied on computer programs such as Ashlar-Vellum, Pro/Engineer, Adobe Illustrator, and Adobe Photoshop to execute and finesse the design before it went to manufacturing.

On its debut, the SenseWear earned positive reviews. Its battery is rechargeable, it can be easily repaired and maintained, and, despite its small size, it does what once required much larger and more expensive lab equipment. "From top to bottom, SenseWear was designed to move with the body. The gentle curves, stretch materials, smooth texture, and soft colors made the product feel more like a fitness product and less like a medical device, an important perceptual requirement in this market," says Kasabach.

⊗ Designers spent considerable time selecting materials and processes to make the armband hypoallergenic, small, comfortable, durable, water resistant, and easy to clean.

⊗ Opposite top left and middle: Once designers determined that the SenseWear would be fitted to the upper arm, they developed custom, skin-sensitive elastic capable of fitting a wide range of arm sizes and compositions. Numerous design studies were generated to define the topology of the product's underside for maximizing sensor-to-skin contact and minimizing pressure and heat buildup.

⊗ Opposite bottom left: The SenseWear armband and a medical gold-standard product were tested simultaneously on users to validate SenseWear's accuracy.

⊗ Opposite far right: Once the design was finalized, a part file and detailed drawing were created for each part.

⊗ Designers opted to design the sensor for placement on the upper arm, a new location for skin-touching wearable monitors.

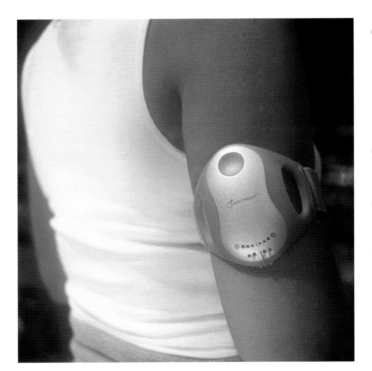

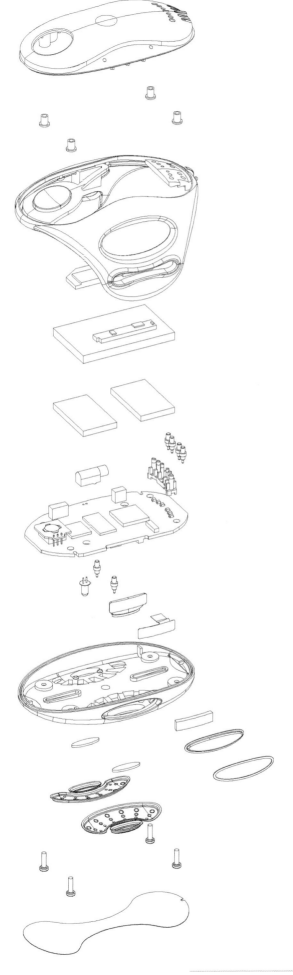

Infiniti 500 Rollator With the baby boomers reaching their senior years, the demand for rollators, or wheeled walking aids, is increasing.

The Infiniti 500 Rollator incorporates a cableless braking system, a large and comfortable flip-up seat, and a unique sliding tuck-away basket. Due to innovative manufacturing techniques, the Infiniti is also more easily customized and less expensive to produce than traditional rollator designs.

Until recently, manufacturers of these products competed primarily on price. The Infinity 500 Rollator changed all that.

The idea for the Infiniti 500 Rollator came from Doug MacMillian, president of Dana Douglas, Inc. "Doug had been listening and documenting the feedback from therapists, dealers, and end users for ten years," says Bjarki Hallgrimsson, principal of Hallgrimsson Product Development. "Most of the competitors in the market were trying to compete by lowering their prices, whereas Doug wished to establish Dana Douglas as a key innovator in the market. He approached us to see if innovative manufacturing techniques could be combined with novel ideas that would enhance the performance of the product."

Hallgrimsson was given the objective: to create a new line of rollators that incorporated all the features and benefits that for years had topped users' wish lists. This meant eliminating brake cables; adding a flip-up seat; offering a range of walker heights and widths; allowing for a wider seat; and above all, making the rollator lightweight and easily portable. Hallgrimsson's goal was to achieve these objectives *and* find a way to lower production costs in terms of manufacturing and inventory.

"We knew that the product would be put to the test by end users who really depend on it," remembers Sarah Dobbin, design project manager. "The feel of the brakes had to be just right, the seat had to be comfortable, and the product had to be easily foldable into a compact position to fit in the trunk of a car. The product also had to withstand the strain and stress of constant use in a wide variety of environments and climates. The product development was very focused on the needs and expectations of the end user."

Designers started by exploring ways to eliminate the costly process of welding and bending aluminum tubing, which is how these products are typically produced. Designers developed a plastic seat frame into which straight tubing for legs and handle-

The Dana Douglas Infiniti 500 rollator is a wheeled walker that allows people with mobility problems to maintain an active lifestyle both indoors and out.

Opposite top: Designers eliminated the need for welding and tube bending by developing a plastic seat frame into which straight tubing for legs and handlebars was connected. This design modification, compared to traditional rollators, resulted in a bulkier, less robust product. They tweaked the concept and investigated using an aluminum die-cast seat frame instead.

Opposite bottom: The concept sketches evolved from an injection-molded seat frame toward a die-cast connection system.

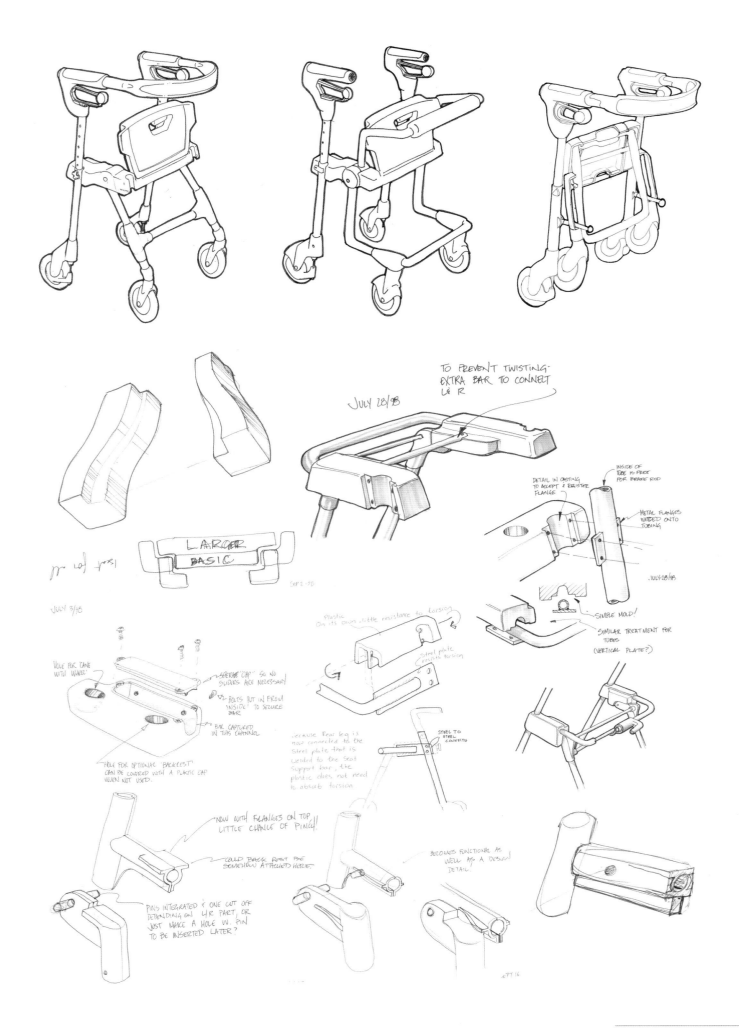

TO PREVENT TWISTING - EXTRA BAR TO CONNECT L & R

JULY 28/98

DETAIL IN CASTING TO ACCEPT & REGISTER FLANGE

INSIDE OF TUBE TO FREE FOR BRAKE ROD

METAL FLANGES WELDED ONTO TUBING

JULY 28/98

SIMPLE MOLD!

SIMILAR TREATMENT FOR TUBES (VERTICAL PLATE?)

LARGER BASIC

JULY 3/98

HOLE FOR CANE WITH WHEEL

SEPARATE "CAP" SO NO SLIDERS ARE NECESSARY

BOLTS PUT IN FROM INSIDE TO SECURE BAR

BAR CAPTURED IN THIS CHANNEL

HOLE FOR OPTIONAL BACKREST CAN BE COVERED WITH A PLASTIC CAP WHEN NOT USED.

Plastic
On its own little resistance to torsion

Steel plate resists torsion

Because Rear leg is now connected to the Steel plate that is welded to the Seat support bar, the plastic does not need to absorb torsion

STEEL TO STEEL CONNECTION

NOW WITH FLANGES ON TOP! LITTLE CHANCE OF PINCH!

COULD BACK POST BE SOMEHOW ATTACHED HERE?

BECOMES FUNCTIONAL AS WELL AS A DESIGN DETAIL!

PINS INTEGRATED & ONE CUT OFF DEPENDING ON L/R PART, OR JUST MAKE A HOLE W. PIN TO BE INSERTED LATER?

bars were be connected, eliminating the need for welding and tube bending. "Our initial concept sketches revolved around this idea. It quickly became clear that this approach would likely result in a bulkier and less robust product," says Hallgrimsson, who, based on his experience in designing cast-aluminum parts for the medical and telecommunications industries, investigated using an aluminum die-cast seat frame instead.

A trip to a die-caster confirmed the idea of using die-cast aluminum as the main connector for the legs of the product, as it would provide a much stronger and more reliable connection.

Having achieved two of their goals, simplifying assembly and lowering costs, designers turned their attention to making the rollator more user-friendly than any other on the market. "The first challenge was to develop a braking system that would eliminate the external brake cables, which tend to get caught on things and require frequent adjustments due to the cable stretching," says Dobbin. Through a series of trials, designers developed a new type of system, which they eventually patented. One evening, in Hallgrimsson's basement, they built a crude mock-up out of bits of styrene that was enough to prove the concept. They continued to refine the design in 3-D in Solidworks, which allowed constant evalution of the product's weight and strength through Finite Element Analysis (FEA).

Next, designers tackled the flip-up seat. "Not only was this an important feature for easier navigation around areas of the home like the kitchen—users can get closer to counters and cupboards—but Doug MacMillan knew that therapists were looking for this feature to help their patients," says Hallgrimsson.

Two years after its design start, the new rollator was completed. "The longer than usual timeframe allowed new ideas to incubate and later become incorporated as a part of the product," says Hallgrimsson. Examples of features that came to fruition late in the process are the retractable shopping basket and the rotating back strap that lets users sit on the walker facing either way.

In the end, the Infiniti 500 represents a brand new rollator technology that incorporates all the features—and then some—requested by users and therapists. Thanks to innovative manufacturing techniques, the Infiniti is also more easily customized and less expensive to produce than traditional rollator designs. In fact, it increased Dana Douglas's sales by 30 percent and made it a leader in the field.

"A product such as this one has to work flawlessly," Hallgrimsson says. "Users depend on it for their safety and mobility. Because the product has new features and functionality, it was paramount to do a lot of testing, to make sure that the new innovations would be accepted, and also to make sure that everything would work in a reliable fashion. Once we understood where the weak spots where, we could improve the design prior to releasing the product to market. I guess the thing to keep in mind is to be your product's harshest critic."

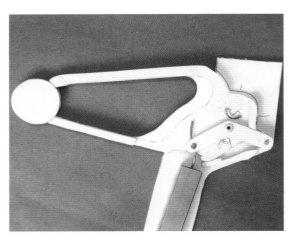

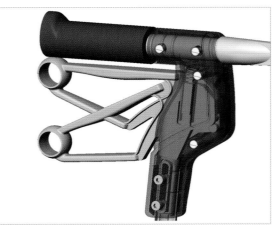

More elaborate prototypes, such as this one, were created in Solidworks software.

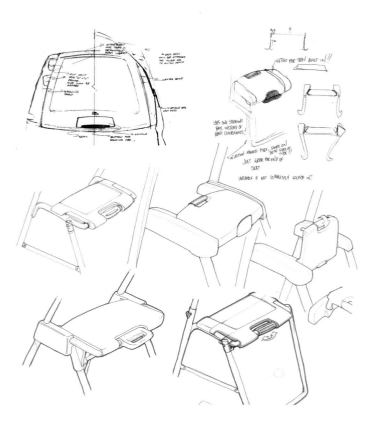

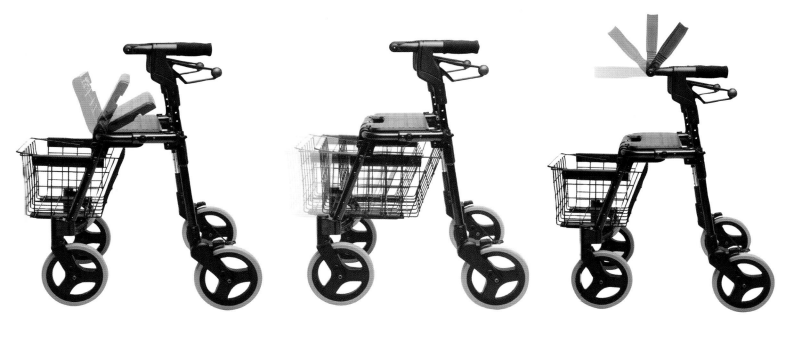

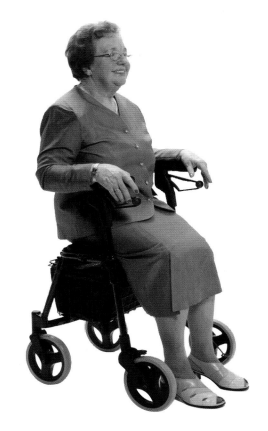

Opposite top: Hallgrimsson's team developed many of the product's most innovative features through a hands-on approach. Some of the early mock-ups of the brake mechanism were crude—this one was built one evening in Hallgrimsson's basement—but they proved the idea and allowed for faster, more reliable product development.

Opposite bottom: A folding lock handle was integrated as a visual and safety element in the seat. This area is easily accessible from both the front and the back of the rollator.

Top left: The flip-up seat was a must-have feature requested by physical therapists so patients learning to walk after a stroke could see their feet during gait training.

Top middle: A shopping basket can be easily accessed, yet it is designed to slide underneath the seat to secure belongings.

Top right: A rotating back strap allows the user to sit on the walker facing either way. This means the walker can be pulled up closely to a table for convenient seating.

Right: The rotating back strap makes seating easier by eliminating the need for the user to turn the rollator 180 degrees or back into a table.

HeartStart Home Defibrillator Can good product design **save lives**? It can, if it makes a **life-saving** medical device **accessible** to the general public.

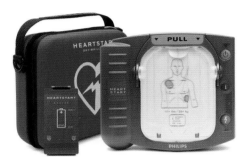

⊘ The final product, shown with its thermo-formed foam and fabric carrying case, also includes a pediatric cartridge so it can be used on children.

That was the idea behind Philips Medical Systems' development of the HeartStart Home Defibrillator, the first defibrillator designed for use in the home to receive FDA clearance.

Every two minutes, someone in the United States needs a defibrillator. Without defibrillation, the chance of survival of a person having a heart attack decreases 7 to 10 percent per minute, and research has shown that the average distance most people live from emergency professionals with defibrillators is six minutes. It is no surprise, then, that of the 250,000 people killed each year by sudden cardiac arrest, 70 percent die in their homes. The mission before Philips Medical Systems was clear: Get defibrillators into the home.

The challenges behind designing the device, however, were equally clear. Traditional defibrillators are heavy, complex machines that take extensive training to operate. The design for a home defibrillator had to address the sight, hearing, and dexterity issues that face its potentially elderly market. The design team also had to keep in mind that users may be panic stricken, especially since they would likely be using the device on a friend or family member. Or, as Kurt Fischer, one of the designers of the HeartStart, states, "Users need to be guided very explicitly in a very straightforward and nonthinking manner at probably the worst moment of their lives."

The design team had a previous product, a defibrillator called the FR2 whose market was primarily medical response teams (MRTs), to use as a jumping-off point for their design. The team wanted to make the home defibrillator smaller and more intuitive than the FR2, yet it had to display more information, as users would have less training. As Fischer says, "How do you add more information and make a product simpler? That's a tough problem."

Early on, the HeartStart team decided to simplify the device by eliminating features home users didn't need, such as the electrocardiogram (ECG) screen, and by preconnecting the defibrillator pads. To add information, the team decided that the defibrillator would employ voice prompts to help users through the process as efficiently as possible.

While the design team initially felt a shield metaphor would be an appropriate way to convey the ruggedness of the product as well as the protection it provides, it was difficult to integrate that with the heritage of the product line, which marketing felt was important to emphasize. Some of the early designs referenced the "1, 2, 3" user interface employed on the FR2, while others used an interface similar to that of a fire alarm. Versions of both interfaces were chosen for prototyping.

In these initial sketches, the design team brainstormed the device's shape and user interface. Four of the concepts all featured an external connection to the defibrillator pads; the version at the bottom left has preconnected defibrillator pads, a feature the team decided was important for this market. This design was chosen for further development.

Below: "We wanted a bit more of a consumer aesthetic, a power tool look as well as a consumer electronics look," says Fischer. The early design shown here reflects this influence. At this stage, the design includes a proposed UI that would work in a high-noise environment or during a speaker failure, allowing users to follow the LED to guide them through the process.

Bottom: These further explorations resulted from internal concerns that the design, as it had been developed so far, was too large. The design team worked on reorienting the circuit board horizontally to make it appear more compact. At this point, the team worked on developing a top-to-bottom order of operation of the user interface.

The team then began to test six variations of the product on a total of 260 users—starting with MRTs and other advanced users as well as untrained laypeople and senior citizens. "We wanted to really push the cognitive and physical boundaries of our product," explains Fischer. "If it could work fine for [untrained laypeople] in a pinch, then we knew we had something that everyone could use." The prototype consisted of a stereolithographed model with a bread-board user interface (UI) and power source mounted inside. A wireless speaker system and LEDs, controlled by remote, were also inserted. The team transmitted the voice prompts by computer through the speakers as users went through each step, realistically replicating (yet invisibly controlling) the user's experience.

Testing uncovered four major hurdles for users: They often had difficulty turning the device on, they didn't know what electrodes were or how to access them on the device, they had trouble placing the electrode pads properly, and they could not always hear the instructions the first time.

To address the first two problems, the team made use of two interfaces everyone can navigate: a fire alarm and a peelable foil seal. While untrained users often searched for a way to turn on the device, they had difficulty seeing a green button and turning it on—but they had no difficulty understanding a handle labeled "pull" (just as on a fire alarm) and colored green, which is synonymous with "go." Fischer says, "We thought that since some people were having trouble turning the device on but everyone was getting the lid open, why not just work with that and have the device turn on when they get the lid open? Let's cater to what

people do naturally." Then, instead of referring to electrode pads, which most users couldn't identify in testing, voice prompts directed them to remove a "protective cover," which gave access to the pads. Fischer says, "They saw a foil tab, and they intuitively knew what to do with that."

To address the problem of users placing the electrode pads incorrectly, the team tested various types of labeling on the face, but initial attempts proved confusing. "One of them was a real upfront reference of how this device works, and people ended up pressing the graphics, kind of like a microwave," recalls Fischer. The team discovered that simply having the voice prompts tell users to look carefully at the pictures on the white adhesive pads immensely enhanced proper pad placement.

Finally, to address the fact that some users need to hear the instructions more than once, the team honed the reactivity of the device. If the device sensed that a user had not moved on to the next step in the process, it would repeat the audio instruction, and if the user still did not proceed, it assumed that the user was stuck and gave more detailed instructions.

Fischer cites these tests—especially team members' presence at them—as being crucial to the product's successful development: "We were able to watch the people we were designing for. It really brings the mission home—you can see how what you do is affecting the people you're trying to help." Even better, since the product's release, the team has received living proof that good product design *can* save lives—they've met grateful owners whose lives have been saved by the HeartStart product.

This iteration features the top-to-bottom UI orientation favored by the team. The black background at the top of the face of the device was planned to serve as a UI dashboard; the icons would show up at each phase as needed. However, the group felt that this version was still too large, since the footprint was the same as on the FR2. It then became the mechanical engineers' mission to make the electrical components smaller. Engineering was also told to work on the preconnected pads cartridge so that it would be modular and replaceable.

These designs tried to bring back the design connection between this product and the FR2 that the team felt was lacking, including the "1, 2, 3" button concept. The top right and the lower left versions were chosen for further development. The team was still unsure whether the "1, 2, 3" concept should be kept or whether it would be distracting to this audience.

Two variations of the design on the top right and three of the one on the bottom left were prototyped and given over to user testing. In testing, the biggest problem of the device on the top left was that the on button was not prominent enough. "We needed something blaring and overwhelming to get people over that first hurdle in a hurry," says Fischer. The team continued to develop variations of the bottom left version, further developing the fire alarm theme and testing various colors and shapes.

directory

Page 90
PRODUCT: Logitech Pocket Digital Camera
DESIGN TEAM: IDEO
100 Forest Avenue
Palo Alto, CA 94301
Phone: 650-289-3400
Fax: 650-289-3707
www.ideo.com

Page 94
PRODUCT: Motorola NFL Headset, Generation II
DESIGN TEAM: John Hartman, Steve Remy, Elliott Hsu,
Jason Billig, Don Wolf (Herbst LaZar Bell, Inc.); Terry
Taylor, Dan Williams, Luigi Flori, Connie Kus, David
Weisz, Geoff Frost (Motorola, Inc.)
Herbst LaZar Bell, Inc. (HLB)
355 North Canal Street
Chicago, IL 60606
Phone: 312-454-1116
Fax: 312-454-9019
www.hlb.com

Page 98
PRODUCT: Maxim Sport Safety Eye Gear
DESIGN TEAM: James McGee, Dave Honan, Todd Taylor,
Ngee Lee (Insight Product Development); Keith
Fecteau, Chet Nadkarni, Glen Stanley, Art Salcy (Aearo
Company)
Insight Product Development, LLC
23 Bradford Street
Concord, MA 01742
Phone: 978-371-7151
www.insightpd.com

Page 102
PRODUCT: CDI Dial Torque Wrench
DESIGN TEAM: Tor Petterson Associates, Inc.
31248 Palos Verdes Drive West
Rancho Palos Verdes, CA 90275
Phone: 310-544-6000
Fax: 310-544-6002
www.tpa-design.com

Page 106
PRODUCT: John Deere Spin-Steer Technology
Lawn Tractor
DESIGN TEAM: Henry Dreyfuss Associates
5 Research Drive
Ann Arbor, MI 48103
Phone: 734-222-5400
Fax: 734-222-5417
www.hda.net

Page 110
PRODUCT: Water-Gate
DESIGN TEAM: MegaSecur, Inc.
145, Jutras Boulevard East
Bureau 3
Victoriaville, Quebec
G6P 4L8 Canada
Phone: 819-751-0222
Fax: 819-751-5550
www.megasecur.com

Page 114
PRODUCT: Watercone
DESIGN TEAM: Stephan Augustin
Augustin Product Development
Eengstrasse 45
80796 Munich
Germany
Phone: 49 89 2730690
www.watercone.com

Page 118
PRODUCT: Dutch Boy Twist & Pour Paint Container
DESIGN TEAM: Nottingham-Spirk Design Associates, Inc.
11310 Juniper Road
Cleveland, OH 44106
Phone: 216-231-7830
www.ns-design.com

Page 122
PRODUCT: Handy Paint Pail
DESIGN TEAM: Worrell, Inc.
6569 City West Parkway
Eden Prairie, MN 55344
Phone: 952-946-1966
Fax: 952-946-1967
www.worrell.com

Page 126
PRODUCT: Master Lock Titanium Series Home and
Garden Padlocks
DESIGN TEAM: Roy Thompson, Noelle Dye, Harry West,
Ph.D., Maryann Finiw, Joe Geringer, David Chastain,
John Fiegner (Design Continuum); John Heppner, Jesse
Marcelle, Paul Peot (Master Lock)
Design Continuum, Inc.
1220 Washington Street
West Newton, MA 02465
Phone: 617-928-9501
Fax: 617-969-2864
www.dcontinuum.com

Master Lock
2600 North 32 Street
Milwaukee, WI 53210
Phone: 414-444-2800
Fax: 414-449-3142

Page 130
PRODUCT: Soft Edge Ruler
DESIGN TEAM: Eric Chan, Jeff Miller, Rama Chorpash
ECCO Design, Inc.
16 West 19th Street
New York, NY 10011
Phone: 212-989-7373
www.eccoid.com

Page 132
PRODUCT: The Rabbit Corkscrew
DESIGN TEAM: Pollen Design, Inc.
128 Wooster Street, 4th floor
New York, NY 10012
Phone: 212-941-5535
www.pollendesign.com

Page 136
PRODUCT: Malden Mills Polartec Heat Blanket
DESIGN TEAM: Heather Andrus, Dan Cuffaro
Altitude
363 Highland Avenue
Somerville, MA 02152
Phone: 617-723-7600
www.altituteinc.com

Page 140
PRODUCT: Whirlpool Duet Fabric Care System
DESIGN TEAM: Global Consumer Design, Whirlpool
Corporation
Whirlpool Corporation
1800 Paw Paw Avenue
Benton Harbor, MI 49022
Phone: 269-923-4671
www.whirlpool.com

Page 144
PRODUCT: Wolf Convection Oven
DESIGN TEAM: Jerome Caruso Design, Inc.
470 Stable Lane
Lake Forest, IL 60045
Phone: 847-295-2995
Fax: 847-295-2919

Page 148
PRODUCT: sōk Overflowing Bath
DESIGN TEAM: Kohler Co.
444 Highland Drive
Kohler, WI 53044
Phone: 920-457-4441
Fax: 920-457-6952
www.kohler.com

Page 152
PRODUCT: New Century Maytag Neptune Washer
DESIGN TEAM: Maytag Laundry Industrial Design
403 West Fourth Street N
Newton, IA 5c208
Phone: 641-787-8738
Fax: 641-787-8839
www.maytag.com

Page 156
PRODUCT: Birkenstock Footprints: The Architect
Collection
DESIGN TEAM: Yves Behar, Johan Liden, Geoffrey
Petrizzi
fuseproject
123 South Park
San Francisco, CA 94107
Phone: 415-908-1492
Email: info@fuseproject.com
www.fuseproject.com

Page 160
PRODUCT: Nike Presto Digital Bracelet
DESIGN TEAM: Scott Wilson, Garth Morgan, Mark
Eastwood (Nike, Inc.)
One Bowerman Drive
Beaverton, OR 97005-6453
Phone: 800-344-6453

Nike European Headquarters
Colosseum 1
1213 NL Hilversum
The Netherlands
Phone: 31 35 626-6453
www.nike.com

Page 164
PRODUCT: First Years Comfort Care Baby Products
DESIGN TEAM: Will Wear, Anthony Pannozzo, Matthew
Marzynski
Herbst LaZar Bell, Inc. (HLB)
355 North Canal Street
Chicago, IL 60606
Phone: 312-454-1116 (Main Office)
781-890-5911 (Boston Office)
www.hlb.com

Page 168
PRODUCT: Perfect Portions
DESIGN TEAM: Wayne Marcus, Dot Studio, Charles H.
Keegan and Brian Sundberg, Safety 1st Inc. (Dorel),
Elizabeth Lewis, Insight Product Development, Steven
L. Trosian, Velocity Product Development, and David
O'Connell of Danebroch Studios for Safety 1st Inc.
(Dorel).
DESIGN FIRM: Dot Studio, Inc.
For more information, contact Wayne Marcus, Director,
Design
Product Ventures Ltd.
55 Walls Drive
Suite 400
Fairfield, CT 06824
Phone: 201-319-5916
wmarcus@pvldesign.com

Page 172
PRODUCT: Evenflo Triumph Convertible Car Seat
DESIGN TEAM: IDEO
100 Forest Avenue
Palo Alto, CA 94301
Phone: 650-289-3400
Fax: 650-289-3707
www.ideo.com

Page 176
PRODUCT: East3 Thoughtcaster
DESIGN TEAM: Jay K. Fording, Ian Cunningham,
Keith Savas (BOLT); Bill Riley, Sean Anderson
(SPARK Engineering)
BOLT
1415 South Church Street, Suite 5
Charlotte, NC 28203
Phone: 704-372-2658
Fax: 704-372-2655
www.boltgroup.com

Page 180
PRODUCT: Joey Clamp & Cutter
DESIGN TEAM: Philip Leung, Carrie Bader, Carrie
Labunski Shimek (Design Edge); Dr. Richard Watson,
Ron Hicks (Maternus Medical)
316 North Lamar Boulevard
Austin, TX 78703
Phone: 512-477-5491
www.designedge.com

Page 186
PRODUCT: SpeedBlocks Head Immobilizer
DESIGN TEAM: Jim Traut, Sean Phillips (Laerdal Medical
Corporation)
Andrew Serbinski, Mark Rosen, Mirzat Kol (Machineart
Corex)
167 Myers Corners Road
Wappingers Falls, NY 12590
Phone: 800-648-1851
Fax: 845-298-4555
www.laerdal.com

Page 190
PRODUCT: IV House UltraDressing
DESIGN TEAM: Bryce G. Rutter, Ph.D.
Metaphase Design Group, Inc.
12 South Hawley Road
St. Louis, MO 63105
Phone: 314-721-0720
Fax: 314-863-2480
www.metaphase.com

Page 194
PRODUCT: SenseWear Armband and Innerview Software
DESIGN TEAM: Chris Kasabach, Vanessa Sica, Ivo
Stivoric, Scott Boehmke of BodyMedia, Inc., Jason
Williams of K Development, Inc.
INTERFACE DESIGN: Chris Pacione, John Beck, Steve
Menke, Eric Hsiung of BodyMedia, Inc.
BodyMedia, Inc.
4 Smithfield Street, 12th Floor
Pittsburgh, PA, 15222
Phone: 412-288-9901 x1217
www.bodymedia.com

Page 198
PRODUCT: Infiniti 500 Rollator
DESIGN TEAM: Bjarki Hallgrimsson, Sarah Dobbin
Hallgrimsson Product Development
360 Summit Avenue
Ottawa, Ontario, K1H 5Z9
Canada
Phone: 613-858-4363
www.hallgrimssonproduct.com

Page 202
PRODUCT: HeartStart Home Defibrillator
DESIGN TEAM: Kurt Fischer, Seiya Ohta, Jon Bishay
Philips Medical Systems
2301 Fifth Avenue
Seattle, WA 98121
Phone: 866-DEFIBHOME
www.heartstarthome.com